*Venetian Renaissance
Fortifications in the
Mediterranean*

Venetian Renaissance Fortifications in the Mediterranean

Dragoș Cosmescu

McFarland & Company, Inc., Publishers
Jefferson, North Carolina

LIBRARY OF CONGRESS CATALOGUING-IN-PUBLICATION DATA (new form)

Names: Cosmescu, Dragoş, author.
Title: Venetian Renaissance fortifications in the Mediterranean / Dragoş Cosmescu.
Description: Jefferson, North Carolina : McFarland & Company, 2016 | Includes bibliographical references and index.
Identifiers: LCCN 2015041705 | ISBN 9780786497508 (softcover : acid free paper)
Subjects: LCSH: Fortification—Italy—Venice—History. | Fortification—Mediterranean Region—History. | Fortification—Cyprus—History. | Fortification—Greece—Crete—History. | Fortification—Greece—Kerkyra—History. | Venice (Italy)—History—1508-1797. | Venice (Italy)—History, Military. | Renaissance—Italy—Venice.
Classification: LCC DG676.8 .C67 2016 | DDC 909/.098224—dc23
LC record available at http://lccn.loc.gov/2015041705

BRITISH LIBRARY CATALOGUING DATA ARE AVAILABLE

ISBN (print) 978-0-7864-9750-8
ISBN (ebook) 978-1-4766-2018-3

© 2016 Dragoş Cosmescu. All rights reserved

No part of this book may be reproduced or transmitted in any form or by any means, electronic or mechanical, including photocopying or recording, or by any information storage and retrieval system, without permission in writing from the publisher.

Front cover: *top* Heraklion—Castello del Molo at the entrance of the harbor; *bottom* Corfu—the ditch, the Savorgnan bastion and the southern part of the Old Fortress (photographs by the author)

Printed in the United States of America

McFarland & Company, Inc., Publishers
Box 611, Jefferson, North Carolina 28640
www.mcfarlandpub.com

Table of Contents

Acknowledgments vii
List of Figures ix
Foreword by Elisabetta Molteni 1
Introduction 5

Part I. The Republic of Venice 11
1—Venice and the Sea 11
2—The Venetian Strategy of Defense 20
3—The Art of Fortification in the Renaissance 25

Part II. The Island of Cyprus 39
4—Nicosia 43
5—Famagosta 53
6—Cerines 71

Part III. The Island of Crete 74
7—Candia 85
8—Canea 109
9—Retimo 128

Part IV. The Island of Corfu 139
10—Corfu 143

Part V. The Defenses Under Attack 170
11—The War of Cyprus, 1570–1574 173
12—The War of Candia, 1645–1669 180

13—The War of Morea, 1684–1699 189
14—The War of 1714–1718 192

Conclusion 199
Appendix I: Chronology 203
Appendix II: Glossary 206
Appendix III: Table of Architectural Features 208
Chapter Notes 209
Bibliography 217
Index 225

Acknowledgments

I would like to extend my gratitude to the many people who have supported me throughout my research, especially Elisabetta Molteni (University Ca Foscari, Venice), Guido Candiani (Laboratorio di Storia Marittima e Navale, Genoa), Gheorghe Stoica (University of Bucharest), Mauro Scroccaro (Marco Polo Systems g.e.i.e), Grigore Arbore Popescu (ISMAR, Venice), Piero Lucchi (Correr Museum), Carlo Urbani (Istituto Veneto di Scienze, Lettere ed Arti), Anna Turcato (Studium Venezia), Codruta Zus (Univ. Bucharest), Amalia Tsitouri (Hellenic Ministry of Culture), Elisabetta Sciarra (Biblioteca Nazionale Marciana), and Diego Paganini (Adrifort Project).

List of Figures

Figure 1. Lion of S. Marco, symbol of Venetian sovereignty, present all over her territories. Shown here is one in Famagosta, Cyprus. — 14

Figure 2. Cannon of French origin, Famagosta, on the premises of the ruined Palace of the *provveditore* — 25

Figure 3. Drawing of a bastion by Buonaiuto Lorini, 1597 — 28

Figure 4. The elements of the idealized bastioned front in the 16th–17th centuries (courtesy Niculae Cosmescu) — 32

Figure 5. Venetian mortars at the start of the bridge of the Old Fortress, Corfu — 34

Figure 6. The cathedral of S. Sophia (left) and the Orthodox church of S. Nicholas (right) — 44

Figure 7. Caraffa Bastion, flank and *orecchione*. On the other side of the bastion is Porta Giuliani — 46

Figure 8. Francesco Valegio, Nicosia; In insula Cipri metropolis fertilissima (1625) — 47

Figure 9. Salient of the Caraffa bastion — 48

Figure 10. Recessed eastern flank of the Podocattaro bastion — 48

Figure 11. Porta del Provveditore. Note the width and height of the adjacent curtains — 49

Figure 12. Porta Giuliani, exterior view — 50

Figure 13. Porta Giuliani. The main hallway with the city exit in the background — 50

Figure 14. Porta San Domenico, with ramps. The wall on the right is in North Nicosia — 51

Figure 15. S. Sophia Cathedral, Famagosta — 54

Figure 16. Giovanni Francesco Camocio, *Famagosta*, 1574 (detail) — 56

Figure 17. The level of the moat; the Arsenal bastion to the right and the Camposanto in the background — 58

Figure 18. Camposanto cavalier and bastion; background left, Andruzzi cavalier and bastion — 59

Figure 19. Arsenal tower and curtain — 60

List of Figures

Figure 20. Foreground: terreplein above the entrance to the Andruzzi bastion; background: Camposanto cavalier and bastion — 61

Figure 21. Background: wall with embrasures, Andruzzi bastion; foreground: Camposanto cavalier — 62

Figure 22. Interior layout of top platform of the Camposanto bastion — 62

Figure 23. Sea Gate—town side, with large lion statue — 63

Figure 24. Entrance to the Citadel — 64

Figure 25. Del Mezzo cavalier, the largest cavalier in Famagosta — 64

Figure 26. Descent to the *piazza-bassa* of the Martinengo bastion along the S. Luca cavalier; ramp and platform of the bastion — 65

Figure 27. The cavaliers on the sides of Martinengo; ascending and descending ramps. Note the size of the structures, compared with church on the left — 66

Figure 28. Looking south from the flank of Martinengo; *piazza-bassa* below — 67

Figure 29. From the face of Martinengo bastion, looking south: Pulacazzaro bastion, Moratto bastion and cavalier and, lastly, the cavalier and the Land Gate. Diocare is hidden behind Moratto — 67

Figure 30. Land Gate with its ravelin and cavalier, with current access bridge. Note the original drawbridge door in the southern face of the ravelin — 68

Figure 31. The current town gate, the Land Gate, and ramps to the curtain and cavalier — 69

Figure 32. Inner structure of the ravelin of the Land Gate — 69

Figure 33. Southeast corner tower and curtain — 72

Figure 34. Filling between the old Lusignan walls and entrance (left) and the Venetian curtain (right) — 72

Figure 35. Castelfranco; gate and southwest corner tower — 78

Figure 36. Grabusa. View from above the gatehouse, towards Grimani Bastion — 80

Figure 37. Spinalonga, view from the southeast — 81

Figure 38. Inside Mocenigo fortification — 81

Figure 39. Suda, view from north (Akrotiri peninsula). Foreground left, the bastions of Martinengo and Michele — 83

Figure 40. View of the Martinengo and Michele bastions and Mocenigo cavalier — 84

Figure 41. Loggia of Candia — 87

Figure 42. Arsenals in Candia — 90

Figure 43. Castello del Molo at the entrance of the harbor — 91

Figure 44. Vincenzo Coronelli, *Pianta del Castello di Candia*, 1696 — 91

Figure 45. From the roof of Arsenali Nuovissimi, looking east, from the left: Sabbionara bastion, Zane cavalier, and the old sea walls — 92

Figure 46. Vincenzo Coronelli, *Pianta della Real Fortezza e Città di Candia*, ca. 1690 — 94

Figure 47. Santo Spirito ravelin, from the S. Andrea curtain — 97

List of Figures xi

Figure 48. Panigra bastion, northern recessed flank. Note the postern in the *orecchione* — 98

Figure 49. Panigra Gate, exterior — 99

Figure 50. Gate to Bethleem bastion — 100

Figure 51. View from the southern flank of Bethleem. In the background, Martinengo cavalier, bastion and ditch — 101

Figure 52. S. Giorgio Gate — 103

Figure 53. S. Giorgio flank, with the S. Giorgio Gate and arches of the Venetian aqueduct — 104

Figure 54. View from the salient of Venier bastion of Fort S. Dimitri — 105

Figure 55. *Piazza-bassa* in the flank of S. Francesco — 107

Figure 56. Arsenals in Canea — 111

Figure 57. Medieval tower as base for later constructions — 112

Figure 58. Porta del Colombo — 114

Figure 59. Vincenzo Coronelli, *Città e fortezza della Canea, pianta*, 1696. South is up — 116

Figure 60. Embellished entrance on the second floor of the S. Salvatore barracks — 118

Figure 61. Remains of the Genoese Torrione — 120

Figure 62. Gritti bastion, with the obtrusive Xenia Hotel (now gone) — 121

Figure 63. Lando cavalier, west view — 122

Figure 64. Schiavo bastion and square cavalier — 123

Figure 65. Retimiotta *piattaforma*, with S. Maria cavalier, looking west — 124

Figure 66. Santa Lucia salient — 124

Figure 67. Western curtain, cut right next to the vault of the sealed Sabbionara gate. Note the structure of the wall — 125

Figure 68. Overview of the citadel of Retimo, from the south — 128

Figure 69. Olfert Dapper, *Vesting van Retimo*, 1702 — 130

Figure 70. The curtain wall being demolished between Sta. Barbara and S. Veneranda bastions — 130

Figure 71. Bastion of S. Paolo, with many buildings in the background — 132

Figure 72. Sta. Elia and S. Paolo bastions — 134

Figure 73. S. Luca cavalier — 135

Figure 74. Salient of S. Paolo bastion, with sentry box — 136

Figure 75. On top of S. Luca bastion, looking towards Sta. Elia. Vaulted casemates of the *piazza-bassa* in the foreground — 137

Figure 76. Southwest view of the Dandolo fortified country house — 141

Figure 77. View of Spilia and Campiello neighborhoods from the New Fortress. The twin peaks of the Old Fortress are in the background — 143

Figure 78. View of the building of the Spilia Gate, town side — 146

List of Figures

Figure 79. Vincenzo Coronelli, Corfù, *Città e Fortezza*, 1689 — 147

Figure 80. Jan Jansson, *La Cita de Corphv*, 1657 — 148

Figure 81. Vincenzo Coronelli, *Fortezza Nuova di Corfù e Fortezza Vecchia*, 1689 (detail; south is up) — 149

Figure 82. Martinengo bastion, seen from the glacis — 150

Figure 83. View of the Martinengo's flank from the ditch below the bridge — 152

Figure 84. The ditch, the Savorgnan bastion and the southern part of the Old Fortress — 152

Figure 85. Savorgnan bastion and cavalier as seen from the Versiata tower — 153

Figure 86. The Sea Castle, with the British hospital in the foreground — 154

Figure 87. Panorama of the old town taken from the top of the Land Castle — 155

Figure 88. Overview of the lower ward of the Old Fortress, on the north side — 155

Figure 89. Military constructions of various periods, towards Caposidero — 157

Figure 90. Vincenzo Coronelli, *Corphou*, 1696 (detail) — 158

Figure 91. Sarandario bastion and curtain — 160

Figure 92. Vincenzo Coronelli, *Fortezza Nuova di Corfù e Fortezza Vecchia*, 1689 (detail; east is up) — 162

Figure 93. Land gate to the New Fortress — 162

Figure 94. New Fortress. Note the sheer height of the structure — 163

Figure 95. The ditch and the flank of the Sette Venti bastion — 165

Figure 96. Magazine sunken in the terreplein of the Sette Venti bastion — 165

Figure 97. Tunnels inside the New Fortress — 166

Figure 98. The Scarpone hornwork — 167

Figure 99. Face of bastion Sei Venti, with ditch and hornwork — 168

Figure 100. Giovanni Francesco Camocio, *Famagosta*, 1574 — 175

Figure 101. Ruins of the Church of Sta. Annunziata in Corfu, where the fallen from Lepanto were buried. Note the effigy on the right side and the typically Italian bell-tower — 178

Figure 102. *Citta' della Canea*, map of the siege of Canea in 1645 — 182

Figure 103. *Pianta della Citta' et Fortezza di Retimo*, 1646 — 184

Figure 104. *Pianta della citta di Candia assediata dall'armata ottomana con il terzo attacco fatto dal Gran Visir l'anno 1667 sotto il Generalato dell'Ecc.* Antonio Barbaro, 1667 — 187

Figure 105. Bust of Morosini as doge, on the wall of the Venetian Loggia in Corfu — 191

Figure 106. Vincenzo Coronelli, *Corphou*, 1696 — 192

Figure 107. View of the Abraham hill from the New Fortress. Sette Venti in the foreground — 194

Figure 108. Schulenburg still watching over the fortifications of Corfu — 195

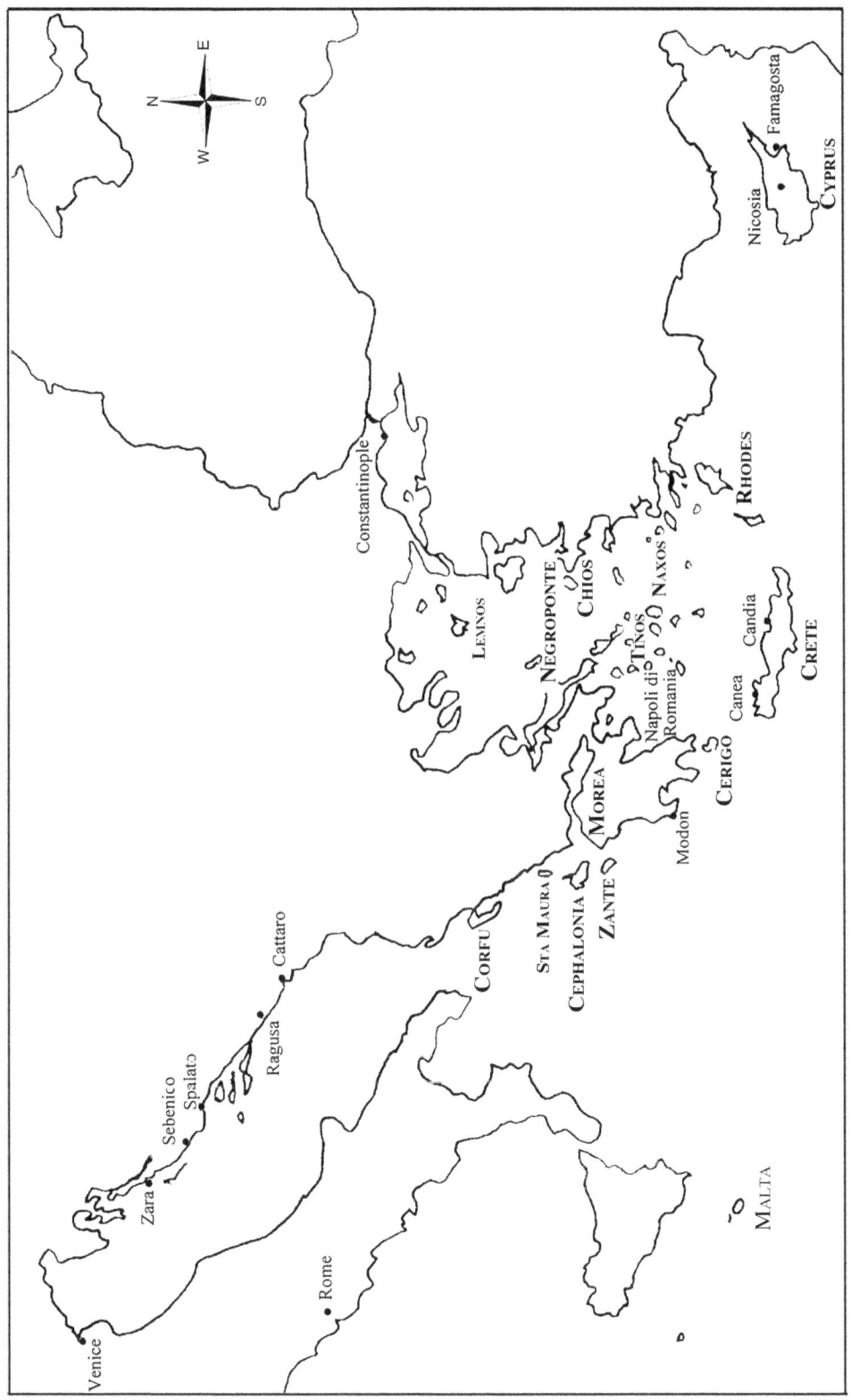

Main cities and territories in the Renaissance Mediterranean.

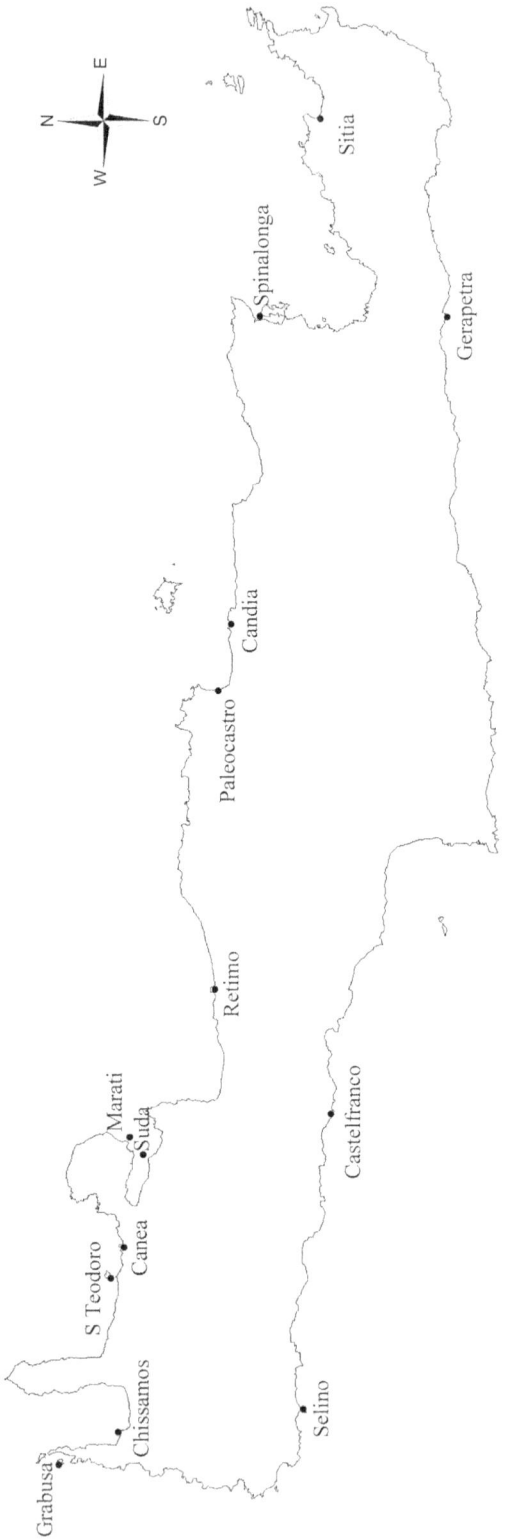

Main cities and fortresses in Venetian Crete.

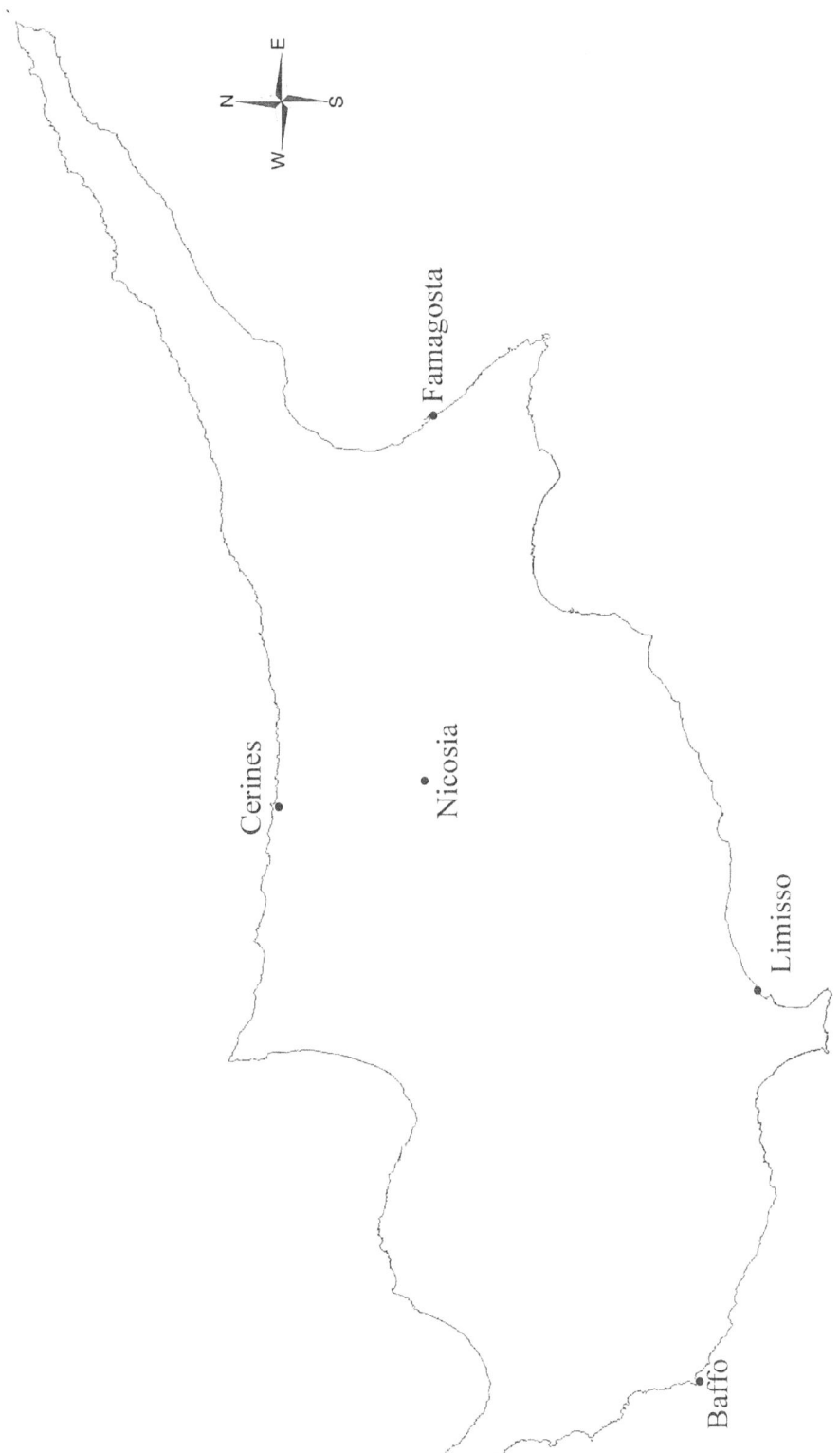

Main cities and fortresses in Venetian Cyprus.

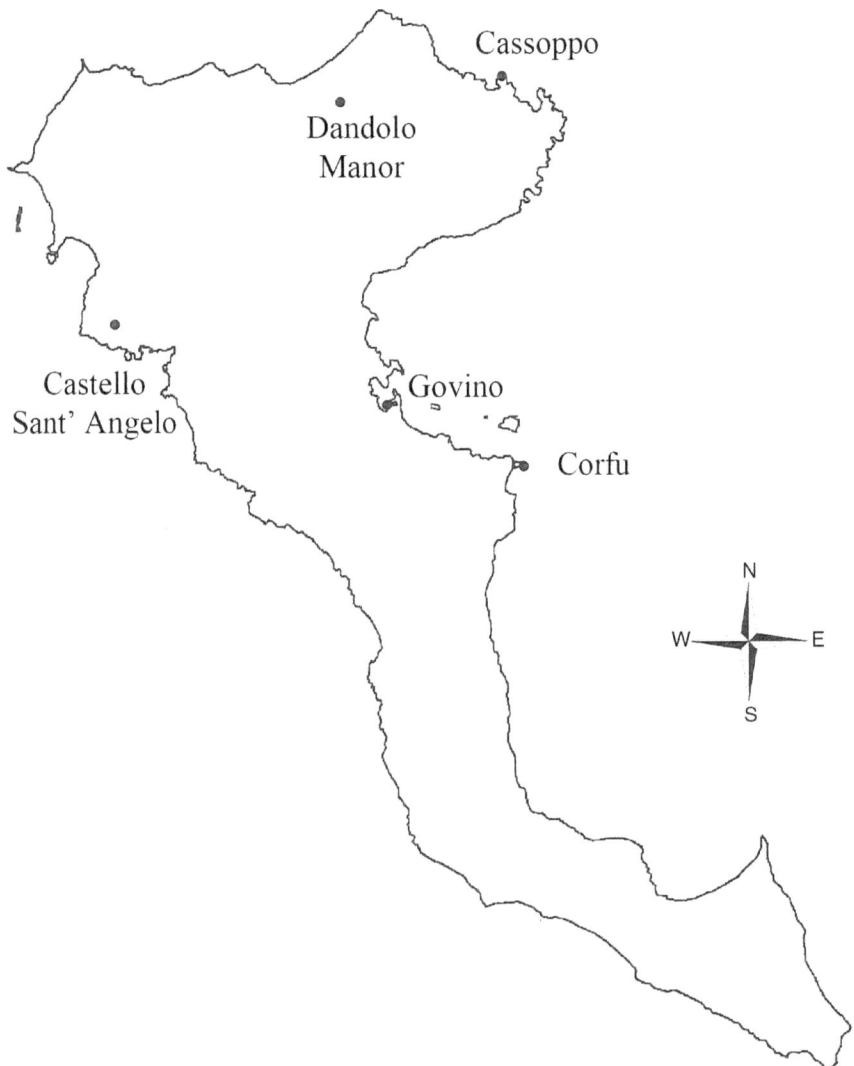

Main cities and fortresses in Venetian Corfu.

Foreword by Elisabetta Molteni

This book offers an overview of the Venetian fortifications in the Mediterranean on the three places that, over the centuries, have played a decisive role in the history of the Republic: the islands of Corfu, Crete and Cyprus. In the global strategies of defense of the Venetian state, the city of Corfu, governed uninterruptedly by Venice from 1386 until the fall of the Venetian Republic (1797), is the defensive outpost of the capital, thanks to its geographical location at the mouth of the Adriatic, the stretch of sea which, with due pride, historical maps call the *Gulf of Venice*. The island of Crete (named Candia in the Venetian documents) belonged to the Serenissima from the early years of the 13th century until the Ottoman conquest of the place in 1669, although some strategic outposts survived under the control of Venice until the beginning of the 18th century. Finally, Cyprus, another large island of the eastern Mediterranean, which belonged to the Republic for a shorter period, between the 15th and 16th centuries, was a place of considerable importance not only from a strategic point of view but given the very special political and institutional arrangements used by the Republic in appropriating it. The present text opens with a discussion on the general aspects of the history of Venice and the military arts and, followed by three chapters dedicated to each of these territories, the volume concludes with a section on the main episodes of war and siege that affected the major strongholds of the three islands, from the siege of Nicosia (1570) to that of Corfu (1716).

This approach is certainly very interesting in many respects, since these three islands allow us to follow the history of the Republic along much of its existence, and represent different Venetian ways of designing and practicing the government. This approach it is very demanding and presents some risks that should not be understood as limitations: indeed, these risks could be the starting point of useful ideas for further studies of academic nature. But let's proceed in order.

It is not easy, for the modern mind, to identify the reasons that have allowed the city of Venice to exercise such a vast and praised power throughout the Mediterranean for many centuries. Certainly this result was not achieved thanks to the use of force or through a particularly aggressive military policy. The tools that allowed Venice to become, in the Middle Ages, a partner of the Eastern Roman Empire and, later, to maintain its autonomy thanks to a position of neutrality whether towards the large territorial states of Europe of the Modern Age, or towards the Ottoman Empire, were of a different nature.

The main tool of the Serenissima was certainly her ability to govern, primarily through

the construction of a very complex and detailed institutional system, in which a multitude of Magistracies assured the regulation and administration of the main aspects of public and social life. At the same time, the system allowed a relatively small group of people to firmly keep under control all the most important political decisions. The Venetian aristocracy was certainly one of the strengths of this system, both in the Middle Ages and in the first centuries of the modern era: a cultivated ruling class, educated in the spirit of foresight and international scope, equally attentive to the innovations of science and perfectly aware of the effectiveness of political and cultural propaganda.

Another key "weapon" of the Republic was the great attention in administering its domains. Official representatives of the State, each with different tasks, were present in considerable numbers and widespread throughout the ruled territories, and informed in detail the Senate in Venice on any administrative and patrimonial matter, even the most minute, so that each decision could be included in the comprehensive plan of the government. Literally, rivers of ink were spent in the correspondence between Venice and these representatives to inform, monitor and seek a balance between the goals of the State and the demands and expectations of the community and the nobles. Thus, as any other "government work" involving all aspects of social and economic life, the implementation of any fortification in the *Stato da Mar*, after being evaluated by the local representatives of the Republic and the community, must be examined and authorized directly by the leading institutional organs of the State, the Council and the Senate in Venice.

This synthetic overall picture, however, though essentially very true, is somewhat different throughout historical moments so that, in fact, corresponds to different "Venices." It would be very simplistic to think that the Venetian state has ruled these places with the same tools, the same principles and in the same way from the Middle Ages to the late 18th century. Despite the fact that, since the 16th century, the political propaganda of the Serenissima has emphasized aspects of perfection and continuity of its government, in Venice between the Middle Ages and Modern Age everything changed: the institutional framework, the concept of sovereignty, the government objectives and finally, not only the role of the army and of the fortifications, but also the techniques and tools of the military art.

The first challenge of this book is therefore to accept the need for some simplifications in order to regain the essential big picture. In the first part of the book ("The Republic of Venice"), for example, the reader will find, in concise pages, a synthesis of many aspects of Venetian history, each of which would otherwise require many readings to be fully understood since we're dealing with grand historical themes: to give just a few examples, the relationship between Venice and the sea, the role of the Arsenal in commerce and armed forces, and the role of architecture in the development of the modern fortification system are all issues on which to bring together all existing studies would occupy entire libraries. So this summary inevitably presents certain simplifications but indeed allows, especially those who are becoming familiar with these topics, at first to grasp the meaning of the fortifications: a historical and cultural heritage of the highest importance, not just as architectural works of great technical and cultural value, but also as works that represent the history of a state and the condition of its population.

The work plan of Dragoş Cosmescu, in his examination of the Venetian military architecture on these three islands is without a doubt, as previously said, interesting and original. Focusing the research interest on the major islands allows us to consider, first of all, one of

the most peculiar aspects of the Venetian state, which is the shifting of its territorial boundaries over the centuries. The continuous system of cities and ports that went from the Adriatic to Cyprus, dissolves after 1540, first with the loss of Nauplia and Monemvasia and then with that of Cyprus (Famagusta falls in 1571). After Lepanto (1571), the task of controlling the routes of the Eastern Mediterranean lies entirely on Crete, which will be exceptionally held, until the fall of Candia (Heraklion) in 1669. Apart from the reconquest campaign at the end of the 17th century, which will be headed by Francesco Morosini (aptly named *the Peloponnesian*), there will be no more Venetian bases in Morea. Subsequently, the Republic founded its rule primarily on the control of cities and commercial and strategic posts, rather than on substantial territorial possession. This factor is also of fundamental importance in understanding the reasons why Venice preferred to strengthen some places rather than others. The main interest of the Venetian state is to maintain open the sea routes necessary for trade and communication with the capital. These are thoroughfares for the transit of diplomatic information and indispensable tools for the military. One could even argue that the fortifications of the main cities in the *Stato da mar*, as well as the existence of strongholds of a more particularly military destination, are primarily related to the control of sea routes, but although this aspect is central to the organization of the defenses, other factors, as documented by the events and manuscripts, are considered equally important: the safety of the spaces where commercial and productive activities are developed, the places where the representatives of the government reside, the safe haven for the population of the city and the surrounding territory. The system of defenses intervenes significantly in the physical configuration and the organization of public spaces of the city. The islands examined in this book represent very well these complex and ample problems.

The main defenses built between the 15th and 17th centuries change on the basis of several factors: the consistency of the defended territories is different, different systems are used for defense, and especially different are the cultural, intellectual and administrative premises on which the complex defenses of the city and the territory depend. Indeed, to focus the fortifications to the basic applications of technical and military knowledge, to consider them only through the analysis and description of the defensive systems constructed, would be to overlook important historical and cultural significance of these buildings that is brought by the transformations of political, administrative, cultural and intellectual knowledge of their age.

Of course, the places researched by Dragoş Cosmescu do not lack studies in political and economic history, history of the art and the city life, so the author's choice to bring them together in a joint and comparative framework deserves due consideration, and is certainly the newest and most interesting aspect of this work. The author had to tackle a huge mass of studies: first of all, with an important number of Venetian documentary sources, either manuscripts or prints, with maps and documents that reconstruct the physical layout of these places, and especially with the research results of scholars coming from the many European nations to which these territories now belong. Indeed, it is very difficult to bring together different knowledge, skills and research perspectives. To study the works of architecture in relation to their conservation and protection is different depending on their significance in the framework of the design choices or public policies. All too often studies have parted ways because of the lack of communication due to differences of ideological language: if the military works are in fact protection that the government offers to its subjects, at the same time they

could be interpreted as an instrument of oppressive power with respect to local communities. The Cosmescu book certainly uses a thorough and wide selection of the key documents and key studies, from different backgrounds and with different research perspectives.

Another interesting aspect of this book is the idea to reconstruct the historical events starting from the sites, from their works, not neglecting but in fact also considering as a starting point precisely their present condition. The pictures in the book are also documents that may be useful in future studies. Each description is preceded by a brief note that allows the reader to identify the main events that took place around these sites, examined first under the Venetian government and then under their other various fates.

Special attention is also due to the description of military events that took place in the main centers of the islands (in the chapter "The Defenses Under Attack"). Starting from this research, and using an approach that in recent studies has been very useful, you can certainly better determine how the transformations of the fortification systems are largely linked particularly to the military actions in which they featured. This is, in my opinion, another interesting aspect of the work, the ability to present to a large audience (and not just the one interested in the military fortifications but also history in general) a very broad view of the historical significance of the described places.

Finally, this book presents geographical areas that are perhaps little known to the general public (a relatively "exotic" panorama) but which are of great interest to European history. These regions still preserve, in the configuration of the cities and their architecture, the testimonies of their history and also have an important role in the Mediterranean politics of today.

Elisabetta Molteni is a professor of history of architecture in the Department of Humanities of the Ca' Foscari University at Venice. She has studied various aspects of Mediaeval and Renaissance architecture and the city, with particular respect to Venice and North Italy. Her main interest lies in the relationship between the knowledge of architecture and institutions and society. This is the context of her studies of Venetian military architecture in the 17th and 18th centuries in Venetian States "da Terra e da Mar" (1998, 2001 with Ennio Concina, 2004) in Candia (2008), Corfu (2006) and Zara (2014).

Introduction

Throughout the world, Venice stands out as a prime example of an embellished city of the Middle Ages and the Renaissance, whose seafarers were masters of the Mediterranean. The Republic of Venice herself is a symbol of good government and political equality. She rode the waves of time with the tenacity of her famous galleys, and through trade, diplomacy and war carved for herself a prominent, permanent place in world history.

The territories she commanded stretched from the north of Italy to the lands of the Levant. Venice was at the forefront of all visual, literary and performing arts, but also science and technology, and she made constant efforts to protect her people and interests. The best preserved of the fortresses of the Renaissance bastioned style are to be found in the Levant, although Lucca, Bergamo, Verona, Grosetto and many other towns of the Italian peninsula retain to a remarkable extent their historical walls from the 16th century. Venice's erstwhile islands contain some of the most perfectly preserved examples of Renaissance military architecture, whose sheer scale and tumultuous history compels a closer look.

In the eastern Mediterranean, the town of Corfu and the forts on the islands of Crete and Cyprus attest the magnitude of the Venetian Republic. These walled cities and fortresses offer an interesting study of the ingenuity and fertility of invention in overcoming the natural obstacles and difficulties of the sites. Places such as Canea, Corfu and Retimo unveil picturesque old towns that retain a lot of their Renaissance splendor, bearing strong resemblances to the city of Venice itself.

The present book is more than a catalog of research into the Renaissance fortifications; it sets out to present to a larger audience the majestic beauty of this land art. The large, town-size fortifications, with their solid bastions and monumental gates, are a representative example of the art of defense in the Renaissance, and the ones on the islands of Cyprus, Crete and Corfu are some of the most impressive monuments of their kind in the Mediterranean. Their importance for the study of fortification architecture is high, since they are some of the most exquisite that survived in Europe, both structurally and aesthetically.

The cultural significance of these monuments came to the attention of the UNESCO itself—the main body in charge of the preservation of cultural heritage of universal importance. From an initial project involving the scientific communities in Italy, Greece, Croatia and Montenegro and debated throughout 2012–2013, eventually five proposals were filed with UNESCO for their inscription on the list of world heritage monuments on the grounds of their outstanding universal value. These submissions were filed from October 2013 to Feb-

ruary 2014 and address the fortresses of Terraferma (Peschiera del Garda, Bergamo, Palmanova, Venice and Chioggia), and, separately, the "Venetian works of defense between the 15th and 17th centuries" in Croatia, Montenegro and Greece, while the island fortress of Spinalonga received its own individual nomination.

The Renaissance was a revolution of ideas, and architecture was one of its frontrunners. Of the various branches of architecture, the first to break away completely with the past was military design. The Venetians had the will, the need and especially the means to implement the construction of strong and expensive defenses. These were built according to the Italian fortification system, with bastions joined by straight sections of thick curtain wall, slanted outwards to make projectiles bounce off without serious damage to the stone masonry structure.

Renaissance artists also concerned themselves with military architecture, either from a scientific background, such as Galileo Galilei, who wrote *Trattato di fortificazione* (1593), or with a focus on sculpture and architecture, such as Michelangelo Buonarotti, who proposed plans for various fortresses in the lands of the popes (e.g., Civitavecchia). There are also important theorists of the Renaissance military design—called at the time *fortificazione alla moderna*. Venice herself nurtured such thinkers as Girolamo Maggi, *Della fortificatione delle città* (1564), Buonaiuto Lorini, *Delle fortificazioni* (1596), and Francesco Tensini, *La Fortificatione, guardia, difesa et espugnatione delle fortezze* (1624).

The Renaissance also enhanced the tradition of the historical account. The political events of the period are richly captured in Paolo Paruta's *Storia Veneziana* (1599) or Girolamo Brusoni's *Della Historia d'Italia, dall' anno 1625 fino al 1679* (1680). There were ambitious regional chronicles, from the oldest times to the contemporaneity, like Andrea Marmora's *Della historia di Corfu* (1672) and Etienne de Lusignan's *Chorograffia et breve historia universale dell'isola di Cipro principiando al tempe di Noe per insino al 1572* (1573).

A remarkable feature of the Italian Renaissance is the accuracy and wealth of information and detail found in the war chronicles. Accounts on the war of Cyprus are given by Pietro Valderio in *La Guerra di Cipro* (1573), Paolo Paruta in *Guerra di Cipro* (1572) and Giovanni Pietro Contarini in *Historia delle cose sucesse dal principio della Guerra mossa da Selim Ottomano a Venetiani* (1572).

The War of Candia is recalled in the chronicles of Sertonaco Anticano, *Frammenti istorici della guerra di Candia* (1648); Andrea Valerio, *Historia della Guerra di Candia* (1679); Bartolomeo dal Pozzo, *Historia della sacra religione militare di S. Giovanni Gerosolimitano detta di Malta* (1715); and Johann Bernhard Scheiter, *Novissima Praxis militaris oder Neu-vermehrte, und Verstarckte Festungsbau und Kriegsschul* (1672). In fact, Scheiter was actively involved in the group of engineers and artillery officers defending the city of Candia in the last years of its siege, and his book is organized as a theoretical manual, with Candia given as a textbook example. Essential for the understanding of the war of Candia are a series of maps depicting sieges, maneuvers and battles throughout the conflict, gathered at the Correr Museum in Venice, under the title *Carte topografiche, piante di città e fortezze, disegni di battaglie della guerra di Candia (1645–1669)*.

Historical maps represent a solid primary source for the study of Venetian fortifications. The stages of development in the art of defense in Western Europe and their implementation in the dominion of the Republic of Venice are documented in rich engravings and drawings. The late 16th century maps of the cities are accurate in their depiction of the features of

walled enclosures, but less thorough when it comes to their proportions. Also from the same epoch we have the good example of the prolific Braun and Hogenberg atlas, *Civitates orbis terrarium* (1572), which offers a bird's eye view over many towns in Europe, including Corfu, Candia and Famagosta.

The quality of Western cartography improved markedly at the start of the following century, and the Venetians arranged careful drawings of the towns and fortifications in the island of Candia, with proper attention to proportions and details: Angelo Degli Oddi, *Città, fortezze, porti, redotti et spiaggie del Regno di Candia* (1601); Giorgio Corner, *Il Regno di Candia* (1625); Francesco Basilicata, *Relatione di tutto il Regno di Candia* (1630); Raffaele Monanni, *Descrizione topografica di Candia* (1631); and Marco Boschini, *Il Regno tutto di Candia* (1651). This Venetian school of cartography was crowned at the turn of the century by the grand figure of Vincenzo Maria Coronelli, author of beautiful cartographical representations: *Morea, Negroponte and Adiacenze* (1686), *Atlante veneto* (1690) and *Teatro della citta* (1693).

For the extensive and modern earthworks in Corfu, the 18th century produced lavishly illustrated maps, with a tremendous level of detail not only of military architecture, but also of street planning and civilian facilities. The Correr Museum gathers many such drawings, particularly large maps from Alessandro Ganassa, Giovanni de Honstein and Giovanni Battista Bragadin.

Developments in technology allowed the production of large-scale plaster and papier-mâché reliefs. From 1692 date a series of astonishingly detailed models of fortresses in the *Stato da Mar* (now at the Naval Museum in Venice), although some of them are mislabeled (Spinalonga, Famagosta, Zante). However, the information presented has exceptionally accurate details, particularly in the case of the fortifications of Suda and Corfu.

Photographic evidence also offers a compelling source of information. The 19th century brought with it the development of photography, and this medium allowed the preservation for posterity of places and moments that man had forsaken, while political developments also opened these islands to Western researchers—details of particular importance specifically for Cyprus and Crete. Upon the former's occupation by the British, in 1878, the photographer John Thompson stopped to immortalize the island on his way to his China travels that made him famous.

In Crete, the final pacification of the island in 1898 opened the way for a thorough investigation of the land art, with an Italian team, headed by Federico Halbher, documenting every Venetian and ancient monument and ruin on the island. The most famous member of this team is Giuseppe Gerola, a young archeologist doubling as the expedition's photographer.

The greatest work on the cultural heritage of Venice in the Mediterranean is undoubtedly the five volume collection by Giuseppe Gerola entitled *Monumenti Veneti nell' isola di Creta: Ricerche e descrizione fatte dal dottor Giuseppe Gerola per incarico del R. Istituto Veneto di Scienze, Lettere ed Arti* (1905–1931). The most important volume for our research is the first, published in two parts; the first part (1905) starts with a general presentation of the context of the Italian research expedition to Crete, a presentation of the premises of the research and a general outline of the island and its archeological features, and then begins the actual analysis of its medieval fortifications. These are continued in a separate volume—marked Volume 1, Part II (1906)—with the *fortificazione alla moderna*, the bastioned fortresses of the Renaissance. Volume 2 (1908) deals with the churches of the island, and Volume 3 (1917) with the public

and administrative buildings, as well as the mansions of the countryside and the urban palaces; finally, Volume 4 presents all the water-related structures (wells, fountains, aqueducts, arsenals), as well as reproductions of inscriptions and heraldry. In all, Gerola's over 1,000 photographs bring to life the Venetian fortifications, private palaces, country mansions, and public monuments—an exceptional effort, since sadly many of these are now gone.

Meanwhile, in Cyprus, the French art historian Camille Enlart had arrived to study the local Gothic architecture, so reminiscent of his native land, and produced *L'Architecture gothique et de la Renaissance en Chypre* (1899), followed by the British George Jeffery with his survey *A Description of the Historic Monuments of Cyprus* (1918). The American interest in the Medieval Greek world was pioneered by Kevin Andrews with his *Castles of the Morea* (1953), a seminal work to this day.

The penchant for the study of the Renaissance on the shores of the Mediterranean started in earnest with the influential French postwar school of history, with Fernand Braudel's *The Mediterranean and the Mediterranean World in the Age of Philip II* (1949). A colossal work in this field is that of Kenneth Meyer Setton; his thousand-page volumes dedicated to the history of eastern Mediterranean, from the political relations between Latins and Byzantines, to Venice and the Habsburgs pitted against the Ottoman Turks being *The Papacy and the Levant, 1204–1571* (1976–1984) and *Venice, Austria and the Turks in the Seventeenth Century* (1991). The books of Frederic Lane and John Rigby Hale bring a particular focus to the glory and glamor of Venice; their studies are continued, in recent times, by people including David Chambers, David Jacoby, Michael Knapton, Benjamin Arbel and Sally McKee.

Interstate cooperation brings together researchers from successor states of the Republic of Venice. Italian academics such as Ennio Concina, Elisabetta Molteni, Piero Lucchi, Guido Candiani and Camillo Tonini have delved into the study of various aspects of the colonial empire: fortifications, arsenals, naval strategy, and cartography. Gianni Perbellini remains to this day the go-to source for Cyprus, while in Greece, the study of Venetian fortifications is exemplified by the teams around Amalia Tsitouri at the Hellenic Ministry of Culture, or Michalis Andrianakis in Crete.

In the last decade, various EU and national programs—Interregional Cooperation Programme INTERREG IIIB Archimed, INTERREG IVC and especially the Regional Law 1/2008 of the Veneto Province—offered substantial funding for architectural restoration and research projects. Thus, the period brought about an impetus of the study and preservation of Venetian defensive structures throughout the Mediterranean, among other aspects of research on the history of the Republic.

The novelty of the present book is that it is among the very few to deal with defensive structures on the three most important and largest islands of the Venetian Republic in the Mediterranean. There are a lot of strong academic works concerning one of them, or even two at a time, but no extensive comparative research by a single author treating all these territories. Comprehensive works on Venetian fortifications have also been produced in the past, but they were collective papers, not individual, and not on this scale. Also, these collective books were reuniting academics and researchers from Italy or Greece, countries with vested interests in the cultural heritage of the Republic of Venice.

The methodology focused on personal and on-site research of the military architecture. Years of explorations of the culturally fertile islands of the Mediterranean have produced an extensive collection of scientific material, which sheds a new light on this topic. Few

researchers make the effort to actually explore all the large, relevant fortresses themselves; in fact, there is little consistent regard for such an extended topic gathered in one individual work.

Primary sources were of paramount importance for this research, and maps, chronicles and photographic collections formed the majority of such archival resources, which offered a rich view, particularly of the elements of fortifications now lost. That these particular fortifications had been subjected to disputed sieges by powerful armies justifies them as indispensable examples for the study of Renaissance military architecture and artillery defenses.

To reconstruct the military systems of defense of Venetian fortresses and strongholds, built along maritime routes in the Mediterranean and oriented towards the sea to protect commercial traffic, we must start by looking at the triggers of such developments, to the history of the Republic of Venice and its relationship with the sea.

The general and military history of the period creates the background for this research on the design and quality of the fortresses and the innovative ingenuity of Renaissance military architecture.

We will proceed with an overview of the history of Venice in the Levant, the philosophy of her expansion and the defense of her territories—which prompted her to focus on the fortification of her ports of call and the development of her brilliant navy. In Part I, we will present the special relationship of Venice with the seas: from dependency to mastery, from humble beginnings to ruler of the waves. The location of the settlement on the islands of the lagoon is a testament to the symbiotic relationship between the people of Venice and the sea, a special bond that lasts to this day in one of the world's most famous, romantic and beloved cities.

Starting with Part II, we will analyze the fortifications erected by the Most Serene Republic on her largest and most important island possessions during the Renaissance: Cyprus, Crete, and Corfu. One part will be dedicated to each of these lands. All these islands had their main cities fortified with state-of-the-art bastioned enclosures in the second half of the 16th century—and since this art evolved in the following decades, Venice kept with the times. As a result, Candia and Corfu had a string of outworks constructed beyond their bastioned circuits, while Nicosia and Famagosta, lost earlier to the Ottomans, didn't feature such important additions.

The third generation of protective works of outlying forts is found in Corfu, built in the aftermath of the victorious defense of 1716 (but not in Candia, lost in 1669 after a siege spanning no less than 22 years). Herein lies the second reason for their order in the book: the chronology of the wars with Turkey which put these fortifications to arduous tests. The bastions of Cyprus were beleaguered in 1570–71, the turn of Crete came in the climactic struggle of 1645–1669, and the final assault on the town of Corfu was in 1716.

We will also take the time to examine the state of the fortifications today, and to observe the extent of their preservation, which brings us the sense of living history when walking around their walls and ditches.

After the theoretical and practical analysis of these fortifications, we will have to inquire how worthy they have proven under attack, whether and how well they withstood the ultimate test of an artillery siege. The all-out wars and gallant defenses are discussed in Part V, where we will see how the good design and professional construction of the fortifications allowed Venice to protect the land and populace and to hold out in face of a huge adversary—the Ottoman Turks.

Note on the Use of Toponyms

Below are the most commonly used toponyms in this book, along with their contemporary versions. These are the names that were used for centuries, and researchers of Renaissance history use them to this day. This book, likewise, uses the traditional Venetian names.

	Venetian Name	Current Name	Current Nation
Cyprus	Famagosta	Famagusta	Cyprus
	Cerines	Kyrenia	Cyprus
	Limisso	Limisso	Cyprus
Crete	Candia	Crete	Greece
	Candia	Heraklion	Greece
	Canea	Chania	Greece
	Retimo	Retymnon	Greece
	Suda	Souda	Greece
	Grabusa	Gramvousa	Greece
	Girapetra	Ierapetra	Greece
	Cerigo	Kythira	Greece
Ionian	Corfu	Kerkyra	Greece
	Cefalonia	Kephalonia	Greece
	Zante	Zakynthos	Greece
	Santa Maura	Lefkada	Greece
Mainland & Aegean	Morea	Peloponnesus	Greece
	Napoli di Romania	Nafplio	Greece
	Modon	Methoni	Greece
	Coron	Koroni	Greece
	Malvasia	Monemvasia	Greece
	Lepanto	Naupaktos	Greece
	Navarino	Pylos	Greece
	Negroponte	Euboea	Greece
	Tine	Tinos	Greece
Dalmatia	Cattaro	Kotor	Montenegro
	Zara	Zadar	Croatia
	Sebenico	Sibenik	Croatia
	Spalato	Split	Croatia
	Lesina	Hvar	Croatia
	Ragusa	Dubrovnik	Croatia

PART I. THE REPUBLIC OF VENICE

1

Venice and the Sea

The image of Venice is compelling. The splendor of the city and its thriving life was unparalleled in the Middle Ages and Renaissance. The public and official imagery boasts that Venice drew its wealth and power from control of the sea, as seen in the allegory of the power of the Republic of Venice, the painting of Giovanni Battista Tiepolo entitled *Neptune Offers the Wealth of the Sea to Venice* (1750), where the god of the seas humbly pays tribute to the enthroned female personification of Venice (in full regalia and protected by the lion of S. Marco). For over seven centuries, every year the Republic celebrated the elaborate and extensive "Marriage to the Sea" ceremony, whereby the Doge—on board his famous galley the Bucintoro—offered a sacred ring to the waters of the Lagoon, claiming the sea in holy matrimony.

From the very beginning of Venice, control of the sea was essential for its defense, to an extent unprecedented and unmatched. Part of the Roman Empire, the settlement of Venice started on the mainland, in the north of the lagoon, but ceaseless barbarian invasions from the 5th century onwards created an unacceptable insecurity that was countered by the establishment of a solid community on the small islands in the lagoon. First settling around the isle of Torcello—where the first cathedral of the republic still stands on the backdrop of snowy mountains, the beautiful Byzantine temple of Santa Maria Assunta[1]—the community then moved southwards to the islands that now lie underneath the town of Venice.

Moving the town from land to water was a defensive strategy mimicking Paleolithic lake settlements. From the start, it meant that defending the waters around the islands was enough to keep the enemy at bay; there was no need of a significant land army, there was no pitched battle to be fought if you simply denied the assailants a landing opportunity. This wisdom became clear when the attack of the Frankish king Pepin of Italy was repelled in the 804 by preventing his makeshift fleet of landing vessels from making for the main islands of the town. The subsequent treaty between the Franks and Byzantines contained specific provisions for Venice tantamount to *de facto* independence.[2]

The logistics of late antiquity and the Middle Ages meant that possessing a strong fleet—or even a functional fleet—allowed you to have an edge over strictly land-based opponents. The proof lies in the fact that Byzantine cities on the coasts of Italy (Taormina, Bari) survived longer after the interior was lost, because they could be resupplied by sea. Another effect was the advent of Italian port towns, growing faster and stronger than those in the interior of the peninsula.

In the case of Venice, its insularity had another advantage: it could rely on itself for protection. Venice was, in fact, a loyal possession of the Eastern Roman Empire at the time of the Exarchate of Ravenna, the Theme of Sicily and the Catepanate of Bari. From the 8th century, after the fall of Ravenna, it had moved towards greater autonomy and, discretely, into independence, but without a violent and sudden break from Byzantium.

The political and cultural links to Byzantium were deep, and it can be asserted that Venice was built as a neo–Byzantine state. The connections with the Roman East were always strong: the title of doge is in fact a corruption of the Roman title of *dux* (duke), which, despite its Latin form, was used extensively in Byzantine administration even after the Hellenization of the state during the emperor Heraclius I (7th century). The early Venetian public buildings were constructed in Byzantine style, most visibly in the churches of Torcello and the ducal chapel of San Marco. The latter was intended as a copy of the important church of All Saints in Constantinople, pantheon of the East Roman emperors and although the main arches on the front now look Gothic, due to later additions, the original Byzantine features of this church are easily recognizable from the courtyard of the Doge's Palace.

In fact, it is a common mistake that S. Marco was the cathedral of Venice, when, at the time of the Republic, it was strictly the chapel of the Doge, while the cathedral was at Torcello and, from 1479, at San Pietro di Castello, where the archbishops' palace also existed. The cathedra was only moved to San Marco in 1807, after the fall of the Serenissima. Even the main burial place for the Doges was not there, but in the large Gothic church of SS. Giovanni e Paolo (San Zanipolo). This is certainly explicable, since the bishopric belonged to the pope, a different entity than the political structures that ensured the governing of the city.[3]

On the sea, Venice faced competition from Byzantium itself, which had maintained a noteworthy navy before 1282, but its true nemesis was Genoa. This northern Italian republic, having mastered the Tyrrhenian Sea by muscling out Pisa and then Amalfi, had taken a similar approach to that of Venice, by establishing its bases and the sources of its wealth in the ports of the Levant. Genoa came directly in conflict with the Most Serene Republic, both in the Holy Land and in the internal affairs of Byzantium, where it replaced Venice, after 1204, as the empire's main sea-trade partner. All this culminated in the War of Chioggia (1378–1381), when the Genoese had the audacity to enter the lagoon itself and even to occupy a town at its southern end (Chioggia).

When the Byzantines recaptured Constantinople in 1261, they granted Genoa substantial trade rights, as well as a number of important posts in the Aegean, particularly the islands of Chios and Lesbos. Genoa then expanded her influence into the Black Sea, establishing many trading stations in the Crimea. As the power of the Byzantine Empire began to be supplanted by that of the Ottoman Turks, the Genoese lost their main ally in the Eastern Mediterranean; a long war with Venice culminated in the Battle of Chioggia in 1380, the Genoese fleet was destroyed and, thereafter, Genoa went into stagnation and decline in the Levant.

The Italian maritime city-states of the Middle Ages trace their origins to the need to develop powerful navies to protect the peninsula from the raids of Muslim pirates. By the 11th century, the Italian fleets had overcome them—helped on land by the Normans, who drove the Arabs out of Mezzogiorno—and then chased them back to the coast of North Africa. Subsequently, the Italian city-states began to take control of the lucrative maritime trade routes in the Mediterranean.

The four most successful maritime city-states were Amalfi, Pisa and Genoa, in the west of the peninsula, and Venice, in the east. Even today (and since the conquest of the whole of Italy by the kingdom of Sardinia) the jack of the Italian navy is quartered with the four coats of arms of their greatest medieval maritime republics, clockwise from the top left: Venice, Genoa, Pisa, and Amalfi.[4]

Amalfi was the first to gain momentum, but it lost out after the Norman conquest of Mezzogiorno encroached on its freedom of movement. This prompted a shift of the Mediterranean trade, to Pisa and Genoa in the Tyrrhenian Sea, and to Venice in the Adriatic, at the very time when the powers of their respective imperial suzerains (German and Byzantine) were waning.

The Crusades opened up many new markets for these maritime states in the East, and the classic conflict between Genoa and Venice started at this time, when they clashed over trading rights, tax privileges, and territorial control of strategic trade posts in the Roman Empire and the Holy Land, then in the 14th century over Cyprus, Crete and control of the islands in the Aegean (the War of Chioggia ignited over the possession of the strategic island of Tenedos).

The star of Venice rose when in 1202 it offered its ships to the less wealthy leaders of the Fourth Crusade (which, unlike the previous two crusades, was not led by royalty) in exchange for military assistance in Dalmatia to take Zara from Hungary in 1203, and in the Aegean, where it orchestrated the downfall of the Roman Empire and the partition of Romania,[5] in 1204.

It is interesting to note that the First and Fourth crusades, which were not led by kings or the German emperor, were the crusades that produced new states and, thus, new sovereigns. Thus petty nobles carved for themselves states in the Levant in 1097–1101, and also from the territory of the Eastern Roman Empire, in 1204.

The other crusades were undertaken by royalty, monarchs who had the financial and military backing of their states, and in most cases even relied mainly on their own fleets to transport them to the Holy Land. When they enlisted the naval support of the Maritime Republics, this was done on equal footing, and the princes were not obliged to commit their forces as mercenaries for the commercial goals of traders. In the crusade of 1202, lesser nobles joined, but no heads of states, and these leaders lacked the political muscle to deal with Venice; they lacked the financials to properly enlist the Venetian ships, and the fact that they were not sovereigns attracted them to the promises of royalty encapsulated in the plan to carve up the Roman Empire.[6]

The doge of Venice, Enrico Dandolo, offered to help the recently deposed Roman emperor Isaac II regain the throne, in exchange for funding that, it turned out, Byzantium no longer had. This so angered the crusaders that they sacked the capital city of the empire, established their own Latin empire and partitioned the Byzantine territories among their allies, including Venice, which received three-eighths.[7] (Eventually, in 1261, the Lascarids and Paleologi of Nicaea were able to restore Constantinople to their empire.)

It was the beginning of the rise of Venice to European power. In 1204, Boniface of Montferrat, leader of the crusaders, ceded his rights over the island of Crete to the Venetians in exchange for money and a number of territorial concessions. Venice laid the foundations of its maritime empire when it began the conquest of Crete and occupied Coron and Modon, two strategic ports in southern Messenia. The second stage of expansion in Romania took place in the last decades of the 14th century, when Venice extended its domination over the

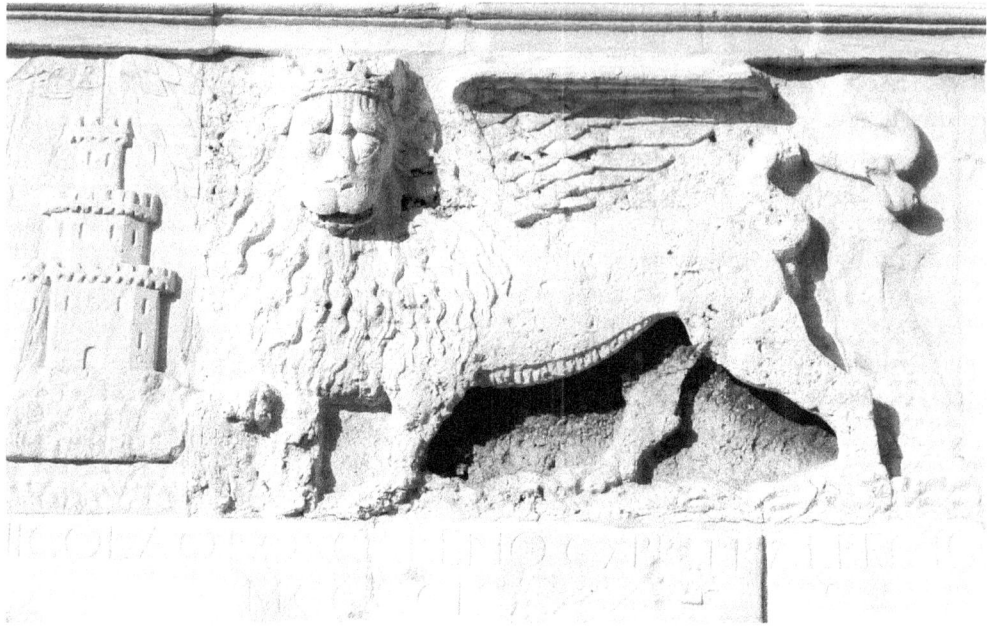

Figure 1. Lion of S. Marco, symbol of Venetian sovereignty, present all over her territories. Shown here is one in Famagosta, Cyprus.

island of Corfu, the whole of Negroponte, and further cities and lordships in the Peloponnesus and the Aegean.

Due to its proximity to home waters, Dalmatia was the object of early Venetian expansion, but high Middle Ages saw only brief control (Zara, Nona, Spalato, Trau[8]) and intense competition for dominion with the Kingdom of Hungary and the Republic of Genoa (late 14th century). Eventually, internecine Hungarian struggles led to the sell of the territory to Venice (1409) and by 1420 the Republic had taken actual possession of the principal port-towns and islands of Dalmatia (except Ragusa). Definitive control over the gulf of Cattaro (Cattaro, Perasto[9]) was also from this period, along with the area known as Albania Veneta (from Budua[10] south to Dulcigno[11]).

The expansion on the Italian mainland (Terraferma, as the Venetians called it) was quick, but came about much later, at the start of the 15th century. Venice had mastery of the shores of the lagoon, to ensure a better defense of its islands, but on the mainland were strong Italian principalities, such as Padua and Verona. Eventually, after much opposition, Venice did manage to break through, taking Treviso in 1389 and Verona, Padua, Vicenza and Belluno in the short period 1404–1406. The Duchy of Friuli was added in 1420, along with the consolidation of territories in the March of Istria, while in the west, Brescia fell in 1426, followed by Bergamo in 1428.[12] From the Duchy of Milan further territories were chipped away over time, such as Crema and Cremona, while in the south Venice made inroads into Romagna and Apulia, but most of these were temporary and largely reversed, after Venice's defeat at Agnadello (1509).

In the late 15th century, particularly after the deaths of Ludovico Morro of Milan and Lorenzo the Magnificent of Florence, Venice took part in many conflicts; its successes elicited such widespread jealousy that it brought about the League of Cambrai—formed by France,

the German Empire, the Papal States and the Duchy of Ferrera—a collective action meant to check the expansion and power of Venice. Fortunately for the Republic, the quick and total success of the French and imperials following the annihilation of the Venetian army at Agnadello (1509) caused a split within the alliance, and the participants changed sides many times. Eventually, Venice recovered all of Terraferma, from Padua to Bergamo, and only suffered marginal losses (particularly the lands in Apuglia, Romagna and Trentino occupied since 1494). After the peace of 1516, the borders of the Serenissima in Italy remained largely unchanged until the end of the republic in 1797.

Venice began her European isolation after this conflagration, although only visibly after Lepanto (1571), missing the major continental conflicts (except a proxy war in Mantua 1629–31 and pan–European wars against Turkey in 1683–1718), but maintaining her independence when most of her peninsular counterparts lost it.

After Venice had acquired the Terraferma, it started focusing on the affairs of the Italian peninsula, largely neglecting its *Stato da Mar*—its first base of power—and, subsequently, its navy—its true base of power. However, by the 1400s new territorial acquisitions in the Levant were getting scarce. The gradual loss of the Frankish Levant (1450–1715) to the Turks meant that the flowering establishments planted by the Italians in the Morea, the Aegean, Cyprus and Crete disappeared, and today almost the only large physical evidence of great commercial colonization of the Middle Ages that remains is found in the magnificently built fortresses of the period.

The Renaissance also witnessed the change of the strategic center of gravity of the world towards the ocean routes and the states that were vying for global reach and control. For those who were cut off from this geostrategic game, decline was inevitable. The Thirty Years' War (1618–1648) brought the collapse of vertical trade with the Germanic countries devastated by the conflict. There were only a few unconcerted attempts by Venetian merchants at action on the high seas. A notable example is a historic voyage of a Venetian squadron around the coast of Africa, aiming for the Gulf of Guinea[13]—the main European area of trade, both in raw materials and slaves, ever since the Portuguese established El Mina, in 1482. This voyage took place too late (1784–1787) to redraw the trade axis of Venice towards Africa and the Americas.[14]

The achievements of Venice should be approached with an eye towards the **organization** of the Most Serene Republic, her administration and her mercantile aristocracy, observing the roles and rights of its nobles (to elect and to be elected).

The Republic of Venice had a very democratic organizational structure, with a strong system of checks and balances. Although it was advanced democratically, this qualification should not be understood in the sense of the term today, when it refers to government by all the citizens of a state. In fact, there was political equality only among the noble families of Venice, not including ordinary people. The political body of the Republic of Venice was limited to a virtual oligarchy, but within this group there was clear equality, and any of its members could run and be elected for any of the public offices, going up to the highest magistracy.

The **doge** (duke) was the highest individual office in the Venetian organization, and the title was conferred for life. The duke was elected by a commission made up of 41 members selected from the Grand Council, and he presided over the sittings of the Grand Council and the Senate. In a world of ever-changing regalia, the image of the Venetian doge is one of the

most recognizable, by its consistency and continuity, from the high Middle Ages onwards (alongside that of the pope). The best known element of ducal identification is the perennial *corno ducale*, a red hat shaped like a horn, worn over the *camauro* (a traditional cap from the papal wardrobe). Whenever a coat of arms is crowned with such a *corno*, it shows that the escutcheon belongs to the doge.

The lodgings of the state leader were in what is now called the Palace of the Doge, but, in reality, the building included the meeting halls of all the major offices in the administration of the republic: the Senate, the Grand Council, the Council of Ten. The concept was that the doge would be readily available to participate in the meetings of the legislative and executive offices of the republic.

The impressive meeting halls of these participative institutions resound even today with a feeling of democratic equality in the heart of the republic. In fact, the one case of a doge wanting to gather more power for himself was that of Marino Faliero in 1354, and he was soon deposed and executed, while being condemned to *damnatio memoriae*; even his place among the frescoes of all the doges, in the huge Hall of Grand Council, was replaced with a black cloth and an epitaph. Thus the name of the large imposing Gothic building called Palazzo Ducale is misleading because it implies an undue personalization.

The **Venetian Senate**, established in 1229, started with 60 members, but was supplemented to about 200 members by the start of the 16th century, when it assumed jurisdiction in political, legislative and administrative matters. Then came the **Grand Council**, which, albeit initially based on an election system, was made into a hereditary council in 1319. Over time, it began to surrender its functions to the Senate, although preserving broad legislative powers on important matters. All Venetian nobles aged 25 and over sat on the Grand Council.[15]

The only other office to which a noble was appointed for life was that of the procurator of San Marco; there were six **procurators** in the Middle Ages, but the number grew greatly in the Renaissance. The position was a recognition of significant involvement in financing the Republic, and it was important because it was crucial in electing the doge.

Finally, the **Council of Ten** was an institution with strong checks and balances, officially composed of ten members, elected for one-year terms by the Great Council. Members of the council could not be elected for two successive terms, and no two members from the same patrician family could sit simultaneously in this council.

These bodies administered the territory of the republic, which was centered on the Dogado (the dukedom), comprising the actual islands of the lagoon, the islets that now are grouped in the township of Venice. On their Italian mainland, the Stato da Terra included the current Veneto, Friuli, Lombardy as far as Bergamo, and, temporarily, Romagna along the coast around Ravenna.

The *Stato da Mar* (State of the Sea) was formed by the lands on Istria, Dalmatia, Albania Veneta, the Ionian Islands, Crete, Cyprus, Negroponte (Euboea), Morea and the Duchy of the Archipelago (numerous small islands in the Cyclades, centered around Naxos, and later Tine).[16]

The cities in the realm of Venice, either in Terraferma or the *Stato da Mar*, had established a civic council, an organization in which the inhabitants of the territory were represented. The number of participants and the functions of the assembly varied. The Civic

Council was generally endowed with deliberating power on a series of matters concerning the city's internal organization.[17]

The territories enjoyed significant degrees of autonomy in self-government, which was exercised by Rectors, who were generally nominated by the local councils. In the main cities, the state duties were undertaken by a Podesta for the civilian and judicial matters, Capitano for military issues, Camerlengho—finances, Castellano—commander of the citadel.[18] These local positions could be superseded by central-nominated offices.

There were also direct representatives of Venice, among which the most important was the **provveditore generale** (general provider), who had tasks such as monitoring and disciplining public officials, and supervising construction of public works (including military). This *provveditore*, as officer sent by the republic to administrate these territories, was also in charge of their military defense.

The powers granted to the *provveditore generale* in all matters political and military made him the top leader of the respective island or group of islands.[19] In exercising his mandate, he could in fact take any action without the validation of the Venetian Senate or civic council of the island. Among his obligations was the writing of detailed reports on all matters concerning the island, at the end of his two-year tenure, and these reports form the basis of numerous firsthand accounts of invaluable source for the historians.[20]

The role of *provveditore* combined civilian and military authority, and the reality was that there was no clear-cut primacy on decision-making, which many times entangled him in legal conflicts with other local or appointed authorities. In moments of such tension, there was also a *provveditore extraordinario*, who had more specific, definite powers of control and intervention.[21]

Earlier, in the Middle Ages, many such attributions were the domain of the **bailo** (bailiff), who was in charge of the judicial and financial affairs (mostly tax collection) of the Venetian community. There is some controversy regarding the equivalence between the position of *bailo* and his other function as the permanent Venetian ambassador in Constantinople. In fact, this was not another position which was sharing the same name; the Ottomans were regulating the affairs of all communities, even internal, by communicating with their highest representative, as a single point of contact—hence the combination of roles under the same title.

Alongside this complex, regulated bureaucracy and administration, the republic used architecture as propaganda for the wealth and progress brought by Venice to their foreign acquisitions. Among the main buildings of Venetian politics in the territories, the loggia was the center of local administrative and social life. Italian political customs demanded the construction of such a public building in the main cities. It served as a stage for civic life. Here were tackled topics concerning various local policies. In towns like Candia, Retimo, Zara, and Lesina there still exist very beautiful loggias, all designed by Michele Sanmicheli.

Besides the organization of the Venetian and other Latin communities in her domain, the republic counted on a majority, native Greek Orthodox population in the Mediterranean realm. Established firmly among the local Greeks, all the French and Italian rulers were faced with the issue of administering this different population with whom they clashed mainly on the problems of religious denomination and freedom, and also on taxation.

In the religious realm, the Catholic governments introduced their rites and at times

actively tried to induce the locals to convert, while supporting the Western clergy and minimizing the state assistance for the Eastern Church.[22] In administration, the taxation was similar to policies enacted in Western feudalism, but somewhat close to the Eastern Roman Empire, which also had a strong state apparatus.

The only firm allegiance was to the deity. Earthly rulers and conquerors had no fundamental bearing on the souls and minds of their subjects, but the line was drawn at religion. Thus, freedom of religion was the most essential element of the political culture of the inhabitants of Eastern Mediterranean. And while the Latins (Franks and Italians) were Catholics and thus proffered the universal dream of the papacy, actively interested in converting their subjects, the Turks gathered all the Orthodox peoples into one group, the Rum Millet.[23]

Thus, all the Eastern Christian peoples, which were mainly Greek and Orthodox, were allowed to practice freely their beliefs and even to rule themselves, to a certain extent. The fact that the religious figure of a local community was treated by the Ottoman authorities as their single point of contact meant that priests and high church officials were also considered responsible for the civil obedience of their ecumenical subjects. This explains why many of the Turkish atrocities in the 19th–20th centuries were directed at religious figures, including the patriarch of Constantinople, the "pope" of the Orthodox world.

It's difficult to properly assess the position of the local Greek Orthodox population towards the prospect of Turkish takeover. While marred by the massacres started in the 1820s and continued throughout the century,[24] the initial reaction in the Aegean basin to the rule of the Ottomans was quite acquiescent, since their administration offered a major advantage compared to the rule of the Latins: the Turks ran their state following the Arab example of dividing the people based on religion. This was actually the common philosophical way of establishing communities in the Mediterranean since the dawn of developed religion.[25]

And so, to this extent, the Greeks did enjoy much more religious freedom under the Turks, than during the Frankokratia (Rule of the Franks).[26] Also, taxation and tax collection were more lax under the Ottomans, who did not have the rigorousness of Catholic Europe, another reason to be at least neutral on the issue of changing the Venetian administration for Ottoman suzerainty. This would backfire dramatically when the true morbidly repressive nature of the Ottoman state was revealed, when actually faced with ethnic discontent and political demands.

As always throughout history, it was important to integrate affluent and industrious natives, in order to secure their allegiance, by not alienating them through the denial of social mobility. Once integrated, these local nobles proved faithful and a great asset in the administration of the entire territory. Basically, this is the success story of the ancient Roman policy throughout the conquered lands in Europe and the Mediterranean. Thus many natives were integrated in the administration and had a share in the riches of the territories, especially in Cyprus and Candia (especially after the end, in 1367, of several Greek uprisings there).

Overall, the Venetian impact was very positive, and with welcome lasting results in a wide array of fields. The islanders experienced the Cretan Renaissance—an unique fusion of both Eastern and Western artistic traditions, from literature to painting, where surged the Cretan School, epitomized by the famous El Greco and represented by Andreas Ritzos,

Michael Damaskenos or Giorgios Klontzas. The memory of that period of prosperous cohabitation is exemplified in the fact that many contemporary Greek names are simply phonetic corruption of Italian names (and, to some extent, even French): *kastelli* from castle, *vourgoi* (suburbs) from burg. To this day, Venetian influence remains evident in several surnames, such as Kornaros (from Cornaro), Dandolos and Dandoulakis (from Dandolo), and Vailakis or Bailakis (from the Venetian office of *bailo*).

2

The Venetian Strategy of Defense

The strategy of defense of the Republic of Venice focused on the navy and the fortification of key territories. This was particularly valid for her overseas properties of the *Stato da Mar*. The paramount importance of these lands for the Most Serene Republic is symbolically revealed in the heart of her central political buildings: on the ceiling of the hall of the Council of Ten (inside the Doge's Palace complex), there are four frescoes of female characters personifying only four of its provinces, and these are specifically Venice, Morea, Cyprus and Candia.

The strategy of Venice centered on the need for better control of her Levantine territories. Communication and control of these lands was ensured by the navy, and the local structures of defense, respectively.

The Arsenals and the Ships

The Venetian fleet dominated the Mediterranean. The Venetian ships were famed and respected throughout the Mediterranean, and their service record was rooted in the shipbuilding capabilities of the Arsenal and the seafaring skills of their crews.

The Arsenal is the utmost identification of an instrument of power for Venice, and the republic developed additional such structures at major stations along its communication lines. Venetian arsenals were important structures, places for ship building, repair and provisioning. Some arsenals had shipyard capabilities (Candia, Canea, Govino, Lesina), while others were meant to store equipment and supplies (Famagosta, Corfu, Cattaro, Zara).

Among the main stations on the maritime trading routes of the Mediterranean were the harbors of Zara, Lesina, Cattaro, Corfu, Modon and Candia, where the Venetian merchant fleet and navy could stop for supplies and repairs. The Venetians relied on their know-how as cartographers to chart the shores and their bays, and their products—*isolari*—were famous and respected throughout the area.[1]

Their mighty fleet would sail out of the lagoon, into *il gulfo* (the Adriatic Sea), calling at Zara, moving to the bay of Cattaro, through the channel of Corfu, stopping for water and shelter in the gulfs of Morea guarded by Modon and Coron, then turning north to Constantinople or continuing east to Crete and further on, to Cyprus and Alexandria.

Many types of vessels were built at the Arsenal. The famous Venetian galleys were armed

merchantmen, and few ships or nations would prey on such dreadnoughts of the Renaissance.

The **galleys** were in fact rowing boats, direct descendants of the Byzantine dromon,[2] a staple ship of the early Middle Ages. The galley was a long, narrow and low ship, equipped with a lateen (a triangular sail) and up to 180 oars; it was 160 ft. long, 20 ft. wide, and held a complement of up to 500 men.[3] The larger galleys, used as squadron leader, were called *lanternas*, which is a direct reference to their having a large lantern post, whose light was used for guidance.[4]

The *galeazza* was the largest of the galleys, designed specifically by the Venetians in the 16th century, and it played an essential role in the victory at Lepanto. The larger ships were usually armed with around 70 iron or bronze cannons of various calibers, arranged on two bridges to form two main batteries. In the lower battery of artillery were placed cannons of bigger caliber, for better balance and for bracing against the recoil effect. On the main deck were placed, of course, the smaller sizes. On the fore and aft castles were distributed culverins in variable numbers.

The *galeazza* was 165 ft. long and 30 ft. wide (40 ft. at the stern and aft castles). It had 340 rowers, as well as three-masted lateen sails. At the bow a tower with elliptical doors for the artillery was built; at the aft there was another castle to accommodate soldiers and artillery.[5] Above the oars there were two defensive parapets protected by four doors for medium-caliber weapons, thus also allowing the broadside to protect the crew. The ship had a complement of about 700 men, soldiers included, and around 30 cannons.[6] But the most important feature of the *galeazza* were the round castles at stern and aft, where a lot of cannons were fitted and could bring massive firepower upon the enemy, much like a round artillery tower.

Because of the size of the *galeazza*, it was very slow and had to be brought to the battle line usually towed by a **brig**, a type of low vessel, with two masts, shipped at 200 to 300 tone. Another kind, the **fusta** (galliot), was a small ship, like a thinner galley, 110 ft. long and 15 ft. wide, with 20 benches on each side and two rowers on each bench.

Created in the 15th century, the **galleon** had a more seaworthy stern, unlike the low bow of the galley, and thus was better suited to deal with the rough sea; coupled with the square sails, this improved the effectiveness of the steering. It had four masts, two with square and two with lateen sails, and was capable of mounting dozens of large and small cannons (demi-culverins).

These types of ships were used in combination in major naval battles, especially in the Dardanelles, where the galleys, in the absence of wind, were useful for rowing and for fighting an enemy fleet that had the same composition.

The rowing boats (galleys, *galleazzas*, fustas, etc.) were manufactured in the Arsenal of Venice, while larger vessels with square sails (such as the galleons) were not a staple of the Venetian navy. They appeared in use during the war of Candia (1645–1669), when they were actually purchased or rented, sometimes complete with crew, especially from Holland and England. (The 30 armed merchant ships hired by Venice were two-thirds Dutch and one-third English).[7]

Eventually, the Venetians saw the value of faster and more maneuverable ships such as the galleon, and started producing them, to a certain degree. As part of the naval reforms issued during and in the aftermath of the long war for Candia, Venice created a special division

of galleons, called *Armia Larga*,[8] which played a significant role in the victories over the Turks in the next conflagration (1685–1699).

At the beginning of the War of Candia, the crews of the 85 galleys of the fleet had to be provided for as follows: Venice had to arm 50 galleys, the cities of Terraferma 12 galleys, Candia 10, Istria two, and Dalmatia (Zara, Spalato, Trau, Cattaro, etc.) a total of 11 galleys.

Manning the galleys with an experienced crew was essential. The clear advantage of the Venetian crews is that they were formed by free men, which meant, first, that they could be counted upon for experience and expertise, and second, especially in the case of the armed merchant galleys, that the rowers could even go out on the deck to help the defense of the ship once it was boarded in hand-to-hand combat. But also there were some condemned men sent to the galleys as punishment, from the realm of the Serenissima, as well as from states without navies, such as Modena, Mantua and the landlocked German states.

Apart from the freemen rowers who could engage in close-quarter combat, on board each Venetian vessel, depending on the tonnage, were one or two companies of regulars, formed by mercenaries hired often in Germany and France. Each company was composed of a captain, two bishops, two sergeants, corporals and 400 men.[9]

The renowned galleys of Venetian times were built to act both as trading ships and as fighting ships, and in this case a complement of free men also helped. The issue of the armed merchant ship was raised by the range of piracy in the Eastern Mediterranean (13th–16th centuries) and then the Western Mediterranean (16th–19th centuries).

Piracy remained widespread throughout the Renaissance, especially in the form of the Barbary States, which terrorized the Mediterranean. In fact, Barbary pirates even arrived off Iceland in 1627 and in 1631 raided County Cork in Ireland.[10] Spain had tried to crush them at their bases but, after initial victories at the turn of the 16th century, Turkish involvement in the affairs of North Africa supplied the pirates with significant resources, and in the end Spain lost Algiers, Bugia, and la Gollette-Tunis by 1574.

Barbary pirate raids targeted coastal areas and merchant ships, and booty included prisoners, who were either sold in slavery or freed on ransom, and merchandise, which was sold as contraband in friendly ports. Muslim pirates operated from major harbors on the north coast of Africa, especially Algiers, Tunis, Derna, and Tripoli, while Christian corsairs used Valletta, Marseilles and Livorno as their bases. The navies of each camp had free license to attack hostile ships and to take possession of the sailors and commercial content. In this context, the Venetian navy reigned supreme, and hardly any pirate squadron dared engage its vessels during the Renaissance. In the Middle Ages, Venetian trade relied on a well-organized system of convoys, consisting of merchant vessels escorted by men-of-war,[11] similar to the Spanish *carrera*, (the famous route that called every year at Cartagena, Porto Bello and Havana on its way back to Cadiz with the riches of the Americas).

The naval battles between galley fleets took place as follows: the galleys would form a battle line, juxtaposed to the extent permitted by length of the oars, and the two enemy armies, at the first shot of the *Capitana* (the flagship), advanced against each other. The ships were useful at a distance because of their larger artillery; but they could not fire too early for fear of missing the target, nor too late because of the danger of being hit first. Then the ships would clash, trying to inflict as much damage as possible with the spur. At the same time the canons were discharged on the enemy, to decimate it before the actual hand-to-hand fight;

then followed the collision and a general melée on the boarded ship (which unless was burned in the battle, was captured, and very rarely sank).[12]

In the field of active duty, the most important magistracy was that of *Capitano Generale da Mar* (Capitain General of the Sea),[13] to all extents and purposes direct commander of the commissioned Venetian war fleet. Among these leaders were renowned figures such as Sebastiano Venier, Tommaso Morosini, Lazzaro Mocenigo, and Francesco Morosini, heroes of the great wars of the 16th–17th centuries.

Venice had to provide land troops for the defense of her islands. In peace time, the garrisons of Crete and Corfu were primarily made up of troops from Terraferma and central Italy (Abruzzi, the Marches, and Emilia), the traditional recruiting source of the Serenissima.[14] Mercenaries were widely used in the land forces too. By the 17th century, the Venetian army counted on Italian and Corsican soldiers, as well as *oltramontani* (literary "people from beyond the mountains"—that is, the Germans) and *oltramarini* (people from beyond the sea—Balkan light cavalrymen). These were the Stradioti (Croats, Albanians, Greeks and Vlachs), skirmishers much appreciated and used by the Venetians in all their conflicts, from Istria and Dalmatia to Crete and Cyprus.

By the late 17th century, many officers and commanders were of foreign origin, such as the Swede Otto Wilhelm Königsmarck, head of the German mercenaries forming the bulk of the Venetian troops that conquered the Morea, and the hero of Venice and Corfu, Saxon marshal Johann Matthias von Schulenburg. Attesting to the large-scale employment of foreigners in direct military commands, there is a marble plate on the left wall of the inner chamber of the gate of Old Fortress of Corfu, naming another German commander, Karl von Kronenburg, and the year 1691.

The Fortifications

The Republic of Venice made up in strong and sound fortifications what it lacked in numbers, and relied heavily on the quality of her architects and constructors for the preservation of her possessions.

In the Middle Ages, the defense policy of the Venetians in the Levant was limited to improving the already existing structures. This was due to the fact that siege warfare did not progress much during this time, so structures that were sound in 1204 were just as good in 1453.

For Venice, it was important to protect its most important communities, and these were town-based, merchant colonies, in the sheltering harbors in the Morea, Crete, and Corfu. This required either a simple citadel or the actual enclosure of the entire city with walls.

The city walls were the first point of reference to travelers and merchants, who were hurrying to enter the gates before sunset or after sunrise. Goods and people moved in the town through the main and auxiliary gates. Guards controlled the entry and exit of people and goods through the gates, which were further protected by heavy doors that opened at dawn and closed at dusk.[15] After dusk, access was not granted inside the walled enclosure, thus legally rendering the people on the other side outside protection. This is why, for instance, some religious orders based their churches and monasteries right outside the city walls—literally *extramurros*, in Spanish—in order to be able to provide assistance or even sanctuary to travelers forced to spend the night without the protection of the fortifications.

This system was particularly true during the Middle Ages and is found in many medieval laws.

The intensification of Muslim pirate raids after the loss of Rhodes by the Knights of S. John (1522) and after the battle of Preveza (1538) triggered the fortification of all the major islands. Because of this constant state of latent war and the development of new siege weapons (artillery), Venice steadily modernized and improved its fortresses in the Mediterranean.

After the setbacks in the latest war with Turkey, which had cost Venice her prized Peloponnese possessions of Napoli di Romania and Malvasia, the 1540s represented a major turning point in the development of the Venetian defense system. In 1542 a **Magistracy of Fortresses** was established, which had jurisdiction over the fortifications in the maritime and mainland dominions, and over the arsenals of sea territories of the republic.[16] From its responsibilities, it was clear that sea power and land fortifications went hand in hand and represented the basis of the Venetian philosophy of defense.

In 1546 the **Sea Militia** was formed, which was entrusted with the task of enlisting and provisioning galley rowers. This organization included four members from the Senate and 16 from the Grand Council, in addition to members from various ancillary administrative and military magistracies. Supplementing the strategic needs was the office of **Artillery Administrator,** composed of three Venetian patricians, in charge of planning the artillery needs and the assignment of artillery to both the fleet and the fortresses.

These new organizations coordinated their efforts to deploy the best architects to the all the hotspots. These engineers employed the best and most recent constructions techniques to design and build state-of-the-art, up-to-date fortifications.

At least one major location was fortified on every island or territory; no one was left undefended from potential raiders. The great importance Venetians attributed to the geographical position of her main islands, dotting and securing the road to the East, essential for the development and protection of trade, resulted in the implementation of a huge fortification program, unmatched in all of Renaissance Europe in the 16th century, in terms of size and timespan of construction.[17]

3

The Art of Fortification in the Renaissance

The Renaissance, essentially a revival of the vision and ideas of ancient Rome and Greece, was just as much an artistic movement as it was an intellectual one. In architecture, the Renaissance manifested itself through a return to the forms and ideals that defined Greek and Roman architecture: columns, simple geometrical shapes, harmony and symmetry.

The Renaissance and its art and architecture began in Florence in the second half of the 15th century and from there spread throughout the Italian world and all over Western Europe. The military architecture of the Renaissance is also centered on the works of Italian masters, and the walls and intricate levels of mathematically designed defenses form compelling shapes that amount to nothing less than land art.

In the early 15th century, gunpowder (a mixture of nitrate, sulphur and carbon) became available in Europe on a large scale, and thus came to play a major part in warfare, radically changing military science and particularly replacing existing war machines and neutralizing the defensive capabilities of the existing medieval fortifications, designed for the demands of the martial art of their era (spears, bows, crossbows, battering rams, and projectile rocks).

Early cannons were just heavy iron tubes mounted on a wheeled wooden carriage that was meant to ease deployment but was rather bad on recoil. Firing consisted simply

Figure 2. Cannon of French origin, Famagosta, on the premises of the ruined Palace of the *provveditore***.**

of inserting iron or stone cannon balls at the open end, and at the other end igniting the gunpowder with a red hot iron poker. Basically, early cannons were just much more accurate trebuchets, but their balls were just as crude, very different from the shells of modern warfare.

In reaction to this new weaponry, a new system of fortification was designed in Italy in the very early 1500s. Because of high-impact stone and iron balls projected by gunpowder, the walls had to become shorter, thicker, and slightly inclined on the exterior side, and the bastion, as emplacement for the defending artillery, became the basis of fortifications for the next few centuries.

This new system is known as *trace italienne*, although its contemporary Italian authors refer to it only as *fortificazione alla moderna*. This bastioned fortification was based on mathematic and geometric principles for maximal flanking capabilities, in response to the need to eliminate the blind spots created by the square medieval towers. This was first achieved with the creation of the round artillery tower, and soon after with the advent of bastions with sharp salients.

Bastioned fortification was defined in Italy in the very late 15th century as a reaction to the growth of firepower and accuracy of projectiles, with the onset of cannon and gunpowder. Eventually the *fortificazione alla moderna* evolved into a massive system of trenches and earth embankments to protect from active artillery fire on the enemy side.

It is not surprising that these new types of perfected, geometric defenses surfaced and thrived in Italy, under the works of Italian engineers, since this land is where the genius of Renaissance men met with the wealth of the state and also the need for defenses to supplant the lack of large standing armies. The drawback was that there was a lot of warfare in Italy, more than any other region in Catholic Europe in the late Middle Ages, so a lot of fortresses were built to defend the land. The great generations of Italian military architects include Antonio da Sangallo the Elder, brother Giuliano da Sangallo and nephew Antonio da Sangallo the Younger, Baldassare Peruzzi, Giovanni Battista Antonelli and his younger brother Battista Antonelli, and Francesco Laparelli. When France replaced Italy and Spain as the richest and most important country in Europe, in the 17th century, it became the frontrunner of military architecture and it's no surprise that the great engineer Sébastien Le Prestre de Vauban worked and created for the great king Louis XIV. Later, his tradition was continued throughout the 18th century by people such as Cormontaigne, Montalembert, and Carnot.[1]

The basic principle of flanking is that the length of the curtain must not exceed the range of weapons placed in the flanks. Thus, the flanking crossfire offered by the new Italian bastioned system reduced the blind spots virtually to zero.

The profile of the bastioned fortification is low, and the walls appear sunken in the ditch; every elements of defense is always covered by fire coming from neighboring sections; and access and communication is facilitated along broad curtains at the same level as the bastions.[2]

This new type of structure was first employed at the fortress of Salses. This fortress was built between 1497 and 1504 by the king of Aragon, Ferdinand VI, on the French-Spanish border of the time. Similar early developments occurred in the case of the fortresses of Vasto (1499) and Barletta (1537), and especially in Rhodes, in the modernization efforts of the early 1500s under the Grand Masters d'Aubuson, d'Amboise and del Carretto, which included the first polygonal bastion (S. George), as well as a range of initiatives in what would later be established as *fausse-braye*, tenaille, and caponier.

The military had always noticed that in front of the corner towers there remained an area hidden from the flanking towers adjacent to the shooting; by turning a square structure 45 degrees, the salient becomes a pointed arrowhead that eliminates all the blind spots, provided the bastions are set in geometrical correspondence.

The ramparts' remedy to the problem of blind spots is to draw the fortress out from the trajectories of artillery fire. Basically, first the artillery emplacements are established; construction follows the resulting alignments and produces a continuous trace. When the ground is uneven in altitude, the ramparts are positioned on the reliefs and their angle varies accordingly (like Spinalonga or Palamidi). If the fortress is built on an open and wide plain (like Palmanova or Nicosia), the radial symmetry can be maintained.

By extending salients out from the main curtain to form bastions, a wider line of fire is created, which can be concentrated at any point on a circumference around the fortification corresponding to the range of the canons, while also minimizing the exposure of any individual salient to concentrated bombing from beyond. If before, in the case of a straight defensive line, the artillery barrage could be directed at a wide target—which called for little accuracy—now enemy cannons have to hit first the salient and faces of a bastion, which account for a very small percentage of the entire trace and thus demand much more accuracy or time.

In the first half of the 16th century, the Italian school of military architecture proposed the *fortificazione alla moderna* system, with polygonal or semicircular bastions projecting perpendicularly from the neighboring curtain. Next, in the second half of the 16th century, the main front was supplemented by the outer defensive line—the second phase of development of the *trace italienne*. With the lengthening of the reach of cannon shot, the defense would be pushed farther from the walls.[3] The enlargement of the range of artillery, in the second half of the 16th century, called for a wider front and more distance from the curtain and the center of the place; to achieve this, the salients were detached from the main fortifications and instead of being proper bastions linked with thick curtain walls, they were distributed as separate outer forts, forming a new defensive ring. This was the case of Candia and Corfu, where the initial enclosure was doubled with a newer set of defenses—outworks consisting of ravelins, hornworks, crownworks and redans.

The Bastioned Fortification

The **bastion** is the main feature of the defensive design of the *fortificazione alla moderna*. Bastions are large, solid constructions projecting from the main line of defense, designed to enable troops to see and defend the perimeter in front of the ramparts.

Bastions were linked by straight sections of wall known as curtains, made of thick earthworks inclined on the exterior to form the scarp, and revetted with ashlar blocks. Sturdy stone foundations were required to support this massive superstructure.

In the drawing on the following page by Lorini[4] can be seen both the parts of the bastion and the construction techniques. The parts of the bastion are the flank (which joins it to the curtain), the shoulder (the point of junction of the flank and the face), the faces (which joint in the salient), the *orecchione* (literally "ear," which protected the recessed flank) and the gorge (the open section towards the back). The projecting front angle of a bastion is called the

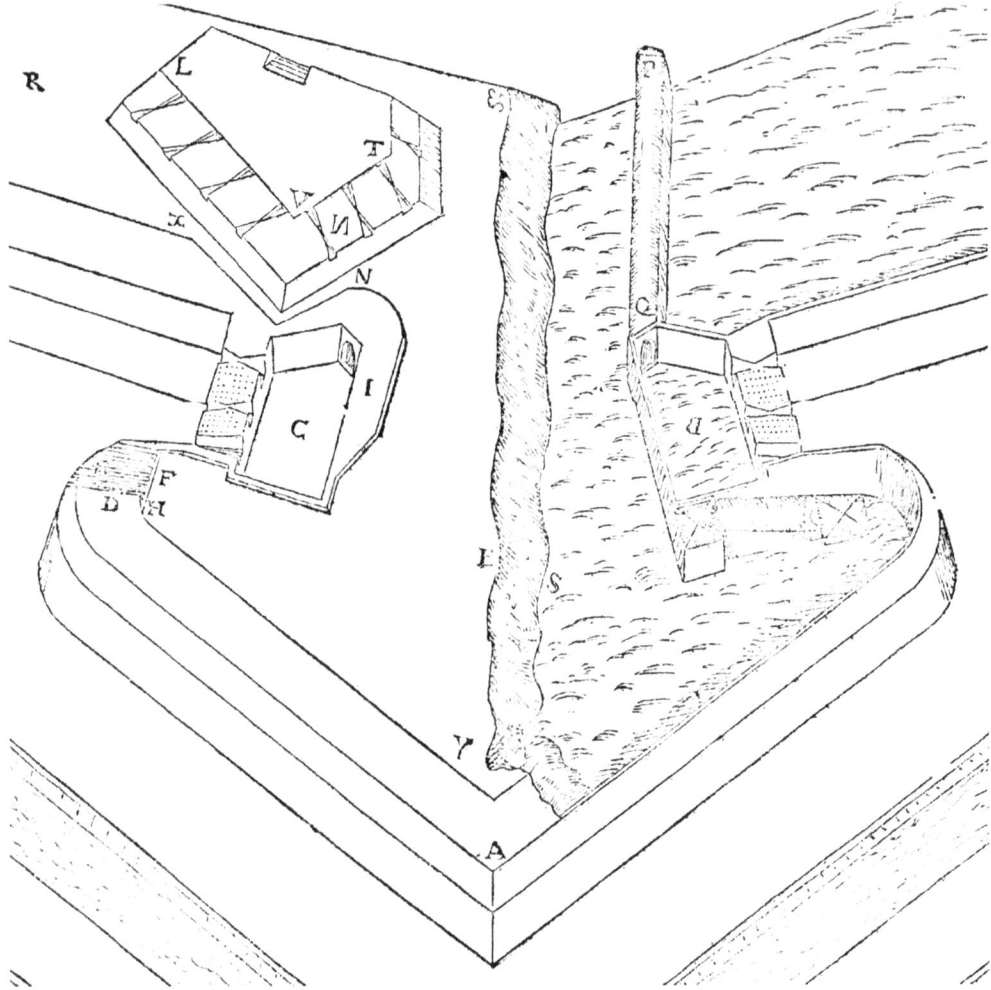

Figure 3. Drawing of a bastion by Buonaiuto Lorini, 1597.

salient. The gorge is the interior side or neck of a bastion, not protected by a parapet on the town side. The bastion has two flanks, designed to defend an adjoining work and also to provide enfilading fire.

A very distinctive feature of the Italian bastion of the 16th century was the *piazza-bassa*, constructed in the recessed flank, where the bastion abutted the curtain wall. The *piazza-bassa* was built at an intermediate level between the ditch and the parapet, a low platform in the flank of a bastion, with a casemated battery. It was protected by the *orecchioni*, section at the end of the bastion face, either rounded (as at Candia) or square (as at Corfu).

The *piazza-bassa* ensures a double rate of fire to flank the wall, needed in the phases of the siege that suppose infantry gaining the ditch to try and scale the walls. These *orecchioni* gave the Italian bastions their characteristic arrowhead form. The later polygonal bastion shapes were obtained by removing the ears of such structures.

There is also the **demi-bastion**—bastion with only one face and one flanks, and the

piattaforma (platform)—a flat bastion, where the angle of the salient is about 180 degrees, which was designed to increase the flanking possibilities and acted like a cavalier placed in the middle of the curtain. Such a *piattaforma* existed in the middle of the new curtain in Corfu (S. Atanasio), between the Sarandario and Raimondo bastions; and in Candia, Bethleem and Gesu (Jesus) have a salient angle so wide they can be considered platforms.

The Venetians also constructed gun platforms known as **cavaliers**, initially built on the curtain walls (Camposanto–Famagosta, San Marco–Canea) and later on the bastions (Martinengo—Candia). There are square cavaliers (Savorgnan, Martinengo–Corfu), rectangular (Del Mezzo, Andruzzi—Famagosta) and even round ones (Lando, Sta. Lucia—Canea).

The **curtain** is the main wall of the defenses, and represents the length of the earthworks between two bastions. It is a very thick wall of earth or masonry forming the main defense of a fortress; normally it is reinforced from the rear by the **terreplein**, which is the packed earth forming the body of a rampart.

It is necessary to have long, sloping **ramps** to drag guns and other heavy equipment up to the top of bastions and curtains. Such ramps exist in Famagosta, Corfu and Candia; in the large fortifications of Rhodes, however, there is only one large ramp remaining, to the north of S. John's Gate, as well as one climbing along the Amboise Gate. Otherwise, there are only three infantry stairways to access the walls, and this certainly could not have been the case for such a long enclosure of high walls with so many gun embrasures. The **embrasure** is an opening cut in a parapet, through which a cannon would be placed and manned, without exposing its crew; the embrasure is wider at the front than at the interior of the wall.

Located near or on bastions, **magazines** are designed for the storage of gunpowder barrels and other munitions. Built of stone, they were normally square and domed (as in Retimo, Candia or Porto Trapano[5]) or square with a pyramidal roof (as in Candia); later, in Corfu, they were rectangular and flat-roofed. They had windows to allow possible explosions inside to dissipate instead of causing havoc by blasting the entire stone structure.

The **scarp** is a defensive work integrating a slanted wall, in order both to strengthen the foundations and to increase the structural stability of the wall. The scarp ended in a semicircular cornice known as the **cordon**, above which there was a perpendicular parapet. To prevent—or at least make very difficult—the climbing of the walls by the attacker, the scarp wall was limited to two-thirds of the height of the curtain, and at its top end was placed the cordon, slightly protruding from the edge of the wall above.[6]

The **parapet** is the top part of a rampart, intended to provide shelter for troops behind it. The parapet features embrasures, where cannons were trained towards the glacis; also, the parapet had a banquette, for the infantry to fire over the breastwork. In fact, in the Italian design, both bastions and curtains included a thick breastwork with embrasures for placing cannons and a parapet for muskets.

The **sally port** (postern or sortie) allowed soldiers to reach the ditch and the subsequent outworks. This *porta falsa* was a concealed gate or an underground passage leading from inside a fortress into the ditch, or from inside a bastion into an outside area. In Candia, these sally ports are paved vaulted passages built within the bastions and accessed from the *piazzabassa*; in Corfu, the posterns open in the curtain of the new walls. In the walls of Rhodes three sorties have been preserved, and they are quite impressive in their architectural details (their shape, and additional features, such as murder holes).

The **gatehouse** with its drawbridge was placed in the middle of the curtain and was protected by a ravelin, as in the case of Corfu, or by the *orecchioni*, as the Giuliani Gate in Famagosta or S. Giorgio and Panigra gates in Candia. Usually the exits of gates were protected by the *piazza-bassa* and the guns on the shoulders of the bastions, while a vaulted passageway led from the town either to the surrounding countryside or the ditch.

There is value in the design of a curved access to the inside of a city or fortress, since this prevents the use of efficient breakthrough machineries. Dislodging the defenders from the exits of such positions is difficult because the access corridor is narrow and curved. This is true for all Venetian fortresses (Cerines in Cyprus, Castello del Molo[7] in Candia), with the exception of Retimo. In the Latin East, the gatehouses of the Hospitaller fortifications are the most intricate and impressive, from Krak des Chevaliers to Rhodes, and even later in Birgu (Couvre-Porte).

In the fortificazione alla moderna, the **ditch** was dry, deep and very wide to increase the distance and keep the enemy even further from the walls. A rainwater trench known as the **cunette** ran down the center of the dry ditch, parallel to the walls.

On the side of the ditch opposite the scarp, there was the **counterscarp**, also revetted in stone. In general, in the 16th century, the wall of the scarp was 26–33 ft. high and the counterscarp was about half the height of the scarp, since it was covered by the guns mounted on the curtain and bastions.[8]

In front of the ditch laid a wide open field, called a **glacis**, a sloping ground in front of the fortress spanning from the top of the counterscarp into the open country. This area was required to be clear in order to sweep it with artillery fire from the walls; if there were buildings, for instance, enemies could take cover behind them, no matter how ruined they might be. In case such a space did not exist when the walls were erected, it had to be created by clearing the land (such as the case of Nicosia, where constructing the new walls meant doing away with whole neighborhoods and significant buildings—monasteries, churches, and palaces). Since the glacis was basically a large open space around city walls, very few have survived, because they were often the first target of town enlargement. Currently, the Spianata Square in Corfu comprises the actual glacis in front of the Savorgnan and Martinengo bastions of the Old Fortress, and in Famagosta the southern glacis has survived, almost intact.

On top of the counterscarp was the **covered way** (*strada coperta*), functioning as a wall-walk from which the defenders could fire on the approaching enemy. From the curtain, individual firearms had limited efficiency against enemy advancing over the glacis. So while the guns from the walls swept the glacis, foot soldiers were engaged by their counterparts from this covered way. Another solution—visible in transitional fortifications in Rhodes, for instance—is a *fausse-braye*, a second parapet at midheight of the wall, where soldiers were placed to double the firepower from above them.

The **escutcheon** is a large heraldic artefact usually made of stone or marble, fixed to a wall, above a gateway, bastion or curtain, on which is depicted the coat of arms of the sovereign state or of a noble, the year of construction, dedications or other texts. The Venetian walls were always studded with escutcheons, most of which were above the gates, on bastion's *orecchioni*, or curtain walls. These emblems and coats of arms bear witness both to the presence of Venetian nobles and officials and to their involvement in the various phases of the building or maintenance of the fortifications. The winged Lion of S. Marco, symbol of the Serenissima, is always depicted in relief and is encountered in versions such as the heraldic position of

andante (walking) or *in moleca* (medallion). Many such architectural elements are still found today in Famagosta, Candia and Corfu.

The Outworks

In the second phase of development of the *fortificazione alla moderna* system, outworks were added to enhance the front line and move it farther from the curtain (thus, from the defended town itself). Outworks are detached structures meant to guard the approaches and deny the enemy close-range attacks. Outworks were not protected on their interior side, so that in case the assailant did conquer them, enemy soldiers could not count on a parapet for protection from fire from the adjacent bastions and curtains.

Advanced works were placed ahead of the main ditch, to cover parts of the ground not easily seen and defended from the main wall. They were projecting combat positions that occupied a portion of the glacis in front of a curtain or a bastion. They were designed to force the besiegers to begin a siege from a greater distance.

The main outwork is the **ravelin**. This is usually a triangular structure placed in front of a curtain to defend it. One of the first and most relevant examples of this shape is the ravelin of the fortress of Sarzanello, Italy (1496). In other functions, the ravelin hosts the main road into town and, thus, is placed in front of the gate, which opens in the middle of a curtain. Such was the Grimani ravelin, in Corfu, in front of Porta Reale (both structures now gone).

This defensive work is like a small fort independent of the rest of the structure. It protects the gateway to the town and also provides an excellent flanking capability for the defense of the moat. In the Renaissance, the ravelin had a clear triangular configuration, headed by two faces and a gorge opened towards the fortress, with which it communicated through a drawbridge or caponier.

The position of the ravelin on a corner angle, as in Famagosta, is very rare, since normally a ravelin stands in the middle of a curtain, to obtain increased protection on a wider front (the curtain and its two bastions). This was understood in Rhodes, where, from the siege of 1480 to the one in 1522, elaborated constructions—amounting to ravelins, but without their classical shape—were built away from the gates, towards the middle of the curtain (S. John's Gate, S. Athanasius Gate, Amboise Gate).

There is a difference between ravelin and demilune (***mezzaluna***) that is perceivable in the Italian school of fortifications design, but that loses its nuances in the latter theorists, and so in modernity, these two names are most of the time considered synonyms. In the philosophy of *fortificazione alla moderna*, the ravelin is the trademark triangular form placed in front of a gate; when placed before a curtain and without providing cover for the access to the fortress, it is a *mezzaluna*. In fact, the crescent shape of this outwork is reminiscent of the Italian staple household tool of the same name.

The **hornwork** (*opera a corna*) consists of a front of two demi-bastions joined by a short curtain wall and linked to the main ditch by two parallel flanks. There were hornworks constructed in Candia (removed in the middle of the 20th century), while a large one still exists today in Corfu, in front of the New Fortress. The **crownwork** (*opera a corona*) had a front like two hornworks glued together: one bastion and two half-bastions, linked by two small curtains. The **redan** (*freccia*) was a small arrowhead formed by two protruding faces, placed

either ahead of the salient of a bastion in the main walls or in the crownwork. Such a position was chosen in Candia, where a *freccia* protruded from the center salient of the Sta. Maria crownwork and from the neighboring S. Nicolo ravelin.

The improvements brought about in the 17th century, especially by the French architect Vauban, included several new types of outworks—tenailles, counterguards, caponiers, and redoubts—which, however, were not particularly specific to the Renaissance architecture discussed in this book, so we will not present them in further detail. The tenaille was a low wall placed in the ditch at the foot of the main curtain between the flanks of the bastions. Its purpose was to protect the base of the curtain and flanks of adjacent bastions from bombardment and assault. The caponier was a protected corridor enabling the communication between the main enceinte and a ravelin or demilune. It was placed across the ditch and continued by a postern passing under the rampart. The counterguard was an outwork placed in front of a bastion or a demilune, whose purpose was to protect the salient point and both faces.

Figure 4. The elements of the idealized bastioned front in the 16th–17th centuries (courtesy Niculae Cosmescu).

Figure 4 shows the different types of elements in the bastioned front: the heart-shaped bastion, with *orecchioni*, with or without *piazza-bassa*; the polygonal bastion, the corner polygonal bastion. On the terreplein there are pentagonal and rectangular cavaliers. The curtain is straight and has a *fausse-braye* on the right. In front of this is the tennaille, and the outworks are, from the left: crownwork, hornwork and counterguard. From the front of the hornwork a caponier leads to the ravelin.

Siege Warfare

The development and diffusion of more accurate artillery triggered the progress of fortification design. The planning was based on new elements of the art of fortification with the

establishment of the bastion and the needs that arose from the invention of gunpowder. The new fortified enclosure had a larger perimeter than the town itself and was meant to keep the enemy away from the settlement. For example, in the cases of Candia and Verona, Venice built the new walls a lot further out than the previous enclosure, first to accommodate the already expanding town, and second to leave enough space for further advances. Thus, there was usually a lot of empty space between the walls and the actual civilian accommodations.

The enclosure was formed by bastions, linked together by curtain walls. The distance between bastions was precisely calculated so that enfilading crossfire from cannons behind embrasures or within casemates would provide maximum protection but would not cause damage to adjacent parts of the enceinte. The distance from the flanks of a bastion to the salients of their adjacent counterparts had to be less than the maximum range of the principal firearm of the period, the musket (800–900 ft.),[9] just as the distance between the towers on ancient and medieval forts was determined by the range of the bow. This meant that soldiers stationed on one bastion would be able to cover, with the weapons of their time, the entire open space up to the next similar defensive structure.

The steep angle of the scarp was particularly effective during a siege, since it caused a lot of enemy fire to ricochet. The thickness of the earthworks forming both curtains and bastions was equally important, for it rendered the walls capable of absorbing projectiles.

In turn, siege tactics changed too. Efforts were made by attackers to protect their own artillery from defender's fire, as well as to bring troops and guns closer to the walls. First, the besieging army would try to establish a blockade of the city, not just to stop military aid from arriving, but also to try to create a shortage of victuals. Then it would also try to secure the protection of its own troops by building earthwork lines of defense, one against the sorties by the garrison, another, at their back, against possible relieving forces. This is the philosophy that made Julius Caesar successful and famous at the siege of Alesia (52 BC).

The main part of the siege was spent building approaches for troops and cannons, which was done by digging trenches along parallel lines, allowing attackers to get closer as safely as possible. Such trenches had to be wide enough for engineer traffic and tall enough to ensure soldier protection; they were reinforced with fascines, brushwood or planks.[10] The lines were parallel, because thus they actually moved the front line closer to the enemy; the connection between parallels was done with zigzag corridors, to minimize direct fire. Eventually, the attackers would get close enough for their guns to achieve a breach in the walls and collapse the scarp, which filled the ditch, partially, with stone and earth debris. The breach has to be brought down to a scalable height and the counterscarp broken to fill the ditch on the glacis side. The wall would collapse in such a way that it created a natural slope, which besiegers could easily scale.[11]

By the late 16th century, siege artillery became standardized and was composed of two main types of pieces: cannons and mortars. The field gun was mounted on an elongated carriage with two large wooden wheels, while the fortress cannon had a sturdier truck carriage made of more elastic wood and supported by four small wheels. The mortar was a heavy siege weapon, with a massive carriage without wheels and short and wide barrels. Its purpose was to launch large cannon balls in a high-curved trajectory (45–75 degrees)—creating plunging fire—which allowed it shoot over fortification walls.

Another tactic commonly used in sieges was mining. Specially trained sappers would dig underground tunnels supported by wooden props, leading right under the fortress walls;

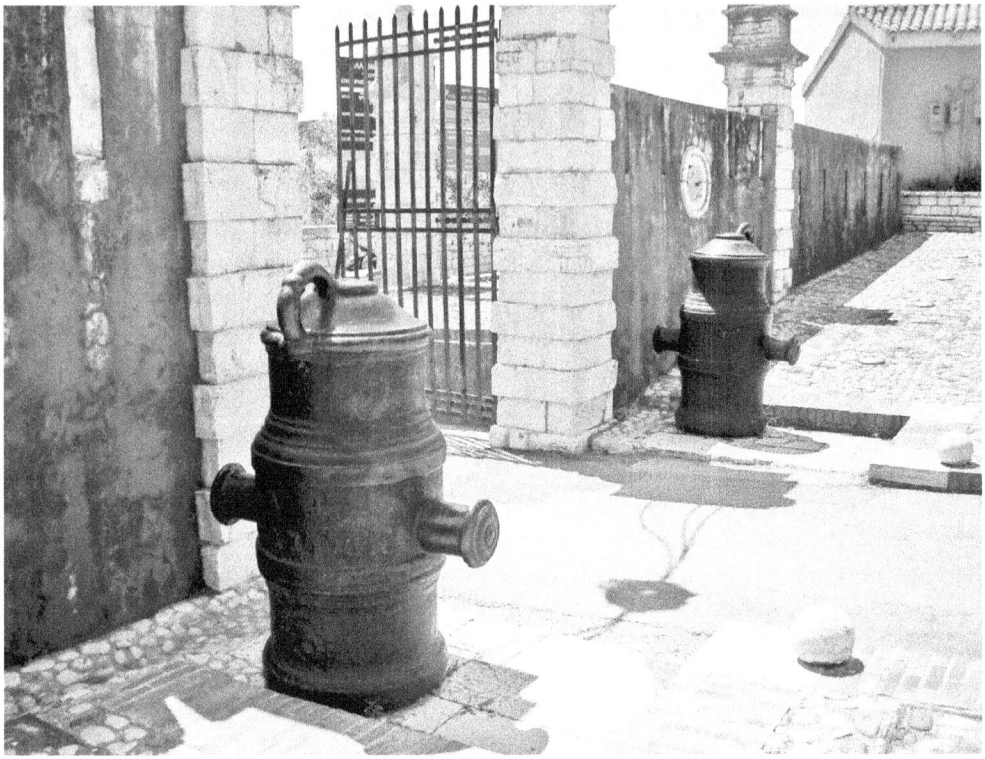

Figure 5. Venetian mortars at the start of the bridge of the Old Fortress, Corfu.

then combustible materials or explosives would be ignited, leading the underground passageways to collapse and the ground above to subside, dragging down sections of the wall above.[12]

This prompted the defenders to use countermining, by building their own tunnels in front of the bastions, to anticipate where the attacker might come. In fact, such tunnels were a part of the construction of the fortifications, and were already in place before any siege would begin. Many historical maps, such as the map of Canea by Vincenzo Coronelli,[13] show networks of defensive tunnels extending from the bastions.

The design called for a long tunnel right in front of the salient, from which smaller tunnels branched left and right, trying to anticipate the enemy. Many times, these tunnels were the scene of heavy fighting when the opponents came in contact.

The Construction Techniques

The construction of the Venetian Renaissance fortifications followed the usual practice of similar defensive structures. The first step was tracing the line of the walls on the ground; this was followed by excavating for the foundations of the bastions. The front face of the walls was built of quarried stone; the revetment of the main wall was a stronger construction, in order to withstand artillery attack, while the revetment of the inner wall, the counterscarp and the cavaliers were less strongly built.[14]

Earthworks were the revolutionary advancement of the Renaissance fortification. Pressed earth proves to be as strong and more elastic than stone construction, even though much thicker. The question is only to find a way to retain the earth in place, and that solution is used today for civilian works: a sloping stone wall. More than simple piles of pressed earth, in the Renaissance such a structures were reinforced with stone buttresses, timber, and deep foundations, bringing together masonry and earthwork.

Another solution, used particularly in the early 16th century transitional fortifications, addressed ways to enlarge the existing medieval wall. Essentially, the thickness was enhanced with rubble and mortar thrown between a double envelope of stone or brickwork, as in the case of Rhodes or Cerines.

The bastion was normally earthwork with stone faces, built of squared sandstone blocks and lime mortar, applied to form a thick, irregular joint. The wall was more abruptly scarped at its base, for better protection, and the fact that it was slanted meant it was much more difficult to throw scaling ladders against it. The scarp was crowned by a round cordon, which served as the base for the parapet, which was usually masonry-built and plastered over.

The inner wall, which retained the terreplein on the town side, was generally built of rough stone and mortar, but it was weaker since it did not need to endure direct projectile shots.[15]

In most cases, the curtain wall and the inside of the bastions were reinforced with dense, rectangular inner buttresses that were covered over by the earth of terrepleins. This was visible, during restorations, in the Gritti bastion in Canea, or the Savorgnan and Martinengo bastions in Corfu.

The salients of the bastions were made of roughly hewn boulders, and this is visible in the famous Sangallo bastion in Fano (Marche, Italy),[16] as well as in the salient of the Schiavo and Santa Lucia bastions in Canea. In fact, this Sangallo bastion is one of the most important and famous examples of Renaissance fortifications, an imposing structure, completed in 1552 after various phases of construction. It was part of a string of coastal defenses, from an expansion project of the defensive system of Antonio da Sangallo, in his capacity as architect of the Holy See. The architectural style is that of the bastion coming out of the wall circuit; the sides of the bastion are perpendicular to the walls of the city and the faces, formed by scarp walls, and incorporate the upper square (*piazza-alta*).

The fortifications were surrounded by a broad dry ditch, and in the process of excavating the moat—dug into the same rocky ground upon which the fortifications were raised—the stone and other material from the excavations was used to build non-visible parts of the wall masonry. The counterscarp that retains the slopes of the ditch was also built of common masonry.

It should be noted, of course, that the fortifications were built using labor contracted through feudal laws requiring subjects to perform a specific amount of service for lord and state, as such works would not have been possible without extensive manpower. The local male population up to the age of 60 was obliged to labor on public works for few months every year.[17]

The Architects

The *fortificazione alla moderna* system demanded greater specialization by architects and engineers; the art of fortification was becoming a science, leading to the standardization

of military architecture. Numerous famous Renaissance personalities theorized and even designed fortresses, such as Galileo Galiei, *Trattato di fortificazione* (1593), and the ultimate Renaissance artist Michelangelo Buonarotti (who designed the fortress of Civitavecchia near Rome and was in charge of fortifications during the siege of Florence, 1529–1530).[18]

Theorists were commended by the republic and were put in charge of making proposals for the fortresses of the realm. **Girolamo Maggi**, who wrote the pioneering and influential *Della fortificatione delle città* (1564), was sent to Cyprus, where he oversaw works improving the siege-worthiness of the defenses.[19] Also in the service of Venice was **Buonaiuto Lorini**, author of *Delle fortificazioni* (1596), a detailed and extensive book covering diverse and exhaustive issues: mathematics and geometrical applications; rules to form the plans of the fortresses; and measurements, construction techniques and materials; as well as a discussion of the characteristics of each and every one of the features available at the time (square towers, round towers, bastions, *piazza-bassa*, cavaliers, etc.).

Many architects and military engineers were involved in the fortification of the territories of the Republic of Venice, from Terraferma to Cyprus—some just as designers, others also as the engineers in charge of managing the relationship between military command and technical execution. Their activity played a decisive role in the organization of an efficient defense.

The most famous and important Renaissance military architect was undoubtedly **Michele Sanmicheli**,[20] Italian architect and engineer who assumed duties as general overseer of all fortifications of the Serenissima, in February 1538.

Michele Sanmicheli started with Crete, where he stayed from 1538 to 1539, planning and studying models of the fortifications at Canea, Retimo, Sitia and Candia, while also supervising their construction. His designs were in accordance with the demands of the military innovations of the Renaissance: the new line of walls enclosed a much larger space, strengthened by heart-shaped bastions. The wall circuit of Canea was rectangular in form and had two bastions and two demi-bastions with *orecchioni*. Retimo's new walls consisted of an east-west rampart wall connecting the two coasts of the peninsula. The walls of Candia (largely completed by 1566) were by far the most impressive, with seven bastions of various types, three cavaliers and a strong fort with the function of a ravelin.

Another major Sanmicheli work was the enclosure of Verona with large, solid bulwarks (which today are altered, and only the curtain, the gorgeous gates and the terreplein with its cavaliers are original; the scarp of the bastions was replaced with structures modernized by the Austrians in the 1830s). Also in Verona, he built most of his civilian masterpieces— palaces and chapels—and he was also active in Venice and other cities in Terraferma. Along with his nephew Gian Girolamo, Sanmicheli modernized the ramparts of the Old Fortress in Corfu. Towards the end of his activity, in 1539, he traveled to Sebenico in Dalmatia, where he designed the exquisite island fort of S Nicolo.

The radical restructuring considered by Sanmicheli for the fortresses of the Serenissima, to make them as impregnable as possible, proves Venice's regard for the safeguarding of its territories and the well-being of its subjects.

A worthy successor was **Giulio Savorgnan**, who also worked extensively on the most important Venetian walled cities. In 1540 Savorgnan was named chief garrison commander at Zara. In 1546 he left for Corfu as general overseer of the fortifications. In 1562, Giulio Savorgnan embarked on a four-year journey, on which he visited all the fortresses of the Venetian maritime dominion, from Cyprus to Istria. He was in Crete in 1562 as chief fortress

commander. In 1566 he returned briefly to Dalmatia, and in 1567 arrived in Cyprus, the Serene Republic's most important possession in the East.

Between 1567 and 1569 he designed the new fortifications of Nicosia in Cyprus and oversaw their construction. After the demolition of the old city walls dating back to the times of the Crusades, the new city wall was equipped with 11 strong, heart-shaped bastions.[21] Following the fall of Cyprus to the Ottomans in 1571, Savorgnan worked on the fortifications at the Lido in Venice, as well as building Fort San Andrea, a strong gun platform commanding the entrance to the lagoon of Venice.

In 1592, Savorgnan became general superintendent of magistry of the fortresses and in 1593 was called by the republic to build a new fortress in the area of Palma, which then took the name of Palmanova; it was a masterpiece of architecture. This was the largest single Italian fortification project of the 16th century, and with its nine bastions, radial geometry and centralized planning is a wonderful example of Renaissance urbanism's quest for the perfect city.[22]

Ferrante Vitelli (c. 1550–1584) was employed for years in the service of the duke of Savoy, inspecting and renovating the fortresses in his realm, working on projects in Mondovi, Nice, and Torino, where he connected the citadel to the city walls.[23] From 1576 to 1578 he was loaned to the Most Serene Republic, in whose service he went to Corfu to design the new walls and build the strong New Fortress (Fortezza Nuova). His project for the gate of the citadel in Torino is strikingly similar to his Porta Reale in Corfu.

Several other engineers contributed directly to various fortifications throughout the Venetian realm. After the loss of Cyprus in 1571, a vast program of construction was implemented in Candia, under the supervision and design of **Latino di Camillo Orsini**, governor of the island. He directed the fortresses of Suda, Spinalonga and Grabusa. In the same program was included the citadel of Retimo, designed by Sforza Pallavicini. **Gian Girolamo Sanmicheli**, nephew of Michele, followed in the trade and worked on military installations in Istria, Dalmatia, Corfu and Cyprus. His traces are found extensively in the latter, where he died and was buried in the cathedral of Famagosta. After active duty in the defense of Candia during the 1660s, **Filippo Verneda** was sent to Corfu in 1662–73, where he came up with plans for the line of outworks securing the new town enclosure.[24]

These architects were the masters of the *fortifacazione alla moderna* and the majority of the fortifications in this book are attributable to them directly.

The fresco of essential personalities in the life of Renaissance fortifications in the Mediterranean must be completed with the figure of **Giuseppe Gerola**, who brings a quintessential contribution to the archeology of the Venetian traces in these lands.

Gerola, an Italian medievalist, was sent in 1900 by the Venetian Institute for Science, Letters and the Arts (IVSLA) to study the Crete's Byzantine and Venetian monuments; this land had recently been opened to archeologists since its liberation by the Great Powers and the removal of the Ottomans (1898). It took him two years to complete his mission, during which he visited every corner of the island. From 1905 onwards he began publication of *Monumenti Veneti nell' isola di Creta*,[25] which included lavish illustrations of all the Venetian monuments. The project comprises over 1,000 excellent pictures of cities and monuments of Crete, maps and moldings of heraldry. It represents an exceptional material on the Venetian era (1204–1669) in Crete.

His work is of an inestimable value, since he managed to study, photograph and record

Venetian monuments in Crete before the passage of time consumed them. Sadly, many of these, including many fortification features, were lost shortly after his departure, or even while he was there, to neglect and disregard. Thus, he gathered wonderful photographic evidence, just as they disappeared, of the Harbor Gate and S. Francesco bastion in Candia, Porta Retimiotta, Porta del Colombo and the Piattaforma in Canea, and also the land walls of Retimo.

It is natural to find beautiful examples of Renaissance defensive capabilities in the cites of Venice in the Levant. Since the earliest decades of the 16th century, the number-one enemy for any Venetian territory in the East was the Ottoman Empire. This threat, in conjunction with the development of military architecture and the achievements of defensive technology, as a consequence of the supremacy of artillery, shaped the evolution of the fortifications in the *Stato da Mar* and offers us to this day some of the finest examples of bastioned walled cities in Europe, on the islands of Cyprus, Crete and Corfu, which we will analyze next.

PART II. THE ISLAND OF CYPRUS

Part of the Greek world since the 5th century BC, Cyprus came in the spotlight as one of the prizes of the wars that followed the untimely death of Alexander III the Great of Macedonia. Subsequently, it was ruled mostly by Lagid Egypt, throughout the Hellenistic period, and finally fell to Rome in the year 31 BC, along with all the possessions of Cleopatra VII of Egypt.

With the division in two of the Roman Empire in 395, Cyprus fell to the eastern part. The rise of Islam and its subsequent spread of its naval power throughout the Mediterranean, in the third quarter of the 7th century, made Cyprus an easy target. Eventually, during the period of renewed power of the Roman Empire known as the Macedonian Renaissance (867–1056), Emperor Nicephorus Phocas brought back Cyprus into the empire (965), just as he previously had done with Crete, and defenses were built to protect the island from further Arab raids.

Internal strife among the Byzantine nobility left Cyprus to be administered independently, as of 1185, by a scion of the Comnenos family, who then committed a major *faux pas* in seizing a Crusader princess washed up on his shores in a shipwreck. The ultimate chivalric king, Richard I the Lionheart of England, on his way to the Third Crusade, came to the rescue of the princess in 1191, deposing the tyrant. He then proceeded to occupy the island and, eventually, the island passed in 1192 to Guy de Lusignan, as compensation for his loss of his rights to the kingdom of Jerusalem. It was he who established the Frankish dynasty on the island (1192–1489).

The first half of the 13th century was a period of intensive building. The impressive cathedrals in Nicosia and Famagosta were erected—some of the finest example of Gothic architecture around the Mediterranean. In the 14th century the island prospered—as a natural center of seaborne trade—and Famagosta replaced Acre as the main Christian trading post in the Levant. The Lusignan kingdom reached the height of its power under King Peter I (1358–1369), a brilliant soldier who won victories over the Mamluks in Asia Minor and went on to sack Alexandria itself (1365).

Internal conflicts occurred soon after Peter's assassination, which led to intrusions by the Italian city-states with large mercantile interests in the Levant. Genoa was intent on conquering the entire island, and almost managed to do just that, eventually settling to just holding Famagosta (seized in 1373). A devastating invasion by the Mamluks in 1426 resulted in an annual tribute to be paid to their sultan in Cairo. The considerable involvement of Venice in

support of the Lusignans resulted in the eventual liberation of Famagosta. The Venetians provided King James II with a queen of their own, Caterina Cornaro, and upon his death in 1473, she assigned all important posts to her countrymen. In 1489 she abdicated and handed over the island altogether to the Venetian Republic.[1] Herself a scion of an important Venetian family, she thus bequeathed the island to her home town.

An inextricable part of the Greek world, the Cypriots rebelled in 1821 like all their brethern throughout the eastern Mediterranean and the Danubian lands. Occupied by England in 1878, the island was properly annexed in 1914, upon the outbreak of World War I. Remaining outside the Greek state and ruled by a Great Power, it was missed during the large population exchanges in the 1920s. Even Rhodes and the whole Dodecanese became firmly Greek after 1947 when the islands were reunited with the homeland, but Cyprus took a different path. Here, especially after the creation of a militant organization poised to bring about the *Enosis* (union) with Greece, England pursued a destructive policy of pitting one ethnicity against the other, which left the country deeply mistrusting of a fifth of its population at the moment of its eventual independence, in 1960.[2] When an ill-advised and short-lived pro–Greek coup occurred in Nicosia in August 1974, Turkey was prompt to seize the moment and invade, even after any foreseeable threat to its minority was averted by the immediate failure of the radical coup. Although separated ever since, the land is now peaceful, circulation is free between the two parts and there are great hopes that the divide will be bridged.

The Defenses of the Island

The defenses of the island of Cyprus evolved with the rulers and the times. Initially, using the defense philosophy of medieval Europe, crusader castles were built perched up on mountain tops, at S. Hillarion, Buffavento and Kantara in the high Pendaktylos mountain range. All of them were rebuilt during the 13th and 14th centuries. The castles were positioned in naturally protected areas and were made up of several wards, with good flanking support structures.

The objective of this defensive mountain zone was to guarantee the survival of the nobles and the population in case of extensive raids or even occupation of the whole island, using a coordinated system consisting of the mountain castles and the port of Cerines right below them (the harbor is visible from both the S. Hillarion and Kantara castles).

Additionally, the Knights Hospitaller were granted substantial territory near Limisso, where they built a square keep at Château de Colosse,[3] still standing today. For a while, before they took Rhodes from the Byzantines in 1309, the Knights had their quarters here, and the island remained one of their main priories long into the Renaissance.[4] Cyprus was a very important source of income for the knights, especially from sugar cane production, and the tower at Kolossi was actually a defensive structure for the neighboring sugar mill (itself a wonderful surviving example of a medieval production facility). Similar fortified structures that protected agricultural production can be found in Kouklia and Episkopi, related to areas known for salt, sugar or cotton production.

Around the capital, on the central plains, there were also the castle of La Cava (near Nicosia) and the castle of Segouri (at Lysi), which were, however, as medieval as the Saranda Colones ("Forty Columns") in Baffo[5] (destroyed by earthquake in 1222).[6]

The coastal defenses consisted of castles in Larnaca, Limisso, Baffo and Kouklia, as well as a range of coastal towers, such as the Venetian one that still stands in Kiti, or Pyla and Alaminos. In many other parts of Frankokratia such defenses were found in Chios, Negroponte, Beotia, Attica or Crete and mostly known today as *vigla*.[7] This defensive system is similar to the one employed in Malta, an island closely dotted with such coastal towers, whose function was not just to signal but also to delay approaching raiding parties and deter single ships.[8]

Venice had always tried to appease the rising Ottoman Empire, since it controlled areas vital to its own trading emporium. But after the defeat at Preveza and the loss of its important strongholds in Morea after the peace of 1540, Venice embarked on a serious program to fortify its empire.

To face this danger the Venetians concentrated their energies on the construction of massive defense works, but focused on the major ports and the capital, abandoning the obsolete medieval castles in the mountains.

The expansion of the Ottoman Empire and the extensive generalized use of artillery had to be countered by the introduction of new military architecture. Famagosta received a complete circuit, while its rectangular citadel was reinforced by doubling the medieval walls. In the same way the citadel in Cerines, on the northern coast, was also upgraded; while in the capital Nicosia, a spectacular, perfect circular enclosure with 11 identical bastions was completed in only three years before the Turkish invasion. These would be the last military improvements on the island, as neither the Turks nor the British brought its defenses up to date.

Here it is useful to analyze the British strategy in the Mediterranean, as it concerns, from the 19th century onwards, all the islands that are the subject of this study.

In 1870s, the British were looking for a foothold in the eastern Mediterranean to guard the approaches to Egypt, the Suez Canal and, by extension, the maritime route to India. In 1877, following another ethnic crisis in the Ottoman state, which led to a massacre of the Bulgarians, the Great Powers intervened, either directly (such as the Russians, by means of outright war with Turkey), or indirectly, temporarily occupying territories: Austria-Hungary occupied Bosnia and Herzegovina, and Britain took Cyprus. These territories would be annexed altogether (in 1908 and 1914, respectively).

For the British, mastery of islands as forward bases was paramount. In the Mediterranean, too far from their home waters, they did not seek to establish themselves on land—with the exception of Gibraltar, which, in fact, acts very much like an island with a very narrow causeway. Instead, their policy since the very early 18th century pointed to dominion over islands, which were harder to reach by the enemy and easier to supply and reinforce from England (from which the navy could arrive in time to ensure the relief of a besieged settlement).[9] In fact, this is the same strategy of development pursued by Venice in the Middle Ages.

This strategy drove the British to secure the western Mediterranean by holding Minorca after the War of Spanish Succession (1701–1714)—since it had the best deep-water natural anchorages in all the Middle Sea, at Port Mahon, which its bottle neck shape made it very easy to defend—by building large forts at its entrance (such as Fort S. Phillip).

Then, in 1802, they moved on Malta and dislodged the French from there (when it became clear the islands were a must for any French enterprise in Egypt and the Levant).

The island become even more important since the British had to relinquish Minorca for good after the American Revolutionary War.[10]

After exchanging Minorca for Malta, they did the same with Corfu (handed over to Greece in 1863), by replacing it with Cyprus (which they occupied from Turkey in 1878 and formally annexed in 1914). While the seven Ionian Islands had proved of little strategic worth—since they controlled an Adriatic subject to the allied Habsburg Empire—Cyprus, on the other hand, established the British firmly in the Levant and secured their control over the Suez Canal.

By 1898, when yet another massacre by the Ottomans against their non-Turkic subjects brought about the international occupation of Crete, Britain was not the only significant naval power in the Mediterranean, and so it did not man that island alone, but as part of an international coalition, along with France, Italy and Russia.

As compared to Malta—where the British did add their own modern fortifications, such as the Rinella Fort or the Victoria Lines–Cyprus, although held for over 80 years, was not significantly enhanced militarily. Following the protracted independence and the failure of the expected *Enosis* (union with Greece), the United Kingdom held in sovereignty two bases for military use, at Dikelia and Akrotiki, in the south of the country.

4

Nicosia

Nicosia has been the capital of the island of Cyprus since the end of the rule of Byzantium, with its separatist leader Isaac Comnenos (1185–1191), during the short-lived rule of the Knights Templar, and especially under the government of the French crusader family Lusignan (1192–1489), which also provided kings of Jerusalem and of Cilician Armenia.

Under the Lusignans, the island kingdom reached the zenith of its wealth and influence. The richness of the Gothic in Cyprus is virtually unparalleled in the Mediterranean west of Sicily. Even the magnificent Rhodes can only count on the civilian and military Gothic, while Nicosia and Famagosta excel in the stupendous south French Gothic of their churches and cathedrals. There was never any competition, since the monastic martial brothers never did aspire to the level of splendor exhibited by the French Lusignan dynasty of Cyprus.

The Town

In the religious center of medieval Nicosia, you can see the cathedral of S. Sophia. Immediately next to it is the renovated Orthodox church of S. Nicholas. To its right lies the Chapter House, and close the church of S. Catherine.

The Gothic cathedrals of Nicosia and Famagosta are among the most beautiful in their architectural family, outside of their homeland, France.[1] Regrettably, the sturdy Gothic towers were pulled down by the Turks and were replaced with minarets (disproportionately thin when compared with the nave of the Gothic temple).

The main Orthodox church (S. Nicholas) is very close to the Catholic cathedral (S. Sophia); in fact, they are only a few feet apart. These churches have coats of arms and even retain some of the original Christian imagery: S. Nicholas displays a figure of its patron above the main entrance, and also an image from the life of the Blessed Virgin; the cathedral of S. Sophia, now a mosque, has figures of saints in the first portal on the left, in the narthex.

The palace of the kings of Cyprus was situated in the current Sarayonu Square, and when the British came it was still standing, under the Turkish name of Konak. Today, nothing is left of the royal palace of the Lusignans, but the Lapidarium Museum in north Nicosia preserves a huge Gothic window from the palace, which, at over 10 ft. in height, gives an impression of the size and splendor of the French Gothic in the Levant.

In Nicosia there are examples of civilian, private buildings, but not as many have survived

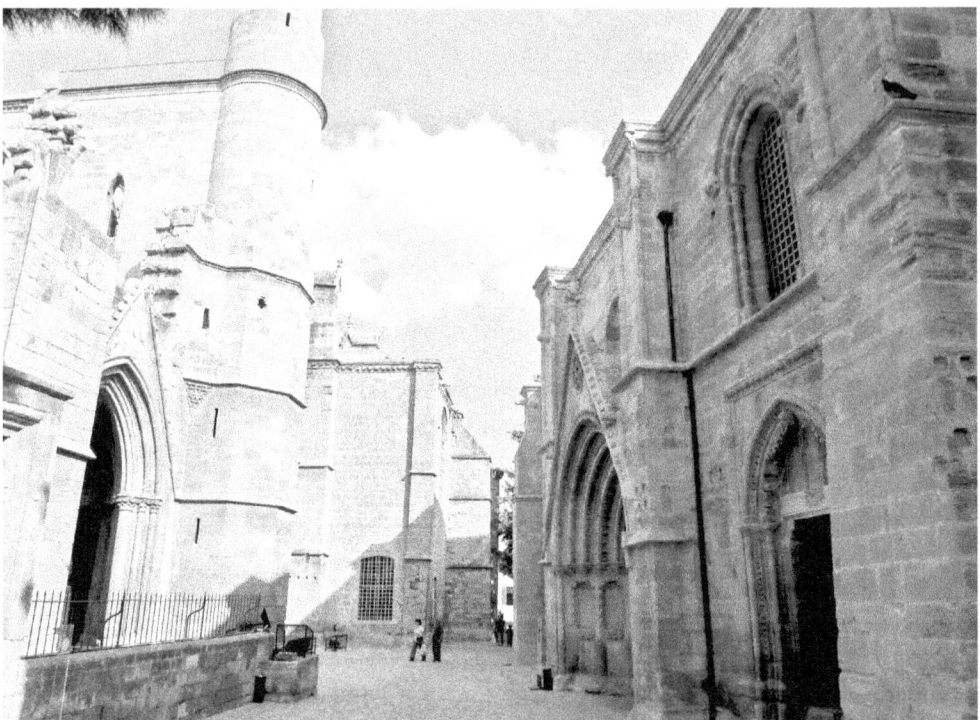

Figure 6. The cathedral of S. Sophia (left) and the Orthodox church of S. Nicholas (right).

as in Rhodes. From those that didn't, impressive lintels and coats of arms were gathered in the Lapidarium Museum and the yard of the church of S. Catherine.

The Venetians inherited a rich and modern town, so they had little need for an extensive construction program inside the city itself; and so the whole town preserved its Gothic character, in both public and domestic buildings. Perhaps the most singular Venetian landmark is the column in Sarayonu Sq. (North Nicosia), originally an antiquity, with the base adorned with nobles' arms. Likely it was supporting a statue of the lion of San Marco as symbol of Venetian sovereignty. Such columns were erected by the Republic in its towns in Italy, although in those cases the lion is still present (such as in Verona, Vicenza, and Padua); also there was a similar column in the harbor of Canea. What was, however, intrusive in the legacy of the Venetian presence was the crash program to build the walls of Nicosia, which tore through the southern neighborhoods and brought down about 80 churches and two large monasteries.[2]

The Ottoman occupation (1570–1878) made Nicosia—and Cyprus as a whole—a backwater of the Turks' empire. Unlike Rhodes, which was used as the main arsenal, and Crete, where some defensive works were undertaken—first to adequately repair the Venetian fortifications, then to construct village defenses against the rebellious Greek population in the 19th century—Cyprus was left to its own devices, despite the island's potential.

Taken immediately after the British arrival in Cyprus in 1878, the material of the photographer John Thompson[3] shows the desolation of the once-great medieval city, where the Gothic churches towered over miserable one-story adobe houses. The island missed even the late 19th century Neoclassical Turkish revival that left so many significant public buildings in Rhodes and Crete.

Before the British arrival in 1878, the town had continued to be confined within the Renaissance walls, with the original three gates remaining the sole means of access. Towards the end of the 19th century, when the colonial administrative offices were relocated outside the walls, the first openings above the walls were constructed into passages in the form of bridges, allowing a more direct connection between these regions and the old town.[4] After the 1974 invasion by the Turkish military, the city was divided, and now four of the city walls' bastions remain under the Turkish side, while two bastions are in the UN buffer zone.

The Fortifications

When Nicosia became the capital of the Lusignan kingdom in 1192, it was defended only by a Byzantine fortification. In 1368 King Peter I started the construction of strong medieval town walls, which were continued throughout the reign of the next French kings.[5] The general appearance of the Nicosia defenses remained naturally quite medieval until the middle of the 16th century.

Decades after Venice obtained sovereignty over the island, it decided to embark on a tremendous program to offer a more efficient defense system throughout its realm, especially for the most important and vulnerable possessions, like Cyprus. Thus, the architect Giulio Savorgnan was invited to redraw the fortifications of Nicosia. His design called for 11 bastions (named after Venetian and local aristocrats) and their arrowhead design made them better suited for the artillery engagements.

The Nicosia fortifications in their present form were built in 1567–1569 in anticipation of a likely Ottoman attack. Almost half the earlier Lusignan fortifications were demolished to create a glacis and allow the creation of a round enclosure.

The fortifications of Nicosia must be understood in the context of the larger Renaissance project of designing the perfect city: functional urban life protected by strong, efficient fortifications. Nicosia and Valletta are the best practical examples of this idea, whose theoretical bases can be traced to Vitruvius, Durer and Filaret.[6] The latest and most important development in military architecture is observed in Nicosia where it assumed the most advanced features to be found in Renaissance treaties: *fortificazione alla moderna*.

The audacious Ottoman assault against the Knights Hospitaller in Malta in 1565 signaled the renewed Turkish interest in offensive operations in the Mediterranean. So far, since the Battle of Preveza (1538), the Porte's offensive actions had been limited to the actions of the Barbary pirates,[7] although many of these had official titles within the Ottoman military and administrative bureaucracy. The conquest of Tripoli (1551) and the naval victory at Djerba (1560), as well as the actual military cooperation during the alliance with the France of Francis I, were performed initially by corsair forces. In Malta, these were accompanied by significant Ottoman land troops, under direct command of Ottoman high officials from Constantinople. The Turkish intent of expansion was clear.[8]

In the aftermath of the victorious defense of Malta in 1565, major fortification works were undertaken throughout the Christian Mediterranean. In the Venetian overseas empire, these focused on the larger colonies (such as Candia and Cyprus) and key places (such as Corfu and Cattaro). Other key fortresses, such as Napoli di Romania, Malvasia, had been lost in 1540 and Modon and Coron previously (1500). Renowned military architects such

Figure 7. Caraffa Bastion, flank and *orecchione*. On the other side of the bastion is Porta Giuliani.

as Giulio Savorgnan and Michele Sanmicheli were dispatched to these important islands, which were within easy reach of the enemy.[9]

In the early 1560s, Nicosia still was surrounded by the old crusader walls, with typical medieval towers and curtain, ill adapted for artillery fire. The enceinte was larger than the current Renaissance walls, which still cover a significant area.[10] Giulio Savorgnan arrived in Cyprus in 1566 to advise on the defenses of Nicosia, and he designed the immense earthworks faced with masonry.

The walls of Nicosia, like those of Valletta, were finished in an astonishingly short period (1567–1569). The perfect shape of Venetian Nicosia is unique: a circle, the most perfect of the geometrical forms, with its center quite close to the cathedral of S. Sophia. Such perfect shape was chosen on other occasions—such as for the fortresses of Palmanova (Friuli) and Neuf-Brisach (Alsace)—it was not applied to cities, and certainly not ones of such political importance or geographical extent.

From top, clockwise, the bastions and gates are as follows (read down, then across):

- Barbaro Bastion
- Loredan Bastion
- Flatro Bastion
- Caraffa Bastion
- Porta Giuliani
- Podocattaro Bastion
- Constanza Bastion
- D'Avila Bastion
- Tripoli Bastion
- Porta San Domenico
- Roccas Bastion
- Mula Bastion
- Quirini Bastion
- Porta Del Provveditore

The remarkable feature of the walls of Nicosia is that these 11 bastions are identical; so it is enough to analyze one bastion to understand all their architecture. Apart from that, only the curtain, the ditch and the gates have distinctive features.

The front is bastioned in the Italian style. The bastions are virtually huge gun platforms,

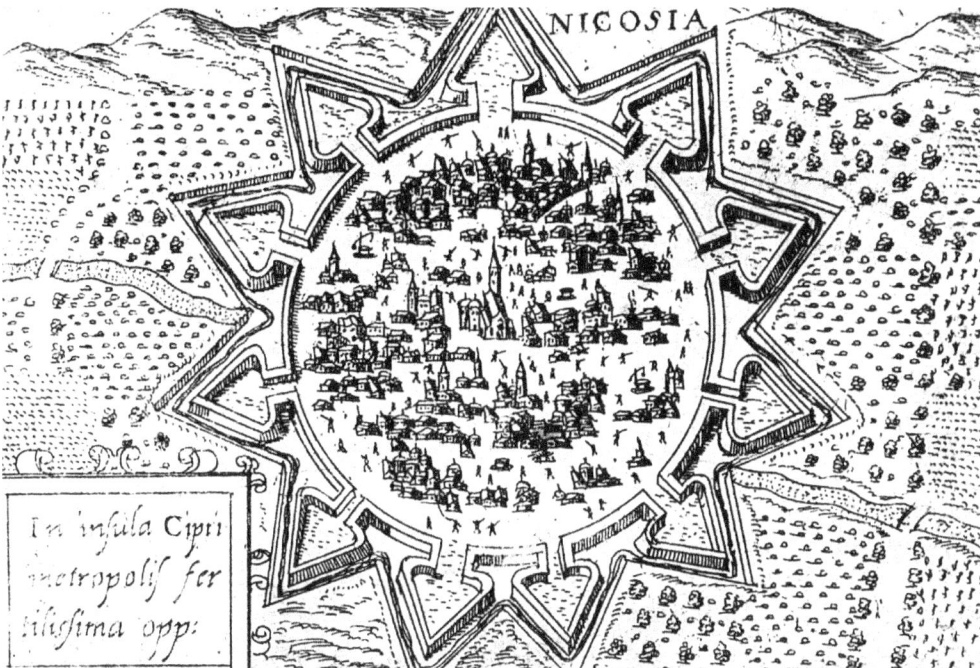

Figure 8. Francesco Valegio, *Nicosia*; *In insula Cipri metropolis fertilissima* (1625). Courtesy of the Ministry of Culture and Tourism, Biblioteca Nazionale Marciana Venezia. All rights reserved.

since they are filled and have no interior chambers or access gates; they have *orecchioni*, but they have no embrasures, nor *piazza-bassa* (as in Candia, Birgu, Valletta), nor cavaliers or any kind of additional gun platforms (like the Lando round cavalier, in Canea). The existing fortifications of Nicosia have a perimeter of around three miles, three gates and bastions with rounded *orecchioni* that cover retired flanks. They stand about 880 ft. apart, have a face and gorge of 400 ft. and rise 25 ft. at the salient. The fortifications were surrounded by a deep ditch 240 ft. at its widest.

To make way for the walls, the ditch and the glacis, and also to achieve the perfect circular shape, a large part of the old town was demolished, particularly to the south of the city.[11] Here, from the bastions Roccas to Caraffa, many religious buildings were removed, such as the Dominican monastery, and especially Orthodox ones, in the area of the ditch from Tripoli to Caraffa, where the Greek population lived.[12]

Initially the walls were not entirely covered with stone, but the demi-revetment was completed by the Turks, and the work was mostly of lesser quality. At the time of the siege of 1570, the curtain walls were half faced in stone, half earthworks. It was the Turks who completed the stone covering of the ramparts, which in places was not stitched smoothly (as seen in the faces of the Podocattaro bastion).

There are differences in the height of the curtain and bastions, but these are due to interventions in the latest centuries. From Tripoli to Quirini, the height of the curtain is 19 ft.; otherwise it stands at 13–14.5 ft. The salient of the Caraffa bastion reaches in excess of 22 ft., otherwise the bastions stand at 19 ft. at their highest points.

The scarp on the northern bastions is straight, while on the southern side it curves sig-

Figure 9. Salient of the Caraffa bastion.

nificantly midway up, which is proof of the reconstruction work needed after the bastions from Caraffa to Tripoli were subject to six weeks of bombardment.

Excavations around the D'Avila bastion, in the early 2010s, have revealed traces of the medieval enceinte, while renovations on the western recessed flank of Podocattaro unearthed elements of gun embrasures.

Although picture-perfect from the air, the reality of the fortifications of Nicosia is somewhat disappointing: the curtain is rather low, and there are no *piazza-basse* (like in its contemporaries, the bastions of Candia, Corfu or Valletta) nor cavaliers (although historical accounts describing the siege recall the hastily construction of cavaliers on some bulwarks, most likely the southern ones.)[13]

Without these and without outworks, their flanking and supporting fire capabilities are

Figure 10. Recessed eastern flank of the Podocattaro bastion.

greatly diminished, which also explains why this perfectly planned design failed to deliver. The bastions are huge and solid, but the curtain is low, the moat is not wide or deep enough for a dry ditch and there is no counterscarp visible. They also have different heights—for example, Barbaro's *orecchioni* are visibly dwarfed to just around 9 ft.

Besides being obviously unfinished, the fortifications of Nicosia have been rebuilt in places. This is understandable for the southern bastions, which were heavily bombed during the siege of 1570, but the makeshift nature of the northern fortifications could seem rather puzzling. In addition, the only parts of the fortifications that still preserve the cordon (the seal of origin) are the face and *orecchione* on the Podocattaro bastion. The reason the walls appear to have been modified by the Turks is that the Venetians had only faced the lower half of the trace in stone.[14]

Most disturbing for its siege-worthiness is the lack of outworks. The fortifications of Nicosia do not even have ravelins, not to mention crownworks and hornworks (which were present in Candia and Corfu). Although preliminary plans for this fortification are not available, it would be a surprise if the design left them out altogether, and it was probably only the quick onset of the siege that prevented their construction.

Certain historical maps[15] show a river passing through the middle of Nicosia, but this is inaccurate, since the river Pedios was diverted around the town in order to keep the ditch dry. In fact, the exit of the Giuliani Gate is right at the bottom of the ditch and the presence of water would have made it impractical.

The Turkish siege works were concentrated on the south side of the town, where the high ground overlooked the defenses: the hills of Santa Marina and Santa Margarita. In this area the besiegers' gun emplacements would have been at almost the same level as the bastions and could have dealt enfilading and ricochet fire at close range. It never came to breaching fire, since the ditch was filled and Podocattaro bastion was escalated after only six weeks. When the fortifications were designed, including the high ground to the south of the capital within the new defenses was considered,[16] but this plan was abandoned to allow for the perfect circular shape worthy of a Renaissance perfect city.

The main gate, Porta Giuliani,[17] is located on top of the Caraffa bastion, opening behind its right *orecchione*. The gate is most impressive and is among the best preserved of such

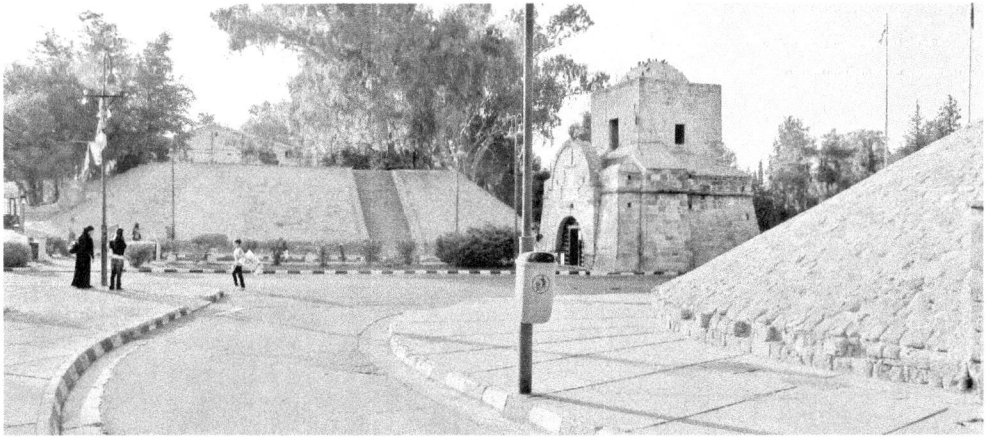

Figure 11. Porta del Provveditore. Note the width and height of the adjacent curtains.

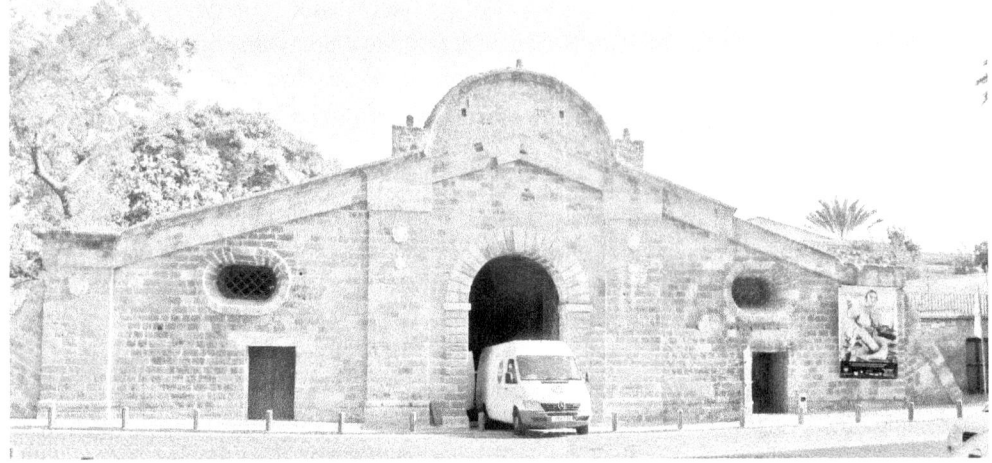

Figure 12. Porta Giuliani, exterior view.

architectural features from that period in the Mediterranean. Its design is very similar to that of the now-lost gate of S. Giorgio in Candia.[18] The access is through three vaulted corridors; the middle one is higher and wider, and the only one to open in a cylindrical chamber, although at a narrower entry than from the city side. The two side passages only have small window openings. From this last chamber an even smaller doorway leads into the ditch, protected by the western *orecchione* of the Caraffa bastion. Several small coats of arms adorn

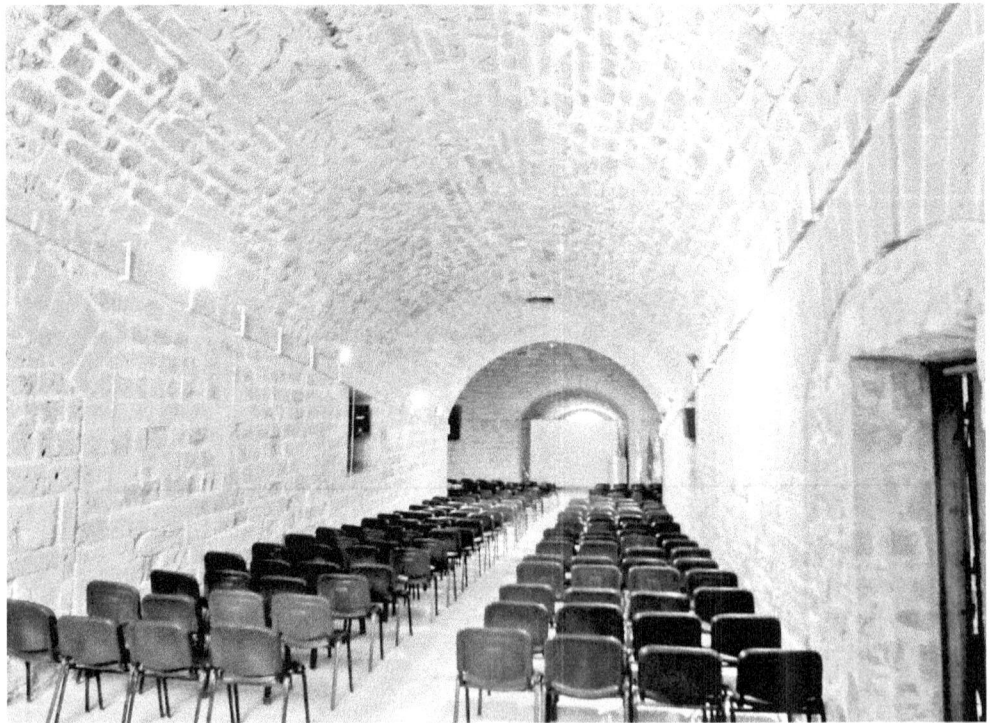

Figure 13. Porta Giuliani. The main hallway with the city exit in the background.

Porta Giuliani. The smaller entries have wide circular opening (*oculi*), and the rusticated main doorframe ends in a keystone.

The two other gates are the Porta San Domenico[19] and Porta del Provveditore.[20] They are not elaborate structures but small openings in the walls to allow incomer screening. There is a Latin inscription on the town side of the Porta del Provveditore, marking its construction at 1562.

San Domenico Gate features a long vaulted corridor, flanked by two ramps, initially without stairs (nowadays, the left one has a flight of stairs). The ramps were used to usher cannons and other military equipment to the top of the walls. The doors of the gate are very old, made of wood, pegged with large iron nails, and reinforced, on the exterior, by sheets of metal plates. The morphology of the gate was the same for Porta del Provveditore, a fact confirmed by historical photographic evidence.

Breaches have been cut through the walls to allow modern traffic, near the Porta San Domenico. They were cut on both sides of the hallway at Porta del Provveditore, so the ramps that made it virtually identical to Porta San Domenico are now lost. The idea of cutting through the walls to open traffic was later abandoned by the British for the solution of bridging over the walls, which meant raising the level of the town, so that now a ring runs on top of the terreplein rather than at the base of the wall, as normal.

The curtain, normally 50 ft. wide with its terreplein, has been virtually buried (with the exception of some areas around the Roccas bastion and the *Porta del Provveditore*). In the first half of the 20th century, a ring was built around the houses of old Nicosia and, because its streets were too narrow, the road was raised to the level of the wall-walk, to insure broadness. This modern intrusion has destroyed the inner revetment on its city side and, most likely, the artillery ramps (still visible at the Porta San Domenico). A building like the medieval hall called Kastelliotissa, close to this gate, is now half buried compared to the floor of the street, and shows where the original ground level was. Basically, the terreplein is mostly lost; only the scarp is original.

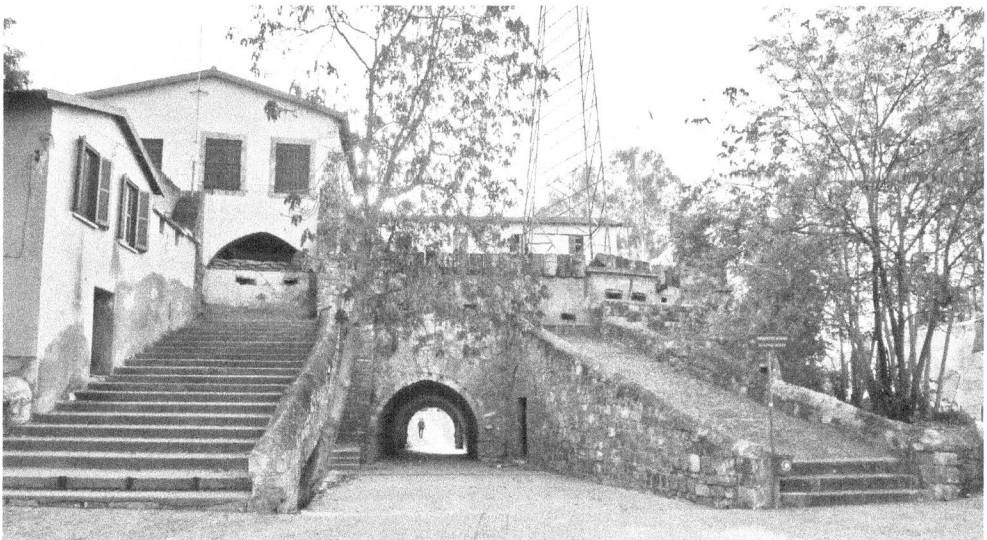

Figure 14. Porta San Domenico, with ramps. The wall on the right is in North Nicosia.

The Fortifications Today

The town of Nicosia is easily accessible, being the capital of the country of Cyprus, member of the European Union. All the southern bastions (Tripoli, D'Avila, Constanza, Podocattaro, Caraffa) and the ditch are accessible and in very good shape, although many are affected by modern development (car parks, public buildings). In the south are also located the Famagosta and Paphos gates.

In the north lie five more bastions (Roccas, Mula, Quirini, Barbaro, Loredan) and the Kyrenia Gate. The Barbaro bastion is inaccessible, housing a military barracks complex, and there are warning signs of "photos forbidden." The 11th bastion, Flatro, is also inaccessible, being occupied by UN troops, in the buffer zone between the two communities. In fact, because the Flatro bastion and adjacent ditch are inaccessible, they are the best preserved.

The capital Nicosia has been divided since 1974, and access to the northern part of the city is through a vehicle crossing at Ledra Palace and a pedestrian crossing in the heart of town, in Ledra Street. To visit the entire bastioned front is a lengthy process, since, after covering half the circle, you still have to go to the center of this rather large town and cross over. Crossing the border is very easy for EU citizens, who only have to show a passport. For citizens of other countries, it requires a visa (depending on country of origin).

5

Famagosta

After the loss of Acre in 1291, the port of Famagosta rose to its greatest importance, replacing the great crusader harbor as the base for commercial transactions with the East. The kings of Cyprus had also been the kings of Jerusalem in the last half of the 13th century, and the nobility of Cyprus had participated in the gallant defense of the last crusader city. Thus, most of the Latin merchants of the Levant naturally moved to Cyprus, and the island needed a significant harbor for trade.

Its exceptional commercial importance prompted the Genoese to seize it in 1373, in a war that strove for the conquest of the entire island. Famagosta remained in their hands until 1464, in spite of several attempts to recapture it by the kings of Cyprus. Despite its length, the Genoese administration of Famagosta left no visible traces.

The Venetians arrived officially in 1489 and decided to rebuild the fortresses and walls of the island's ports, which were at the center of their philosophy as a sea merchant nation, and were vital for their commercial routes and easier to reinforce if attacked. In the strategy of the Republic of Venice, the defenders would hold on to costal strongpoints until help arrived; so medieval castles perched high on mountain tops, such as S. Hillarion, Buffavento, and Kantara, were of no use to them, and so were abandoned.

The spread of the cannon made it necessary to remodel the entire defenses, and so the square, medieval, towers were replaced with round artillery towers. The first objective of the Venetians was the fortification of Famagosta and was undertaken by the two earliest governors, Nicolo Foscarini and Nicolo Priuli. They are mentioned in dedications above the gate of the citadel and on the Moratto bastion, respectively.

Work on the Venetian enceinte started in 1492, when the transformation of the citadel also began, while both the Sea Gate and the Land Gate took shape in 1496. In the case of the citadel, the original towers were shortened but retained, encased in the subsequent, thicker enceinte. A marble slab on the Moratto bastion, recording its erection by Nicolo Priuli, dates the west wall of the city to 1496. At the southwest corner of the ring was built the great ravelin to protect the main entrance, and at the southeast corner, where the wall meets the sea, the tower of the Arsenal.

Gian Girolamo Sanmicheli, the nephew of the famous Michele Sanmicheli, came to Famagosta in 1550 for the purpose of designing the new fortifications, and died here in 1559, being buried in the Cathedral of S. Nicholas.[1] Among his previous military works were the

fortifications of Zara and the fort of S. Nicolo at the entrance of the Gulf of Sebenico. He is also credited with the exquisite Martinengo bastion, which we will analyze later.

The Town

The walled town of Famagosta is an unexpected gem, offering an exhilarating feeling for the history aficionado. There is only one intrusive, contemporary glass building in the whole town, while every historical building is easy to access and observe on all sides, and well over a quarter of the old town is still open space, which is amazing in itself, in a day and age where the special interests encroach on every available plot of land.[2]

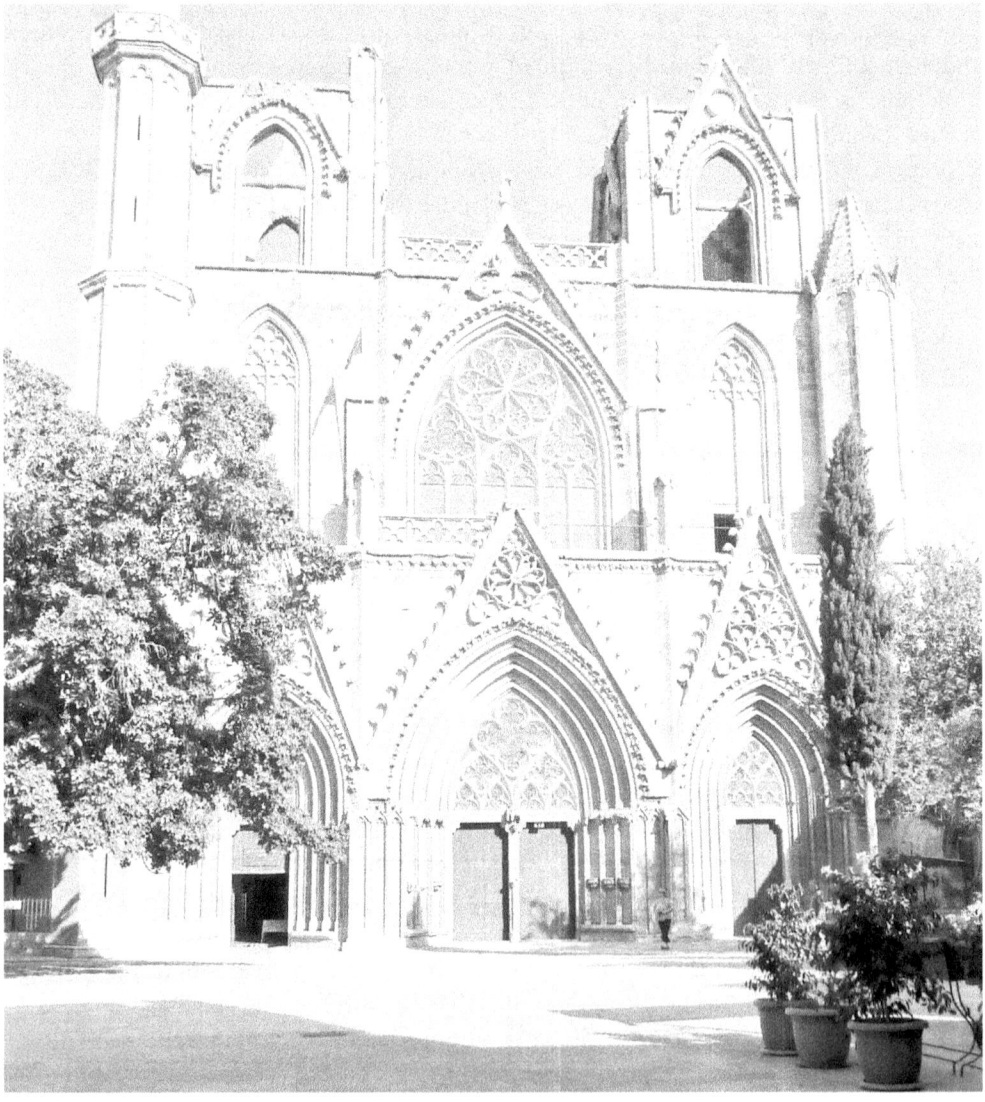

Figure 15. S. Sophia Cathedral, Famagosta.

Famagosta sports numerous superb buildings, particularly ecclesiastical ones. Being culturally anchored in the Latin West, the town was embellished with a gorgeous Gothic cathedral, in the French style, and well as stupendous Latin churches—such as S. Peter and Paul, S. George, S. Francis, and S. Anna—but also the remains of a rare Orthodox church in the Gothic style (S. George of the Greeks). The most beautiful churches date from the 14th century, and show the architectural influence of the Provence and Champagne Gothic. We also find typical Byzantine churches in the southern, Greek quarters, and churches of denomination not endemic to the island, such as Armenian or Nestorian.[3]

S. Sophia Cathedral is where the Lusignans would be crowned kings of Jerusalem, after they had been anointed kings of Cyprus in the S. Nicholas Cathedral in Nicosia. Such was the importance of Famagosta that the town had a princely palace built. A medieval palace at first, after 1489 it became the residence of the Venetian *provveditore* and, in fact, the remains belong to the Italian Renaissance: the L-shaped building presents rows of identical rusticated windows on two floors, and has a small chapel to its side, right behind the larger church of SS. Peter and Paul. The entrance has three Renaissance arches, with pillars and a small coat of arms, but it doubles a previous Gothic portal with pointed arches.

An impromptu open-air museum, in the courtyard of the Lusignan Palace, hosts piles of genuine cast-iron cannon balls, as well as three artillery pieces; one British, late 19th century, a conspicuously Ottoman-looking bombard, and a beautiful Renaissance cannon[4] with an exquisite escutcheon. It is crowned with a coronet, and marshals four coats of arms, two of them in *pretence*. Still, the arms have more references to mainland France than to the royal house of Lusignan. The inscription on the barrel reads "Opus Alixandr / Oardi e Mateus / Orfrida 1539."

The Fortifications

There are very few available sources on the Renaissance objectives in the north of the island of Cyprus. More date from the first phase of the British occupation (1878–1914) than from the colonial period (1914–1960). Even so, the short period of statehood (1960–1974) before the invasion of 1974 has isolated the sites; for decades, it was difficult to even travel to Northern Cyprus, due to the obvious passport issues raised by the status of a territory outside of the international law. In 2008, many crossing points were opened between the Turkish-occupied North and the Republic of Cyprus, and thus facilitated an expedient crossing for any holder of valid EU passport.

Until recently, the moat, walls and tunnels of Famagosta's fortifications were run and used by the local military since 1974. Thus there was almost no solid scientific work done on these fortifications, and almost all details of the tunnels and the interior of the bastions comes from pre–1974 research, as scarce as interest was, in those days, for such studies.

Famagosta is a wonderful example of artillery fortification, protected by ramparts whose enclosing wall, built of ashlar masonry, is complete. The walls of Famagosta are two miles long and 32 ft. high. The Venetians built 14 bulwarks and two gates, clockwise, from the citadel: Sea Gate, Arsenal, Camposanto, Andruzzi, Santa Napa, Land Gate/Ravelin, Diocare, Moratto, Pulacazzaro, San Luca, Martinengo, Del Mezzo, Diamante, and Signora. The bas-

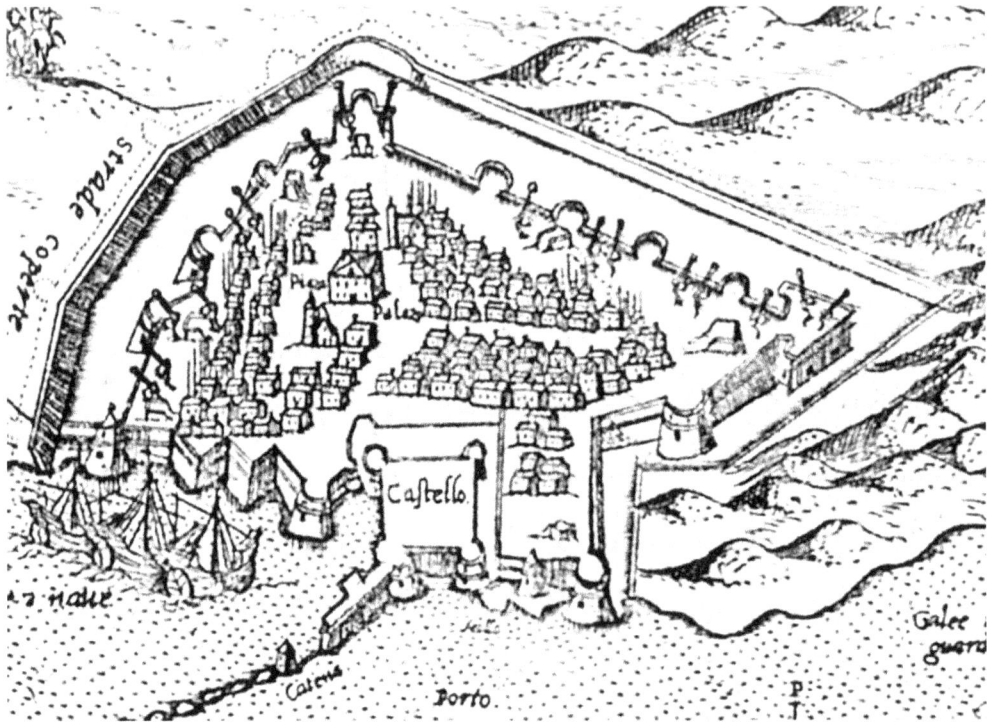

Figure 16. Giovanni Francesco Camocio, *Famagosta*, 1574 (detail) (courtesy the Ministry of Culture and Tourism, Biblioteca Nazionale Marciana Venezia. All rights reserved).

tions are some 98–115 ft. apart on the southern front, but much wider spaced on the western and northern fronts, ranging from 300 ft. (between Martinengo and Del Mezzo) to even 650 ft. between Pulacazzaro and Moratto.

From the harbor on the map, clockwise, the features are (read down, then across):

- Citadel
- Sea Gate and Sea Tower
- Arsenal action and cavalier
- Camposanto bastion and cavalier
- Andruzzi bastion and cavalier
- Santa Napa bastion and cavalier
- Land Gate ravelin and cavalier
- Diocare bastion
- Moratto bastion and cavalier
- Pulacazzaro bastion
- San Luca bastion and cavalier
- Martinengo bastion and cavalier
- Del Mezzo bastion and cavalier
- Diamante bastion and cavalier
- Signora/Madonna bastion

This circuit presents nine cavaliers (stone-clad earth platforms for gun emplacements, provided with long access ramps) supporting the main bastions. In Famagosta they are pentagonal and rectangular; the largest cavalier is Del Mezzo cavalier, whose sides are 115 ft. each.

We will analyze the fortifications starting counterclockwise from the Ravelin and doubling back to observe the Land Gate. The first is the Land Gate, its cavalier and, especially, the preserved southern glacis.

The current access gate was opened in the 18th century by the Turks, and runs next to the original port. Above the entrance, the Ottomans built merlons. Such additions can be seen in many fortresses conquered by the Turks (S. George Bastion in Rhodes; the gate to Retimo citadel in Crete). These were constructed to protect infantry troops when shooting against assailants at close range, which denotes both the expectation of being attacked by light infantry and also a certain lack of apprehension for the use of artillery fortification and its value, even when deterring skirmishers armed with small firearms or less. In Western Europe, when medieval defenses gave way to artillery fortifications, it was understood that there was no place left for close combat between troops on top of the walls and those at the bottom, even when equipped with firearms, simply because there would be no way to reach the bottom of the wall and mount up a ladder, medieval-style. You would literally have to bring down the wall, or else the flanking fire of an artillery fortification would make it virtually impossible to get close; thus, firearms or bows shooting through gunholes were rendered obsolete in Western military philosophy by the advent of the artillery tower, in the early 1500s.

The ditch is hewn out of the bedrock, especially at its most inland portions (the bedrock is no longer visible where the ditch meets the sea). The ditch was dry, although there are no low gun ports, except on the *piazza-bassa* of Martinengo. The ditch is 130 ft. wide, but it does not follow the frontline, so it shrinks to a little over 65 ft. in front of the bastions. The bedrock decreases towards Andruzzi, from half the height of the curtain wall to just a quarter, and almost disappears from there towards the sea level.

The fact that the glacis still exists is exemplary. Too few artillery fortresses still preserve their glacis, for the simple reason that since it became obsolete, its characteristics as a very wide and open space right next to the city walls made it an easy target of urban development. Especially in the case of a walled town, the pressure for urban expansion overruns the empty field of the glacis in no time.[5]

The glacis is an artificial slope designed to keep assailant under the fire, in clear and open space. In Famagosta, the glacis was 400 ft. wide; the south side is more preserved, except for a road that cuts it in half (the compact zone measures 130 ft.). From the glacis almost no modern buildings are visible over the walls. This makes for a great skyline, almost unique, and the sight isn't even obstructed by trees, as it is in Rhodes. The cathedral spires would have been visible from the glacis, the only feature to break the line of sight of the battlements (however, the last level of the cathedral towers, the spire itself, was brought down after the Ottoman conquest, to allow the minaret to be the tallest fixture of the structure).

Such intact glacis can also be found in Corfu, in front of the original walled enclosure (Old Fortress), and around the land walls in Rhodes,[6] but in both cases the zone has been converted into a park, and this obscures the view. Here in Famagosta, the almost pristine state of the glacis conveys the feeling of living history.

The presence of the southern glacis is actually even more impressive, since this is the side of the fortifications where the Turks mounted their assaults during the entire siege. The attack front covered the fortifications from the Ravelin complex to Santa Napa bastion, Andruzzi bastion, Camposanto bastion and, lastly, the Arsenal bastion.

Niches for coats of arms can be seen on the flanks of the ravelin and in the curtain between the main land gate and the Santa Napa, undoubtedly belonging to the Republic of Venice, or to Venetian nobles or dignitaries. The same empty niches can be found elsewhere

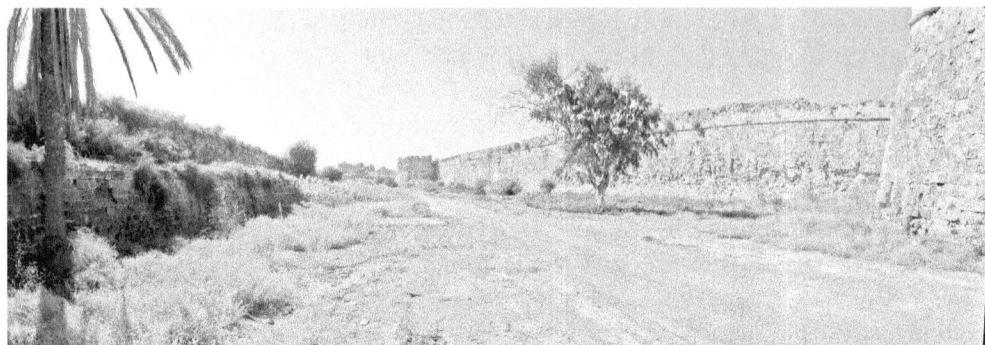

Figure 17. The level of the moat; the Arsenal bastion to the right and the Camposanto in the background.

along the walls, especially on the ravelin (the original land gate). In the whole of Famagosta, the Venetian lion can be seen only over the lintel of the Sea Gate, the Citadel Gate, and one corner of the citadel, while having been visibly removed from the outer walls of the city.[7]

The moat is over 130 ft., and the city walls are very tall, rising to almost 65 ft. The lower half is cut into bedrock, which hampered sapping during the 1571 siege. The moat is very wide and very well preserved, without any significant modern intrusion. Only a few trees grow in the moat. There is a dirt road formed by years of traffic; and there are several stone stairs leading out of the ditch.

The counterscarp is intact, although it was most likely largely reconstructed after the siege. On the southern moat, the counterscarp presents a wide embankment, which would qualify as a covered way, except that it is almost 8 ft. below the glacis edge, making it impracticable for infantry defensive fire.

The existence of the glacis allows the viewer an accurate perspective on the typical artillery fortification: a very high wall, but sunken into a deep ditch, leaving only the last 6.5–9 ft. over the counterscarp, that is into the enemy's direct, breach or enfilade fire. The walls and bastions are revetted with stone masonry filled with compacted earth, which gives them a tremendous solidity and resistance to the devastating impact of artillery, which hurdles heavy stone or iron balls with precision.

The walls bristle with gun ports, and from the glacis you can see how the embrasures sweep exactly at that level. The gun-chambers of the lower tier of the towers could enfilade the ditch completely and the high platforms (cavaliers) were intended to have an extensive range over the adjoining countryside.

Other Renaissance enclosures, such as Ferrara and Padua, had more sunken walls and a more shallow ditch. However, the proximity of the Ottoman Empire and its medieval army, tactics and logistics meant that even modern Renaissance fortresses needed to protect themselves from ladders and sapping, to a greater extent than the theory of siege warfare recommended for the 16th–18th centuries. Huge protruding bastions as gun platforms were not quite enough against an army that relied more on its forced labor of miners to undermine the walls in ancient fashion than on artillery alone to crumble modern walls through cannonades. A puzzling example of such anachronism is the Turkish use of a wooden siege tower in the 1565 siege of Senglea,[8] in an age where no European siege featured such literally antiquated machinery (invented in the late 4th century BC by Demetrios Poliorcetes).

The bastions at Famagosta are round artillery towers, with the exception of the Martinengo bastion and the complex of the Land Gate. By the mid–16th century, the art of fortifications had moved on definitively to the polygonal bastion, where the two faces formed a salient pointing outwards from the curtains. However, the round towers did offer more tiers of fires, since they had several stories, while the usual Italian bastions were essentially earth-filled, reinforced gun platforms. Nevertheless, even as late as the second half of the 17th century, Venice still made use of the former design, as in the case of the Zeno bastion in Chios (build during the brief Venetian occupation of 1694–95). The towers sport three embrasures on the upper tier, placed at 90 degrees to each other, geometrically disposed, just like in the Versiata and Mandrachio towers in the Old Fortress in Corfu.[9]

Above the terreplein are rising cavaliers build on the southern enceinte wall: one immediately to the left of Santa Napa, two between Andruzzi and Camposanto, and one on top of the former Arsenal. They are designed as slanted, square earthen mounds and are revetted in stone; as compared with the huge cavaliers of Birgu and Valletta, which are much taller, pentagonal, and with halls and corridors inside. In our present case, they are accessed from outside, over ramps of earth; for the cavalier above the Land Gate, the ramps are even more intricate.

The front is not a straight line. From the ravelin to the sea, the front curves, to allow the towers to flank the ditch and support each other. From the ravelin north, the front is flanked all the way from the grand Martinengo bastion, which basically renders unnecessary the supporting functions of the Diocare, Moratto, Pulacazzaro and San Luca bastions. Actually the latter—where the medieval wall used to turn towards the sea, bearing northeast—became embedded in the new curtain and only a small arch remains exposed.

The Camposanto cavalier is one of the most impressive and best preserved, with two gun ports on each side. Right in front of it, in the curtain wall, a cannon ball can be seen stuck between the stones.

The Camposanto bastion was heavily altered by the Ottomans, who removed the three gun embrasures and replaced them with high crenellations and merlons. A peculiar fixture is found right next to the Camposanto bastion: a filled archway, covered by four arrow slits

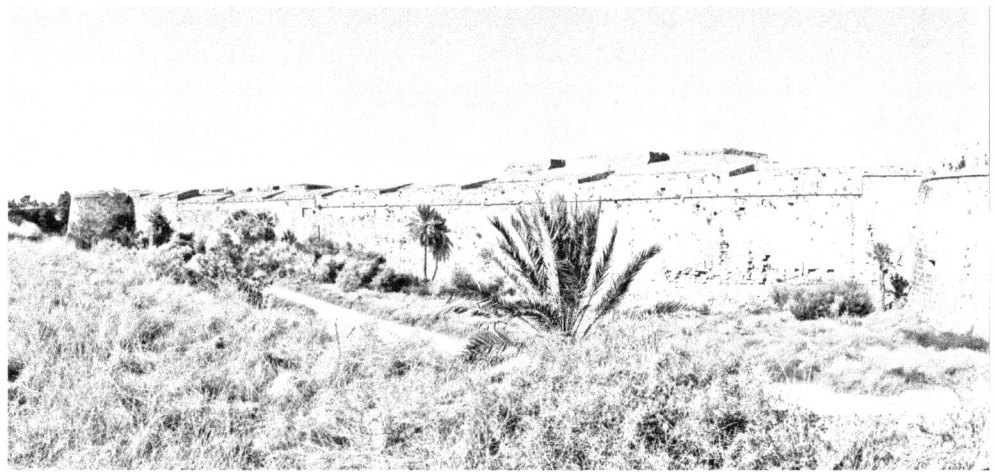

Figure 18. Camposanto cavalier and bastion; background left, Andruzzi cavalier and bastion.

to the sides. This opening was situated at over 6.6 ft. above ground level and is now filled. Another outline of a walled-up entrance, identical in design and positioning, is midway through the curtain between the Campo Santo and Andruzzi bastions. Apparently, traces of another gate, tall as a doorway, survive in the curtain between the Diamante and Signora bastions.[10]

Towards its seaward end, the whole curtain features a patchwork of remodeling, with little sound military value; for instance, a parapet was added in front of the slope of the embrasures, in some cases even blocking the gun ports.

The Arsenal tower doesn't retain its ports at the lower levels and now is oval. However, since siege accounts recall it being extremely damaged,[11] with only the flanks remaining standing, there are indications its actual shape was pentagonal (similar to the faces of the ravelin or the S. George bastion in Rhodes, or the much larger De Redin bastion in Mdina, Malta), because the western flank of the bastion is a definite flat surface, not round. It was not build as a solid earthwork or casemate, and inside the structure, there is a large vaulted gallery, 100 by 19 ft., running along the sea wall, which now serves as a history museum.[12]

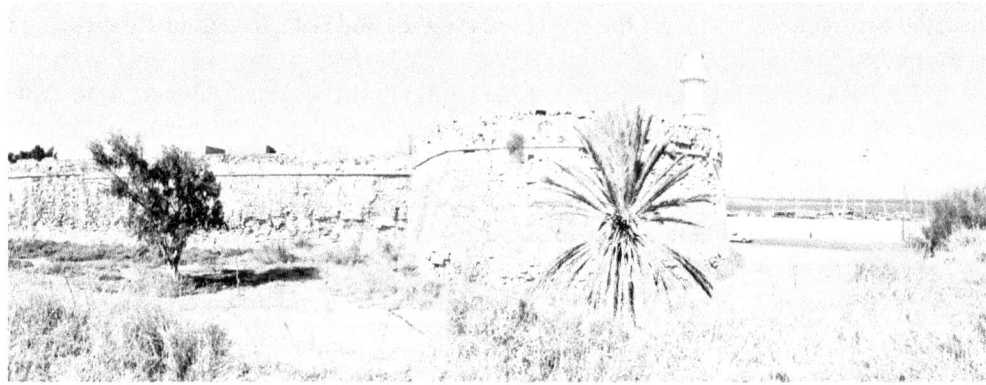

Figure 19. Arsenal tower and curtain.

A rather fanciful mural of the siege of 1571 is nicely displayed on the fence of the docks, and has the merit of presenting an insert of the actual engraving by Stefano Gibellino. By the contemporary docks there is currently an opening in the walls, which the locals call Arsenal Gate, but, like its symmetrical counterpart, the New Gate (in the middle of the Diamante curtain), it is not a historical gate, but a modern breach in the walls, conveniently wide enough to accommodate a two-lane road.

Once inside the town, the whole open space encountered was the place of the Venetian Arsenal. It was a single-nave, oblong construction, and a solitary arch remains of that at its western end, along with the vault of the bastion itself.

Along the wall there is stairway access to the terreplein, and the view is impressive. The intrusion of the modern in the urban fabric of the old town is scare and discreet. Very few contemporary buildings are two stories tall or more, and this allows the taller ecclesiastical edifices to stand up and dominate the skyline, just like they did for over 700 years.

Large open spaces still survive, unclaimed by private developments or encroached by special building interests. The former arsenal area features small warehouses and allows the visitor a clear view of the sea wall, as well as of the terreplein of the land walls. The sea walls are just made of stone and supports, without the expected terreplein behind them.

On the other parts of the enceinte, earth has been banked up on the inside of the wall and its buttress, but this is not the case for the curtain fronting the sea and the harbor. The sea wall, however, is rather damaged by the removal of the earthworks and inner revetment that were buttressing it; currently, only one such vault remains, and work is being done to strengthen the wall. The sea wall was much thinner than the land walls. However, half of it sports gun embrasures, although lacking the wall-walk, so it is obvious that it was subjected to serious remodeling in the recent centuries. Before that, the wall between the Arsenal bastion and the Sea Gate abutted directly in water, as seen in the 1878 photos by John Thompson.[13]

The wall-walk is, on average, 60 ft. wide and is mostly intact. While the scarp itself is 20 ft. wide almost everywhere, the earthwork reaches 130 ft. in width in some places, to accommodate the Camposanto, Andruzzi, Diamante and Del Mezzo cavaliers.

Figure 20. Foreground: terreplein above the entrance to the Andruzzi bastion; background: Camposanto cavalier and bastion.

The earth has been removed in two places, along the southern walls; aside from this, the terreplein in Famagosta is one of the best preserved in Europe, *in situ*, and without any significant intervention. There are also wide and accommodating entrances to the Camposanto, Arsenal and Andruzzi bastions, and ramps and ventilation shafts are found regularly.

The cavalier of the Arsenal is quite shallow, and extensive rework is visible on the curtain, from here to Camposanto: the parapet was raised, so now it is just as tall as the top of the embrasures. This was done again to allow cover for shooters, acting as a breastwork, with merlons and crenellations. At the start of the curtain, the embrasure mouths were obscured by this breastwork and the actual gun ports were thus rendered useless.

The original Venetian works are displayed in their full glory starting with the Andruzzi curtain, Camposanto cavalier, Andruzzi cavalier and Andruzzi bastion. The Camposanto cavalier has two sloping faces to deflect cannon balls, and its wall is 33 ft. wide (compared with the 19-ft. width everywhere else in the *trace*), while the Santa Napa cavalier is one of the most elaborate of the structures of the south wall, being entirely revetted in stone and forming a solid structure, with its front half buried in the earth of the terreplein.

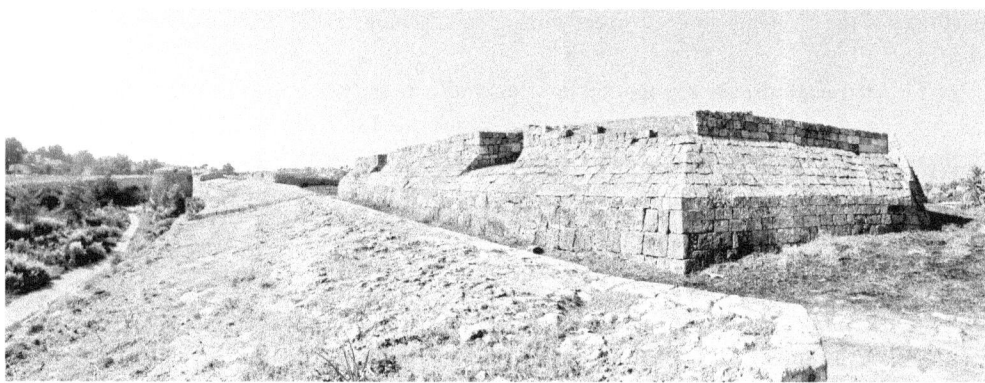

Figure 21. Background: wall with embrasures, Andruzzi bastion; foreground: Camposanto cavalier.

Most artillery towers in Famagosta have the same external and even internal structure: the tower is crowned with a stone banquet, with three embrasures, accessed by a stone ramp; at each side of this podium, where the tower meets the straight line of the curtain, there are two more gun ports, directly sweeping the moat below the curtain wall. The internal structure consists of two floors with a central rectangular hall, which accesses two casemates for cannons on each side of the tower, flanking both neighboring curtains.

Figure 22. Interior layout of top platform of the Camposanto bastion.

The elegant Sea Gate is another round tower, albeit not as tall as the land bastions; it only has only one large domed hall, which allows passage from the town to the sea. The big and beautiful stone lion next to the Sea Gate, on the town side, belongs to the Hellenistic era[14] and is not a Venetian lion of San Marco, as might be expected.[15]

The Sea Gate was one of the earliest Venetian works to be completed, in 1496. It sports

a portcullis, and on the seaside, it is adorned with a Venetian lion of San Marco. In this area of the town more heraldry can be found on the southeast and southwest corner towers of the Citadel, as well as on the entrance to the "Othello Tower"—as the citadel is now known, for promotional reasons. But in fact, there existed a certain Cristoforo Moro, Venetian governor of Cyprus (1506–1508); this name, of course, might be expressed as "the Moor of Cyprus," referring to the famous play by William Shakespeare.[16]

The beautiful, large coat of arms in the citadel, showing a crowned lion of S. Marco, seems quite reconstructed, as its entire left panel, showing a tower structure, is very new. The panel was dedicated by Nicolo Foscarini, governor of Cyprus, in the year 1492.

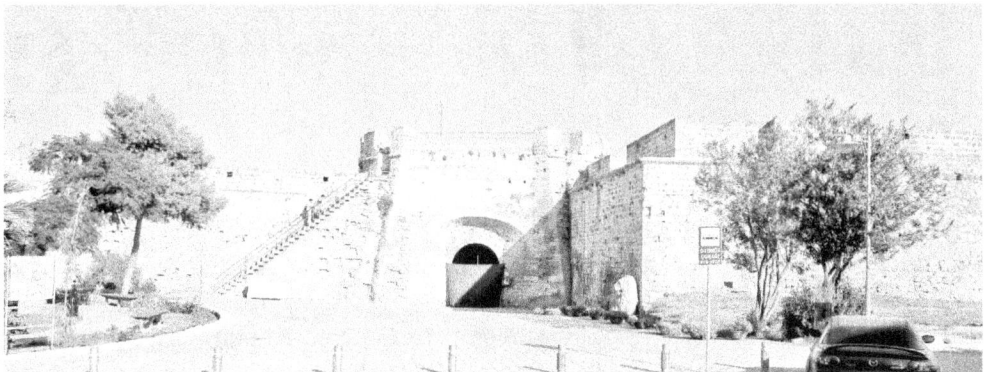

Figure 23. Sea Gate—town side, with large lion statue.

The citadel itself is in fact largely Lusignan, and belongs much more to the Crusader architecture of the Levant than to the Renaissance defensive structures that are the object of this research. The inner yard (165 by 50 ft.) as well as the interior halls are crusader in construction and style. Its towers are just as shallow as the Sea Gate; within the Venetian round towers the original medieval structure is encapsulated, with its four square corner towers and the groin vault chambers alongside the walls, in typical Latin medieval fashion. Two square medieval towers are clearly visible inside the new walls. The technique of adding new walls to thicken the old walls is also found in Cerines, where the Venetian doubled the strength of the walls in a similar fashion.

On the south side of the citadel, the new walls are 49 ft. thick, but on the other three sides they reach 33 ft., including the previous structures pegged against the walls. The whole structure is in need of repairs, especially since most of the parapet near the entrance is gone and the southeast corner tower has no gun ports (like the large Venetian sea-tower gate).

From the citadel, a pier jets into the sea and is finished with a small rectangular tower. In this area, between the Sea Gate and the Citadel, lay the docks in the Middle Ages and the Renaissance.

From the Citadel, the walls move north to the small Madonna tower and arrive shortly at the large round Diamante bastion. From here the curtain should follow a straight line by north-west, to the Del Mezzo tower, but the architect opted to create an ample pointed concavity, to allow more exposure for the guns on the strong Diamante bastion.

The north front is not a straight line, and the walls between the Citadel and Martinengo are supported by large, sturdy defenses: the Signora tower guarding the sea, the Diamante

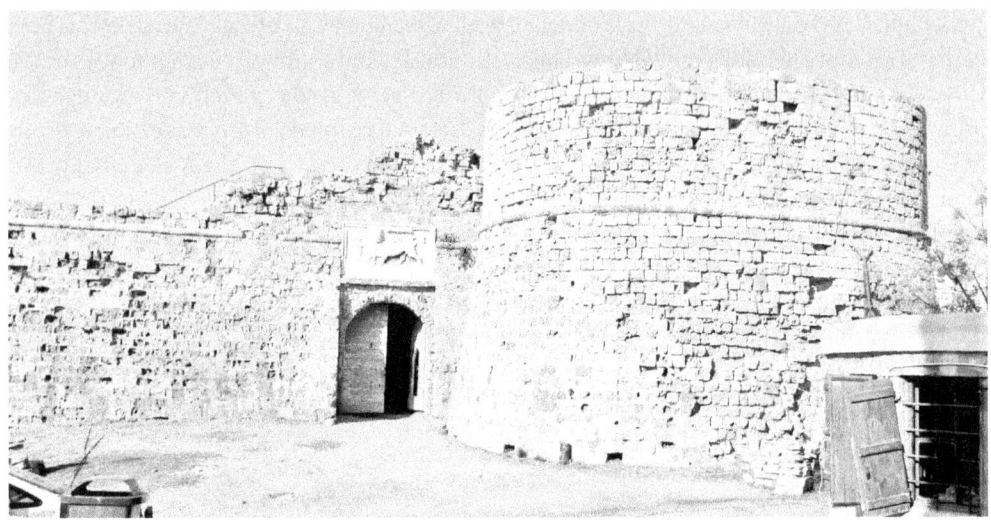

Figure 24. Entrance to the Citadel.

and Del Mezzo cavaliers are imposing rectangular structures, built from the ground up as large pyramidal frustums. They are almost twice as wide and large as the similar gun platforms on the southern curtain (in fact, they have the size of the original crusader fortress—roughly the courtyard of the Venetian citadel).

Figure 25. Del Mezzo cavalier, the largest cavalier in Famagosta.

The Martinengo bastion is one of the finest examples of military architecture in the Mediterranean, and was built by the Venetian architect Gian Girolamo Sanmicheli, between 1550 and 1559. Martinengo is a huge, solid work of stone masonry, covering more than one square mile and with a scarp 20 ft. thick. This alone seems to have deterred the Ottomans, who did not even attempt to storm this point during their siege.

The Martinengo bastion is a very complex structure, with a huge heart-shaped bastion, *orecchioni*, two *piazza-basse*, three ramps, and not one but two cavaliers for additional support. Though very large, it is not as large as the Martinengo of Candia, or the bastions of Nicosia. Its faces are unequal; the northern face is 262 ft., while the western is 295 ft. long; the flank of the ear is 49 ft. wide. Its *orecchioni* are not semicircular, like those in Nicosia and Candia,

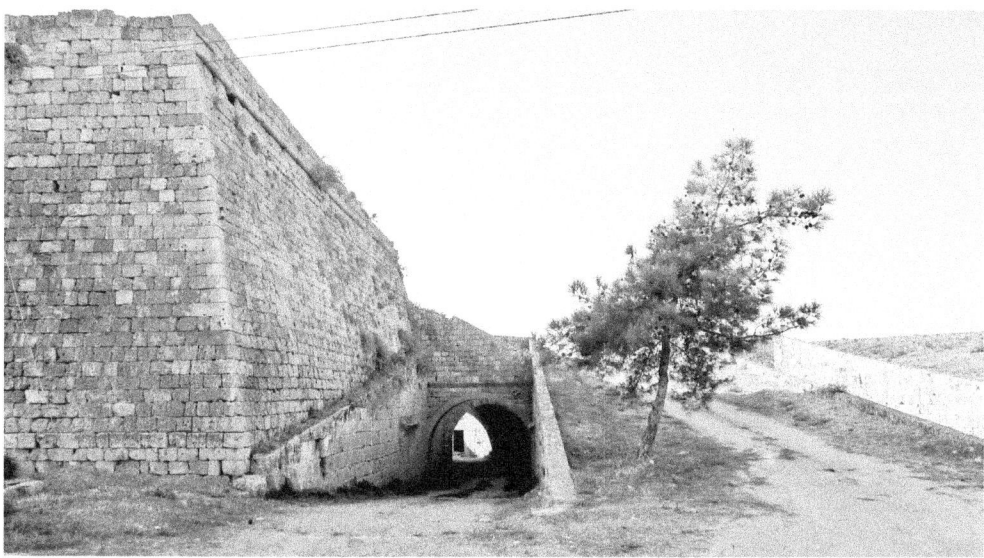

Figure 26. Descent to the *piazza-bassa* of the Martinengo bastion along the S. Luca cavalier; ramp and platform of the bastion.

but squared, like those on the Savorgnan and Martinengo bastions in Corfu. Also, it has nine ventilation shafts, for the escape of gunpowder smoke.

Movement from one *piazza-bassa* of the bastion to the other was facilitated by a passageway within the earthworks, but this has been bricked up. Access to the each *piazza-bassa* is through two uncovered alleys, unlike in latter designs (Candia), where these fixtures are accessed through passageways inside the bastion. It was not possible to build cavaliers right behind the gorge of the bastions, so instead they were built on either side of the bastion flanks. However, it may also be argued that, in fact, one cavalier belongs to the engulfed bastion of S. Luca (whose access port is still visible and accessible).

The cavalier on the right offers sweeping views over the entire town; its ramp is, however, a modern addition. Access to the cavalier was originally from the terreplein like in Canea, as well as from ramps. The area where Martinengo lies was forbidden ground until 2008, while the area was being run by the local military; the guard post and typical barrier still remain.

Martinengo presents a wonderful, sloping 245-ft. ascent, a wide ramp on whose side two 210-ft. passages descend to the *piazza-bassa*, its two-story flank. This *piazza-bassa* is an earlier model; the floor is rather low, almost at ditch level, and accessed through the flanks of the bastion. In the later, perfected models (Candia, for example), the *piazza* is just a story below the bastion level. Because at Martinengo the *piazza* is situated so low, its embankment is very tall, since the embrasures are deep.

In Figure 28 you can see the western line of fortification, looking south from the recessed flank of the Martinengo bastion: in the foreground, left, San Luca is encased in the curtain, visible in front of the large cavalier; Moratto is in the background. Also you can see, inside the town, the roofs of the S. Ana and Armenian churches. From the *piazza*, Martinengo covers the ditch up to the Moratto bastion, but from the gun ports on the *orecchione*, it covers all the way to the Ravelin Gate.

From the Martinengo bastion back to the starting point, the Land Gate, the wall is for-

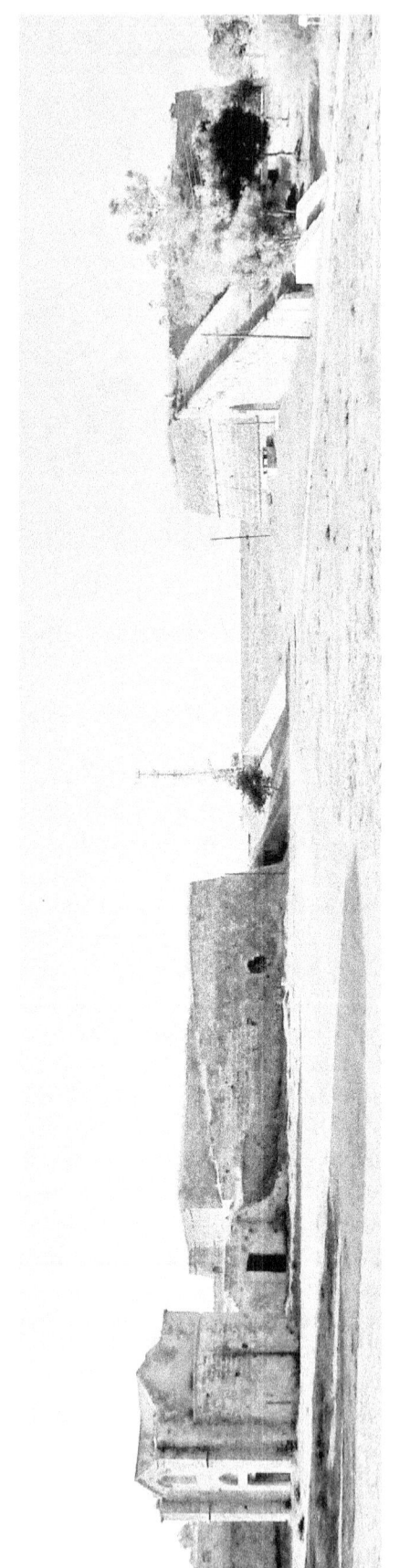

Figure 27. The cavaliers on the sides of Martinengo; ascending and descending ramps. Note the size of the structures, compared with church on the left.

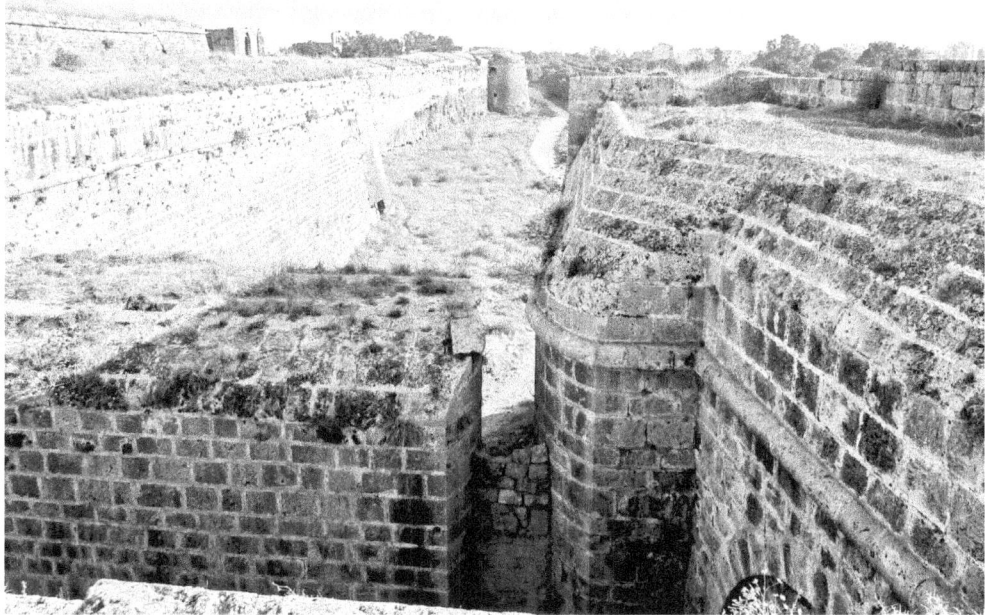

Figure 28. Looking south from the flank of Martinengo; *piazza-bassa* below.

tified by the round towers of San Luca, Pulacazzaro, Moratto and Diocare, which share characteristics with the other round bastions of the enceinte, both on the interior layout and the exterior appearance, although those have a smaller circumference.

The Land Gate, dated 1544, is a particularly impressive complex, remarkable both in construction and plan, and is reminiscent of the intricate gateways in the city of Rhodes.

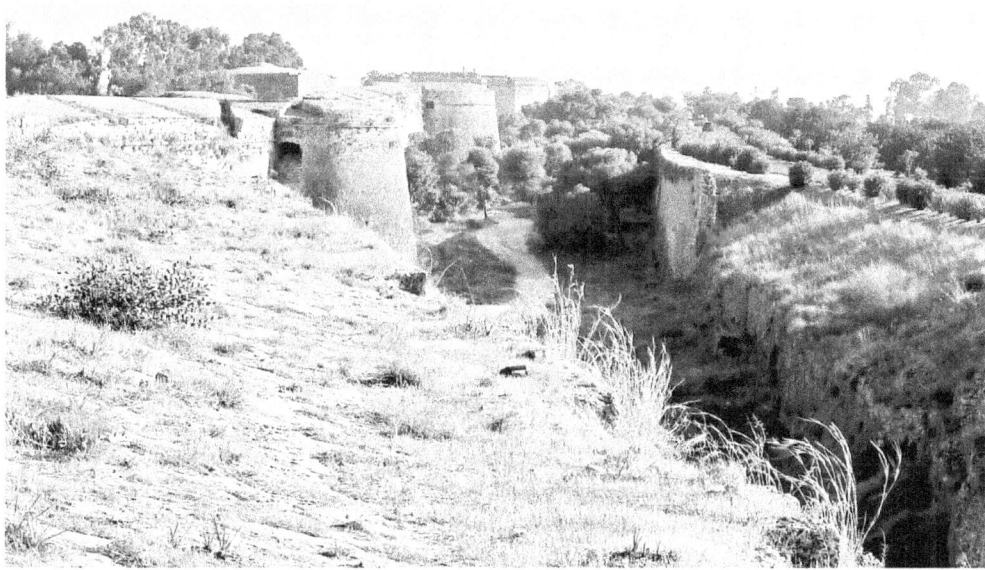

Figure 29. From the face of Martinengo bastion, looking south: Pulacazzaro bastion, Moratto bastion and cavalier and, lastly, the cavalier and the Land Gate. Diocare is hidden behind Moratto.

Before the town's 20th century expansion, the ravelin formed the principal landmark of the region, and could be seen from a long distance across the flat country near Famagosta.[17] Constituting the most advanced point of the city, this fort was detached from the castle and allowed the control of most of the wall, ditch and glacis.

The entire Land Gate structure was the original city access, and bridges jutted out of the flanks of the ravelin. You can still see the slots, above the gateway, where the arms of the drawbridge—situated above and parallel to the bridge deck itself—would fit, in the closed position.

Initially, there was only one gate, with a groin vault, fronting the town with an immense archway, 30 ft. in height. The ravelin was connected to the gate by a small drawbridge over a narrow ditch, and from the flanks of the ravelin, two bridges were thrown over the moat. Additionally, a wide gun platform was built on top of the gate, with a tall archway on the town side, slightly unaligned with the earlier access structures of the gate.

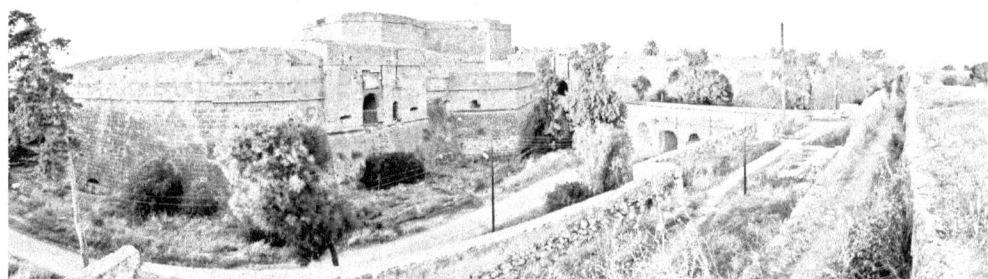

Figure 30. Land Gate with its ravelin and cavalier, with current access bridge. Note the original drawbridge door in the southern face of the ravelin.

The Gate cavalier is equally commanding, the tallest structure in the fortified enclosure and shaped like a trefoil. This club shape is rather unique in the world of 16th century fortification works as cavaliers go, and derives from the fact that since the gate complex serves as a corner bastion, the cavalier supported both the gate and the adjoining curtains.

The cavalier not only overlooks the gate complex, but also flanks the ditch up to the Andruzzi bastion, to the east, and to Martinengo, to the north. From the height of the cavalier, the Venetian guns would sweep virtually the entire glacis, left and right, and mortar would throw hot shot over the enemy trenches.

The Land Gate featured, originally, symmetrical ramps, but the Turks cut a new gate in the curtain, so the southern ramps were removed. On the good side, because earth was removed, you can see the buttresses and the interior stone revetment of the scarp, between the gate and Santa Napa bastion—a rather rare sight among European Renaissance fortifications.

The access to the platform of the cavalier is entangled, due to its impracticable height; thus one smooth 82-ft. ramp raised the gun to the top of the curtain, and from there a second ramp doubled over the first one at 90 degrees. The arched doors of both these ramps survived. The first ramp has been very widened, and now buttresses the inner revetment of the cavalier (whose town side has a crack along its entire height).

The ravelin also offers a unique perspective: over the embrasures, you can see the insides of the structure, since the roof of the lower story is missing. Chamber walls, ventilation shafts, stairways, and ramps are all visible at bird's-eye level.

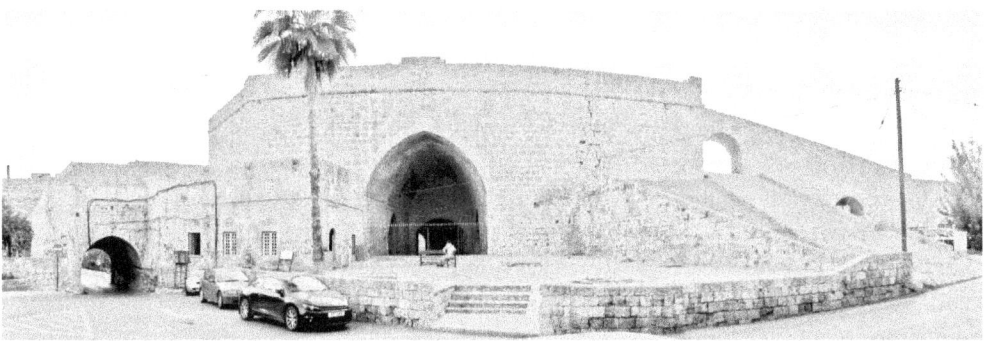

Figure 31. The current town gate, the Land Gate, and ramps to the curtain and cavalier.

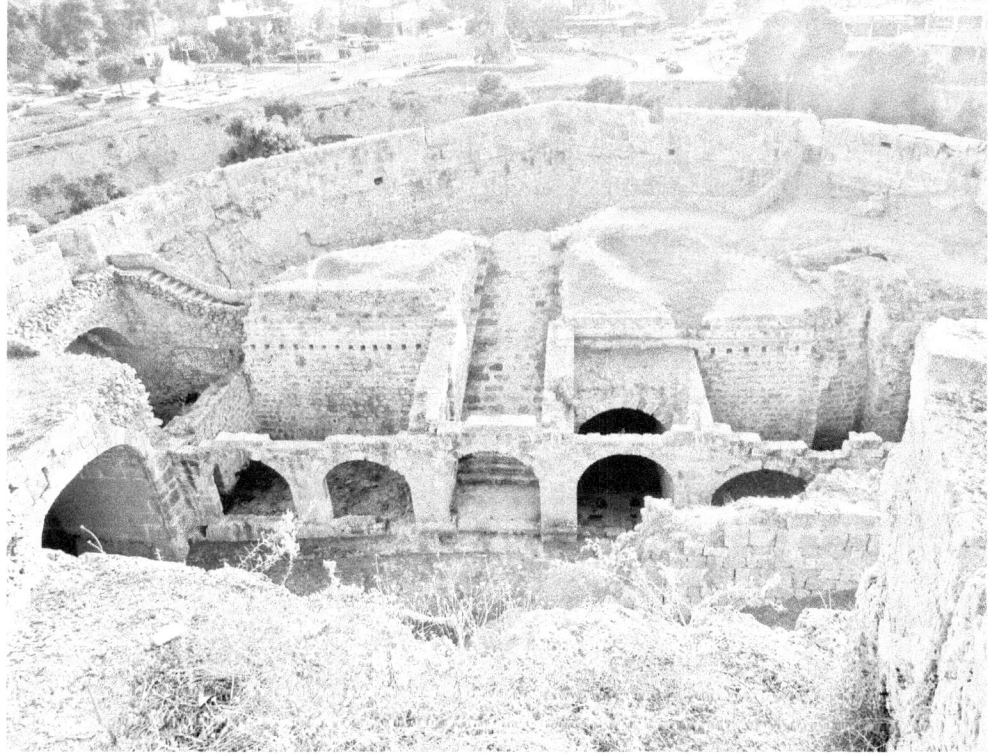

Figure 32. Inner structure of the ravelin of the Land Gate.

Besides opening another doorway in the curtain and spanning a drawbridge, the Ottomans made some alterations to the actual gate, linking up the ravelin with the town entrance itself, filling the small ditch between them, and even erecting thin tall walls with crenellations, at the sides of the formerly detached outwork.

The Fortifications Today

Today, the fortifications are extremely well preserved for something so extensive, in an age where real estate development has infringed on many other similar structures.

In the distance, high apartment buildings were constructed, and they block the view of the famous ghost town of Varosha, abandoned in haste by its Greek inhabitants and fenced ever since. Before 1974, the area was groomed by the government to be the flagship of its tourist industry, and so there are plenty of hotels and amenities considered state of the art for the early '70s.

Considering the lengthy siege, the destruction was quite limited. In fact, the only severely damaged important structures are the Catholic church of S. George and the Orthodox church of S. George. The Latin church is situated very far away from the siege lines, very close to the citadel. The damage to the Greek church is extensive not in the south wall, on the side of the bombarded town wall, but in the north wall.

At the entrance of the city, there is a large monument, presenting a metamorphosis of Mustafa Kemal as Ataturk, called the father of all Turks, even those beyond the borders of his Turkey. From the bodies of his people—civilians and military, subjects and leaders—comes alive the body of Kemal, in a Hobbesian emergence of the Leviathan figure of the ruler.

The walls of Famagosta are among the very best preserved in the whole Mediterranean basin, especially considering they were subjected to a long artillery siege in the 16th century. The curtain and the artillery towers are virtually intact, except for two small breaches made for traffic. The negative impact of the 20th century on the fortifications of this beautiful town is remarkably slight, and this confers on the town of Famagosta an almost unequaled sense of living history.

6

Cerines

In the north of the island lies the port town of Kyrenia, called by the Venetians Cerines. It is the only significant harbor north of the Pendaktylos Range, and it protects the road towards Nicosia, which crosses the mountain range below the castle of S. Hillarion.

In Cerines there was a Byzantine castle, dating from the 7th century, which was enlarged and modernized by the Lusignans shortly after they arrived on the island. From this period date the residential quarters, the inner gate with Frankish coats of arms, the cistern, and the magazines, while from the Byzantine period comes the church and the large horse-shoe tower on the northeast corner. Finally, the most important elements visible today are from the Venetian period.

In 1540 the Venetians enlarged the castle, giving it its present-day appearance, mainly with the addition of thick walls and embrasures for cannons, particularly on the land sides. Its walls also encompassed the Byzantine church of S. George, which previously had been just outside the walls.

The moat on the landward side of the castle was full of water prior to the 15th century and served as a harbor for galleys. When the Venetians enlarged significantly that side of the fortress, the moat became too narrow to accommodate large vessels, and was dried.

The gate of Cerines' castle is on the western curtain, which opens on a bridge spanning the moat, and from here comes a vaulted corridor that leads to the entrance of the Lusignan castle, now encapsulated into the larger enclosure. The area of the old gateway is the only one not bricked-up by the Venetian walls, and thus the structure is visible and accessible. The inner courtyard of the castle contains numerous Gothic buildings dating back to the 14th–15th centuries, serving various necessities of the kings and retinue: guardrooms, warehouses, halls and living quarters.

The castle is built on a rectangular form, and its yard is 280 ft. in length and 195 ft. wide. There is a slender Lusignan tower on its northeast corner, and the northern curtain, towards the sea, is also from that period. The rest was enhanced by the Venetians: the scarp is 20 ft. in width and the filling amounts to 40–45 ft. The eastern walls, also abutting the sea, were less enlarged and are only thick enough to mount cannons.

The southern curtain, however, has been pushed significantly further than the one the Venetians found on site, which they had to demolish, whose base and that of the Byzantine tower are still visible. On this land side, there is a round artillery tower in the southeast corner, with three levels of fire. Access is possible inside the tower at all levels, which is very welcome since it gives an idea of how such round towers are structured.

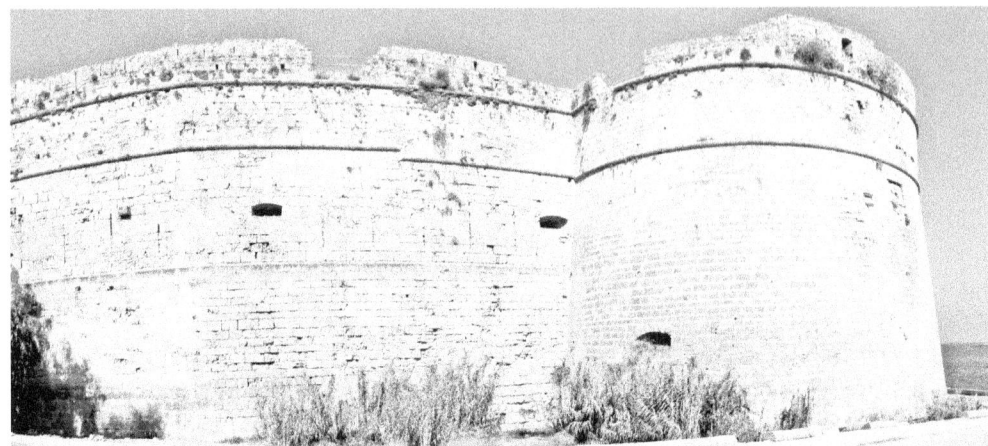

Figure 33. Southeast corner tower and curtain.

On the southwest corner, there is an arrowhead bastion, at lower level than the curtain, with another gun position on the walls. Its flanks are 50 ft., and its faces 100 ft. This lower structure acts like a caponier to sweep the moat on two sides of the fortress. It is comparable in function with Del Carretto bastion in Rhodes, which enhances the capabilities of the Tower of Italy, although that one is round, not rectangular like the one in Cerines.

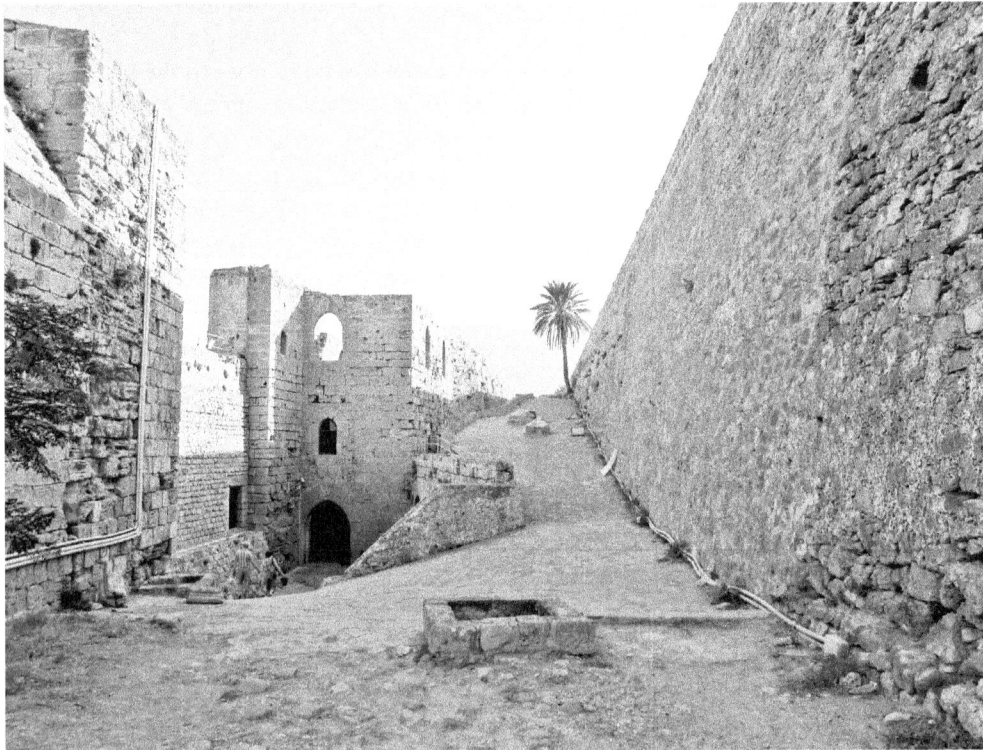

Figure 34. Filling between the old Lusignan walls and entrance (left) and the Venetian curtain (right).

The access-way to this gun platform passes through a small inner yard, on whose northern side three small reliefs with stone lions (pre–Venetian) are visible, as well as parts of ancient columns, reused to fill the wall.

On the harbor side, the western curtain is straight and is the result of raising another wall close to the Lusignan curtain and then filling the space between them with earth and rubble. In this part are buttresses the Venetians used to support the Lusignan curtain when they pressed against it with their own construction material.

Facing the entrance to the harbor, on the northwest, there was another round tower, with the same characteristics as the southern counterpart, only shorter. Unlike the artillery towers in Famagosta or Corfu, this one does not have only three embrasures disposed geometrically at 90 degrees, but has more gun ports running in tangent, like the Del Caretto bastion in Rhodes.

The castle was quite effective even in its medieval form, repelling attacks from the Genoese (1374) and the Mamluks (1426), when these launched campaigns to conquer and sack, respectively, the island (from that Genoese campaign came the occupation of Famagosta, which lasted almost a century). In 1570 the Ottomans obtained the surrender of Cerines simply by presenting the garrison the severed heads of the Venetian commanders of Nicosia.

From the Lusignan period the town was also surrounded by a wall, dotted with five towers, plus one in the middle of the harbor, holding a chain that closed it. These were squat, round towers, only 25 ft. tall, that were neglected by the Venetians, which turned the city from a proper walled town into one defended by a strong citadel.[1] Two of these towers are preserved almost intact: one in the harbor, that was holding the chain closing the port, and one in the southwest corner of the enclosure. Remains of two others exist today, partly immured in more recent constructions.

In Cyprus, the Venetian legacy is limited mostly to the fortifications, which they updated to the standards of the age. The lack of further significant material culture production is understandable due to the short amount of time spent in possession of the island and particularly due to the strong Gothic heritage left behind by the splendor and prosperity of the Lusignan kingdom (which was both difficult and unnecessary to replace).

Part III. The Island of Crete

Crete is one of the most enduring maritime domains of Venice and represents the first significant and large-scale acquisition of the Venetian Republic, either in Italy or in the entire Mediterranean. In fact, the conquest of Italian soil proper began much later than the colonial enterprises of the Serenissima. Before that, they had established emporiums and trading quarters in the Levant, but no actual feudal possession of large tracts of land.

Home to the stupendous Minoan civilization,[1] the island of Crete was taken over in 1420 BC by the Mycenaean civilization of mainland Greece. Eventually, along with the entire Greek world, it became part of the Roman Empire, and was briefly occupied by Muslim pirates from Andalusia (828–961), before being reconquered by the future emperor Nicephorus Phocas.

In the course of the partition of the Byzantine Empire in 1204, Crete fell to the new king of Thessalonica, Boniface I of Montferrat, who, in fact, never directly ruled the island, because he sold it to the Venetians. However, Crete was at first *de facto* ruled by Enrico Pescatore, count of Malta, who, in the name of Genoa, succeeded in occupying it by 1206. However, in the spring of 1209, the Venetians arrived on the island and by 1211 had gotten rid of the Genoese.

The island was incorporated as the *Regno di Candia*.[2] In order to consolidate their hold over the island and bolster the population, the Venetians dispatched their own colonists. In the Carta concessions of 1211, land was offered to the first 10,000 Venetian colonists willing to settle on the island. At that time, this figure meant roughly a sixth of its total population.[3] In general, relatively few Venetians moved to the colonies (roughly up to 10 percent of the whole population)[4] and when they did so they preferred living within the limits of the towns.

In the first century and a half of Latin rule there were significant and frequent native revolts, since this was a populated area of the Byzantine empire, with a strong landed elite. After 1367, the Greek Cretans settled down, following agreements to increase the integration of locals in the affairs of the island; after 1453, the fall of Constantinople brought an influx of artists and scholars. From all this came a flourishing of the arts and a unique cultural fusion between East and West—the Cretan Renaissance.[5] The most famous example of this Cretan Renaissance is the 16th century painter El Greco, who, as the moniker says, was actually a Greek by the name of Theotokopoulos Domenikos.

With an area of 3,218 square miles, Crete is the largest of all the Greek islands and the fifth largest in the Mediterranean. The elongated shape of the island, the inhospitable southern

coast and the high mountains of the interior caused the few natural harbors on its northern coast to be settled and exploited accordingly. Because of the terrain, the winds, and the sea currents, all major cities of Crete were located on the north coast, and the towns that developed there have retained their importance to this day. Economically, Crete was a strong producer exporting wines and cotton, cash crops introduced in the 13th–14th centuries, while the loss of Cyprus made the island the main supplier of salt for Venice.

The Venetians provided superb public buildings similar to those that adorned their homeland, such as loggias, fountains, palaces, and mansions in the countryside. The public and private buildings of the island of Crete, erected during Venetian rule, were magnificent constructions of Gothic and Renaissance style.

Between 1900 and 1902, Giuseppe Gerola photographed an impressive multitude of Venetian mansions in the Cretan countryside. His collection catalogues each as *casa* or *palazzo*, although this distinction is not always clear, since some of those presented as houses are actually villas with a rich display of Renaissance architectural elements, while others are regular-size family lodgings with just a few embellishments, such as medieval lintels or architraves.

The country palaces built by the Venetian aristocracy were found in the following settlements[6]: Travasiana (Villa Trevisan), Paljarumata (Villa Renier), Amnatos (Villa Sanguinazzo), Ethia (Villa Mezzo), Naghijpiana (Villa Clussia), Alikjanu (Palazzo da Molin), Buzunarja (Palazzo Viaro), S. Constantino (Palazzo Barozzi), and Pikris (Palazzo Chioza). There were other palaces, left unnamed, in Apano Vianos, S. Basilio, Monokhoro, Roghdhia, Kriza, Meghali Episkopi, Mundros, S. Giorgio, and Koxare.[7] Most manors had exquisite elements such as rusticated and ornate door and window frames, and exterior stone staircases.

Similar solid Renaissance architecture is displayed in the great convents built or modernized in Crete during the Venetian period, the most famous of them being the beautiful S. Trinita del Zangarol, Ghuverneto and Arkadhi.[8] Even smaller churches featured elements to behold, such as the painted medieval portal of the church of S. Giorgio in Kamarjotis, with the depiction of the lion of S. Marco in the architrave.

Furthermore, private houses with undisputed medieval or Renaissance elements were identified at Bobia, S. Giorgio, Dhrapanjas, Polis, Rodhopu, Khumerjakos, Katekhori, Njokhorjo, Azipopulo, Rusospiti, Arghjiropolis, Vrises, Anopoli, and Venerato.[9]

In the main towns as well, particularly in respect to the lodging, the architecture of the Renaissance was expressed more visibly in façades and doorframes, ornamented with columns, metopes and entablatures. However, most unfortunately, along with almost all rural palaces, so have the urban ones succumbed to neglect or disinterest in the 20th century.

The Venetians also brought with them a rigorous bureaucracy to their possessions. The duke of Candia, elected in Venice, governed with the aid of two advisors, who comprised the Signoria (Supreme Authority) of Crete and served a two-year term. Candia was also the seat of the Capitano di Candia, chief military commander of the island. The high-ranking officials came from Venice and were members of prominent patrician families of the lagoon. The island was initially divided up into six administrative districts, along the lines of the Venetian model, but from the early 14th century these were reduced to four regions. In times of crisis, Venice would send a *provveditore generale*, an official with wide-ranging emergency powers.

The Venetian rule on the island ended during the long War of Candia (1645–1669). By

1650, only the capital city had remained in Venetian hands. Along with a few island strongholds of strategic importance (these were eventually forsaken to the Turks by 1715).

The widespread Greek uprising of 1821 all over the Ottoman Empire brought with it the Egyptian occupation of Crete (1830–1840), meant to preserve Ottoman suzerainty. The pasha of Egypt, Muhammad Ali, came to the rescue of the beleaguered Turks when they could no longer militarily control the Greeks of the Aegean, and the Egyptian army restored those territories to the Porte, Crete included.[10]

Following one of the many revolts against the Ottomans, the international community brought buffer troops to Crete. Under the terms of the supervisory role assigned to the Great Powers in Candia, in February 1897 international forces manned the provinces of the island: the English, Candia; the Italians, Canea; the Russians, Retimo; the French, Girapetra. However, after the Turkish revolt of August 25, 1898, in Candia that killed, among hundreds of others, the British vice-consul Calymachus Calocherino and 17 British soldiers,[11] the Great Power expelled the Ottomans altogether and proclaimed a greater autonomy status for Crete. The Turkish population chose to leave the island, and, at the end of 1913, Crete was united with Greece.[12]

The Defenses of the Island

The defense of such a large and important possession of the republic rested on a wider array of structures than in its other territories. In Crete, we find everything from fortified houses to walled towns. The island is the most fortified large island, after Malta, in the whole Mediterranean, with walled cities, citadels, hill forts, island fortresses and towers.

We will analyze the fortifications on the island of Crete chronologically, architecturally and functionally. There were private defenses—towers and fortified manors—and public defenses—forts, citadels (*rocce*), and walled towns. There were medieval and Renaissance; with military (fortified islands) and civilian (walled towns).

There had been large Byzantine forts build on hill tops since the reconquest of the island in the 10th century, but the first coherent building program was undertaken by Enrico Pescatore when he occupied the island in the name of the Republic of Genoa.[13]

Pescatore was the intrepid count of Malta—a title and fiefdom created by the Norman kingdom of Sicily[14]—who tried to seize the island of Crete after the fall of Constantinople (1204), before the Venetians could get a foothold on the territory. In 1204, when the Genoese Pescatore conquered Crete, he grounded his control of the island on a string of 12 forts and two walled towns (Canea and Candia). The forts were either Byzantine in design and origin (Belvedere, Castel Temene) or newly-built by the Genoese (Bonifacio, Paleocastro di Malevizio, Castel Nuovo, Milopotamo, Bonriparo, Girapetra, Castel Chissamo, Castel Malvesin, Castel Mirabello and San Niccolo).

The Venetians took over the island after a protracted confrontation with the Genoese, but had to face their own problems when dealing with a populated territory in the presence of a coherent, feudal Byzantine organization.

During the first centuries of Venetian rule, the threats were internal, coming from the restless natives, stirred by the yet unintegrated, local Byzantine nobility. After the last and largest Greek revolt (1364–1367), the relations between the two communities were greatly improved,

and such threats disappeared for good. Starting with the 15th century, the new danger arose from the Turkish navies. Thus, the Venetians started preparing their defense towards the outside by building strong forts on the island.

The Venetians settling in Crete preferred the urban residence, although, due to the feudal administration of the territory, numerous keeps and fortified manors were erected in the countryside. Besides the country villas presented previously, the Gerola collection shows the existence of **fortified manors** (*casa fortificata*),[15] mostly medieval in design—towerhouse or keep—at Alizani, Rumas, Castel Cavalo, Kuses, and Su.[16]

There were also coastal **towers**, build by the state—except the early Torre dei Sanguinazzo, east of Retimo—to control the maritime approaches and warn of marauders. These coastal towers were round or square structures, similar to the *viglas* found on other Latin territories in Greece.[17] However, normally the towers found in Crete were feudal keeps, found in the countryside: Pirghos, Alizani, Armirokhori, Kavusi, Anatoli, Vainja, Prines, Elja, Ghjerani, Kumja, Petras, and Voila.[18]

Many **forts** in the interior were situated on hill tops and had a Byzantine origin—Belvedere, Temene, Melissa—while the Venetian built their own forts in the 13th–14th centuries—Bonifacio, Kharakas, Monte Forte, Castel Selino, Castelfranco, and Sitia. The fortifications at Liopetro and Castel di Sfachia were from the subsequent period.

The 10th–14th century castles were medieval structures, organized in wards, either with a keep or with square corner towers. Many were square forts—Castelfranco, Girapetra, Castel Mirabelo, Castel Pediada, Castel Malvesin, and Selino (although the latter is technically not square, only quadrangular). Their size and layout are similar to the initial structure of the citadel of Famagosta (the "Othello Tower").

Of such type of forts, **Castelfranco**[19] is in the best state of preservation. It was built by the Venetians in the period 1371–1374 to protect the plains south of the mountains from pirate raids. The name is an obvious corruption of "Castle of the Franks." Having only regional importance, the fort did not play a top role in the history of Venetian rule, and was simply abandoned with the arrival of the Turks. Its structure was not suitable for anything but medieval warfare, and the area was of little importance for shipping or settlements.

The fort of Castelfranco is a medieval fortification, a rectangle with the northern and southern sides 165 ft. in length, and the smaller sides 82 ft. In the corners, there are four square towers, four levels high. The walls and towers have square merlons. A row of one-story buildings lined the walls, of which only the vertical walls are left; these, however, were simple, unelaborate quarters (unlike the rooms attached to the citadel of Famagosta, for example). Many openings were cut into the walls, including those of the towers, at the ground level; these date from the 19th century, when this fort was used by Greek independence fighters.

The southwest tower is higher than the others, serving as a keep. Above the entrance (situated to the south), there is a large panel that held a dedication, accompanied by a lion of San Marco and two escutcheons, which still remain. There was also a smaller coat of arms on the adjacent wall of the corner tower.

With a similar design, but pentagonal, was **Castel Chissamo**,[20] in the west of the island. Like all the Venetian fortresses, it hosted quartering areas, lodgings for officials, a small chapel and water tanks. After the loss of the island, it was briefly recovered by the Venetian during the 1692 campaign of Aloisio Mocenigo against Canea.

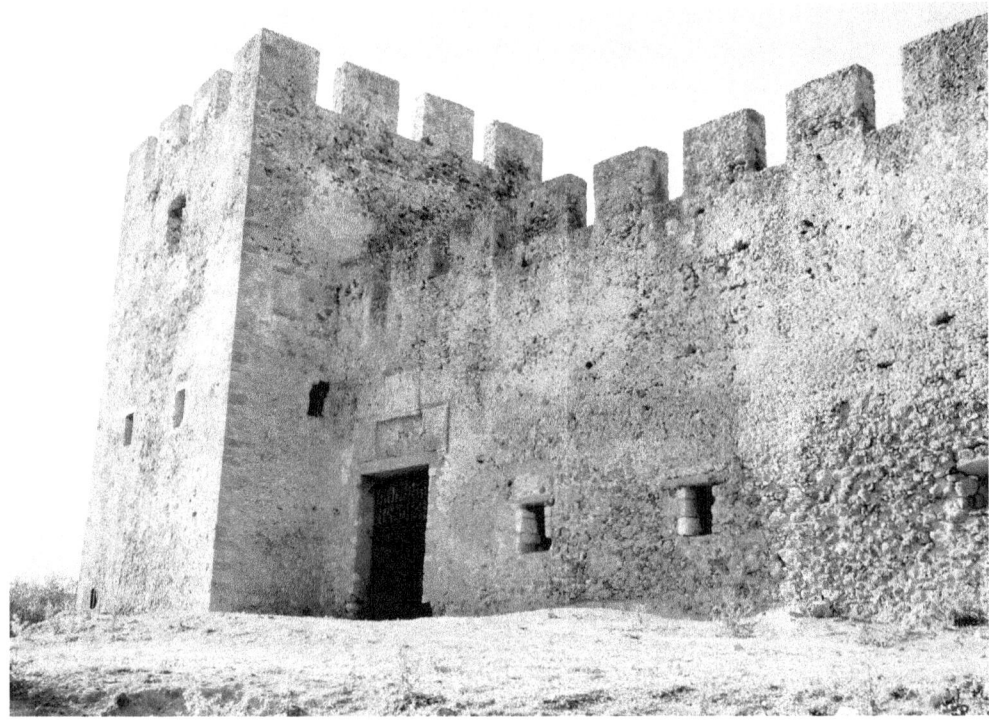

Figure 35. Castelfranco; gate and southwest corner tower.

Besides medieval forts, there were also citadels protecting settlements, such as Castel Sfachia, Castle Chissamo, and Sitia. The latter may also fall into the category of walled towns, as Sitia was surrounded by walls that formed an isosceles triangle: its base was the beach, and the tip was at the citadel (Casa di Armi–Kazarma) on higher ground. The walls were thin, medieval, and not upgraded in the 17th century. The citadel itself was a tall building, like a keep, with a pentagonal yard, with thick walls and a gatehouse.

With the pacification of the interior and the move towards relying on coastal defenses, the modernization works were concentrated on the northern and western parts of the island. The fortresses built by the Venetians along the south shores of Crete were very few (Castel Selino, Sfachia, Castelfranco, and Girapetra), because the area was less populated and economically connected and thus less important.

The expansion of the Ottoman Turks in the area of the Eastern Mediterranean Sea prompted the Venetians to fortify the cities of the island as well as other strategic places. The island suffered two significant Muslim raids, in 1538 and 1571, wars against Turkey in the 16th century. The raid of 1538 was led by the great Ottoman admiral Hayreddin Barbarossa[21] himself, and was part of the campaign that swept the Venetians out of the Aegean—where the Turks conquered Naxos and all the other islands of Archipelago, except Tine—and that laid the siege of Corfu. The raid of 1538 destroyed the settlements and their medieval defenses at Milopotamo, Sitia, Chissamos, Castel del Apicorno, and Castel Chissamo, while the campaign of 1571 destroyed the important settlement of Retimo.

Both instances prompted Venice to embark on two large fortification-building programs, in 1540 and 1573. To the first program belong the bastions of Candia and Canea, while

in the 1570s the fortresses of Paleocastro, Retimo, Spinalonga, Suda, S. Teodoro and Grabusa were built.

In the aftermath of the war of Cyprus and the raid of 1571, governor Latino Orsini stepped forward with a comprehensive program to fortify essential islands off the northern coast, to deter the enemy from landing and to secure sheltered bays. Also in line with this philosophy of defense was the fortification of tall rocks projecting over the sea routes: Paleocastro, near the capital; S. Teodoro, guarding the approaches to Canea; and the citadel of Retimo (*Fortezza*).

An important example of Renaissance architecture is the fort of **Paleocastro,** 10 miles west of Candia, on a rock overlooking the sea. Initially a simple medieval structure, it was included in the 1574 program to reinforce the island. Thus it was rebuilt in a triangular shape, descending a steep slope above the sea. The castle had three uneven wards. The main gate was located on the south edge of the castle and led to the lower square; inside the fort there was a small church, an armory, a cistern, and, on the second level, a small barracks. The fort was meant to cover the sea lanes towards Candia, as well as the plain west of the capital. However, once the grand Turkish siege expedition approached Candia in 1646, it had to be abandoned. The sturdy rock still dominates the coastline to this day.

The island of **S. Teodoro**[22] (also known by its corruption, Turlulu) is located just opposite of the beach of Platanias, immediately west of the town of Canea. It is a large, rocky island, close to an important harbor, with a morphology and potential similar to the islands of Standia[23] (opposite Candia) and Vido (near Corfu town).

After 1573, the Venetians built two small but modern forts here: a polygonal fortress at the top of the island (named Turluru) and a second one in a lower level, on the western cape (named S. Teodoro). The upper fortress (*fortezza da alto*) was an irregular polygon, with salients and thick curtains. *Fortezza da basso* was equally large, but the terrain allowed it to have two identical demi-bastions on each side of the central gatehouse. The layout resembled that of the fort S. Felice a Sottomarina, built by the Venetians to guard the sea approaches to Chioggia. The island was a prime objective for the Turks in 1645, to secure access to the landing beaches close to Canea. It was regained by the Venetians during the war. The two castles are dismantled, with minimal remains of the lower fortress, while the outline of the upper fortress can still be traced from the remaining structural features.

The island of **Grabusa** rises like the rock of the Gibraltar in the north of Crete. There are significant remains of the Venetian fortification, built in 1579–84, at a height of 450 ft. above the natural harbor of the island. The fortress was built on the tall peak dominating the rest of the island; it has a triangular shape, with the long sides falling just short of one mile long. The enclosure is not complete, since the western side of the rock was too steep to be assailable and did not require particular attention. The position of the fort was strategic, since the island protected the sea around northeastern Crete, as well as the link to Cerigotto,[24] Cerigo and the Morea. The fort contained *quartieri* (barracks) around a small *piazza*, which also features small magazines and a church dedicated to the Annunciation, along with several warehouses and a house for the commander. The enceinte was insured by a series of cavaliers (Orsini, Contarini, and Grimani) and salients, since the terrain did not allow for complete bastions, nor did it actually require them.

Grabusa was retained throughout the Candian War and after its resolution, but was occupied by the Turks in 1692, during their campaign to relieve Canea and to recover

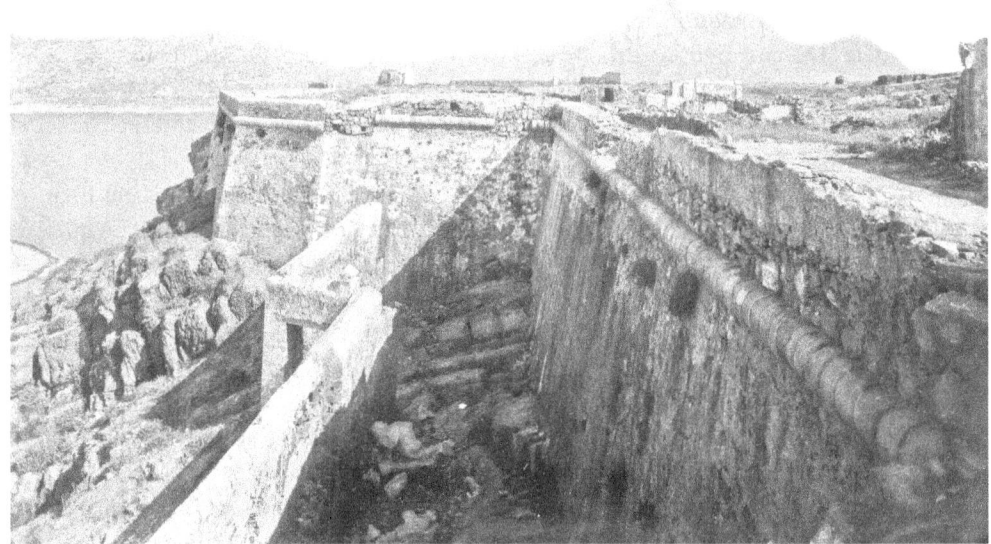

Figure 36. Grabusa. View from above the gatehouse, towards Grimani Bastion (photograph G. Gerola, courtesy Istituto Veneto di Scienze, Lettere ed Arti. All rights reserved).

Chissamo from the Venetian-supported local uprising, in one of the few Turkish successes during the War of Morea (1684–1699).

The island fortresses of Crete are a tremendous example of engineering and resolution. The architects of the Serenissima identified islands where the morphology allowed to crown them with a set of walls all around, leaving no place to land siege equipment, and thus making them virtually unassailable: Suda and Spinalonga. Fortunately, the beautiful island fortresses of northern Crete are very well preserved to this day.

The island of **Spinalonga** is located at the northwestern part of the bay of Mirabello in eastern Crete. Because of its morphology, it was called Spinalonga ("long spine"). In 1579 the Venetians constructed a fortress on this island, part of the extensive program of fortification in Crete after the loss of Cyprus and the raids of 1571.

Its design, following the topographical features of the island, made it invulnerable: high walls were erected right on the sea, leaving no room for landing. The main gate, situated in the middle of the western curtain, is an ornate structure, with rusticated stone and two pillars supporting a metope bearing a Latin inscription.

The widest side of the island is on the south, where two bastions were built: Tiepolo and Donato.[25] The latter bastion features an *orecchione* on its eastern flank, and a postern opens here from the curtain inside. The eastern, Tiepolo bastion, is square, and resembles much more a square cavalier, like S. James in Valletta, than an actual bastion with its specific features.

On the southern side, above and between the bastions, towards the demilune Mocenigo, is a massive circular structure with several robust gun ports, very similar to the one right below the Land Castle and next to the Campana bastion, in the Old Fortress in

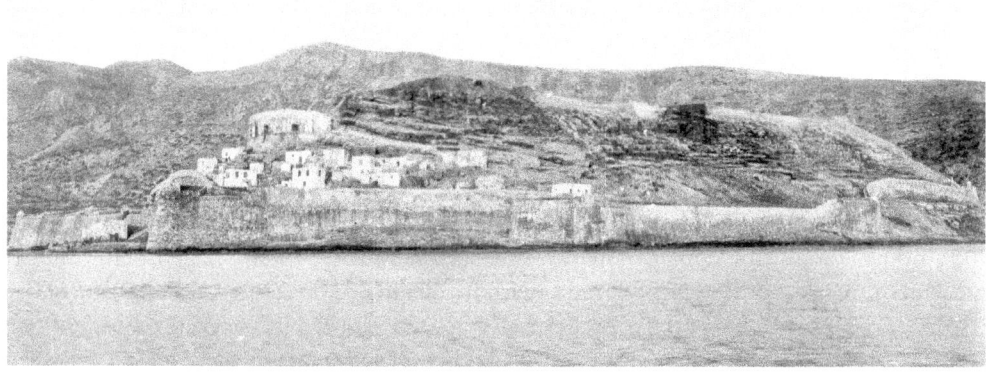

Figure 37. Spinalonga, view from the southeast (photograph G. Gerola, courtesy Istituto Veneto di Scienze, Lettere ed Arti. All rights reserved).

Corfu.[26] The construction is disproportionally large, as seen in Figure 38, the size of the man on the stone stairs climbing over the casemated gun ports, in the background.

On the western side the circuit is banal, with no specific defensive structures, while on the eastern side, the Donato bastion is followed by the Scaramella half-bastion, with an *orecchione* on its south side, and the Molino (Rangone) bastion. At the end of the enclosure

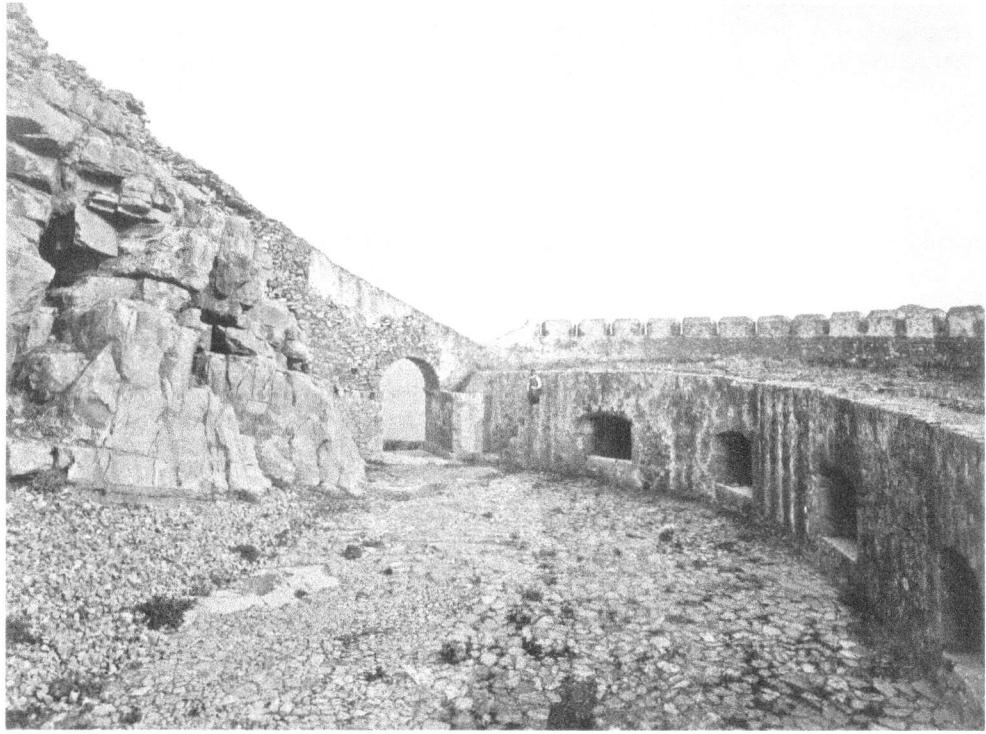

Figure 38. Inside Mocenigo fortification (photograph G. Gerola, courtesy Istituto Veneto di Scienze, Lettere ed Arti. All rights reserved).

stands the Michele demilune. The bastions have embrasures, but the curtain is narrow and only features a wall-walk.

There was also a secondary enclosure, which today is less noticeable, but which is documented in the pictures by Gerola. This wall included the Mema and Falier curtains, towards the Mocenigo demilune, and the Mosta and Moretta *piazze*, on eastern side of the island peak. Entrance into this second ward was through the Carbonaro gate. Behind the Mocenigo demilune are the Miani cavalier and the Venier curtain. From here, northwards, the Orsini cavalier towers over the Molino bastion.

The island was retained by Venice throughout the long war of Candia and after. In 1715, the Ottoman Empire took possession of Spinalonga after a three-month siege, but the importance of the fortress declined over time and from 1903 to 1955 the island became one of the last leper colonies in Europe. Today her walls, as well as many of the Venetian buildings (including barracks, magazines and a small church), are very much intact.

The main importance of such fortified islands, however, was that they were positioned in great anchorage bays and thus could protect ships seeking shelter from adversities such as storms or attackers. Of these, the gulf of Suda is among the safest natural harbors in the Mediterranean. One of the largest natural harbors in the Mediterranean, Souda Bay is sheltered from the prevailing winds of the Aegean by the Akrotiri peninsula. At the harbor entrance there are a few small islands, upon which the Venetians built their fortifications to guard the shore.

The gulf had an extended chronology of fortification works, stretching from the medieval castle at Mirabello (on the shore), to the bastioned fortification of Suda island (at the entrance of the bay, more suitable for naval defense), to the 17th century star fort of Marathi (on the coast of Akrotiri, further north of Suda), and finally the Ottoman Aptera and Itzedin forts, on the south side of the gulf.

The bay of Suda is a great anchorage site and even today is in use by the Greek military and NATO. A medieval fort was built at Mirabello, on the Akrotiri peninsula, but in the 16th century the Venetians fortified the island of Suda, at the very entrance of the homonymous gulf. Also in the gulf of Suda, closer to its northern approaches, was the fortress of **Marati**,[27] designed by the Dutch architect van der Wart, with a very modern star structure, up to date as of the 1640s. By that time, Dutch military architects were prized throughout Europe, following their successful experience in siege warfare in the long war with Spain.[28] It was a period after the age of Italian engineers (such as Sanmicheli and Antonelli) and right before the school of French thought, epitomized by Vauban. One particular modern work undertaken by the van Werts was the star fort on the rock at Marati, at the entry to the gulf of Suda.[29] It was a four-corner fort, with sharp-pointed bastions in each corner of the square, two demilunes, and a ravelin guarding the main gate. This was much damaged during the War of Candia, and the remains outline a curtain and parts of corner bastions.

The best Venetian island fortress in the Mediterranean was **Suda**. The construction of the fortress was started in 1573, in order to reinforce the defense of the gulf. The architect and supervisor of the constructions was Latino Orsini, in charge of the large defensive building program in the aftermath of the loss of Cyprus.

The compound is an example of excellent fortification work, taking advantage of the islet's morphology. Its strategic construction provided smart solutions to possible threats from the neighboring coast and against naval attack.[30]

Part III. The Island of Crete 83

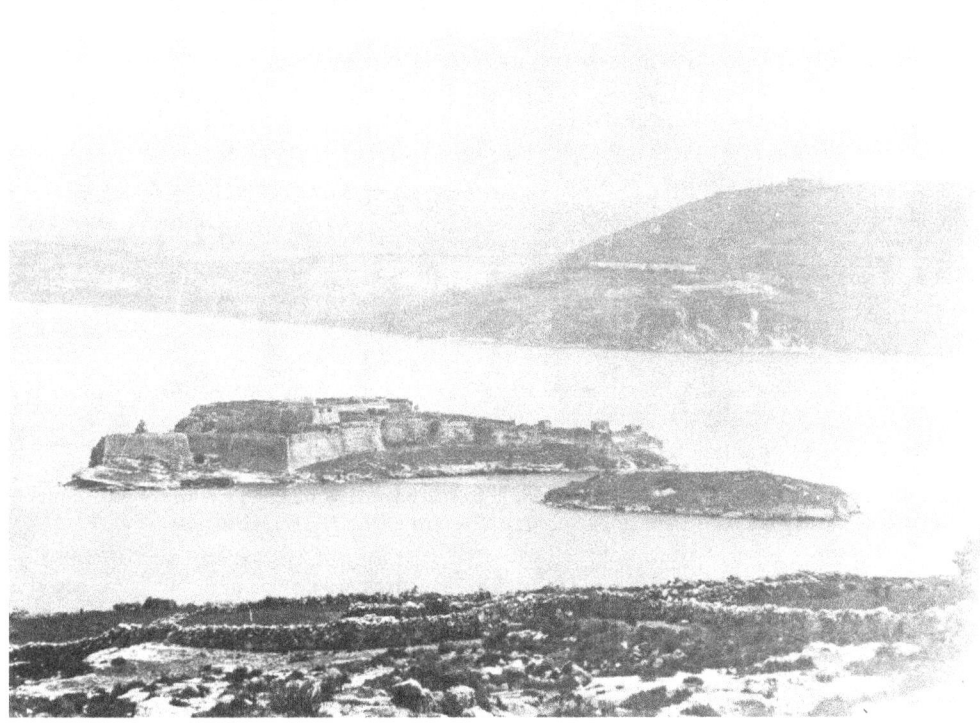

Figure 39. Suda, view from north (Akrotiri peninsula). Foreground left, the bastions of Martinengo and Michele (photograph G. Gerola, courtesy Istituto Veneto di Scienze, Lettere ed Arti. All rights reserved).

On the northern, wider, side of the island of Suda are two bastions, Martinengo and Michele, both with *orecchioni* facing each other. These are tall, stone-faced masonry works covering revetted earth, with a cordon separating the parapet from the scarp. Their lower parts are built on stone outcrop, while the tops are crowned with gun embrasures. Behind them was built the Mocenigo cavalier, a square structure that provides firing cover for both bastions. Michele bastion has an *orecchione* also on its western side, which leads to the Orsini bastion, with its recessed flank, and the Venier bastion, at an angle, with straight flanks.

The Mocenigo cavalier is quite impressive, rising high over the terreplein, with several cannon embrasures. In shape and design it is quite similar to the Camposanto and Andruzzi cavaliers in Famagosta, only taller. At the southern end of the circuit there is a demilune, connected by a caponier to the main enclosure.

In the interior, aside from the areas of military use, there was also a church, a hospital, a prison, and underground water tanks.

After the fall of Candia in 1669, the fortress remained in Venetian possession until September 20, 1715, when it was finally surrendered to the Turkish army after a siege that lasted 72 days.[31]

Later, the Turks built the Itzedin fort overlooking the island of Suda and developed Aptera, on a high hill looking over all these previous fortifications. Its purpose was to defend the Turkish colonists from the numerous freedom uprisings of the 19th century. Also, during World War II the bay played important roles, especially during the Battle of Crete (1941).

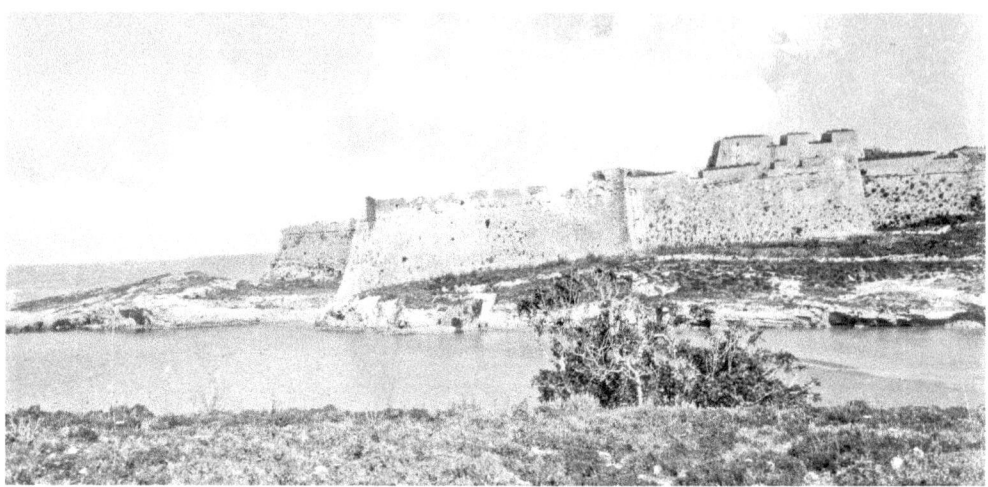

Figure 40. View of the Martinengo and Michele bastions and Mocenigo cavalier (photograph G. Gerola, courtesy Istituto Veneto di Scienze, Lettere ed Arti. All rights reserved).

The fortress of Suda is today intact as far as the structures are concerned, but is overgrown with trees and still faces visiting restrictions, even for researchers.

The fortifications of Crete are in various stages of preservation. Most of the medieval structures have been long abandoned, and usually just some interior structures and the bases of walls can be encountered, although they leave strong enough traces to make out their layout. At the start of the 1900s, Giuseppe Gerola found many of them in an advanced state of decay, and many of these are now all but gone. There are significant ruins in the modern Kissamo and Sfakia, and the citadels of Girapetra, Sitia and Frangokastello are complete. The island fortresses of Spinalonga, Grambousa, and Souda are all intact.

The final and most impressive type of Venetian fortification in Crete was the large walled town, which we will now analyze.

7

Candia

The Venetian walls of Candia are an excellent example of Renaissance fortification architecture and one of the best preserved monumental structures in the whole Mediterranean.

The city's name comes from a corruption of the toponym used during the short-lived Muslim rule: Chandax. After the partitioning of the Byzantine Empire in 1204, the town was offered to the Venetians but was occupied by the Genoese led by Pescatore, although shortly after, it was reclaimed by its official proprietors.

Under the Venetians, the town developed into the political, military, cultural and trading center of the island. It hosted the palace of the governor, palaces for the nobility, and Catholic and Orthodox churches and monasteries, and it had a distinct architectural fabric, typical of cities of its kind in the Venetian colonial realm.

There are robust material traces of Venetian rule in the town, even though this came to an end in 1669, when it finally fell to the Ottomans after a very long siege. What was, however, most damaging was a terrible earthquake in 1856, which leveled many buildings of the old Venetian city and furnished the Ottomans with the excuse to embark on a large construction project. Thus the city was rebuilt as a Turkish town, a typical oriental city of mosques, minarets, coffee-shops and houses with wooden balconies. Later in the 19th century, the neo-classical style appeared, adopted by Turks as a modernizing feature, and embellishing many places in the Ottoman Empire, from Lebanon to Rhodes. The rejuvenation of the Ottoman state in the second half of the 19th century initiated a welcome and long overdue program of building structures appropriate for the pretentions of such an extended state. From Beirut to Thessalonica, the Ottomans sponsored administrative buildings that survive even to this day.

The Town

An introspective view of the Venetian town of Candia comes from remarkable historical maps and drawings from the last century of Venetian rule—from Giorgio Corner, Francesco Basilicata, Marco Boschini, or the Swiss general Hans Rudolf Werdmüller (participant in the defense of Candia in 1667–69)—as well as maps from the next generation of cartographers, such as those included in the works of the cosmographer Vincenzo Coronelli from the end of the 17th century.[1] These priceless materials show administrative buildings, palaces,

military installations (gates, barracks, and arsenals), markets and numerous churches and monasteries (many Catholic, but also Orthodox).

The city's main street was called Ruga Maistra[2] and was the road linking the port to the town's central administrative square, from the Harbor Gate to the Voltone Gate. Most activity turned around the main square in Candia, where the Palazzo Ducale was built, along with the church dedicated to S. Marco, the loggia and the captain-general's residence (Palazzo del Capitano).

The valuable map of the city by Giorgio Corner[3] strives to offer a bird's-eye view of the town of Candia, and as such brings to life the urban fabric of the Venetian town. This is particularly true and useful when it comes to the public or ecclesiastical constructions. It shows the Cathedral of S. Marco was more imposing then, since it sported a typically Italian, square, crenellated belfry tower (similar to the church of S. Annunziata in Corfu), later torn down in favor of a thinner minaret (as in the case of the gorgeous Cathedral of S. Sophia in Nicosia). In front of S. Marco there was the same square as today, with a fountain in the middle, but the buildings around it were totally different, and included, at the northern end of the square, the residence of the governor of the island.

The **Palazzo Ducale**, a two-story structure with arcades on the ground floor, dominated the very heart of the Venetian town, in S. Marco's Square,[4] and served as both the official residence of the governors of Candia and the courtroom.

The Ducal Palace occupied an entire block and was designed along the lines of equivalent buildings in the homeland. The main façade had a large, arched portal on the ground floor and a tripartite main opening flanked by double lancet windows on the balcony above; and the last floor was surmounted by swallow-tail crenellations. The palace had a row of vaulted spaces on the ground floor, four of which are visible to this day on the premises of small shops. Considering the visual evidence from historical maps and chronicles, as well as from similar contemporary public buildings in Italy, we could envision the shape of the Ducal Palace of Candia as similar to the Palazzo Comunale in Piacenza, for example.

At the southern end of this central square stood the **Voltone Gate**, typical in structure and approach to the Italian Middle Ages architecture: a tower-gate, with a tall opening and a few stories above its arch, crowned with sparrow-tail merlons. Similar gates existed at the entrances to the Castello Vecchio[5] of Canea (the core, pre–Venetian, urban center of the town, same as here in Candia). A much larger example of such a gate still stands in Corfu town—Spilia Gate—although with smaller, Renaissance arches.

Although the Venetians did preserve the Byzantine walls after they expanded and modernized the enclosure in the 16th century, they did make certain alterations. As the Corner map shows, east of Voltone Gate, the walls were accompanied by long buildings servings as barracks, while some medieval square towers still persisted. Again, such Byzantine towers are comparable to the ones available in Canea and even Rhodes (bordering the Collachio). To the west of the Voltone Gate, there was another large building complex: the main warehouses (*fondaco*). In fact, the name of the square was Piazza delle Biade (grain market), and further, beyond the old walls, was the Piazza dell' Herbe (spice market). There are still today places with these names in Italian towns in the Veneto and until recently in Dalmatian cities like Zara and Spalato.

The S. Giorgio Barracks were built east of the Voltone Gate.[6] These barracks were the largest and most important such building in the town. Built from 1583 to 1586, they took

their name from the nearby Venetian gate, and should be compared with the Spilia and Raimondo barracks in Corfu or the S. Salvatore and Stradioti barracks in Canea. The building extended to a wide parade ground called the Piazza d'Armi,[7] before the main town entrance (S. Giorgio Gate).[8] The building was an oblong structure originally divided into a row of 150 rooms, capable of accommodating several hundred soldiers.[9]

Along the Ruga Maistra, the first **loggia** in Candia was built in the mid–13th century; the current edifice was built in 1626–1628 by *provveditore generale* Francesco Morosini[10] and is one of the finest examples of Venetian architecture outside Italy.

The loggia is a rectangular, two-story Palladian building, with an open arcade on the ground floor. It features the architectural Doric style on the ground floor and the Ionic on the upper floor. The ground floor has composite piers with Doric columns forming an arcade, with large rectangular piers at the corners. The composite piers are linked by a low parapet, while the central arch is opened to ground level to form the main entrance. The piers on the upper floor have engaged Ionic columns.

Figure 41. Loggia of Candia.

The frieze above the ground floor consists of triglyphs and metopes decorated with sculptural reliefs of the effigy of Venice, trophies, armor and other symbols. The original design included a parapet with statues to be placed on the roof, but this was never accomplished.

In 1902 the building was judged unsafe and demolition work began on the first floor; fortunately, the process was stopped and restoration began in 1915. Italy itself attached such significance to the Loggia of the Regno di Candia that the Venetian stand at the 1911 Rome Exhibition was a faithful reproduction of it (including the statues designed for the roof).[11]

The Venetian **armory** is located behind the loggia. It was built over a number of different periods as a place where the greater part of their munitions could be stockpiled and guarded. The original building dates from the years 1578–1582. The armory is a two-story structure built of hewn blocks of porous stone inclined at the base. There were three windows in the upper floor, flanked with four inscriptions that were later eliminated by the Turks. The first floor was supported by rectangular piers typical of Venetian masonry, with timber rafters above.

On the north façade there is a relief, once part of the Sagredo fountain (1602–04), originally located at the northwest corner of the loggia. Among the rare artefacts, a number of wooden crates were left behind in the armory in 1669 and about five of these survived until 1898 (although they were later lost). The crates were painted and decorated with the lion of S. Marco, and inside there were bundles of arrows, parts of weapons and armor, as well as iron and glass projectiles (17th century proto-grenades).[12]

Going back to Piazza delle Biade,[13] we find the principal Catholic church of the city, dedicated to **S. Marco**. The church is plain in section with a portico covered with six arches (somewhat similar to San Giacometto in Venice), and three naves, with two lines of columns united by Gothic arches, under a wooden roof. S. Marco used to have a square bell-tower, like SS. Maria e Domenigo in Negroponte[14] or Sta. Annunziata church in Corfu. There were more beautiful gothic and Baroque churches in Candia, such as S. Irene, Sta. Caterina, Santi Dieci, Sta. Maria dei Cappuccini, S. Pietro, and S. Giovanni Battista.[15]

The largest and most beautiful Catholic churches have not survived until present day. The beautiful Gothic church of **S. Francesco** was torn down by the Turks after some parts were damaged in the 1856 earthquake, and the Augustinian church of San Salvatore was destroyed in the late 1960s.[16] The large church of **San Salvatore** was built in the late 13th century. The original temple was destroyed by an earthquake in 1508, after which a new one was built on the same site. In 1925 it was judged adequate for use as a school, although necessary alterations involved the addition of a row of windows to let in sufficient light. The church and its original wooden roof survived intact well into the 20th century, and photographic evidence points to its sheer size and solidity. The church was a wooden-roofed basilica, an oblong building 50 ft. wide and 130 ft. long, with a rectangular sanctuary on the short, east side, covered by a closed Gothic vaulted dome. The east sanctuary wall had three narrow lancet windows with plain, porous mullions. The main church consisted of a single space without colonnades. Over 3 ft. thick and 50 ft. high, the side walls had porous stone buttress piers at regular intervals on the outside, with lancet windows in between.

Among the public structures important in the life of the city were the water works. Providing fresh drinking water for the subjects was a social duty undertaken by the Latin rulers, following the tradition of Greco-Roman society. As such, fountains were not simply water taps, but were encompassed in monumental designs, meant to underline the effort of the patrons and to elevate them among the elements of architecture the rulers used to promote their good governance.

In Venice herself, almost every *campo* and *campiello*, no matter how small, has a standard-size well (four feet tall, four sides, and a wide mouth). There are two types of fountains found in the Venetian realm: rectangular and narrow, placed next to a building with embellished entablature (Bembo, Sagredo and Priuli fountains in Candia; Rimonti in Retimo), or round and wide, placed in the middle of a square (Morosini fountain in Candia; Spinalada and Campiello

fountains in Corfu). The Morosini fountain is more ornate than many Venetian fountains outside Italy proper (like Corfu, for example). The **Fontana Morosini** has a basin with a circular base of eight lobes, decorated with water figures from Greek mythology carved in relief, as well as coats of arms of Venetian nobility. At the center of the fountain, on a high octagonal pedestal, are four lions with water flowing from their mouths (however, these are not Marcian lions). At the top of the fountain was a colossal marble statue of Poseidon with his trident, visible in maps but lost during remodeling undertaken by the Ottomans. The Morosini fountain was, in fact, the final section of an aqueduct, inaugurated in 1628, bringing water from the east, from Mount Juktas, 10 miles away. This aqueduct used to go over the walls at the S. Giorgio bastion.[17]

Apart from the Fontana Morosini, there are other Venetian fountains still around, such as the fountain of Bembo of 1588, in the former Piazza delle Biade, decorated with Venetian coats of arms and a headless statue from the Roman period; the fountain of Priuli, built in 1666, and located south of the gate of Dermata; and the Sagredo fountain, originally located in the Armory square.

The beautiful **Bembo fountain** is flanked by two vertical panels decorated with three Italian coats of arms each, and topped by two stylized lions of S. Marco. In its center, there is an ancient headless statue, and to its right the Ottomans built their own typical fountain. Behind the Venetian fountain stood, until quite recently, the imposing church of S. Salvatore, the largest and tallest ecclesiastical building in the city.[18]

Largely due to neglect, many Venetian buildings collapsed or were severely damaged during the 1856 earthquake, and were subsequently demolished. In Candia many solid, high buildings had in fact survived the long siege of 1647–1669, but were heavily damaged in 1856: the prison, the S. Giorgio barracks, the Palace of the Captain General, S. Francesco Church, and the Voltone Gate, which were subsequently demolished by the Ottomans, and replaced with their own preferred style of building.

After the population exchange of the 1920s, Greek state institutions acquired and then sold abandoned Muslim buildings to private individuals. In the Ottoman state, there was no strong separation between church and lay government, since the sultan was also the caliph of Islam (after the conquest of Egypt and Baghdad, whose rulers have previously held this title). Since the Ottoman state had taken over the Venetian public buildings and the Catholic churches, these constructions were now selected for use as private housing, which particularly altered, their internal layout and even the resistance of the structure, with disastrous effects during earthquakes.

The Old Walls and the Harbor Fortifications

The port of Candia included the arsenals, the pier, the fort at the harbor mouth, defensive walls on the town side and two gates leading to the town (one from the pier, one from the arsenals). Unencumbered by the current coastal road, the harbor was much larger, it covered a surface of 30,000 square feet and could accommodate 50 galleys.[19]

The harbor contains the Venetian **arsenals**. These shipyards consist of large, oblong, barrel-vaulted rooms that could house one galley each for repair or construction. If you look at the arsenals of Candia and Canea, you might think they were too low to accommodate the

height of a wooden vessel with sails, but that is because the masts were retractable. In fact, in Malta, in Senglea, there is a large structure—Il Macina—designed to demast ships, but it actually dates closer to the year 1800.

In Candia, three separate shipyard complexes were built at different periods. The first is called Arsenali Antichi, built in the second half of the 15th century and situated in eastern corner of the port. The second complex is called Arsenali Vecchi, constructed in 1550–1556, west of the first one. The third one, the so-called Arsenali Nuovi e Nuovissimi, was built in phases (1580s and 1610s) at the southeast of the old Venetian port. Today only some parts of the third complex, Arsenali Nuovi, and parts of the second one, Arsenali Vecchi, still exist.[20]

Figure 42. Arsenals in Candia.

Figure 42 shows the remains of the Venetian arsenals. The harbor started where the wide road is now. In foreground are the vaulted halls of Arsenali Nuovi; another four extended behind them. In the background is one barrel-vaulted hall of the latest arsenals, which extended further to the left. The same positioning of the arsenals, right by the sea, can be found in Canea, or in Dalmatia, in the cities of Lesina and Ragusa.[21]

There was also an Arsenal Gate, which opened from the area of the Arsenali Vecchi to just behind the Harbor Gate (Porta del Molo), both now gone. In the extensive Gerola collection there are two pictures showing this area when the gates were still standing and after they have been torn down. Here was the pier where ships landed their passengers and merchandise, the same one that still exists today, behind the Venetian fort.

The Arsenal Gate and the sea walls in the harbor area had Italian-style sparrow-tail merlons. A portion of the old sea walls, separating the arsenal and harbor from the living quarters in the city, is visible next to the newest arsenals, where houses have been built on top of the walls and have incorporated them.

The city's fortifications included the construction of a fortress at the mouth of the harbor. The Venetian fort dominates the entrance to the port of Candia. The Venetians called it the Castle of the Pier (Castello del Molo) or Sea Fortress (Rocca al Mare). It is known today as Koules, a name of Turkish origin, a corruption of *Su kulesi* (water tower).[22]

There was an earlier round tower guarding the harbor, very likely similar to the Genoese *torrione* in Canea or any other such Italian medieval harbor defenses, for that matter. This was demolished and replaced by the current fortress—built during the period 1523–1540 as per the inscription on the northern wall, below the relief of the lion of S. Marco.

7—Candia 91

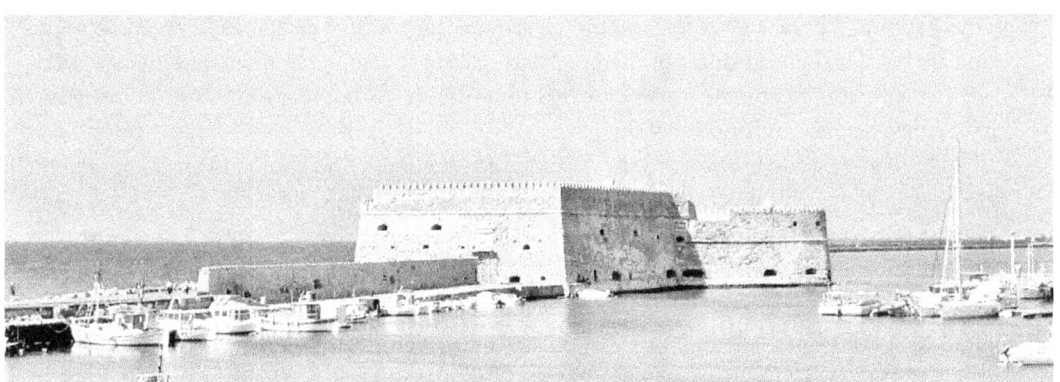

Figure 43. Castello del Molo at the entrance of the harbor.

The natural rocky outcrop was banked up to create the platform on which the fortress was to be built. The outer walls are almost 30 ft. thick, while on the north side they are 22 ft. thick; the interior walls have different thicknesses at various points, ranging from 4 ft. to 9 ft.[23]

The fortress is formed of two sections: the southwestern, rectangular section, slightly higher; the northeastern, semi-elliptical section, slightly lower. The fort is a two-level building

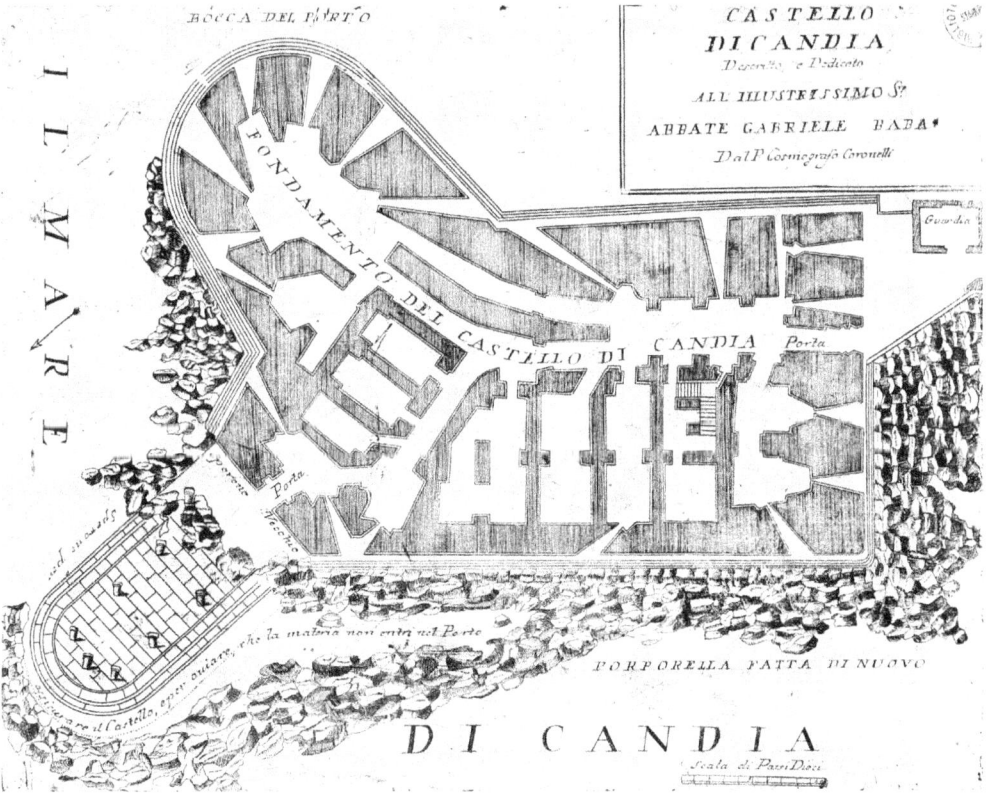

Figure 44. Vincenzo Coronelli, *Pianta del Castello di Candia*, 1696 (courtesy of the Ministry of Culture and Tourism, Biblioteca Nazionale Marciana Venezia. All rights reserved).

with 26 rooms. There were casemates on the ground floor, which also housed various storage areas for food and munitions. On the north side of the spacious top platform, there was the lighthouse tower. There were also quarters for soldiers and officers, and a mill, oven and chapel, ensuring the autonomy of the garrison.

There were two entrances to the fortress, on the north and southwest sides; the main gate was on the north. Historical maps[24] present this as a door, which is very likely, since above it there are the coat of arms of Venice in an exquisite entablature. The south gate entrance to the fort is at the edge of the pier and had solid wooden doors opening onto a vaulted ramp.

There are three marble reliefs depicting the winged lion of S. Marco, the symbol of the Most Serene Republic of Venice: one on the northern side, where a gateway used to be, one on the town side, and a smaller one on the old harbor side, right where the walls change direction. The northern lion is a high-relief encased in a panel crowned with a tympanum.

No major modifications were carried out to the Castello del Molo during the period of Turkish rule, apart from the addition of crenellations for fusiliers, as seen particularly in Retimo, Famagosta or Rhodes. The Turks built a smaller fortress, known as Little Koules, on the opposite breakwater, on the landward side. This was demolished along with part of the Venetian shipyards in 1936, during the modernization of the city.[25]

The first enclosure of Venetian Candia was formed by the original Byzantine walls,

Figure 45. From the roof of Arsenali Nuovissimi, looking east, from the left: Sabbionara bastion, Zane cavalier, and the old sea walls (photograph G. Gerola, courtesy Istituto Veneto di Scienze, Lettere ed Arti. All rights reserved).

which were restored or enhanced over time, but retained their distinctive medieval architectural character. The walls had straight sides, with rectangular towers at intervals, linked by perpendicular crenellated curtains and abutting the exterior of the wall toward the moat. A similar structure existed in Rhodes, where the knights used the Byzantine walls—of which significant ruins still exist—to separate their *collachio* from the *borgo* (where the lay people lived, both Catholic and Orthodox).

The wall rested on a foundation that was made of regularly cut ashlar blocks and was fortified with towers. The sea walls survived almost intact until the beginning of the 20th century, especially in the east and south. These walls survived enough to be photographed by Giuseppe Gerola, and at that time they still covered an area from S. Giorgio Square to the sea, including the Zane cavalier, then stretching behind the sea walls and arsenals to reach the Harbor Gate, where the pier and breakwater from Castello del Molo stood.

The Renaissance Enclosure

Candia has impressive Renaissance fortifications that overshadow all other parts of the city. From the 15th century onwards, expansion of the town beyond the early enclosure created the need for new, strong fortifications to encompass the suburbs. In the mid-century, Venice set about planning and constructing a new enceinte around Candia, but the modernization project only began in earnest in the 16th century, to correspond to the architectural progress of the era. These works were carried out so as to bring the fortifications in line with Western standards and afford protection from large-scale threats, such as the regular Ottoman army.

In 1532 the Venetian engineer Michele Sanmicheli arrived on Crete—having previously worked on the fortifications of Padua and Verona—and renovated the city walls from 1538 to 1539; his work was shortly after continued by Giulio Savorgnan.[26]

There are two phases of construction that correspond to the theoretical developments in the architecture of the *fortificazione alla moderna*. In the first phase of modernization, by the 1560s, the town was defended by a huge circuit of walls with a perimeter of two miles. The circuit boasted solid bastions with stone faces and deeply recessed flanks, and walls up to 140 ft. thick. Additionally, a castle was built guarding the entrance to the harbor, and on a small hill immediately to the east of the town was erected the detached Fort of S. Dimitri, consisting of a *trace* with a central bastion (Venier) flanked by two demi-bastions (Orsini and Michele). In a final phase of building (1640s) the fortifications were extended into a new frontline formed in the surrounding countryside by a series of detached ravelins, hornworks, crownworks and redans.

The Candia enclosure consists of seven imposing, solidly built bastions connected by curtain walls. The landside bastions are heart-shaped in a characteristically Italian style, with *orecchioni* and *piazza-basse*, whereas the seafront Sabbionara and S. Andrea Bastions—at the eastern and western extremities of the city, jutting into the sea—required a less defensive design. The fortifications included cavaliers, as well as numerous detached outworks protecting the curtains and the bastions.

The city had three gates on the land side: Panigra in the west, Gesu in the south and S. Giorgio in the east. Along with the harbor gate, the three land gates closed both internally

and externally, with very heavy wooden doors (like the ones still visible in Nicosia and Cerines).

Besides the four main gates, there were also three smaller entrances: the gate of S. Andrea, the gate of Sabbionara and the gate of Dermata leading to the eponymous bay (located next to the current Museum of Natural History). These entrances were of lesser civilian importance, as no major country roads led to them (the roads from the city to the rest of the island started at the S. Giorgio and Panigra gates). These smaller gates are much less elaborate in their design and were accomodating less traffic.

Additionally, there was the Arsenal Gate and from the earlier medieval circuit of walls stood the Voltone Gate, at the end of Ruga Maistra, and there were also ancillary military gates, leading inside the bastions. Of these, still present are the bastion gates of Panigra, Bethleem, Martinengo, and Vitturi and two gates leading to the two *piazza-basse* of Gesu bastion.

The map of Coronelli shows the road from Voltone to Panigra; one road along the Byzantine walls, from Voltone, led to Dermata and another one to Porta S. Giorgio. These thoroughfares are still in use to this day.[27] The way to Porta del Gesu is not straight, nor wide, proving that this gate was added when the streets were already drawn.

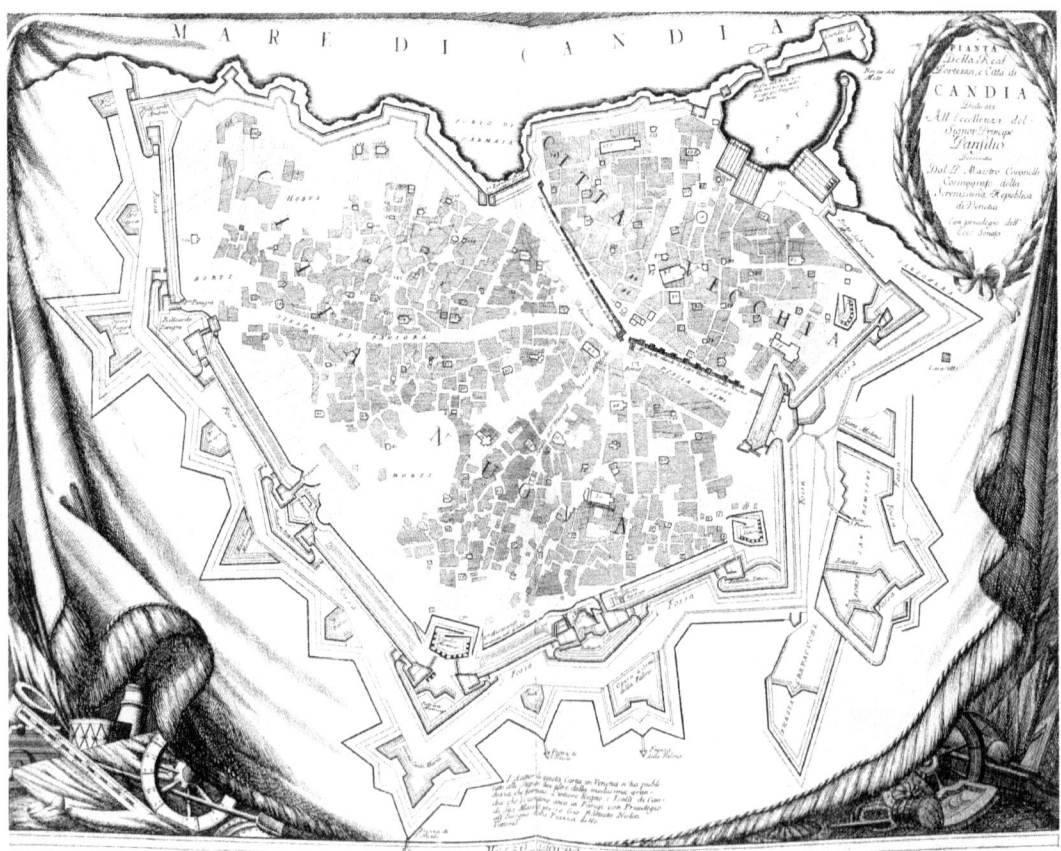

Figure 46. Vincenzo Coronelli, *Pianta della Real Fortezza e Città di Candia*, ca. 1690 (courtesy the Ministry of Culture and Tourism, Biblioteca Nazionale Marciana Venezia. All rights reserved).

From the upper right corner of the map, counterclockwise, the architectural features are as follows:

Enclosure	Outworks
San Andrea bastion	San Andrea ravelin
	Santo Spirito ravelin
Panigra bastion	Panigra hornwork
Panigra Gate	
	Panigra ravelin
Bethleem bastion	Mocenigo mezzaluna
	Bethleem ravelin
Martinengo (bastion and cavalier)	Santa Maria crownwork, Santa Maria redan
	San Nicolo ravelin, S. Nicolo redan
Gesu bastion	Della Palma hornwork, Della Palma redan
Gesu Gate	
Vitturi (bastion and cavalier)	Crepacuore (Crevecoeur) redan
	Fort San Dimitri
S. Giorgio Gate	Opera Molina
Sabbionara bastion and Zane cavalier	
Castello del Molo	
Dermata Gate	

The bastions are solid platforms, earth-filled and revetted in stone, that protruded from the walls, in order to protect a larger area and to support effectively the adjacent parts of the walls. Gunpowder magazines existed near the bastions and on top of the terreplein and are still present, quite frequently, in the turn-of-the-century photos.

The greater part of the original dry ditch protecting the landward side of Candia survives to this day. It once ran from the S. Andrea bastion to the Sabbionara bastion, but is now punctuated at various points by roads bisecting the walls and by recreational facilities.

In order to fortify the weakest positions in the enceinte and keep the enemy even further from the ditch and the walls, the Venetians built 12 additional outworks in entrenched line around the initial perimeter. Defenders reached these outworks by means of passages that ran from the ditch, of which only one is still visible, in the counterscarp below the former location of the Bethleem ravelin.

The bastions have an access from the city, to the *piazza-bassa*, then another less elaborate door in the *orecchione*, travelling down a staircase to a sally port in the ditch. On top of the earthworks, the Venetians constructed a revetted, inclined curtain wall, ending in a characteristic cordon (a semicircular stone cornice). In Candia, the curtain and the bastions have the same height, unlike in Nicosia, for instance, where the salient of the bastions is much taller than the level of the curtain. The scarp of the bastions is not uniform, but descends slightly from the flanks to the salient, whereas in Nicosia the difference in height makes the salients look like the ramming bow of a ship.

Four cavaliers were built on the Candia enceinte, as revetted structures; of these, S. Andrea was built by the Turks when they rebuilt that section of the fortifications, since their bombings and sapping had virtually destroyed it. The original Venetian cavaliers are Martinengo, on the bastion of the same name, at the highest point on the fortifications, and the Vitturi and Zane cavaliers (ruins of the latter are behind the Sabbionara bastion).

The main bastions of Candia—Panigra, Bethleem, Martinengo and Gesu—have the same morphology: a bulwark with two circular flanks, with two *piazza-basse*, accessed through a military gate. In the flanks there are vaulted corridors accessed from the level of the *piazza-bassa* and descending to a sally port opening in the ditch. Each *piazza-bassa* had two gun embrasures.

Historical photographic evidence—particularly from the archives of Giuseppe Gerola and Rahmizade Behaedin—show that the original seawalls had a parapet with proper gun embrasures, at least on the section westwards from the pier towards the San Andrea bastion.

Although historical maps, such as that of Antoine de Fer,[28] do present the walls of Candia full of gun embrasures, today these are gone and on the upper part of the walls the land fill is visible, exactly like in Nicosia and Canea. On the bastions, the parapet is gone and that section of the stone walls is clearly reconditioned, as seen at the Panigra bastion. Both the cordon and the parapet are, however, still present on most of the curtain walls.

The circuit of fortifications starts in the northwest with the bastion of **S. Andrea**. Because of heavy destruction sustained during the siege due to bombing and, mostly, sapping, once S. Andrea was reconstructed by the Ottomans, they eliminated the access routes to and from the *piazza-bassa*. The gate of the bastion was on its north side, and was removed more recently, to make way for the wide coastal road.

The alterations to S. Andrea are the most extensive: it is lower and its *piazza-bassa* is all but gone, along with all significant features. The Ottomans added the cavalier, but they were not consistent with architectural demands, so it is not aligned geometrically with the curtain and bastion. The S. Andrea cavalier is about 13 ft. tall, rectangular, and is accessed by a long gentle slope, suitable for moving cannons mounted on carriages. From this vantage point is visible one of the original features of the enceinte, a battery that flanked the original S. Andrea bastion. Today, the link between them is severed by a wide motorway that runs right along the seaside.

The curtain of S. Andrea has a relief plate of the lion of S. Marco and six aristocratic coats of arms, with the year 1543. Opposite the bastion was the ravelin of S. Andrea, and in front of the curtain, the Santo Spirito ravelin. The ditch between S. Andrea and Panigra has been severely affected by urban sprawl, and the counterscarp is gone, along with the line it traced.

The **Panigra** bastion was a complex fortification, and was strengthened during the long Turkish siege, when additional parapet walls were erected on the bastion. The bastion features two circular flanks with one *piazza-bassa* each. The gate of Panigra was used constantly, until the adjacent curtain was cut through in the 20th century. On the city side, the gate has a monumental façade, with three doors, but inside there is a large hall from which two vaulted corridors start: one leads upwards to the *piazza-bassa*, and the other to the exit in the ditch. On this side of the bastion, the *orecchione* has no sally port, since such a purpose can naturally be served by the gate itself. Otherwise, all the *orecchioni* of the bastions on the western front of the enceinte have such sorties, accessible from a *piazza-bassa*.

The design of the Panigra bastion is unique and important. The bastion turns skillfully at the salient, with the drawback that the bastion loses its trademark symmetry. In most other architectural designs, the front forces the position of the curtains to suit the symmetry of the bastions, many times sacrificing the efficiency of following the terrain to the beauty of the

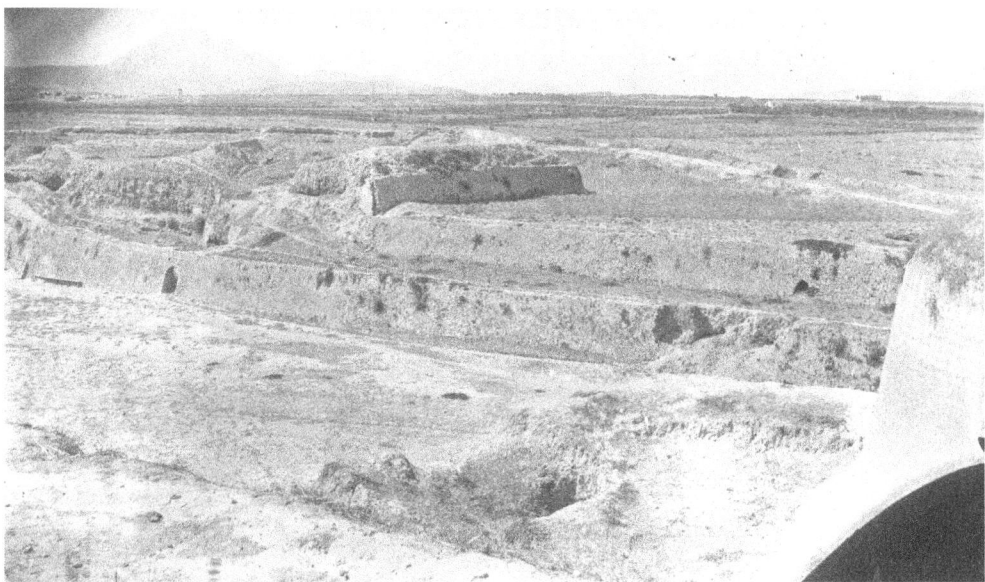

Figure 47. Santo Spirito ravelin, from the S. Andrea curtain (photograph G. Gerola, courtesy Istituto Veneto di Scienze, Lettere ed Arti. All rights reserved).

harmony. In Nicosia, this option was further enhanced by negating almost any considerations other than achieving the perfection of the circle in the design of the walls. (Thus, in the south, the hills were left undefended, and here the Turks set their batteries and mounted their assaults.)

While some bulwark designs shape the land and curtain to follow the desired trace of the city walls, as in Nicosia, others force the design of the bastions, as in Candia. Basically, here in Candia, the Venetians broke the bastion in two: architecturally, their approach was to submit the bastion to the role of protecting the curtain, which, in essence, was its intended original function. Normally architects treat a bastion in all its features as one; here in Candia, the Venetians realized that it is, in fact, only the flank of the bastion that actively covers the curtain. Thus, the design focuses on the curtain. Bastions such as Panigra and Vitturi act as two demi-bastions glued together into one, which accounts for their asymmetry. What is in harmony, in fact, are the flanks of these bastions with the flanks of their neighboring bastions, all converging to maximize the cover for the walls.

Additional cover is offered by the *piazza-bassa*—an open space between the ear and the curtain, shaped either like a trapeze or a square, situated at a lower level than the bastion, but higher than the level of the ditch itself. In the early works of the Italian architects that championed this structure, since there is a *piazza-bassa* (low square), there is also a *piazza-alta* (high square), which is the platform of the bastion. In Candia, most *piazza-basse* had their own military gates, some of which have survived. The southern *piazza-bassa* of the Panigra bastion, overlooking the city gate, still has its intact gun ports, giving an idea of how its symmetrical counterpart would have looked.

The northern *piazza-bassa* of Panigra has lost its gun ports, but the platform and its gate to the city still exist. From the town, a gate leads to the *piazza-bassa*, and from there a door allows access to a vaulted passage descending through the *orecchione*, and opens in a

postern at the level of the ditch, opposite the curtain, and protected by the flank and the *orecchione* of the bastion. On the *piazza-bassa*, there was one gun port, constructed like a covered gun embrasure, but cannons could be mounted on the side of this casemate. All the bastions on the western side of the wall circuit are structured this way, and almost all these features are preserved intact.

In the case of Panigra, at the end of the 2000s, on its northern *orecchione*, the postern was closed with a simple iron net fence, and this was pried opened by locals, allowing unprecedented access in the vaulted corridor running the length of the *orecchione* and going up to the *piazza-bassa*. Inside, there is a large, 9-ft.-wide staircase, all the way to the level of the *piazza-bassa*. This is where the Venetian troops sallied to engage the enemy in the ditch, and also to reach the outlying fortifications (ravelins and hornworks).

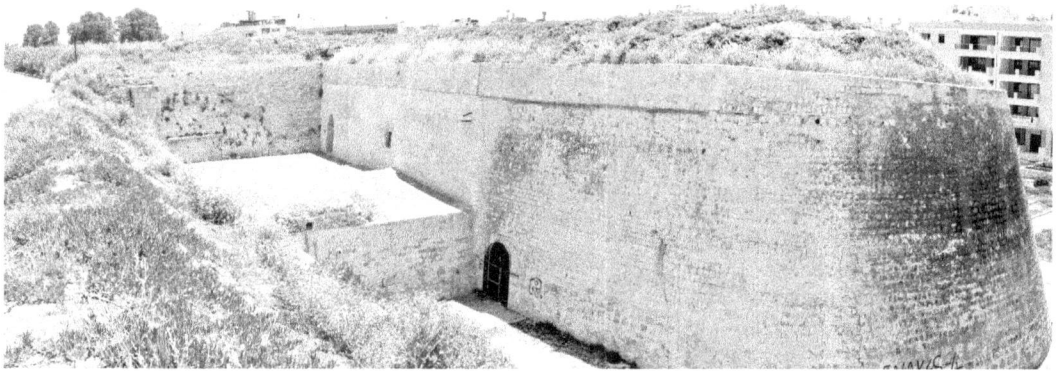

Figure 48. Panigra bastion, northern recessed flank. Note the postern in the *orecchione*.

The Panigra Gate, one of the three main gates, opens to the road connecting the city with the west of the island. The monumental side, designed by Michele Sanmicheli, features three symmetrically arranged vaulted entrances, surrounded by stone slabs and flanked by pilasters. Over the central arch, there are a bas-relief of the lion of S. Marco as patron of the Republic of Venice, and a round cameo with a depiction of *Dominus Dei* (hence the current Greek name of the bastion and gate: Pantocrator). The relief has the Latin inscription *Omnipotens* (Almighty).[29]

The exit of the Panigra Gate is right next to the *piazza-bassa*, in the form of a four-foot-wide door, embellished with a section composed of three heraldic elements: a small coat of arms of the Loredan family, and a square relief of the lion of S. Marco, under the same *Dominus Dei*.

Opposite the salient of the bastion, the Panigra hornwork was built, and in front of the curtain there was the Panigra ravelin, both of which are now demolished. On the curtain between Panigra and Bethleem there is a bas-relief of the winged lion of Venice and an inscription with the names of various Venetian aristocrats.

The next feature in the fortifications is the **Bethleem** platform. On the northern *piazza-bassa* of Bethleem you can see the structure of the casemates, with the embrasure and the smaller gun port. The southern *piazza* of Bethleem has undergone renovations, which somehow failed to restore the doorway that led to the vaulted corridor running thru the orecchione, and now the sally port exists but it seems to come from nowhere.

Figure 49. Panigra Gate, exterior.

In most early designs (seen in Famagosta), the *piazza-basse* had large parapet walls that created two embrasures on its sides, but other variants transformed them into gun ports, by covering them up, and this is most visible in the southern *piazza-bassa* of Bethleem.

The military gate leading to the northern *piazza-bassa* of Bethleem had a rich façade, with an inscribed architrave. From this *piazza-bassa*, as previously mentioned, there was a corridor leading to a sortie in the *orecchioni*.

One winged lion stands in the middle of the Bethleem curtain, and on the very tip of the southern circular flank of the Bethleem bastion there are more heraldic markings, namely a lion of S. Marco holding the coat of arms of the Doge Alvise I Mocenigo (1570–1577) inscribed with the date 1575, above a panel with the escutcheons of five Venetian nobles. Coats of arms belonging to a doge have the *corno ducale* drawn over the family arms.

Here in Candia, it was customary for a few nobles to join together their coats of arms in panels, rather than display them individually. This is clear in the case not only of military works, but also civilian, such as the Bembo fountain. The nobles had a lot of say in running

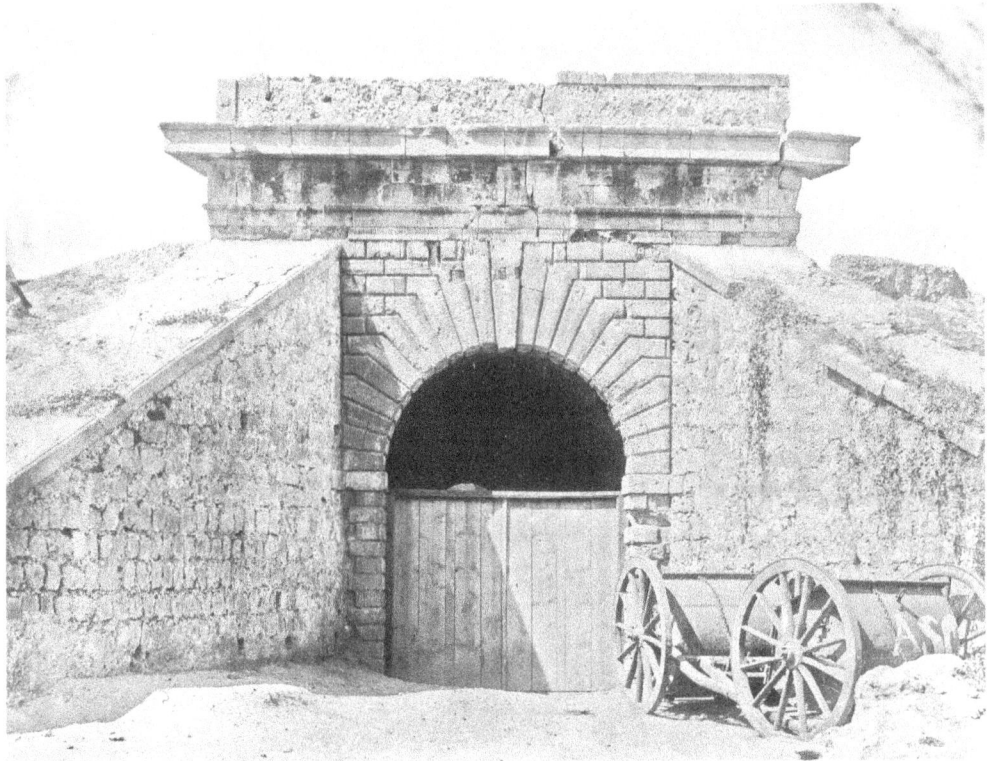

Figure 50. Gate to Bethleem bastion (photograph G. Gerola, courtesy Istituto Veneto di Scienze, Lettere ed Arti. All rights reserved).

the affairs of the *Regno di Candia* and, thus, in financing them; therefore it is understandable that more of them would want to take credit as patrons of significant public works, on equal footing with the central government itself. Another reason is, simply, that the cost of building such huge, state-of-the-art defenses was borne in part by the local nobles, and financing such endeavors was beyond the scope of wealth of only one of them. In the main locations of Venetian power in the eastern Mediterranean, are a few instances when such panels with coats of arms of nobles are still displayed *in situ* (apart perhaps from the church of S. Nicholas and the Giuliani Gate, both in Nicosia).

The salient of Bethleem is one of the few places on the face of the western bastions that the cordon is intact, even though the brunt of the 22-year siege and three-year bombardment was felt almost entirely on this side.

Also, in this area, you can see the best preserved counterscarp, which also includes an access door to the outworks, which are now lost. Opposite the salient of Bethleem was the external fort, Mocenigo, while in front of the curtain lay the Bethleem ravelin.

Between Bethleem and Martinengo the curtain is very well preserved, since it maintains the original cordon, while the scarp and walls of the bastion and the *piazza-bassa* have undergone significant restoration works. In the area of Martinengo the counterscarp is quite well preserved too. On the rest of the circuit, the counterscarp looks rather like a modern wall built to hold the earth, and in all the east side it is virtually lost.

From the curtain of Bethleem is easy to take in the sheer size of the Martinengo bullwark,

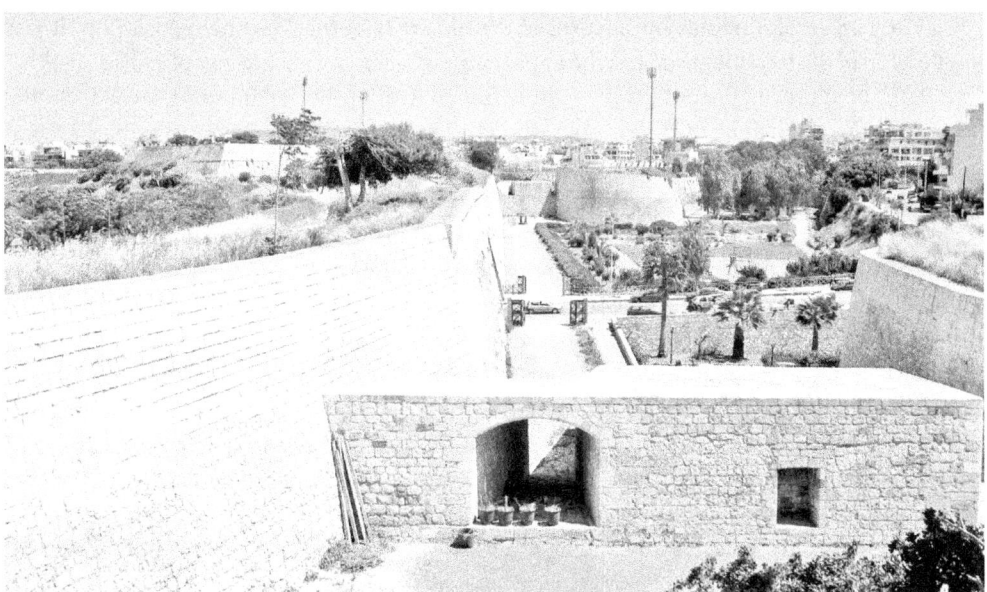

Figure 51. View from the southern flank of Bethleem. In the background, Martinengo cavalier, bastion and ditch.

spanning 540 ft. from the cavalier to the salient. It's so big that there is a normal-size soccer field build on it, and on two sides there was room left for regular bleachers.

The **Martinengo** bastion is the southernmost and highest part of the Venetian fortifications of Candia. It is one of the stronger bastions, a huge landmass encompassed by stone walls, the closest ones in size being Vitturi and Panigra. The Martinengo bastion is a powerful defensive bastion built in the shape of a heart with an acute angle, which expands on the two areas of *piazza-basse* on the flank, dominated by the cavalier behind them. It is the highest section of the Venetian fortifications of Candia and faces south, neighbored by the Bethleem and Gesu bastions. On the west side of the Martinengo bastion is a plaque with the lion of S. Marco and the emblem of Doge Pietro Loredan with the date 1578.

Martinengo was designed to fulfill its purpose as a corner bastion, and thus it has a very sharp angle in its salient, unlike the other bastions in Candia. This bastion has one of the best preserved *piazza-basse*, with deep recesses similar to the bastions of Famagosta and Corfu. Two vaulted corridors descended from the city walls to the two areas of *piazza-basse*, to expose the enemy to hidden fire.

There is an access gate towards the inside of the Martinengo cavalier, which is hollow (as in the cases of the large S. James and S. John cavaliers in Valletta). Here, access to the *piazza-bassa* was designed to be achieved through two vaulted corridors, but only the eastern one was completed in length and its gate is also the gate of the cavalier, while the other one starts inside the cavalier, where there is also a storage space. However, the western flank also has a sally port, like all the other bastions.

The Martinengo cavalier is a pentagonal, frustum-shaped, low structure (compared with the towering cavaliers in Valletta), since it is built on the terreplein and doesn't have to compensate for the difference in height from the ground up. The long side is 195 ft., and the other four are 115 ft. There are ramps on the sides of the cavalier, to access the platform of the bastion.

The cavalier dominates the section of the old walls of the Martinengo bastion. It was built on top of the terreplein and has the appearance of a massive square gun platform accessed by a flight of stairs. Its purpose was to allow full control of the surrounding areas from the bastion. From the height of the cavalier, the view was open all the way to the harbor, and from here the defenders could see the allied fleets of the Venetians and their Hospitaller, French, and Tuscan allies, bombing the Turkish camp during the excruciatingly long siege.

The cavalier stands 40 ft. above ground leve and the curtain is 30 ft. high here. Beyond the moat the external defenses were built: the strong crownwork (*opera a corona*) of the Santa Maria, in front of the salient of the Martinengo bastion, and the redan (*freccia*) of S. Nicolo, along the walls leading up to Gesu bastion, in front of the Martinengo curtain. The area around the faces of the Martinengo bastion is filled with trees, which makes observing from across the ditch difficult.

Maps depicting the siege of Candia—such as those by Antoine de Fer or Vincenzo Coronelli[30]—show that on the largest southwestern bastions (Martinengo and Panigra), traverses were build—protective barriers consisting of a parapet placed at angle to the main line of defense, designed to protect from flanking fire in case the walls were scaled on another portion of the enclosure.

In Candia, Bethleem and Gesu are a special kind of bastion—*piattaforma*. The angle of the salient of Bethleem and Gesu is so wide, close to 160 degrees; this, coupled with the positioning of these two bastions in the middle of a wide, straight curtain between two corner bastions (Panigra-Martinengo and Martinengo-Vitturi, respectively) makes the abovementioned bastions act like a *piattaforma*.

This type of bastion is a product typical of the Italian school. According to Lorini,[31] the purpose behind the *piattaforma* is to play the role of a cavalier, without the risk of being exposed to artillery and mortars by being mounted on high ground (terreplein). Thus, the structure is sunken in the ditch, and possibly enlarged with features like *orecchioni* and *piazzabasse*.

On the south side of the walls, in 1587, the Venetians built **Porta del Gesu** (Gate of Jesus). Designed by Michele Sanmicheli, it is one of the finest examples of Renaissance architecture surviving in the entire city, with its interior façade made of rectangular stones ordered in three symmetrical arches. Like the Panigra Gate, the interior access passages finish in a single doorway. Other openings on either side of the main gateway served as secondary entrances to ancillary areas, such as magazines and guardrooms. In contrast to the city façade, the external one is plain, unlike the stupendous Porta Nuova and Porta Palio in Verona, by the same architect.

The next corner bastion is **Vitturi**, with a rectangular cavalier and a very long 820 ft. The northern flank is recessed, with a *piazza-bassa*, and supported behind by a square cavalier with sides of 147 ft.—which still exists. On the salient there is a large and embellished coat of arms. In the corresponding ditch, the counterscarp is quite well preserved, from the salient of Martinengo to the salient of Vitturi.

The curtain between Gesu and Vitturi has houses and an impromptu parking lot on top of it, much like the western curtain in Canea. The invasion of Vitturi is extensive, and only the cavalier remains unoccupied. At the turn of the 20th century, the original city limits were still broad, with a lot of available space, and it also managed to expand beyond its walled old town in time to avoid its fortifications being overrun by constructions. The eastern walls

were most injured by unsanctioned building and the houses and neighborhood there are the oldest, sign that this part is where the town expanded first. Indeed, during the population exchange in the early 20th century between Turkey and Greece, millions of people were relocated, more Greeks than Turks, since they were a large part of the population of Asia Minor, and have been for almost two millennia.[32] Many of these settled in Crete.

S. Giorgio Gate was built in 1565 and is a vaulted gallery 140 ft. long, leading down to a lower level outside the walls; the long descent of the gallery ends in a round domed chamber (similar to the structure in Porta Giuliani in Nicosia), then turns 90 degrees and opens in a recessed flank. Historical graphic sources present significant constructions (such as S. Francesco monastery and its chapel) being at the level of the rampart. Their protection was insured by the fort of S. Dimitri, which meant cannonballs would not reach the actual area of the S. Giorgio Gate. In Nicosia, the Giuliani Gate had the same architectural arrangement, but without outworks to offer proper protection. On the other hand, gates such as Gesu and Panigra in Candia, or Provveditore and San Domenico in Nicosia, are at ground level. S. Giorgio, Panigra and Giuliani open behind *orecchioni* of the bastion, clearly difficult or impossible to be seen by prying eyes from opposite the ditch and outworks.

The S. Giorgio Gate led to the eastern provinces and the lazaretto.[33] An interesting feature of this gate is that the vaulted corridor leading down from the town walls is not a straight line, like in Nicosia, but is bent at about 120 degrees, and so the exit from the gate is on the recessed flank of the bastion, on the wall next to the *orecchione*, and not on the curtain wall opposite the ear. All the other Venetian gates, in Candia, Nicosia, and Corfu, open on the curtain wall, either behind a bastion flank, or in the middle of the curtain; this is actually the norm for all Renaissance fortifications, making S. Giorgio Gate in Candia an exception.

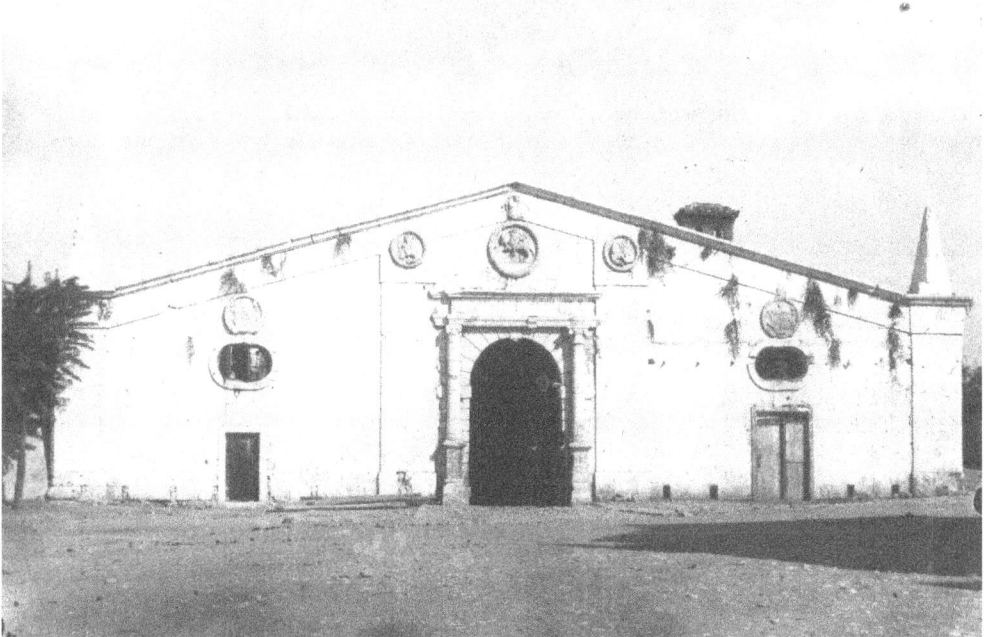

Figure 52. S. Giorgio Gate (photograph G. Gerola, courtesy Istituto Veneto di Scienze, Lettere ed Arti. All rights reserved).

Designed by Giulio Savorgnan and dedicated to S. Giorgio in the year 1565, the monumental city-side façade featured a relief medallion of the saint (in his traditional knight on horseback image), set above the rusticated main portal, along with coats of arms and Venetian lions carved in relief. This gate was demolished in 1917 to make room for the new access road that mounted the walls,[34] just as the neighboring S. Francesco *piazza-bassa* was flattened for same reasons in 1903.[35] The original exit gate is preserved but is obviously a less ornate structure, located behind an *orecchione*.

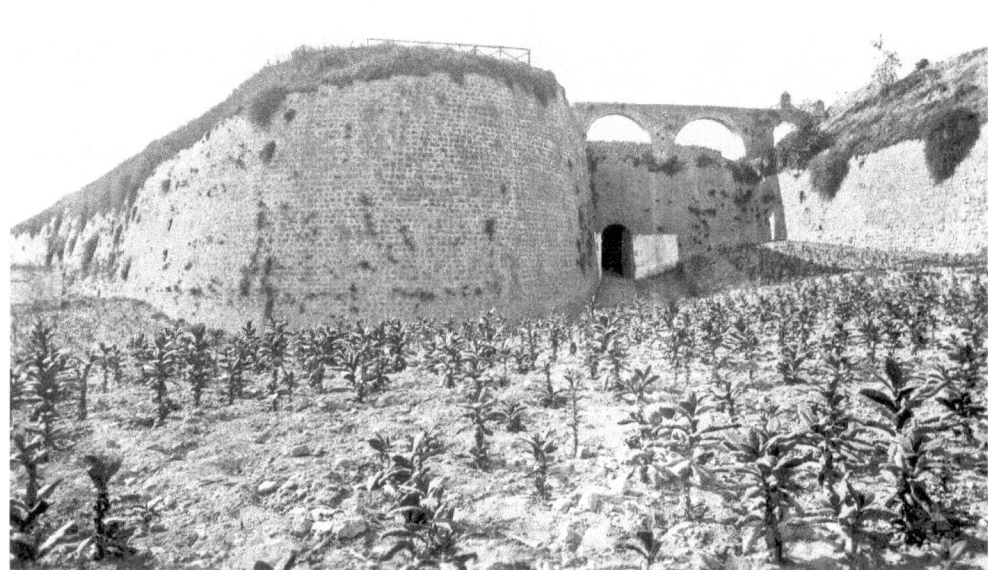

Figure 53. S. Giorgio flank, with the S. Giorgio Gate and arches of the Venetian aqueduct (photograph G. Gerola, courtesy Istituto Veneto di Scienze, Lettere ed Arti. All rights reserved).

There is a panel of five coats of arms next to the exit of the S. Giorgio Gate; also, two beautiful Ottoman drinking fountains are in this area, reminiscent of the Turkish fountains in Rhodes.

Built in the middle of the 16th century, the structures in this part of the walls look east to the fort of S. Dimitri. Gerola mentions here the names of the S. Giorgio and S. Francesco bastions, the retired flanks with their *orecchioni* and *piazza-bassa* of demi-bastions. This architectural solution is explained by Lorini: we are in fact dealing with what he calls "fortificazione fatta con la fronte piatta,"[36] where, on account of the length of the straight section of the trace, he recommends the insertion of such structures, with recessed flanks facing each other at close distance.

Between the two flanks, in front of the gate exit, there was a structure whose northern half is still preserved: a *piattaforma rovescia*, a "reversed platform" as Gerola calls it.[37] This elevated gun platform above the level of the ditch plays the role of a *fausse-braye*.

The name of the **S. Francesco** demi-bastion comes from the nearby large church, once located right on the terreplein. Currently, ruins of the central nave and apse of this church

are visible next to the eastern wall of the Archeological Museum. S. Francesco has the purpose of protecting the S. Giorgio Gate, which is also covered by the large and strong S. Dimitri fort, acting like a large ravelin and controlling the access road to this gate and thus to the whole city. Right when Gerola was in Crete taking his pictures, the *piazza-bassa* of S. Francesco bastion was built over and a road was constructed to allow wider and smoother access to the town. Previously, the top of the S. Giorgio bastion was also where the Venetian Aqueduct, visible in Figure 53, entered the town.[38]

The only outwork still existing in Candia is the detached fort of **S. Dimitri**, to the east of the enceinte, opposite the S. Giorgio Gate. The extensive outworks of Candia, which included ravelins, counterguards, hornworks and even a crownwork, remain visible only in historical maps and scarce photographic evidence.

A good example of such structures belonging to the second phase of Italian fortification design is the S. Dimitri fort. It was constructed on a natural hill, with steep sides, both towards the town and the countryside to the east.

The defensive complex was formed by two half-bastions—Orsini to the north and Michele to the south—and between them the Venier bastion. Basically, the entire front projected like a crownwork of larger proportions. The curtain is still visible, with all three salients, although apartment blocks are built on top of it. On the town side, the fort had a rusticated gate.

The disposition of this fort is so mathematically precise that from the Castello del Molo and Sabbionara, shots would cover the Venier bastion in the center of the crown. In Figure 54, you can see the defensive front extending from the Michael bastion in Fort S. Dimitri, its

Figure 54. View from the salient of Venier bastion of Fort S. Dimitri (photograph G. Gerola, courtesy Istituto Veneto di Scienze, Lettere ed Arti. All rights reserved).

most forward section, to its neighboring Orsini bastion, west to Sabbionara. Further on, in the background, is nothing less than the Castello del Molo.

At the eastern end of the enclosure is the **Sabbionara** bastion. It has an *orecchione* on one flank and is flat on the sea side, and before the 20th century this part of the curtain rose directly from the sea. The seaward defenses consisted of buttressed curtain walls, built, as elsewhere, of revetted earthworks. Embrasures were created in the parapet to protect the city from the seaside. On the eastern side, the sea wall was doubled by the old Byzantine city walls, as seen from the pictures by Gerola.

The unimposing salient of the Sabbionara bastion shows most of its cordon *in situ*. There is less thoughtful design for the seaward section of the fortifications, in Candia as well as in Canea. Being a sea bastion, its defenses were not very elaborate, especially on the sea side, just like the Gritti bastion and Rivellino del Porto bastions in Canea.[39]

Behind it are the remains of Zane cavalier; ruins of its northern scarp are clearly visible, although only three feet high. Sabbionara also features a military gate leading to the ditch, situated in the northwest corner of the bastion. The unadorned exit still survives; the recently uncovered landward façade is an ornate structure with a pediment. Initially there were several such gates, not plain, but with ornate revetted façades, like the Bethleem Gate or the beautiful military gate of the *piattaforma* in Canea. By contrast, in Corfu, such small ancillary gates were less embellished (Raimondo or S. Nicolo gates in Corfu, the latter still extant).

From the harbor further to the west was the Dermata Gate, situated approximately halfway along the seaward wall. The structure, which has three arched openings, was used as a storage area that opened up directly to the sea through long tunnels. The shoreline was extended and land regained from the sea, and this is most visible on the section of the Dermata Gate, since this is now firmly inland, 150 ft. away from the beach. Originally, this gate lay at the back of a small, deep and narrow gulf, whose sides were protected by the sea walls of Candia. The current reconstruction doesn't match, however, the drawings by Gerola.[40]

The Fortifications Today

Candia suffered extensive dilapidation during a period in the 20th century when there were too few official efforts to preserve the architectural material culture. When Gerola photographed the walls and the city of Candia, in 1900–02, there were still a lot of Venetian vestiges still standing, but, over the years, the majority of the Latin churches disappeared. Previously, during the Turkish occupation, these had lost their ecumenical purpose and were converted to public and commercial spaces (for instance, S. Eirene was turned into an opium den, S. Onofrio into a café, and Sta. Maria di Piazza into a market).[41]

Thus, when the Ottoman administration left the island in 1898, and, especially, after the Turkish population left Crete in the early 1920s, these spaces were taken over by the new authorities and sold to private individuals, thus eluding potential state efforts at preservation. Although this is the case of most losses, the most impressive building, the S. Salvatore Church, was unfortunately demolished by the Greek authorities in the late '60s.

Giuseppe Gerola himself spares no wrath in condemning the dilapidation purported or condoned by the local authorities even while he was present on the island, calling the deliberate or irresponsible destruction of portions of the wall vandalism and recalling contempo-

rary Italian reprimand efforts.[42] He also points a finger at the British occupation troops for doing away with the outworks on the western front.

The urban fabric of Heraklion was altered beyond recognition in the second half of the 20th century, and now the old town area is full of tall, unassuming, apartment blocks and hotels. In Heraklion, the walls are now the anachronistic party, since they separate neighborhoods that are too similar in their contemporaneity and lack of character. Put in this perspective, it's a small miracle that the massive walls were not torn down.

The advent of motorized transport in the early 20th century led the city authorities to breach the city walls, so as to assist traffic flow on existing main routes. The breaches were made at points close to the Venetian gates, which were thus rendered obsolete. Initially, roads were opened by cutting through the curtain wall, like in Chania, but soon after this, the authorities decided to bridge over the breaches, returning the walled circuit to its complete status. The opening to the east of the Panigra Gate became known as the Chania Gate, while the one east of Porta del Gesu was named the New Gate. The additional Bethleem Gate includes large archways for motorized traffic and sports a neo–Gothic ceiling with cross ribbed vaults.

Unfortunately, the most destructive interventions in the harbor area were perpetrated in the 20th century with the opening of the coastal road, which demolished much of the Venetian harbor installations, as well as the harbor and arsenal gates, and the sea walls. In the 1920s, on the Sabbionara sea curtain the high residential building Fytaki Megaron, now the homonymous hotel, was constructed.

The land walls suffered less damage, the reason they are largely intact today. Exactly in

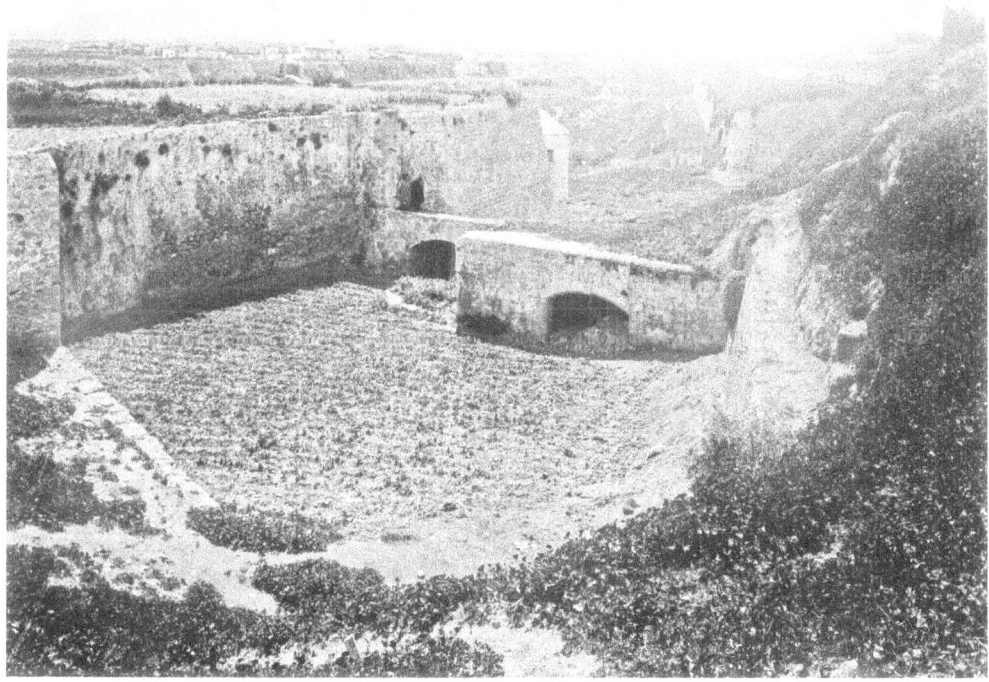

Figure 55. *Piazza-bassa* in the flank of S. Francesco (photograph G. Gerola, courtesy Istituto Veneto di Scienze, Lettere ed Arti. All rights reserved).

the days when Gerola was photographing the town, public works were underway to raise a road into the city, over the southern *piazza-bassa* of the S. Francesco bastion. This made use of the exiting access road into town that finished at the S. Giorgio Gate. The solution is visibly the model the British used in Nicosia in the same period—that of mounting the roads on top of the walls, rather than cutting through the curtains themselves. Latter, new access roads were cut into the curtains at various places, and only some decades ago were these roads covered, to minimize the visual damage done to the walls; this, in turn, allows a superb continuous walk over the bastioned front, from the S. Andrea bastion to the Vitturi curtain. Efforts to acknowledge and promote the value of the Renaissance military architecture in Heraklion led to a didactic panel being installed on each bastion, offering accurate information on the elements available.

A tour of the fortifications can be taken all along the top of the walls, from S. Andrea to Sabbionara bastions. Here the terreplein was restored in a way that allows the visitor to observe the logic of the fortifications. In Heraklion, the image of the fortified enclosure was improved by restoring the sense of a continuous façade, by roofing the roads and turning them into gates, thus allowing the unobstructed passage of vehicular traffic, which had created the need for the breaches in the walls in the first place. This could also be done in Nicosia and Chania, while in Famagosta, the roads were cut through just the lower portion of the walls, and did not require pulling down entire vertical sections of the walls.[43]

8

Canea

The history of the urban landscape of Canea reveals its importance as the second city in *Regno di Candia*. The city and its port were the center of a fertile agricultural region, with strong economic and cultural relations with Venice.

A town with ancient roots in western Crete, Canea was an important port for centuries, and was part of the group of strategic places fortified in 1204 by the Genoese of Pescatore, in their attempt to wrest control of the island before their rivals would establish themselves. Eventually, the Venetians drove the Genoese out and settled to develop the area.

The fortifications of Canea consist of the medieval, internal Byzantine enclosure and the massive Renaissance walls. For the first two centuries of the Venetian period (13th–14th century), the original walls were sufficient for the internal threat mounted by the locals with the limited siege weaponry of the time.

In the first phase, the Venetians of Canea raised against the domestic enemy the repaired Byzantine citadel, whose walls and towers were obviously suitable for medieval warfare. After being taken by the Venetians, the city was rebuilt within the perimeter of its original fortifications. In that age it was already the second-most important city in Crete, and a port of call for Venetian ships.

By the 16th century, defense against a strong enemy like the Ottoman Turks required the construction of powerful modern walls, which were laid out on the modern principles of bastioned fortification by Michele Sanmicheli in 1538, while on his tour of office throughout the island.

Canea was the capital of the island under the Ottomans—and remained so until 1971—simply because the Turks had use of this town right from when they first set foot on the island (as compared to the couple of decades it took them to enter Candia). As a result, the seat of the pasha was here. Despite attempts to free the city, in 1667 and 1692, Canea remained in Ottoman hands until 1898.

The Town

The Venetians first settled the Castello,[1] the naturally fortified hill being the most obvious defensible position. In fact, dating from the city's ancient roots are the main thoroughfares, which follow the Roman principle of urbanism by establishing the *cardo* and *decumano*—

two straight and perpendicular roads—as backbones of the settlement. In this area, the Venetians built the Cathedral of Santa Maria, the governor's palace and the residences of important figures. Initially, they restored the Byzantine towers and curtain around the hill known today as Kastelli; then they improved them, along the same medieval architectural lines, in the 14th century. The first fortification of the city lasted from 1336 to 1356.

Next the Venetians decided to fortify the town, including the suburbs, so they build a walled precinct that would include the entire inhabited region, as it had developed till then.

The new confines of the town included churches such as San Francesco and San Rocco, as well as large public and private buildings, in line with the Western styles of the era. The church of S. Rocco bears a striking resemblance to the baroque church of S. Caterina in Candia, as well as Madonna ta' l-Ittria in Malta. Another exquisite church is S. Francesco, with its strong medieval features (pointed arches, lobed windows, and rosettes), now housing the Archeological Museum.

A wonderful example of a Renaissance private lodging is the Renier palace, of which the portal, chapel, and other buildings survived, in the most Venetian part of town—now called Topanas—behind the western curtain and the harbor. Similar styles can still be found in Retimo or Corfu, but not so much in Candia. In Cyprus as well, most private houses that have survived from the Venetian period display elements more associated with previous architectural medieval styles, specifically Gothic.[2]

There are a lot of Venetian houses left in the old town of Canea, especially in the Kastelli and the Topanas neighborhoods. The beauty of this is that they look more like houses in Venice than most Venetian cities in Terraferma (Padua, Vicenza, Verona), which is understandable since these towns already had a strongly defined character before the Venetian conquest in the 14th–15th centuries.

This evidence is offered especially by the architectural style of the beautiful Renaissance portals. Those preserved to this day are not always as nice as those in Retimo, for example; but in the photographic collection of Gerola a lot more palaces were captured, especially in the Kastelli area.

The **harbor** gathers the best preserved and most impressive Venetian buildings, both public and private. The western section, stretching from the Rivellino to the middle of the port, is bordered by fine Venetian houses, with beautiful exterior iron staircases allowing access directly to the private chambers on the first floor—habitations of the merchants whose entrepôt was on the ground floor.

The harbor of Canea was organized by the Venetians between 1320 and 1356.[3] On its north side the harbor is protected by a breakwater, leading to the lighthouse, and in its middle there is the small S. Nicolo redoubt, which defended the port along with the Rivellino del Porto at the harbor entrance.

The Venetian harbor has a length of 2,100 ft., with a width of 400 ft. in his eastern part, where the arsenals are, and over 1,000 ft. in the west. It had room for 40 galleys, but it constantly silted up and, not being deep, it required dredging.[4] Once the Ottomans took over, this task was not adequately undertaken by the state, and the harbor was abandoned because of silting. The lighthouse was also Venetian, but was altered beyond recognition—hence its minaret silhouette—during the Egyptian occupation of Crete (1830–1840).

The **arsenals**, used to shelter and repair the Venetian ships, were built gradually, over

the course of time, starting in the 14th century. Of the original 17 vaults of the arsenals, seven have survived until today on the south side of the harbor and are in very good shape, as well as two on the east, while a third was recently recreated.

They are long, narrow structures (160 ft. long and 33–40 ft. wide) with high vaulted roofs (about 33 ft. in height) and arched fronts. The walls were made out of rubble and the corners of stacked stone. The arsenals were covered with barrel vaults, and the northern façade ended in a series of gable roofs (in Candia, for instance, the arsenals also had barrel vaults). The back of the arsenals is not renovated, and so you can see here the original masonry; they have two rectangular windows, with a round one over them.

The Grand Arsenal was constructed in 1585–1601 as the last of the numerous arsenal buildings. This construction is 150 ft. long and 52 ft. wide. Originally, this arsenal was only one story high, but the Turks altered it by adding a second floor and changing its function. The addition of another floor after the original building was finished is easy to see because the upper floor is very slightly narrower than the ground floor. This is more visible on the northern corners of the arsenal.

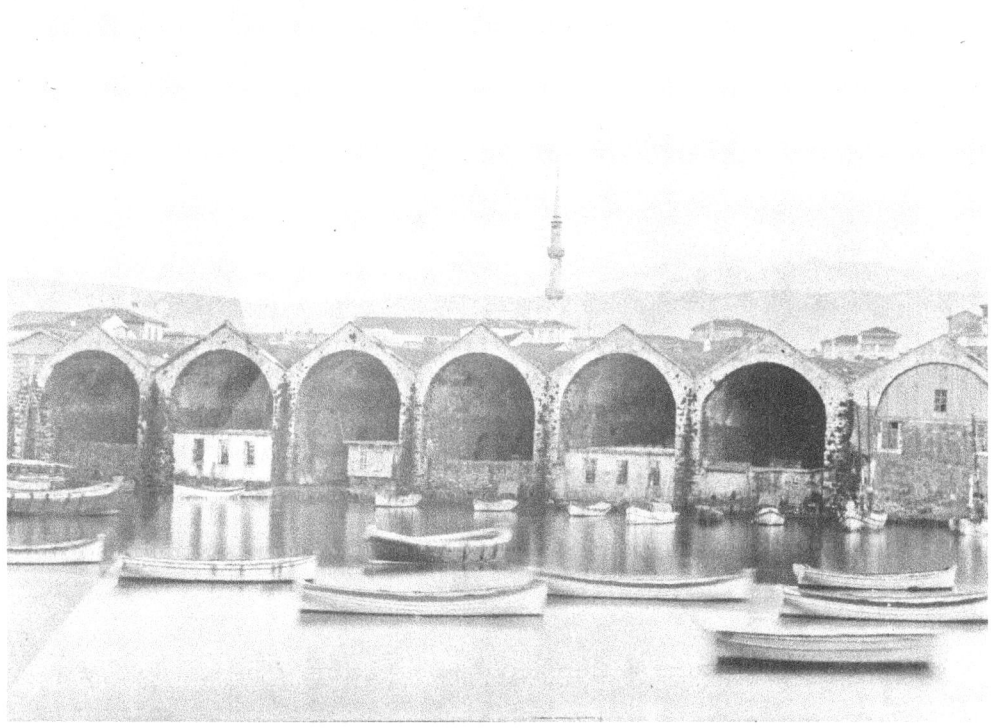

Figure 56. Arsenals in Canea (photograph G. Gerola, courtesy Istituto Veneto di Scienze, Lettere ed Arti. All rights reserved).

The access to the arsenals was directly from the water, not via the quay that exists today. Similar to the arsenals here in Crete, were the size and features of the arsenals in Dalmatia (e.g., Lesina).

Figure 57. Medieval tower as base for later constructions.

The Castello Vecchio

The central hill is the oldest part of the city, for the obvious reason that this naturally fortified mound juts high over the port and is quite steep on the sea side, making it suitable for a settlement. The Venetians, after conquering Crete, settled here and built walls 790 ft. long. The Castello still has a large section of its early medieval wall, with its distinct rectangular towers. In fact, as many as eight of them are to the south, in various heights and states of conservation. These towers are similar to the one that once bordered the Collachio of the Hospitaller Knights' conventual city in Rhodes.

The Castello is a classic medieval walled town consisting of a crenellated curtain flanked by towers. Here, the defenses were based on the usual pre-modern factors since the dawn of time: the naturally strong and elevated position of the hill, the height of its walls and the alternation of tower and wall that insured defense against the conventional weapons of the age (longbows, battering rams, and ladders). The square towers had a side length of 13–26 ft. and internal structures consisting of floors with barrel vaults or groin vaults.

Several such towers remained in various degrees of decay or overgrowth.[5] The ancient medieval walls became, of course, obsolete, and were overrun by private dwellings.

The public buildings were built lengthwise on the central road—*corso*[6]—that crosses the perimeter from east to west, as expected from a *corso* of Roman tradition. The imposing entrances of the Venetian palaces were preserved until the beginning of the 20th century, as witnessed and recorded in Gerola's photographs. His pictures reveal many buildings of Gothic and Renaissance architecture with imposing entrances and ornate window frames, which were the houses and palaces of Venetian nobles, such as Palazzo Premarino, Palazzo da Molin, Palazzo Zangarol.

The enclosure was connected to the town by three gates. Ruins still exist today of the eastern gate; the western gate was demolished in 1928 and the third gate led to the lower town. The gates were built in the form of tower-gates, with the ground floor used for passage and the rest for quartering.

A very beautiful example is **Porta del Colombo**, which only survives in the photos by Gerola. It was a tall structure, with rusticated stone, an architrave holding a Latin text alluding to Venetian protection of trade in the market and dedicated by Niccolo Venier in 1575, with a high-relief of the Marcian lion. This was the Harbor Gate, in a square which collected the main streets coming from new town and *Castello*,[7] and where the *loggia* apparently also existed.[8]

In Canea there were several gates: three connecting the Castello Vecchio to the new town, two on the land fortifications, the Harbor Gate and the Arsenal Gate.[9] The latter two were more modern and thus more ornate than their Candian medieval counterparts. Also in the harbor there were a fountain and a column with a statue of the lion of S. Marco on top,[10] an omnipresent symbol of Venetian civic allegiance, still displayed on columns in cities all over Terraferma (Vicenza, Verona, Udine, Padua).

When the city extended outside the old enclosure, the reconstruction and modernization of the city walls was necessary. Thus, in the mid–16th century the city was refortified under the supervision of the architect Michele Sanmichelli, who designed modern walls in the style of the *fortificazione alla moderna*, developed by the Italian architects of the age.

Figure 58. Porta del Colombo (photograph G. Gerola, courtesy Istituto Veneto di Scienze, Lettere ed Arti. All rights reserved).

The Renaissance Walls

In the aftermath of the disadvantageous peace of 1540, and of the raids on the Venetian islands in the Aegean and the Ionian, it became urgent for Venice to strengthen her fortifications in the *Stato da Mar*—particularly the largest and most important possessions of Crete, Cyprus and Corfu—against the pervasive danger of Turkish attack. The departure of the Hospitallers from Rhodes (1522) and the Christian defeat at Preveza (1538) had signaled Turkish preeminence in the eastern Mediterranean, and so Venice embarked on a large-scale program to refortify its cities and strategic places, and to bring them up to the modern standards of artillery siege warfare.

This program applied heavily to the cities and other key points in Crete, since up to this time, the defensive works built by the Venetians on the island were mainly complementary to the existing fortifications. In 1538 work began on a new enclosure wall for Canea, on the system of bastioned fortification, and in particular to the defense of the port.

The Venetian government called on Michele Sanmicheli, architect of the beautiful Veronese enclosure, to design and build new fortifications of the towns on the island of Crete, including those of Canea. He designed them in 1538–40, and the construction of the new walls was finished by 1568, after some additions by Giulio Savorgnan, who extended the faces of the bastions, shortened the length of the lines of defense (by building a *piattaforma* in the middle of the southern curtain), and broadened the terreplein.[11]

The enclosure wall of the Renaissance town presents all the characteristics of a typical bastioned fortress. It features angular corner bastions of revetted earthworks, linked by a thick curtain. The front was rectangular and symmetrical, down to the shape of bastions and number of cavaliers supporting them, including the fact that the central bastion had two cavaliers, which brought the southern front to a staggering nine gun platforms in just over 2,300 ft.: three bastions, four rectangular cavaliers and two large round cavaliers. Symmetry is a key element in Renaissance fortifications because it insures equal qualities of protection.

The walls form just three sides of a rectangle, since the northern side is the coast and is marked by the breakwater that protects the harbor. The walls trace the shape of the letter U, as the circuit lacks one side (the northern) to make it a complete rectangle. The circuit is not complete, as the breakwater wall—with a total length of 1,900 ft.—and the small and isolated S. Nicolo redoubt, do not exactly constitute a bastioned front.

The western curtain is longer (1,180 ft.), and the eastern one shorter (1,050 ft.). All curtain walls are reinforced by a terreplein and the entire line is surrounded by a wide moat. The ditch is about 1.3 miles long, and its width varies from 140 ft. at the salient of the corner bastions to 195 ft. at the widest point in front of the curtain. The moat is, on average, 180 ft. wide, and the curtain around 33 ft. thick, with a height of similar dimension.

Here in Canea there is an issue with the names of some of the defensive features. Various sources, including from contemporary Greek cultural administration, use names different from historical maps. This is particularly true in regards to Rivellino del Porto and the Gritti/Venier bastion, as well as some cavaliers. Venetian historical maps of the first half of the 17th century (Basilicata, Corner, and Boschini) name the northwest corner bastion Gritti (the same description used by Gerola and Andrews); on the other hand, Coronelli—whose map we have as Figure 59—calls it Venier; and finally, the Greek scholars and administration call it S. Salvatore[12] (after the name of the nearby church, still standing). In other situations, Riv-

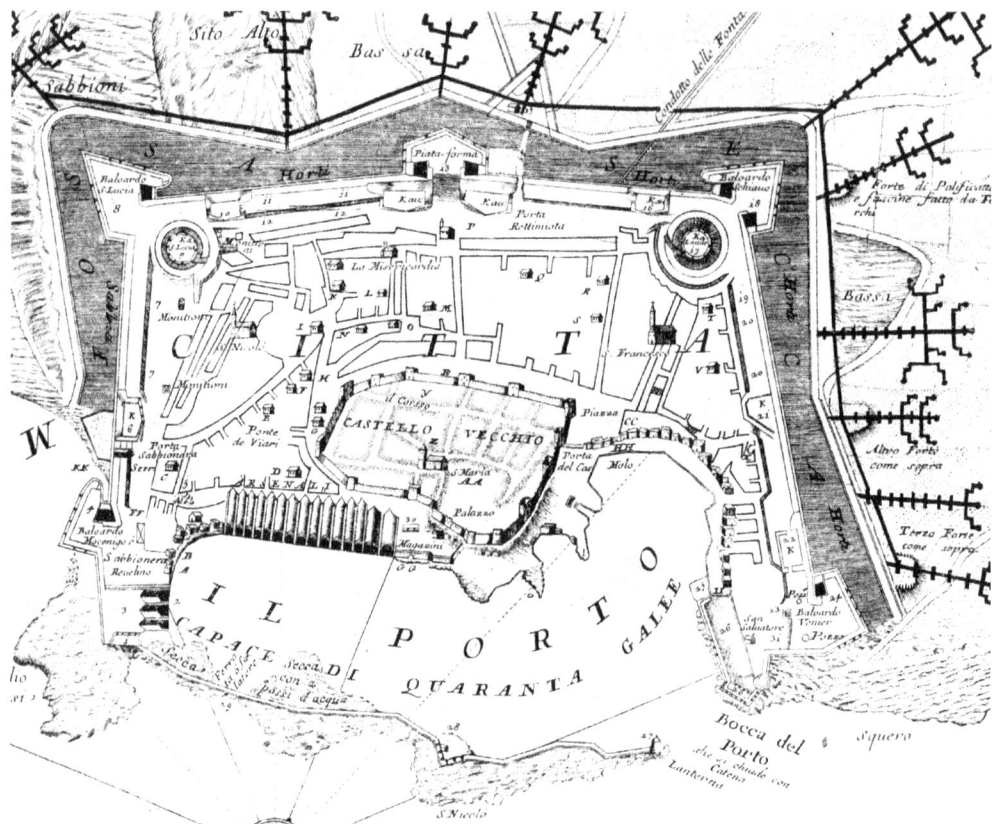

Figure 59. Vincenzo Coronelli, *Città e fortezza della Canea, pianta*, 1696. South is up (courtesy of the Ministry of Culture and Tourism, Biblioteca Nazionale Marciana Venezia. All rights reserved).

ellino is referred to as S. Salvatore, since this was the name of the barracks inside the compound.

We present here all the acknowledged variants of the toponyms, the first being the one we will use here. On the map, from the mouth of the harbor counterclockwise, the defensive features are as follows (read down, then across):

- Rivellino del Porto/San Salvatore
- Torrione
- Gritti/Venier/San Salvatore bastion
- San Marco/Santa Caterina/Santa Maria cavalier
- San Atanasio/San Nicola cavalier
- Schiavo/Lando/San Dimitri bastion
- Lando cavalier
- San Dimitri cavalier
- Porta Rettimiota
- Ravelin
- San Giovanni cavalier

- Rettimioto bastion/*piattaforma*
- Santa Maria cavalier
- cavalier
- Santa Lucia bastion
- Santa Lucia cavalier
- Sabbionara cavalier
- Porta Sabbionara
- Sabbionara/Mocenigo bastion
- Michele/Sabbionara ravelin
- San Nicolo redoubt

At the southern corners of the enclosure wall, two strong bastions (Santa Lucia and Schiavo) enfilade the ditch with fire from their recessed flanks, in conjunction with the flanks of a platform bastion (a *piattaforma* similar to S. Atanasio in Corfu, or Bethleem and Gesu in Candia) placed in the center of the long southern wall and defending the intervening curtain walls. The insertion of a *piattaforma* on this side was essential on account of the front length (2,300 ft.), since it was only by dividing it into two sections that an effective defense of the bastions could be insured, as well as full control over the curtain and the ditch, in order to disallow enemy approaches.

Behind and above the bastions of Santa Lucia and Schiavo stood two cavaliers named Santa Lucia and Lando, respectively. These are embanked towers for artillery, in this case round (although usually, throughout the republic, these structures were square, as in Candia, Famagosta, Corfu or Verona).

At the northern corners of the rectangular enclosure wall stood the two demi-bastions (that is, bastions with a single flank) of Sabbionara and Gritti, which assured the enfilade fire necessary to defend the eastern and western curtain walls. There was little effort needed to cover the sea walls, since they jutted almost directly into the water, making any infantry approach virtually impossible, in combat conditions.

The map by Coronelli also shows the network of underground countermine galleries that ran around the perimeter and extended far out into the approaches, further extending the zone of construction. Such tunnels were dug from the start, and used and extended during a siege. They were meant to cover primarily the approaches to the bastions, as these were the key to any defense.

However, the map also presents in its legend certain elements that the author acknowledges as later Turkish additions, which were also noticed and mentioned by Kevin Andrews in his work: the ravelin protecting the Rettimiota Gate and the Sabbionara cavalier.

The walls facing the sea form a simple straight line, since the danger of assault from this side was considered minor. The form and function of maritime fortifications are quite different from those of land defenses. As in Candia, the city's defensive plans included, among other items, the construction of a strong point at the entrance to the port to ensure the protection of the mouth of the harbor.

The defense of the harbor entrance was assured by a polygonal ravelin—**Rivellino del Porto**—with a series of low, vaulted embrasures to allow the artillery to sweep the surface of the sea, which is the best way to defend against naval attack. This ravelin incorporated the old round tower that once protected the port. In addition, a chain extending from it to the base of the lighthouse could close off the harbor mouth.

It is now known as "Firkas bastion," but it is actually a fort complex, with a gun platform flanking the port entrance and a narrow inner yard hosting several military ancillary facilities (barracks, living and administrative quarters). The structure is a trapeze, with the seaside wall, of 130 ft., a wider interior side of 170 ft., and remaining sides 65 ft. long. Many Venetian symbols are still displayed, such as the lion of S. Marco over the carved entrance on the first floor of the two-story building of the barracks. There are also arched spaces in the gunnery casemates, at the northern part of the fort. The barracks of San Salvatore, inside the Rivellino del Porto, were built in 1629 as lodgings for the troops. These fine structures bear a resemblance to the barracks in S. Elmo in Valletta (although most of those structures date from a later century).

Built as a gun platform guarding the entrance to the harbor, it later developed into a fort, encompassing the very large Torrione (the old Genoese tower) and the military barracks. From this Rivellino del Porto across to the lighthouse, a strong iron ring was placed to which one end of the chain was attached, closing off the harbor mouth. There are six embrasures on the top level, and five others were at ground level (which nowadays is higher, and so some gun ports are half obstructed). A corresponding, but less strong ravelin (Michel) was built in front of the northern face of the northeast demi-bastion of Sabbionara.

Figure 60. Embellished entrance on the second floor of the S. Salvatore barracks.

On the sea side, the walls are 11.5 ft. high at the Gritti bulwark and lower, just 8–9 ft., at the Rivellino del Porto. The wall at its western end, where it joins the *Torrione*, is of a lesser quality, rubble and mortar, but most likely this is botched restoration work that also affected the last gun embrasure. Six smaller gun ports open from the ground level of the fort, directly overlooking the entrance to the harbor. While the south and southeast side of the fort present typical cannon embrasures, its eastern side has only simple merlons, very much like the ones present in Castelfranco. This discrepancy in the type of wall accessories is due to various altering interventions, similar to the obviously anachronistic merlons on the S. George bastion in Rhodes, where the Turks have replaced the normal thick parapet embrasures.

The structure now houses the Maritime Museum, and the tall building above the entrance is painted in the usual crimson that most Venetian buildings in Greece are painted; we find this color in the barracks, prison and even some private buildings of Corfu, or the ruined house that once included the Rimonti Fountain in Retimo.

The current name comes—like the name Koules in Heraklion—from the Turkish word *firkas*, meaning "military division," since the complex was used as the barracks of the Ottomans as well. It has great national importance, since it was here that, on December 1, 1913, the Greek flag was raised, signaling the union of the autonomous Cretan State (1898–1913) with Greece.

Right behind this complex are the remains of a round tower from the earlier enceinte of Canea. The still-standing portion is quite tall, at some three stories high, towering over the other Venetian military facilities in the fort. Originally, the harbor entrance was protected by a single massive round tower—***torrione***—which is partially preserved and which, judging from its structure, probably dates from the 13th century. Similarly, in Cerines (Cyprus), such a large, round harbor tower still exists.

The Torrione had a very large radius, with thick walls and a thick base. Now only the circular arc is left, pegged to the Venetian barracks inside the fort. On the town side, extensive destruction has been caused by people dismantling it for its stone, and the structure is currently in the same state as it was over a century ago, when Gerola photographed it.

On the interior side the line of buttresses that held the beams of the upper level floor has been preserved. When the new fortifications were built, this Torrione was used as a flanking round artillery tower, with the range of action exactly along the northern curtain. The design called for its inclusion in the new *trace* in a position that allowed it to flank and cover the southern face of the neighboring Gritti bastion.

In the northwest corner of the fortress lies the **Gritti** bastion (San Salvatore/Venier). This bulwark is part of a series of works that were already finished by 1549, which makes it the earliest bastion of the Renaissance Venetian fortifications to be completed. Construction of the bastion began in 1538 under the patronage of Andrea Gritti and Alvise Renier.[13]

The bastion insures communication with the Rivellino del Porto, which incorporated the Genoese tower, and also with the cavalier of San Marco. Also, it was built in a position that allowed it to control the entire northwest coast, in conjunction with the fortified island of S. Teodoro, and to protect the entire western curtain, covering it until the Schiavo bastion, at the next, southwestern, corner of the enceinte. It is the lowest and smallest of the four corner bastions. Its length was 280 ft. on the northern face and 180 ft. in the western face and 95 ft. in the flank. Its height until the cordon was 16 ft.

In the southern flank of the bastion (although not recessed), there is a *piazza-bassa*,

Figure 61. Remains of the Genoese Torrione.

with a circular parapet with four gun embrasures covered by two gun ports located on two levels. This is accessed through a low tunnel, with a gateway with a marble coat of arms. The revetted wall is supported by nine internal buttresses that were revealed during renovation works following the removal of modern intrusions on the bastion.[14]

The cordon exists over the entire western front of the bastioned fortification, and should mark the beginning of the parapet, but this last architectural feature is all but gone, or has been restored or replaced with modern masonry, albeit on a much smaller scale and not for the entire height of its usual shape.

The western curtain, between the Gritti and the Schiavo bastions, is one of the best preserved, although it has lost it parapet and cordon. Above the level where the latter used to exist, the earth that filled the fortifications is now visible.

In front of the access way to the Gritti bastion, from the street Theotokopolou, is a gunpowder magazine—a tall, square building, although its roof was altered by the Turks. Above the Gritti bastion there is a gun platform, the cavalier of **San Marco**, built in 1583, and which covered the sea in conjunction with the harbor defenses, as well as a part of the western side of the fortifications.

This cavalier is very well preserved and accessible right behind the Gritti bastion. The shape of the cavalier is square, 65 ft. on each side. It is accessed by two doors and along the access tunnels. One passageway is located on the curtain, in the southern part of the cavalier, and the other one is located in its northeast corner, and is accessed from the Gritti bastion. One opening in the cavalier is visible on the east side, but virtually inaccessible, since the earth of the terreplein has been removed, and so this door is at the level of the second floor of the adjacent house.

Figure 62. Gritti bastion, with the obtrusive Xenia Hotel (now gone).

Further on, in the middle of the curtain, is the S. Atanasio cavalier, a flat, square structure, similar to the ones built on top of the terreplein of the walls of Famagosta. The scarp of the cavalier is intact and dominates the frame of the western curtain. This was a rectangular cavalier, similar in design to the numerous structures in Famagosta, but integrated in the parapet and not behind it, as in the former cases. The structures in this area, in the middle of the curtain, are in better shape; here the parapet—which was higher anyway, to accommodate the cavalier—is almost entirely preserved. The lower half of the cavalier, where the wall is vertical, is half faced in stone, but the sloped upper half is only earthwork.

On top of the western curtain, private houses have been built, along almost the entire length, up to the cavalier of S. Atanasio. Although at first the terreplein was settled without authorization, the officials stepped in and got involved in managing the area, erecting a wooden fence in lieu of the parapet and even installing electrical poles. A staircase next to the Lando cavalier allows access to the terreplein, and there is an unpaved street running between the houses on the curtain. To return to the city, you must find one of the original stone staircases, which will bring you to the back terrace of a garden restaurant, below the S. Atanasio cavalier.

The upper portion of the ramparts, which is not currently revetted in stone, was so in the past, because the cordon is now at the very end of the scarp. Also, there are a few portions left, in the middle of the western curtain and the Sabbionara bastion, which indicates that indeed, in the past, the stone wall ran higher. Also, like in Candia, and Nicosia, there are no embrasures left visible on the wall and bastions, except for the Rivellino del Porto.

The **Schiavo** bastion is situated at the southwestern corner of the Renaissance fortifications of Canea. The construction of the bastion up to the cordon begun in the late 1540s. The bastion has a flank of 80 ft. and the faces have 300 ft. in the west and 380 ft. in the south.

At both *orecchioni* of the bastion there was a *piazza-bassa*, with vaulted gun ports, like in Candia. At the upper level and at the circumference of the bastion, the parapet is sufficiently preserved, along with the remains of the circular sentry box that existed over the salient. The surface of the Schiavo bastion was evidently repaired after bearing the brunt of the Turkish siege of 1645 and the Venetian siege of 1692. At one place on the revetment of the bastion there were even Turkish inscriptions recording renovation works. Since the '50s, a school has existed on top of the bastion.

To the Schiavo bastion corresponds the **Lando** circular cavalier (completed by the start of the 17th century). The round structure was not a tower, but a huge cavalier, with a diameter of 210 ft.; its stone is there just to hold the mass of earth together and has a winding ramp to allow easy access to the top of the structure, which today still overlooks the ramparts, the old city and even the surrounding new town. An exact replica was situated symmetrically, behind the Santa Lucia bastion in the east, but only about a quarter of the earth mound is still standing and it's difficult to make out in the current city landscape.

The Lando cavalier is huge, a wide cylinder with a radius of 105 ft. and a height of approximately 33 ft. Like the rest of the ramparts, it is faced in stone only halfway up. Building this round gun platform is a peculiar choice, since the normative shape of a cavalier is rectangular. This ingenious solution arose from having at disposal a limited space. The height of the cavalier meant that the best way to reach the top of the platform was to build it round, to allow a circular road to wrap around the structure. The entire southern front of the enclosure presented four square cavaliers, in the shape of those analyzed in Famagosta; one each was supporting the corner bastions and two towered over the Retimiotta platform.

The western and southwestern parts of the walls played a major role in the siege sustained in 1645, and serious bombardment damage was incurred, in the area of the Schiavo bastion and the *piattaforma*, as well as the curtain wall between the Schiavo and Gritti bastions. The damage was repaired hastily, and not in the best manner. Further considerable damage

Figure 63. Lando cavalier, west view.

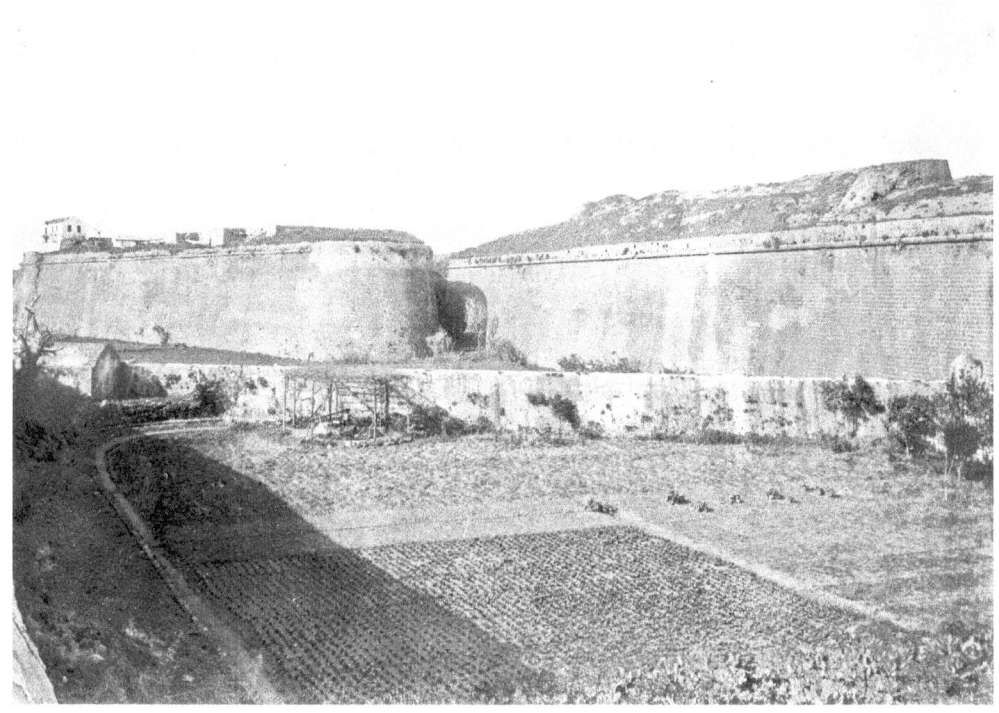

Figure 64. Schiavo bastion and square cavalier (photograph G. Gerola, courtesy Istituto Veneto di Scienze, Lettere ed Arti. All rights reserved).

was caused by the lack of maintenance over the period of Turkish rule, as well as by the Venetian siege of 1692, which was nearly successful.

The main gate, **Porta Retimiotta** (i.e., of Retimo) was also built on the south side of the walls and was constructed of roughly hewn boulders. The internal structure of the gate was rather similar to Porta Reale in Corfu, and Gerola believed its exit was embellished with a large relief of the Marcian lion, coats of arms and ornamental pyramids.[15] The gate was remodeled by the Turks and eventually removed altogether at the start of the 20th century. Next to Porta Retimotta is where the Venetian Aqueduct entered the town. On the east side of the walls Porta Sabbionara was placed, while on the harbor side of the Castello was Porta del Colombo. All gates opened outwards in the middle of the curtain, contrary to the gates of Candia, which opened behind the *orecchioni* of bastions. The main gates into the city were positioned so that they were defended by the nearest bastion.

The *piattaforma* was situated in the middle of the southern curtain. It was a symmetrical structure, with two recessed flanks with *piazza-bassa* and casemated gun ports. The flanks are square, like in the Old Fortress in Corfu, and unlike the bastions here and in Candia. To its right side was the Porta Retimiotta. It was supported by two symmetrical rectangular cavaliers: S. Giovanni to the west and Sta. Maria to the east. The access to the Rettiomoto bastion was done through a beautiful rusticated gate in the back of S. Giovanni cavalier; from here the corridor led to the western *piazza-bassa*, while a tunnel reached its eastern counterpart, and from here the other, symmetrical cavalier, Sta. Maria.

This *piattaforma* was intact in the time of Gerola, since he advertised it as the most ele-

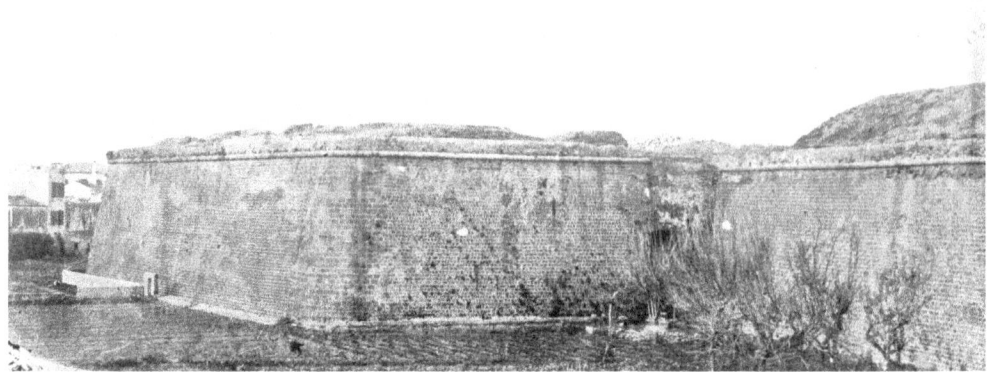

Figure 65. Retimiotta *piattaforma*, with S. Maria cavalier, looking west (photograph G. Gerola, courtesy Istituto Veneto di Scienze, Lettere ed Arti. All rights reserved).

ment suited for study, presenting it as the best preserved in the whole enceinte.[16] Ironically, it was completely demolished at the start of the 20th century to make way for a neoclassical market. Recently, excavations near the current city market have revealed small portions of the base of the scarp and buttresses of its western face.

The bastion of **Santa Lucia** displays a polygonal form, with a parapet above the cordon of the bastion. It had a flank of 90 ft., with faces of 360 ft. on the east and 407 ft. on the south. This bastion was not strafed by cannonades during the 1645 siege, as was his symmetrical counterpart in the southwest corner (Schiavo bastion), although its sentry box, once intact, is now lost.

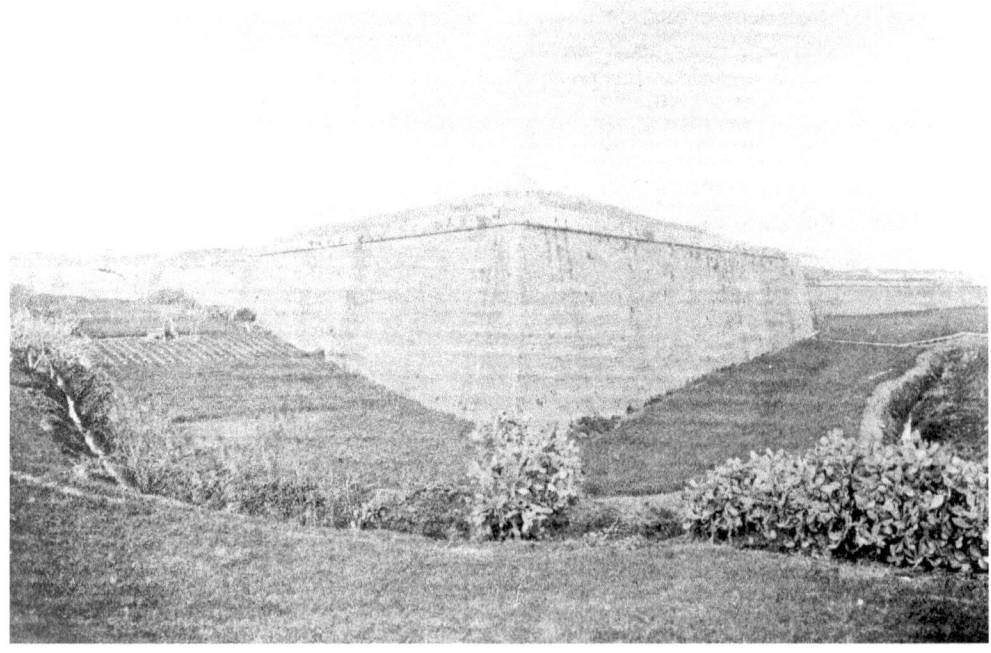

Figure 66. Santa Lucia salient (photograph G. Gerola, courtesy Istituto Veneto di Scienze, Lettere ed Arti. All rights reserved).

Although they might look the same, in fact, the design of the Santa Lucia bastion is slightly different than that of Schiavo: the northern flank is not recessed and the angle between its two faces is quite sharp compared to Schiavo. Parts of the once circular cavalier of Santa Lucia still exist.[17] As seen from the Gerola collection, in this section one could have still observed, at the start of the 20th century, a *strada coperta* (covered way), which formed the first line of defense, about 4.2 ft. lower than the surrounding ground level (since, obviously, it has to accommodate an adult man).[18]

On the terreplein, in the middle of the curtain, was the Sabbionara cavalier, right above the eponymous gate. A square structure, similar to the ones in Famagosta, very little is left of it today, except the stone base outline. Coronelli affirms it is a later Turkish addition, a point observed or assimilated by Gerola and Andrews in their much later researches.

The original **Sabbionara Gate** opened below this cavalier, in the middle of the eastern curtain. The Turks sealed this gate and opened another one, right in the curtain behind the *orecchione* of the bastion. This was most likely an enlargement of an earlier Venetian postern. Currently, the walls were removed between these points, so actually the vaulted chamber of the initial Venetian gate is now visible on the side of the road. You can also observe the scarp and its revetment.

Although this is the only Venetian gate still preserved, Porta Sabbionara was less elaborate, with no significant architectural features; it's just a single-vault corridor, drawn in a straight line, similar to the lesser gates of Nicosia.

The **Sabbionara** bastion, built right up to the sea, is located at the northeastern corner of the Venetian walls. In Canea the sea bastions are irregular, because they follow the terrain

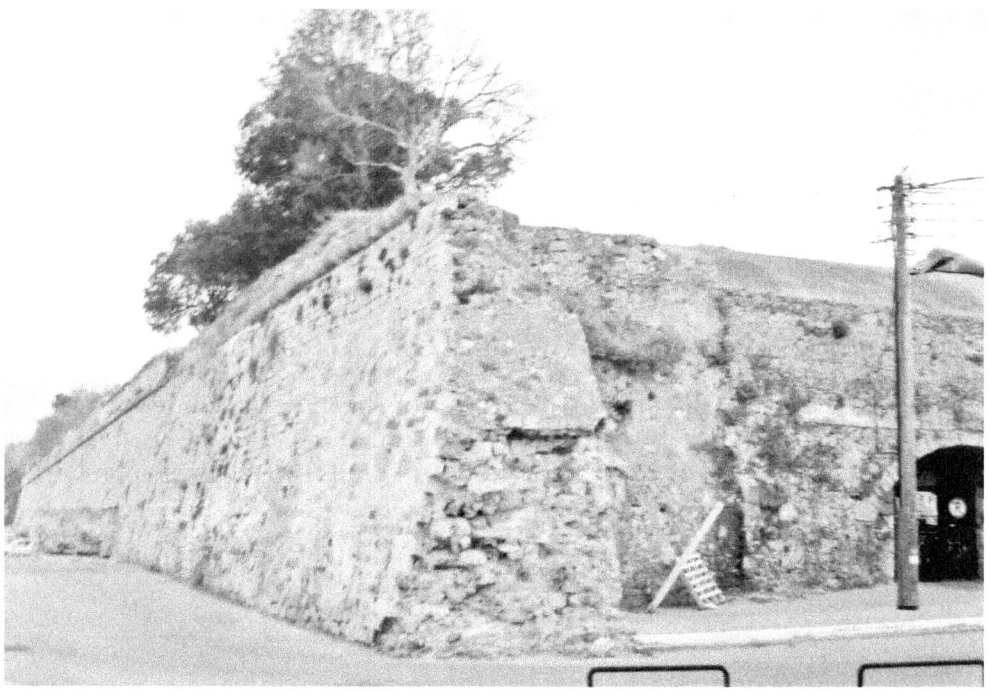

Figure 67. Western curtain, cut right next to the vault of the sealed Sabbionara gate. Note the structure of the wall.

and are built so that they serve both the land and the sea sides. On the land side, their theoretical features are much more recognizable (*orecchioni*, *piazza-basse*), but on the sea side they are simple gun platforms. On the tip of the flank of the bastion there is a round emblem carved in stone showing the lion of S. Marco, one of the few heraldic emblems found on the walls of Canea. The city does not display the variety of stone coats of arms found in Candia, and certainly not the unmatchable wealth of escutcheons of the walls of Rhodes.

The **Michele** ravelin is the eastern counterpart of Rivellino del Porto. This eastern structure, extending the Sabbionara bastion into the sea, is basically a blunt, rectangular gun platform, and three vaulted spaces of the arsenals here were carved into the earth that filled the bastion, which shows that its strategic importance was not deemed too great. Consequently, its size was reduced so that it doesn't even touch the Sabbionara bastion anymore.

The seaward defenses were completed by the **S. Nicolo**, a small triangular redoubt that reinforced the wall of the breakwater, about midway along its length. This tower included a terreplein with embrasures and a paved perimeter path, as well as an inclined access slope.

The Fortifications Today

By the middle of the 19th century the walls had lost their military worthiness and fell into neglect. During the period of international occupation of Crete, barracks and other military installations were built on the ramparts in a number of places, manned by various foreign contingents.

The Venetian fortifications remained virtually unchanged in form throughout the period of Turkish rule. The maintenance of Venetian structures is seen from the fact that the barracks of the Stradioti in Canea, which stretched along the wall between Sta. Lucia and the *piattaforma*, were taken over without alterations by the Janissaries. These barracks had a particularly exquisite lion of S. Marco, mounted on a large marble dedication plate, flanked by columns, as seen from the pictures by Gerola.

At the start of the 20th century, significant sections of the land walls were pulled down to allow greater traffic between the old and new parts of Chania, and the entire defensive structures around the *piattaforma* were torn down to make room for the neoclassical Municipal Market in 1908: the *piattaforma* Retimiotta, and the adjacent cavalier towers of Santa Maria and San Giovanni, and the Porta Retimiotta.

The good thing about the Ottoman lack of consistent involvement in urbanism and their apathy for urban and private development is the lack of interest in remodeling existing structures. Apart from adding the usual minarets to churches, and in the absence of explicit earthquake destruction, there was no extensive remodeling of the urban fabric or individual buildings, which means almost all the Venetian palaces survived till the early 1900s. The *Castello* section of Chania, where the initial medieval town rested, was remodeled beyond recognition in the middle of the 20th century, and now the vast majority of its buildings are modern, while its previous perpendicular main axes were widened.

Starting with the early 20th century, once the city expanded significantly outwards, breaches were made in the northern curtain, in the western curtain wall (between the Schiavo and *piattaforma* bastions), near the Santa Lucia bastion and next to the Porta Sabbionara.

During the 1930s the upper part of the Santa Lucia bastion was pulled down, and the material was used to fill in the ditch. Similar interventions to fill the ditch and turn it into a

road were carried out in the section between the *piattaforma* and Santa Lucia bastions,[19] and in the southern section of the west curtain wall.[20] Shockingly, when a road was cut through the walls, the municipality chose to section along the entire width of the Sta. Lucia bastion, rather than its adjacent curtain, which was half as thick, in a decision as reckless as the sectioning of the tenaille of the Italy curtain in Rhodes. For instance, in Lefkada (Santa Maura), the causeway road goes around the fortress, having the courtesy not to cut through the battery, although that would have made more sense.

More disturbingly, because the lack of municipal authority, unplanned and unlicensed poor suburbs sprang up on the embankments of the western curtain. Just like in Nicosia, buildings were erected on top of the wall along the western curtain. In Chania these are mostly small, one-story, private homes, while the rest of the town's constructions are still under the level of the wall. You can go up the curtain at the Lando cavalier, and you can walk along its length about half the distance; then the only access back into town is over an original stone stairway, which now leaves you on the premises of a restaurant.

During the military dictatorship, vested interests found a way to circumvent sound preservation policies, and were allowed to build the large Xenia Hotel on top of the Gritti bastion,[21] the Asteri cinema in the ditch beside the Schiavo bastion, the Regina cinema beside the Santa Lucia bastion, and the neighboring large Hotel Kriti.[22]

Today, the Venetian harbor accommodates only small craft, while the commercial and passenger port of Chania is located further east in Souda Bay. Of the remaining arsenals, some are used as exhibition and conference halls, but one on the east was still used (as late as 2008) for its original ship-crafting and maintenance purpose, albeit on a lesser scale (on modern small boats, not galleys).

Extensive and accurate restoration works were undertaken, particularly in the last decade, in many areas of the fortified enceinte, particularly the southern curtain, where most modern damage was recorded; also at the Santa Lucia bastion, the Sabbionara bastion, the Lando bastion and the San Nicolo ravelin.

The eastern and western sides of Chania's Venetian fortifications are preserved in reasonably good condition, as is the defensive ditch in front of them. The specific exceptions are the crude openings that have been pierced through the eastern and western walls to allow the passage of traffic.

9

Retimo

Perched on the high rock of the Paleocastro hill, the citadel of Retimo is visible in all its splendor from the highway approaching the town, offering a breathtaking view and a unique scenery.

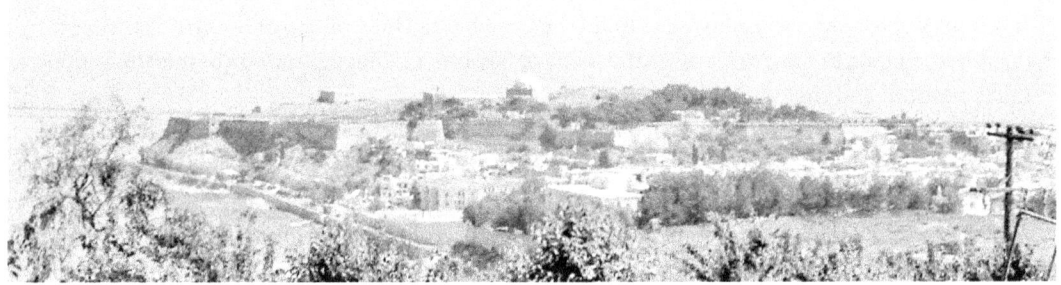

Figure 68. Overview of the citadel of Retimo, from the south.

The settlement of Retimo[1] became a town under Venetian rule. Since the Venetians were dealing mainly with maritime trade, they needed a port on their shipping lanes along the northern coast of Crete, halfway between Canea and Candia. This led to Retimo becoming a city whose expansion required the construction of solid fortifications.

The Town

Venetian houses decorate the streets of the old town of Retimo even to the present day. The influence of Renaissance architecture is most visible in the decoration of doorframes, displaying a rectilinear or semicircular lintel, with tympanum, metope and columns. The entire town abounds of beautiful Renaissance portals, both on churches and on private buildings, a richness not found in Canea or Candia, or the town of Corfu, where the presence of Venice was uninterrupted and its cultural print is stronger than anywhere else among the islands of the Mediterranean. Such magnificent doorframes are now a feature of the former Venetian colonies and are in fact reminiscent of the ones found in Venice itself, more so than even the houses in Vicenza, Padua and Verona.[2] Many buildings have doorframes with Doric

columns or display pilasters with Corinthian capitals and columns with capitals influenced by the Gothic order. Sometimes, there are triangular sides on the semicircular lintels that are ornate with cupids and flower motifs in relief in the crown of the arch.

The churches in Retimo have ornate, imposing portals, better preserved than what remains in Candia or Canea. Many of them present Latin inscriptions and heraldic elements, especially escutcheons. The Church of San Francesco in Retimo was built in 1530, and it has a spacious main nave, with large, arched windows in the clerestory, and a doorway with four staggered Corinthian columns. It also features an auxiliary with cross-ribbed vaulting to the northwest of the main building, and an elaborate, arched stone gate is attached to the east end of the church.[3]

The loggia of Retimo is much smaller than the one in Candia or Corfu and is only one story high. It is situated in the center of the city, along the main road leading from the main gate towards the harbor.[4] The building is from the 16th century and was built according to the plans of the architect Michele Sanmicheli, on a square ground plan with three vaulted sides (excepting the west side). It is built of regular-sized stones and with projections of the cornice. Originally the building was open and had a four-sided roof.

Along the same main thoroughfare, further towards the harbor, the Rimonti fountain has survived. It has four columns, which stand on raised basins, and the water flows from lions' heads; of the three recesses of the fountain, the central one has a rusticated model and a semicircular alcove. It can be seen that the fountain was immured in a larger construction, and photos of the Gerola show it was situated in a vaulted passageway.

In Retimo existed a beautiful clock tower, on the same design used in all the territories of the Republic and which found its greatest form in the clock tower of S. Marco Square in Venice. The presence of a clock tower had an important public purpose and was the civic duty of the Republic to erect one. The clock tower in Retimo was tall, wide and square, very close to the structures in Cherso,[5] Lesina, Udine and Cattaro, and similar to Trau and Zara. The clock was ornamented with zodiac signs, like the one in Paua.[6]

The Land Walls

The town of Retimo started developing around the port and has been fortified since the early 14th century, but the walls were inadequate to protect the settlement during the raid of Barbarossa, in 1538. Immediately after the attack, the town started a project of fortifications with modern walls designed by the ever-present Michele Sanmicheli, during his work on the island.

In Figure 69, in the upper left corner is the large Sta. Barbara bastion, from which the land walls start going west. It is followed by Porta Guora, right in the flank of Santa Veneranda bastion, and the front ends with the Calergi and S. Atanasio bastions.

The city was walled, and these walls ran parallel to the mountains, on a slightly tilted northwest-to-southeast trajectory, in a very straight line,[7] and then they turned sharply to the sea. However, archival and photographic evidence suggest these walls did not form a strong trace; they actually had only one solid bastion, in the southeast corner. This strong bastion, named Sta. Barbara, although twice the size of the bastions of the citadel, was in no way enough to cover the entire front, and two other much smaller gun platforms—located

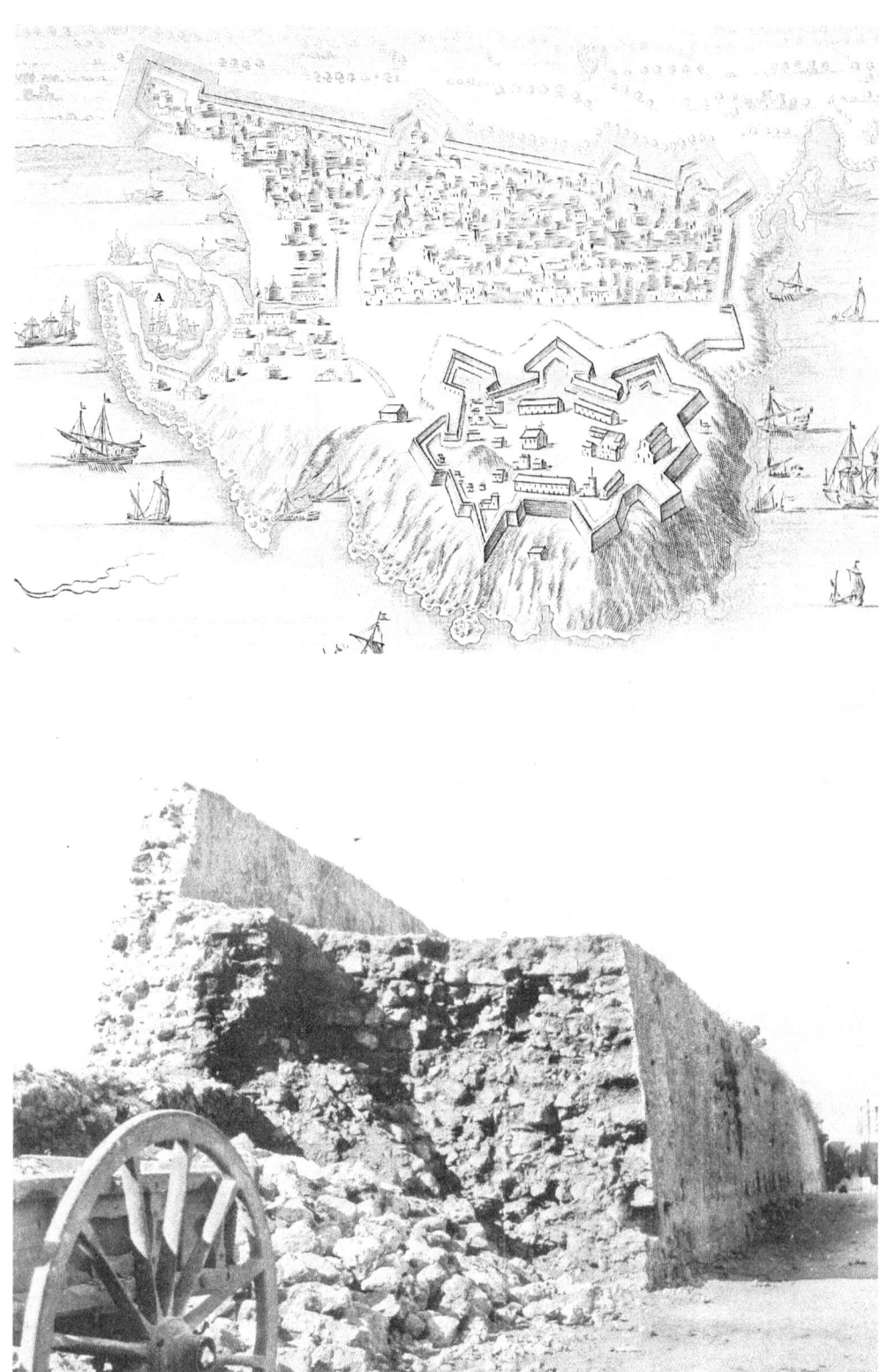

at the opposite corner and in the middle of the walls, next to Porta Guora—were tiny by comparison, and thus inefficient. The front was simply too long—almost one mile—to be covered with just a straight line. And the photo, Figure 70, shows it was rather slim as well.

The fortifications of Retimo had too few bastions, along 13-ft.-thick walls in a straight line, starting from the eastern beach where the bastion of **Sta. Barbara** was located, and ending near the western beach, running along a deep moat. Behind the bastion were the Sta. Barbara barracks, housing personnel manning the land walls (*Quartiere Stradioti*). A few of the vaulted rooms of these barracks still exist, although they are derelict. On a photo by Rahmizade Behaedin entitled *La ville Rethymo: Officiers russes* (1898), the bastion Santa Barbara is prominently featured and the original embrasures on its eastern flank are visible, as well as the southern Ottoman alternations consisting mainly of round merlons, identical to the ones still extant above the main gate in the citadel.

The situation of the other bastions is rather sketchy, with little accurate cartographic evidence, seldom contradicting Venetian sources and virtually no archeological remains. The Turks have added a "bastion" between Sta. Barbara and the beach, which Gerola portrays as a rectangular feature, with no modern flanking capabilities or construction qualities, apart for the sloped scarp.[8] The long land wall was strengthened by two bastions, S. Veneranda bastion and Calergi bastion on the west. Next to the latter there was another small protuberance in the front, making for a sort of flanking platform, as well as the S. Atanasio Gate. These last elements had already been destroyed by 1902 to accommodate the 19th century Turkish barracks.

There was one main gate, opening in the flank of S. Veneranda bastion, named **Porta Guora**. Designed by Michele Sanmicheli, the archway of Porta Guora was crowned with a triangular pediment bearing the symbol of Venice: the Marcian lion. The gate was still in one piece when Gerola photographed it, but now there almost nothing left of its structure with the exception of a stone arch on the town side. From the photos by Gerola, it can be seen that originally this gate was similar in embellishments to the Porta del Colombo in Canea, also lost. Because of its proximity to the central bastion—remodeled by the Turks with merlons—even the records of IVSLA misrepresent it as the actual gate, when, in fact, it is a picture of the Turkish extension of the actual gate, underneath the S. Veneranda bastion.

The defense of the town was weak, since there was no significant protection on the seaside. Indeed, when the pirate Uluj Ali Reis[9] attacked Retimo in 1571 from the sea, he managed to destroy it. Therefore, the Venetians decided to protect the town by building an impressive citadel on the hill of Paleocastro.

The Citadel

The fortress on top of the large seaside rock—which even nowadays the inhabitants call the *fortezza*, in a very Italian manner—was the citadel of the town of Retimo and one of the largest citadels of the Venetian Empire.

Opposite, top: **Figure 69. Olfert Dapper, *Vesting van Retimo*, 1702 (courtesy the Ministry of Culture and Tourism, Biblioteca Nazionale Marciana Venezia. All rights reserved).**
Opposite, bottom: **Figure 70. The curtain wall being demolished between Sta. Barbara and S. Veneranda bastions (photograph G. Gerola, courtesy Istituto Veneto di Scienze, Lettere ed Arti. All rights reserved).**

The *fortezza* of Retimo was built between 1573 and 1578, using the plans of the architect Sforza Pallavicini. After a number of modifications, the fortress was finally completed in 1593, when the cannon ports and parapets were finished.[10]

Covering the entire hill, its size was meant to accommodate the entire population of the town, although not necessarily in comfortable conditions. Even with the urban figures of the time, it looks as though the area of the fortress couldn't possibly have housed the entire old town.

Because the trace of the new, bastioned defense work had to follow the profile of the hilltop, the new fortification had shortcomings, such as the narrow flanks of the four bastions that protected the landward side. The general draft of the fortress provided a polygonal ground plan, including bastions, while the walls were wider and inclined. Due to the morphology of the land only four bastions could be built, towards the south, while the north wall formed three salients and one bastion.

The whole western half of the citadel is barren, which allows a view of the buildings inside from afar. Previously, the whole area was heavily built, and the fortress was inhabited, mostly by squatters, up until the Second World War. Afterwards, a program of sanitization was put in place, which, besides evicting the people living in the monument, also destroyed the buildings deemed irrecoverable, which, by that time, meant the vast majority. With a proper restoration program in place, possibly many or all of them could have been salvaged. But at that time, even if concern existed for preserving the past, it was done in a manner sometimes unprofessional. And so, to relive the beauty of the Venetian town we must rely, once again, on the photos by Giuseppe Gerola.

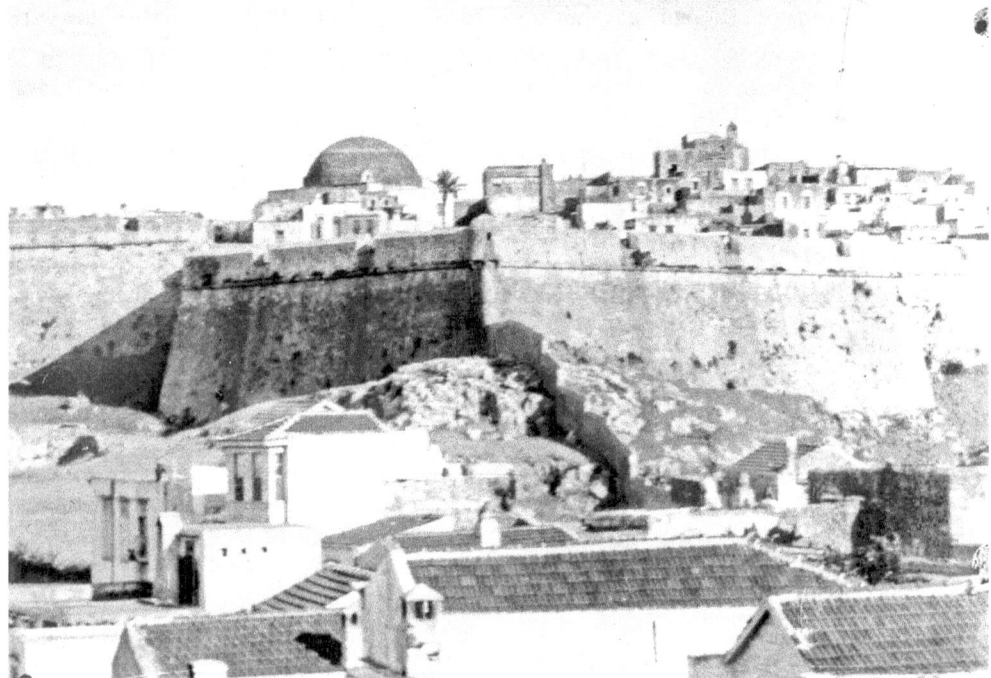

Figure 71. Bastion of S. Paolo, with many buildings in the background (photograph G. Gerola, courtesy Istituto Veneto di Scienze, Lettere ed Arti. All rights reserved).

The main buildings still standing are very visible from far away, because the hill is convex and now quite barren, and so the walls cover only the descent of the slope. Among such buildings, towering behind the walls, are the residences of Venetian high officials and the church of San Nicolo (later turned into a mosque). Public buildings were situated at a distance from the wall and a square formed the center of the locations.

The Catholic see was transformed during the Turkish occupation into the mosque of Sultan Ibrahim, by the addition of a large, semicircular dome and a minaret at the entrance. West of the central square and opposite the cathedral, the city governor's residential premises were built, part of which have been preserved until today. There is also the small S. Demetrius church, behind the S. Nicolo bastion.

Situated on a peninsula, the hill is easily defensible, since two sides (the northern and the western) fall on rocky outcrops jutting from the sea. Here, the architects followed the morphology of the rock and just built salients to cover the entire rim, but, otherwise, the works are not very sophisticated. An attack from troops jumping from galleys to climb a steep and barren rock (particularly so on the north side) was obviously not to be expected. Venice had the good habit of preferring locations situated on peninsulas—as in Zara, Modon, Corfu, Navarino, and Napoli di Romania—for obvious defensive reasons. However, in this case, the walls are quite low, when compared with the citadels of Cerines or Corfu.

The fortress is built on solid rock, making the normal siege sapping process impracticable. Given this and the town's exposure to coordinated pirate attack (like the one in 1571 that destroyed the old town), the Venetian were expecting the walls to resist a rather medieval siege, with assailants relying on numbers to scale the wall, rather than on a protracted artillery siege. This also explains the number and position of bastions.

In a map by Olfert Dapper, *Vesting van Retimo* (1702),[11] the citadel, from the main gate, in the east, counterclockwise, presents the following features (read down, then across):

- Main gate
- San Nicolo/San Salvatore bastion
- San Teodoro/San Sozo salient
- Santa Giustina/Madonna salient
- Santo Spirito salient
- Secondary (western) gate
- San Luca bastion and cavalier
- Santa Elia bastion
- San Paolo/Santa Maria bastion

The walls are vertical, with hardly any slope, except in the salient of the bastions, but this is not as marked as in Nicosia or Candia. Like in Canea, the sea walls on the western front are flat, with few other defensive features. A more bastion-like structure does exist in the middle of the western walls, and two large gun ports point towards the south, covering a secondary gateway. All that remains of these structures are the arched openings and a winding, cobbled road leading down to a small gate, now barred.

The perimeter of the citadel is 4,265 ft. The main gate is located between the bastions of S. Paolo (south) and S. Nicolo (north). From the main gate, clockwise, the front is formed by S. Paolo bastion, Sta. Elia bastion, S. Luca bastion, S. Luca cavalier, Santo Spirito salient, Sta. Giustina salient, S. Salvatore salient and S. Nicolo bastion.

The gate is a typical Renaissance archway protected by a circular sentry-box just over the arch, and a slab for a dedication. Unfortunately the Venetian coat of arms over the gate no longer exists. The sturdy inner door opens onto a long, cobbled, barrel-vaulted corridor.

The curtain above the main entrance to the fortress was remodeled by the Ottomans, who added their characteristic round merlons. The expected gun embrasures were replaced by the Turks with these medieval architectural elements, just like on the S. George bastion in Rhodes or above the new land gate they cut in Famagosta.

The entrance is through a corridor, built almost in a straight line, just a bit turned to the south, but nothing as complex as the entrance of the Castello del Molo in Candia or the citadel in Cerines, both structures with similar functions. Such entrances, in anything but a straight line, have been discovered since ancient times to make specifically difficult the access of the enemy through such a corridor. Even posterns, such as in Corfu (between Sarandario and Sei Venti bastions), or in Rhodes (underneath the Provence curtain) are very curved.

This gate consists of a gallery that ends in two arched recesses, which led to area used as guardrooms. The first building encountered once inside is the artillery magazine, a large, two-story construction, with four arched openings on the ground floor.

The southern and eastern sides of the citadel feature four strong bastions, built with one straight flank, while the other flank is recessed and features a rounded *orecchione*. The designers over-fortified the front: the bastions are so close (200–250 ft. apart) that flanking fire could not have been brought to bear with cannons; it was more likely with firearms (muskets or arquebuses), otherwise a shot from one bastion could only be used for enfilade fire.

Usually, the rule observed was that the flat flank was opposed by the *orecchione* of the supporting bastion, and this is true in two situations: the recessed flank of the S. Luca demi-bastion covers the flat side of Sta. Elia, and the *orecchione* of S. Nicolo protects the gate of the citadel and the flank of S. Paolo. The area deemed most likely to sustain a land siege was more

Figure 72. Sta. Elia and S. Paolo bastions (photograph G. Gerola, courtesy Istituto Veneto di Scienze, Lettere ed Arti. All rights reserved).

defended, and so the curtain between S. Paolo and Sta. Elia is covered by their respective *orecchioni*.

Although up close it might be difficult to observe, from afar it's clear that Sta. Elia, in the middle of the land front of the walls, is lower than S. Luca. It is likely that cannons from the cavalier of S. Luca could fire over the neighboring bastion. In fact, the curtain between all four bastions is roughly the size of just another of these bastions. This creates a very crowded bastioned fortification; the same defense, line of fire and number of guns to bear could have been achieved with one round artillery tower instead of the Sta. Elia bastion.

The recessed flanks have no *piazza-bassa*, but on the bastion's parapet there are gun ports. Thus, because of the height difference, the gun in the flanks of S. Luca, on a lower tier than the top level, could fire right over the parapet of Sta. Elia. The flanks also have arrow slits above the gun ports.

Above the S. Luca bastion is the eponymous cavalier—a large, square structure, covering almost the entire bastion. It has been visibly restored in recent years. A long, straight ramp, similar to the one of S. Andrea in Candia, or Martinengo in Famagosta, allows access to the top of the platform. Large access doors open on the ground level, where there are two rooms, with several windows, few of which retain all of their original features.

Figure 73. S. Luca cavalier.

The cordon runs over almost the entire perimeter, and the parapet above it has embrasures, but also arrow slits and ports for small, personal firearms. The positioning and number of bastions, as well as the abundance of ports for personal weapons, indicates the architects were preparing for a close combat siege, and not one in which the curtain was breached before engaging directly.

The walls are 16–20 ft. high. The parapet is rather narrow, especially when compared with the normal Venetian Renaissance fortifications in Crete and elsewhere, where they are much wider, but more shallow. The main reason was that the parapet in Retimo had to accommodate the use of individual weapons. Even the personal firearms of that age, with their long barrels, could not be used through wide walls such as those in Famagosta or Valletta.

One remarkable feature of this fortification is the presence of sentry-boxes, and in large

number as well. Among the other Venetian defenses covered in this research none have retained so many sentry-boxes, not even in fortresses not ravaged by war or by the neglect of their owners. These guard posts are plain (not ornate like the famous Gardjola of Senglea), but a simple cylinder capped with a round dome and small windows, showing their position in the line of fire. Again, in the case of the sentry boxes in Valletta or Senglea, their purpose was more civic than military, since their windows are large and wide, improper as observation points in the case of an actual enemy siege.

There are nine guardrooms in Retimo, situated on the bastions and the salients on the north side—except the S. Nicolo bastion, whose guardrooms are placed on the tip of

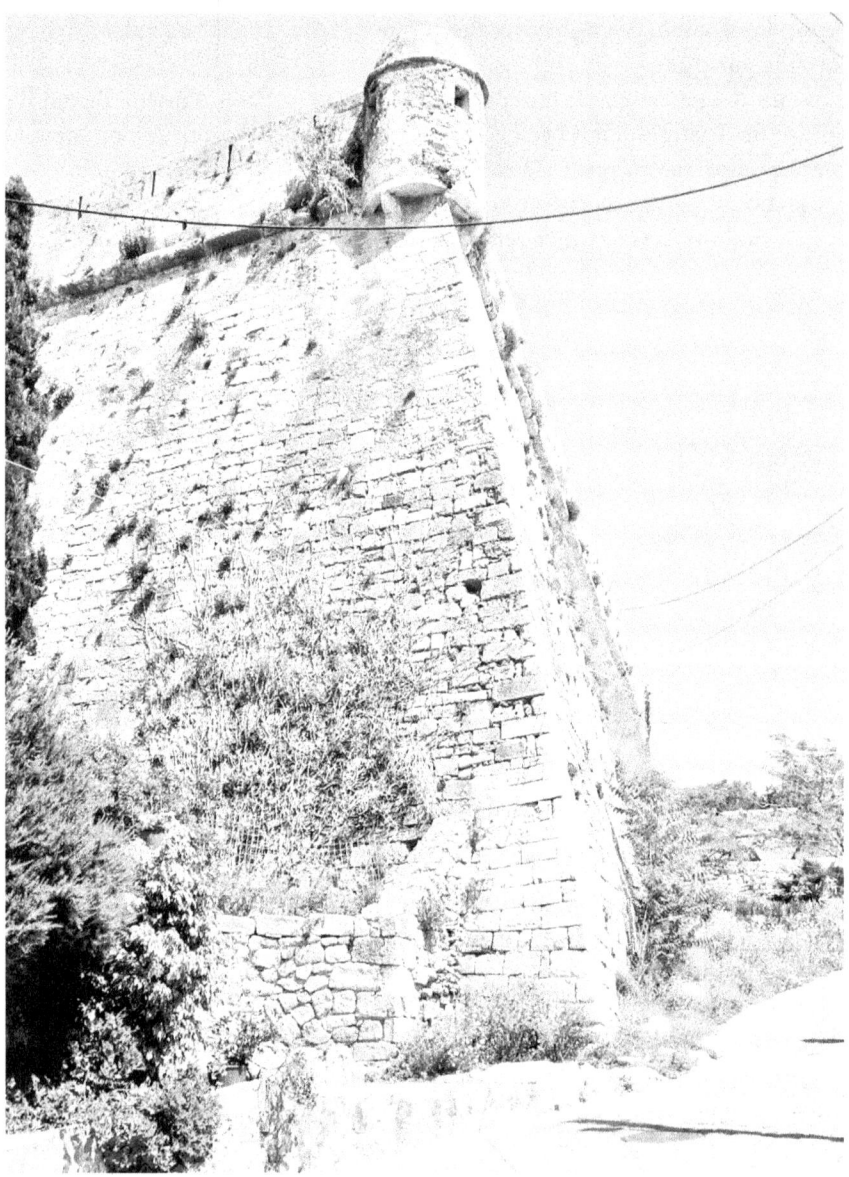

Figure 74. Salient of S. Paolo bastion, with sentry box.

the face of the bastions. The sentry boxes are immured in the parapet for the entire height, up to the dome, unlike their west Mediterranean counterparts.

The citadel of Retimo also features a gunpowder magazine as an architectural element. At the start of the 20th century all of the major Venetian bastioned forts in Crete had such magazines, in abundance, as the photos by Gerola prove. However, all but this one and another one in Canea (near the entrance to the Gritti bastion) were dismantled over time, and this standard structure for Venetian Candia—a cubic stone room, topped with a pyramidal stone roof—became almost extinct. Other magazines, in Corfu, for instance, have different shapes, as we will see later on.

The gun ports on the northern, seaward wall are more rudimentary, most likely from an earlier period than the land walls. There are almost no arrow slits on the sea side, and very few embrasures for serious artillery. This part of the fortress presents, however, a well preserved wall-walk, 3.3 ft. high. On this front, there is another auxiliary port, on the north side, by the sea, in the middle of the curtain between the S. Giustina and S. Salvatore salients.

The small gun ports are reminiscent of the ones found all over Rhodes. As already discussed, firearms are most suitable for use in the flanks of the bastions in Retimo, since the neighboring structures are quite close. Mostly hand guns are suitable for flanking and defending the curtain. The embrasures for cannons are all on the curtain and thus looking towards the town. The S. Paolo bastion has a gun port directly covering the gate, but its height is significantly less than that of the curtain and the S. Nicolo bastion.

We find gun embrasures again from the San Salvatore salient to the main gate, including on the S. Nicolo bastion, which is expected, since this side faced the land. The area around the fortress was cleared to form a glacis, so from here to the Venetian port there was open

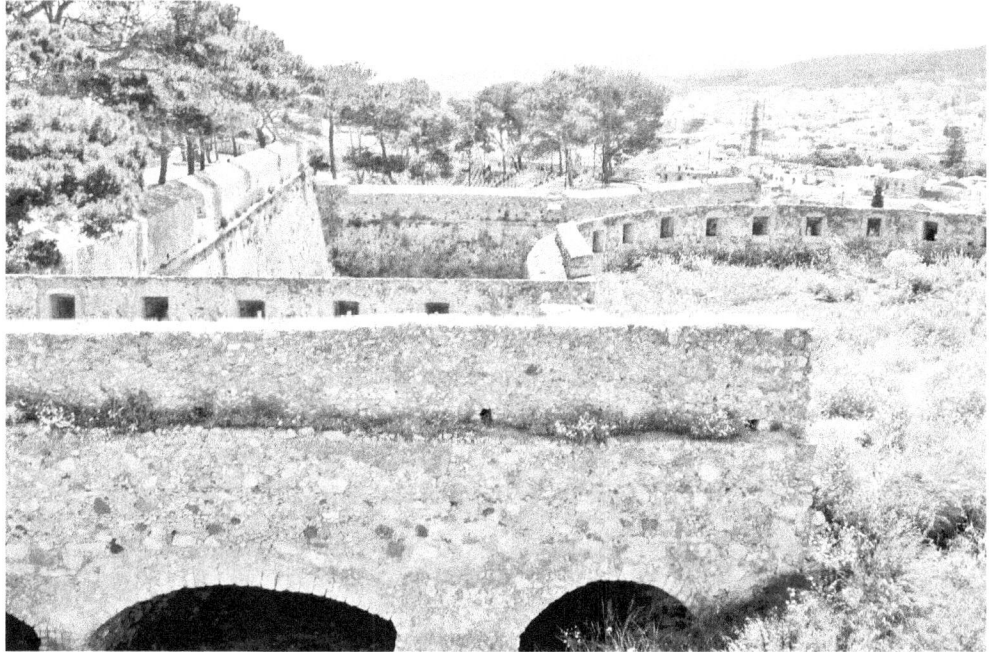

Figure 75. On top of S. Luca bastion, looking towards Sta. Elia. Vaulted casemates of the *piazza-bassa* in the foreground.

space in the 17th century, as only a few rows of houses were ranged around the harbor. On the south side, however, the glacis was rather small.

There is no ditch, not even on the port side, where the entrance is, so there is no drawbridge. Contrary to the current situation, when constructed, the citadel did have a lot of free space on the town side and the harbor side, as the historical maps show.[12]

In front of the gate, the Turks built a pentagonal fort, showcasing their signature merlons. It was supposed to act like a ravelin, meant to guard the access to the citadel, covering the approach to the main gate from the east. However, its features are clumsy and its base too wide, so that fire from the flanks of S. Nicolo and S. Paolo could not avoid this structure, and it could hardly be covered even by fire from the faces of the said bastions. Today it houses the Archaeological Museum of Retymnon.

The Fortifications Today

Today, the citadel is almost empty, much just like Methoni in the south of the Peloponessus, but archival photographs taken by Giuseppe Gerola reveal it was heavily built, with streets, living quarters and various domestic structures. These were demolished after World War II, and only the most solid and complete buildings were left standing, although almost all the others had a similar archeological and historical significance.

In the town, the extension of the built area towards the south led to the almost complete disappearance of the landward walls and the small ditch surrounding them. The size of the wall and its moat are identifiable today, because two close, parallel streets sprung where the fortification stood.[13]

Overall, the island of Crete was a solid territory among the lands of the Serenissima, and the imprint the Venetians left during their many centuries in these parts was so strong that not even time or adversity could undo this architectural heritage.

PART IV. THE ISLAND OF CORFU

The island of Corfu was the key to the Adriatic Sea and to the maritime dominion of the Serenissima. Its crucial nature became especially clear after the definitive loss of Crete in 1669. Corfu played a decisive role in the overall strategy and in the organization of the entire Venetian dominion, which relied on Corfu for command of the seas, just as it relied on the fortifications of Verona for command of the land.

Corfu always had a pivotal importance from a commercial and geopolitical point of view. As such, it was coveted by the nations of the Adriatic as a stepping stone between east and west, north and south. Under the natural sovereignty of the Eastern Roman Empire, it became the target of Norman attention, as a springboard for their drive east in 1085. After a brief recovery by the Byzantines, once the Fourth Crusade partitioned their possessions and established Frankokratia (the rule of the Franks), the island passed to kingdom of Naples (the heir of the Norman state in Mezzogiorno, which also shared its political ambitions). Involvement of the Byzantine despotate of Epirus in the 13th century couldn't stop Naples from establishing itself on the island, as well as in Morea, where the Clermont castle/Castel Tornese[1] was built to guard the capital of the Principality of Achaia at Andreville[2] and the port of Glarenza[3] (now ruined and submerged).

The Venetians' possession of the island began in 1386, when they took it over from the Neapolitans. They concentrated the defense of the island on the chief town, where they employed successive modernization programs that circled it with structures in the style of *fortificazione alla moderna*. Over the next centuries, Corfu suffered several Ottoman sieges, defeated due to the presence of massive fortifications; however, this didn't stop the Turks' going on rampage in the hinterland, looting and destroying the cultivated land, and enslaving the population (such as in the devastating raid of 1537).

The Venetian administration of the island was ensured by a *bailo*, in charge of judicial accountability and financial affairs and also responsible for the defense of the territory. From the 16th century onwards, in Corfu the headquarters of the *provveditore generale da mar* were established—a position with extended powers over all islands under Venetian administration forming the *Stato da Mar* (Adriatic, Ionian, and Aegean seas).

After the end of the War of Candia and the final loss of the respective island, Corfu became the most important strategic and commercial possession of the Serenissima. The period immediately after the war with Turkey was marked by the improvement of the defensive structures of the island. Previous proposals by architects Filippo

Verneda and Ferrante Vitelli were taken up, after 1718, by Johann Matthias von Schulenburg, commander of the Venetian land forces.[4] He supervised the building of the further line of defense around the capital Corfu, with two large forts on the Salvatore and Abraham hills, and San Rocco ravelin between them. Also, in 1728, he proposed to the Venetian Senate the establishment of a military school on the island, with the purpose of improving the militia's military training in manning the fortifications.[5] Due to these Venetian defensive efforts, Corfu was the largest and most important territory in the classical Greek world never under Ottoman rule (along with the majority of the Ionian islands).

When the French dissolved the Republic of Venice in 1797, they took over all its possessions, in Istria, Dalmatia, Albania and the Ionian islands, including Corfu. However, the same atheist policies that had alienated the population of Malta eclipsed in Corfu any other possible enlightened traits of the French reforms in politics and administration. The idealism of lofty principles was arrogantly considered universal, in blatant disregard of people's needs in the pursuit of their happiness.

The European powers mobilized and—in the rarest example of cooperation between Russia and the Porte—their combined forces drove the French off in 1799, establishing a semi-autonomous state: the Septinsular Republic (1800–1807). The Franco-Russian reconciliation after the peace of Tilsit brought the Ionian Islands again under French rule (1807–1814). Finally, the British established their protectorate on Corfu and the other islands, creating in 1815 the United States of the Ionian Islands, the first modern Greek state, even before the revolution of 1821. Eventually the British left and allowed the union of the Heptanese islands with the Greek kingdom, in 1863.[6]

The Defenses of the Island

Unlike Cyprus and Crete, all the significant defenses of the island were gathered in the capital, mainly because it was the only major city, the other localities being of lesser magnitude and importance, as either trading ports or manufacturing and agricultural centers.

As such, apart from Corfu town, there are few other fortresses; those that exist are very medieval, with Byzantine, Angevin and some later Venetian additions. Their purpose is feudal: to serve as defenses for a regional administrative unit, and to offer sanctuary for the local population in case of attack.[7]

Castello Sant'Angelo[8] is the name of an originally Byzantine castle north of Paleokastritsa, perched on the hilltop of a peninsula, built in the 13th century by Michael II, despot of Epirus. The castle had been chosen to protect the local population from enemy attacks, as happened in 1571 when the Turks led an unsuccessful assault against it. In the 17th century, a larger, more modern enclosure was added, but its earthworks added not much more than a thicker, longer curtain around a lower ward.

The **Gardichi**[9] fortress is situated in the south of Corfu island, and is also linked to the period of the Epirote rule on the island (1214–1267). It is octagonal, with eight towers and three gates, as well as various typical medieval features. Today, quite little remains, only parts of one of the towers and of the external walls.

Other ruins exist in **Cassoppo**,[10] from the same medieval period, the location having

Figure 76. Southwest view of the Dandolo fortified country house.

been virtually abandoned by the Venetians, especially after being destroyed during the Turkish raid of 1571 on the island of Corfu. The ruins include parts of the walls, towers, and a gate.[11]

But the most interesting defensive structure of the Renaissance in the countryside is the **Dandolo** tower, at 39.47' north, 19.49' east, in the olive plantations south of Acharavi and down from the old Venetian village of Perithia. The structure is a keep, part of a fortified manor built in the center of olive harvesting and production capabilities. This discovery by the author, in the middle of forests on the hills leading up the mountains, is not yet properly documented elsewhere.[12]

The complex includes the ruins of a rectangular enclosure, with an artificial slope on three sides. The yard is now overrun by trees, but by the gate (of which only the right half

remains, with its *oculi*) there is a small single-nave church, with doorframes and window frames with keystones. While the church is intact and painted white, next to it are the ruins of long storage facilities, with three halls, of which only the vertical walls remain. To the north of the enceinte is the fortified house, a three-floor keep, with windows only on the upper two. The walls are thicker on the ground floor and sloping, and the chambers on the bottom floor are barrel vaulted.

A stone cordon marks the top of the first floor and another one the start of the roof. Only the vertical walls are standing, but the square tower has a separating wall going south-north. From the top of the keep, the sea around the small bay of Acharavi would have been visible.

As we have seen, there were many such country manors in Crete, as documented by Giuseppe Gerola in his explorations of 1900–02, but no other is documented for the island of Corfu.

10

Corfu

The town of Corfu is a virtual open-air museum of an 18th century Venetian town. Narrow streets, multi-storied houses, balconies, stone stairs, arches, wooden ceilings, and porticated ground floors, create a distinctly Italian feeling. There are climbing streets with staircases running the entire width. Some distinctly Venetian buildings have small, sculpted heads adorning the arches of the ground floor. There is even an exquisitely imposing tall building,[1] where the arches are raised two stories high.

Many baroque churches exist in the old town, particularly in the Spilia and Campielo areas, between the Old and New fortresses and close to the Venetian harbor—the densest area of urban sprawl in the 17th century. Here, the entire neighborhood looks very Italian, with many narrow and winding roads and tall, 4–5 story buildings. The tall houses are built of local stone and have wooden attics and handmade tiles.

There are in fact different corresponding areas for the "old town": the initial medieval core settlement was located inside the perimeter of the Old Fortress, while what is currently known as the old town is in fact the zone settled and walled in the 16th–17th centuries. Thus the historical perimeter of Corfu can be split in the area of the Old Fortress and the New Walls (crowned by the New Fortress) surrounding the late Renaissance conurbation.

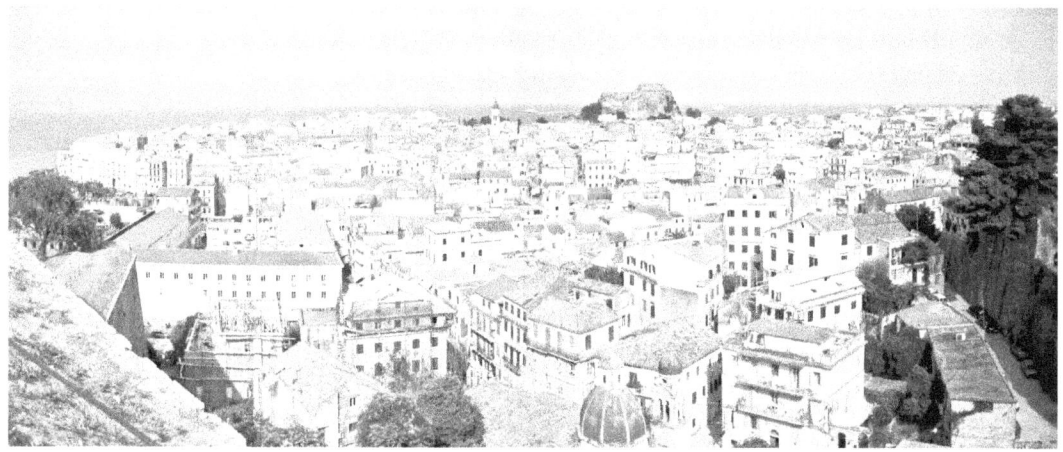

Figure 77. View of Spilia and Campiello neighborhoods from the New Fortress. The twin peaks of the Old Fortress are in the background.

What now is called the Old Fortress is in fact the old town of Corfu. Initially, in the Middle Ages, the town developed on the peninsula, which was centuries later artificially separated from the mainland by digging a wide moat, to form the isle of the Old Fortress.

From ancient times to the 6th century the intitial town of Corfu was situated on the Kanoni peninsula, but it was destroyed by invaders and the locals decided to rebuild it on the peninsula that today is the islet of the Old Fortress. In the 16th century, when the town expanded enough to require a new enclosure, a new line of fortifications was built, which included the large New Fortress complex. Subsequently the harbor was moved in the shadow of the huge 150-ft.-high New Fortress, and the administrative and religious buildings soon followed.

With the displacement of important public buildings from the Old Fortress, the enclosure remained largely void of its original purpose. Next the British came and cleared the area on the south of the fort, leaving the surface as empty as we see it today, while the Venetian structures on the west and north sides were removed around the middle of the 20th century.

On the land side most historical monuments have survived, dating from the 16th century onwards. Among the porticated buildings is the Liston, a wonderful relic of the short period of French suzerainty over the island. The name of this building is however quite Italian, similar to other such places in various towns in the mainland Venetian realm (such as Padua and Verona). The Liston of Corfu was erected by Matthieu de Lesseps, father of the builder of the Suez canal. Close to it, at the end of Spianata Square, is the Royal Palace of Corfu (S. Michael and S. George Palace), built in 1820 by the British governor G. Whithmore—a rare example of Georgian architecture in the Eastern Mediterranean.

The Lodge of the Nobles is now the Town Hall. The construction of the **loggia** began in 1663, and in 1720 the building became the theatre S. Giacomo. On the façade and on the back wall, there are stone decorations representing masks, escutcheons and other symbols, such as the emblem of the island (a boat). On the right side of the building is the bust of Doge Francesco Morosini, in an allegory of his exploits, and surrounded by four cherubs, symbolizing virtues. The loggia in Corfu is less imposing than the grand loggia of Candia, as it is only one story high, but is more robust than the loggia in Retimo.

Next to it, in the same square, the Catholic **cathedral of San Giacomo** was relocated in the 17th century (previously the Doumo was located in the Old Fortress, between the two rocky peaks, where the British Hospital now stands). With the expansion of the town and under the security provided by the new fortified enclosure, many important buildings, both administrative and religious, moved into the new city.

Another important Venetian church is **Sta. Annunziata**, dating from the middle of the 14th century, where the fallen of the climactic Lepanto battle were buried. Sadly, the large nave was destroyed by aerial bombing during World War II, but the beautiful crenellated tower still stands, along with the left quarter of the front portal, with a remarkable plaque with military paraphernalia in vertical bands, flanking a large drape and a dedication (now lost). The bell tower features the Italian sparrow-tail merlons. A similar square bell tower once stood next to the cathedral of San Marco in Candia, but it was demolished by the Ottomans.

The beautiful Baroque church of Sta. Maria del Rosario (Madonna del Tenedo), the church of the military personnel, is situated immediately below the battery of the New Fortress. It is a robust structure, with a dome over the nave, and a round emblem with the lion of S. Marco over the baroque doorway.

Several important military Venetian buildings are still standing in Corfu, such as the Grimani Barracks (now the Ionian Academy), the prison (in the Old Fortress), and the Spilia Barracks (now a bank).[2]

The public architecture is completed by the statue of Schulenburg (near the Old Fortress) and the bust of Morosini—examples of preserving the imagery of commanders from the ranks of previous rulers of the town. The reason these Venetian statues still stand is that the townsfolk associate them with the common cause of defending the town, regardless of nation or allegiance. There are also three Venetian ornated fountains, in the Campielo, Spianata Square and the Old Fortress.

Tangible Venetian heritage can be seen in place names such as Spilia, San Rocco and Campiello, which have survived the centuries (and in the latter's case is directly reminiscent of the organization of the mother city itself). Venice is made up of a myriad of *campi* and *campielli*, small squares, many times centered on a church, and surrounded by tall residential buildings.[3]

The old town of Corfu had three gates on the Old Fortress and four piercing the New Walls. On the artificial island still exist the main gate into the fortified enclosure, and the Mandrachio and the Soranza gates on the north side, towards the initial harbor. The Soranza gate is now walled, but it was the original entry point into the city, before the modernization works of Sanmicheli.

In the New Walls there was an access way behind the flank of the southern bastion called the Raimonda Gate, followed in the center of the walls by the principal and exquisitely beautiful Porta Reale. In the north lay the harbor gate—Porta di Spilia—and further along the coast the small San Nicolo Gate. These last two still exist today.

The main gate, Porta Reale, was built in 1575–1578 on plans by Sanmicheli and was the main port of entry of the town; it was destroyed in 1893 to make way for a new road. The design of the Porta Reale was quite reminiscent of Porta di Terraferma (the main gate) of Zara. The thoroughfare between Porta Reale and the main gate of the Old Fortress has been the same for almost four centuries.

The San Nicolo Gate is placed under the level of the northern coast road, and it is just a simple exit tunnel like the remains of S. Giorgio or Dermata gates in Candia, leading to a narrow strip of beach.

The Spilia gate is a huge, five-story building, with typical Renaissance lintels on the doorways. The gate has a large doorway, rusticated, and two smaller entrances to its side. However, on the harbor side, one of these door has been closed and plastered over.

During the very last years of Venetian rule (1795) there was a proposal to convert the area of the gate, barracks and harbor of Spilia.[4] This idea called for the filling the area with earth from the harbor and building a new section of walls in the center of it (in fact, today that area is indeed filled and organized as an open space and parking lot). In the middle of the walls would have been a new, modern bastion and beside the bastion there would have been a new gate.

While the town counted on the Mandrachio and later on the larger Spilia harbor, the naval arsenals were not situated in the capital city, but close by, to the north, along the coast. Corfu town did not have terrain sloping gradually into the sea, so it was not suitable for building shipyards, this being particularly true in the early part of the settlement (the Old Fortress).

Figure 78. View of the building of the Spilia Gate, town side.

The closest sheltering bay was Govino,[5] so the large fleets stationed in Corfu to guard the Adriatic were anchored there, in the 18th century. After the siege of 1716, it was also decided that a shipyard would be built in Govino, guarded by the small fort Scarpa. The shipyard had three berths, of which the stone arches and pillars are still standing, and a gate with an inscription dating close to the end of Venetian rule, in 1778.

Next to the Spilia Gate is the large complex of the Venetian Spilia barracks and military hospital, a long, L-shaped, three-story building, which served as headquarters for the troops manning the northern section of the fortification, including the large New Fortress complex, Sarandario bastion and the outer forts.

On the other side of the old town, there were the other Venetian barracks about half the size, serving the southern part of the fortifications. The Grimani Barracks date back to 18th century, and in 1824 became the seat of the Ionian Academy. This structure is a long, four-story building, with an entrance on the first floor, accessed by two symmetrical staircases, joined over the entrance to the ground floor and displaying the lion of S. Marco. The first segment of the edifice is now five stories high, the last one being a subsequent addition.

Figure 79 shows the consecutive phases of development of the fortifications of Corfu, starting with the defenses of the Old Fortress, the large Spianata glacis in front of them, the new walls with the New Fortress on the far side and the outworks in front of them. At the far left is represented a proposal for the inclusion of the forward hills of Savior and Abraham in the enceinte—and not the solution eventually adopted, which was stronger and more focused.

10—Corfu

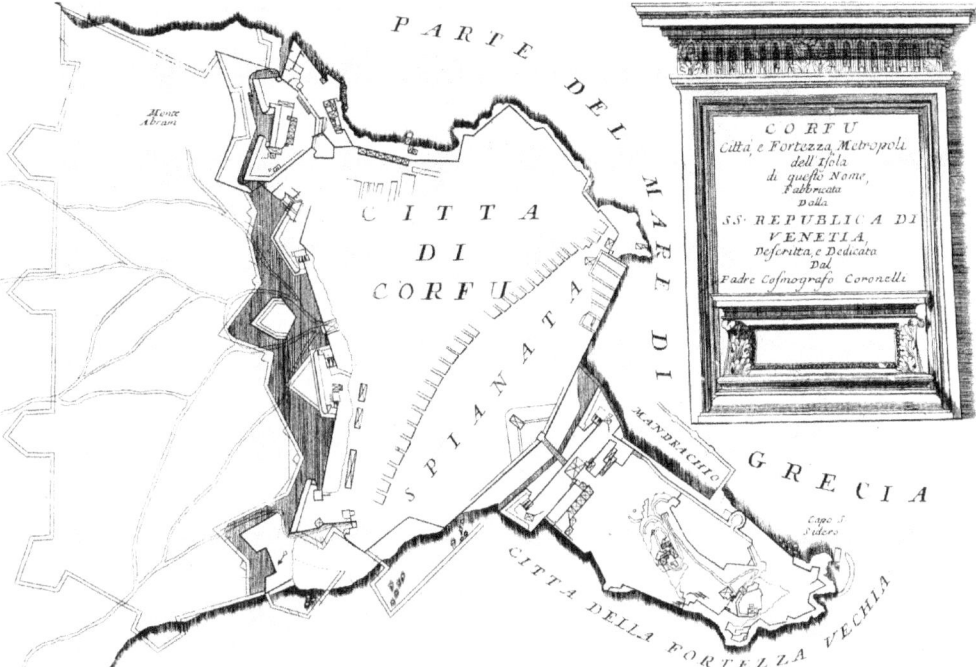

Figure 79. Vincenzo Coronelli, *Corfù, Città e Fortezza*, 1689 (courtesy the Ministry of Culture and Tourism, Biblioteca Nazionale Marciana Venezia. All rights reserved).

Even if the round artillery towers of the peninsula of the Old Fortress had repelled the assailants in 1537, they would have to have been replaced with newer bastions (1557); later in the century the construction of the New Fortress started, along with the organization of the great square of Spianata, as a glacis. The defenses of the town of Corfu in the Venetian era were built in successive phases:

- Phase 1—modernization of fortifications on the two peaks and three round towers on the land side (1506–1532)
- Phase 2—replacement of the three round towers on the land side with two bastions, and extending the walls to cover the Caposidero (1537–1557)
- Phase 3—the new walls, including the New Fortress (1576–1588)
- Phase 4—the outworks (1669–1682)
- Phase 5—the detached forts Abraham, S. Salvatore, and S. Rocco (1717–1730)

The Old Fortress

Various historical maps have survived from the 15th–16th centuries, and depict the old town more faithfully than is usually expected from a period when most drawings were generic. A good example is the one found in a pioneering atlas of city maps and views: Georg Braun and Franz Hogenberg's *Civitates orbis terrarium* (1572). The map, Figure 80, is a reprint of the initial work of Braun and Hogenberg, signed by Jan Jansson, but it follows every detail of the earlier material, except the texture of the sea at the bottom of the drawing.

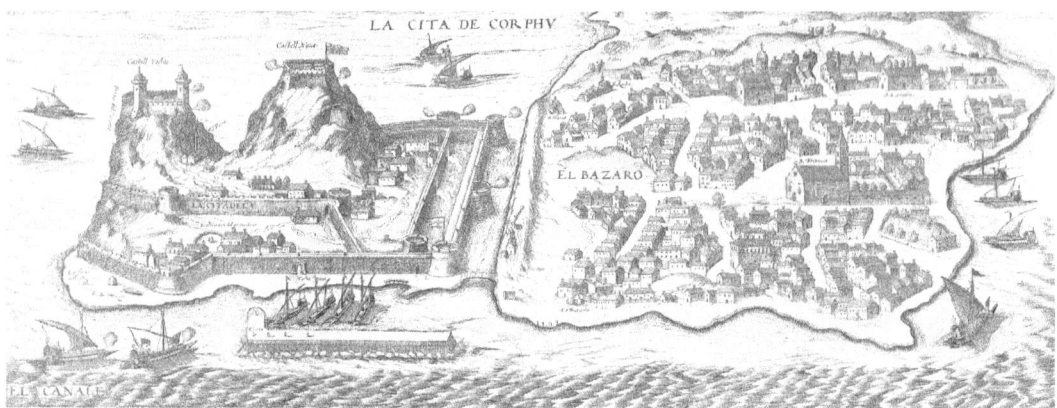

Figure 80. Jan Jansson, *La Cita de Corphv*, 1657 (courtesy the Ministry of Culture and Tourism, Biblioteca Nazionale Marciana Venezia. All rights reserved).

Although it may look small, the inhabitable area in the Old Fortress is about the size of the neighborhoods of Campiello or Spilia. The administrative center of the town was here, before it was fortified on the land side, thus allowing for the significant political and economic buildings to relocate on the mainland. Meanwhile, the habitation of the *provveditore* is clearly represented inside the Old Fortress, close to the sea gate (Soranza)—originally the only access to this town. The Doumo of S. Arsenio is always marked on historical maps as lying between the two high rocks, where the British military hospital now stands.

The important and oldest Venetian buildings, on the north side of the Old Fortress, were removed after the 19th century. Most large buildings surviving today are from the British period (1815–1863). Certainly, by the 1800s, most of this part of Corfu had become obsolete, since the residential and administrative buildings had moved to the mainland, and were eventually followed by the cathedral and the main harbor. But still, these abandoned or even decrepit buildings were once at least two stories high and their preservation would have been of inestimable worth to the researchers of today. Instead, the old town of Corfu—which initially developed strictly on the island around the two rocky peaks—is now largely an empty space, and the buildings taking up most space are British. Thus, between the two cavaliers, long barracks were erected, and to the east there were other barracks built (now housing part of the Ionian University), as well as the most ancient-looking building in all the island: the neoclassical Doric Anglican church (1840).[6] This architectural choice, seeking to give local flavor, is inconsistent with the profoundly Venetian character of the place.

The area of the Old Fortress was initially fortified by the Byzantines and the Angevins, with typical medieval structures. The first fortifications were on the two peaks, known now as Sea Castle and Land Castle. The original name is difficult to ascertain: 16th century maps such as those of Braun and Hogenberg, and Simon Pinargenti, call them Castel Vecchio and Castel Nuovo, indicating an order of construction favoring the seaward fort. However, latter maps such as those of Marcello Alessandri (1620) and Johann Baptist Homann in *Plan de Corfu* (1735) call them Castello da Mar and Castel Vecchio, thus reversing their chronology. Next, Giovanni de Honstein in *Pianta della città e fortezza di Corfù* (1753) and Alessandro Ganassa in *Pianta della città e Fortezze di Corfù e suoi sotterranei* (1750s) refer to them as Castello da Mar and Cittadella.[7]

When the Venetian took possession of the territory, they took care first of the Sea Castle and the Land Castle. Even if certain structures are from this phase, most were modernized by Michele Sanmicheli around the middle of the 16th century. The three round towers on the land side of the Old Fortress in Corfu were replaced by two stronger bastions, huge structures jutting from the sea. Initially, a wooden bridge linked the waterfront, on the Mandrachio harbor side, with the mainland, and the entrance to the town was via the Soranza Gate, located on the northern curtain.

Dating from the first stage of Venetian modernization are the round artillery towers of Versiata and Mandrachio, as well as the separation walls from Caposidero. At that time, towards the land, there was a double line of walls, with, respectively, two and three similar round towers, and between them the current *fossa*. Sanmicheli's work involved replacing the three forward artillery towers with two modern bastions, while the remaining two were transformed into the current cavaliers. Also, in the middle of the land curtain the main gate was built. From the upper right corner of the map, clockwise, the features are (read down, then across):

- Savorgnan bastion
- Main gate
- Martinengo bastion
- Fossa
- Martinengo cavalier
- Soranza Gate
- Mandrachio Gate

- Mandrachio tower
- Caposidero
- Sea Castle
- Land Castle
- Campana bastion
- Versiata tower
- Savorgnan cavalier

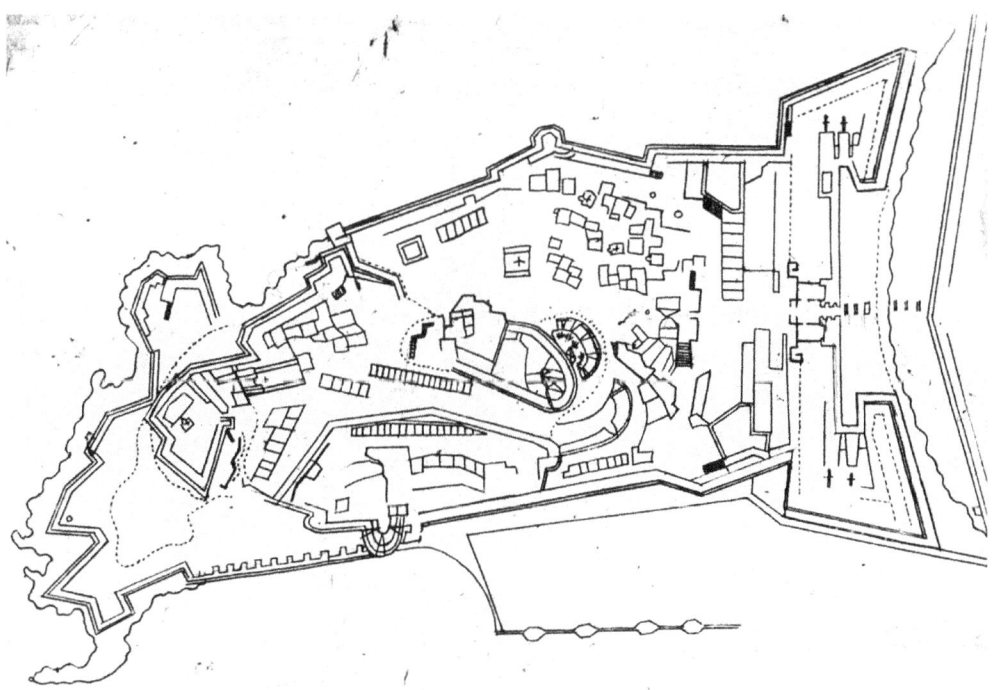

Figure 81. Vincenzo Coronelli, *Fortezza Nuova di Corfù e Fortezza Vecchia*, 1689 (detail; south is up) (courtesy the Ministry of Culture and Tourism, Biblioteca Nazionale Marciana Venezia. All rights reserved).

There are three levels of fortification: first there are the citadels of the place, the Sea Castle and the Land Castle on the two high peaks. Then there is the middle level, between the peaks, guarded by the Campana bastion and once housing the cathedral. Finally, at the ground level, there is a complete enclosure of walls, with two bastions, cavaliers, two artillery towers and salients (Caposidero).

The Land Castle is an oval bastion crowning the peak, with a semicircular battery below it, a ravelin similar to the Mocenigo ravelin in Spinalonga. It is accessed via the Campana bastion, situated in the middle of the peak and guarding any climbing approach. The Sea Castle is pentagonal and without many special features (even fewer than its counterpart). In addition, it has two batteries one in the east and one in the south, each fitted with magazines and embrasures.

The enclosure follows the terrain and starts with two huge bastions, Savorgnan (south) and Martinengo (north); behind them is the ditch (*fossa*) and then their corresponding cavaliers. In front of the two bastions is another moat (*contrafossa*), whose counterscarp is very well preserved. Apart from that, the circuit includes several round towers left on site from the early 16th century fortifications. In the south, there is the Versiata round artillery tower flanking the Savorgnan bastion, and in the north a larger round tower, covering the sea gate from the Mandrachio, the original harbor of Corfu. Also on this site there are three other round towers, from earlier design, although in various states of dilapidation, which formed a wall closing the quarter from the eastern area of Caposidero.

On the land side, the Venetian guardhouse and fence are preserved, with two characteristic Baroque columns, and circular skylights in the brick wall. Right behind the old Venetian guardhouse there is a long flight of stairs descending to the level of the ditch (*scalone della contrascarpa*).

Before the bridge head, on the left, there is a statue of Johann Matthias Von Schulenburg,

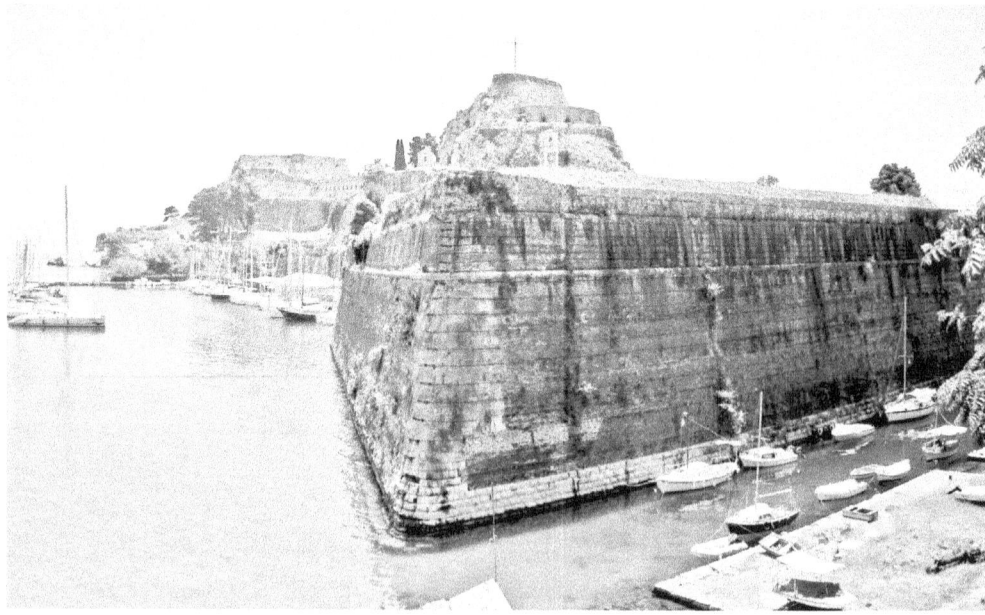

Figure 82. Martinengo bastion, seen from the glacis.

hero of the defense against the Turks, created in 1718 by sculptor Antonio Corradini, in white Carrara marble. It was an exceptional compliment to erect statues to persons still alive (the precedent being that of Francesco Morosini in the Senate, in 1687).

From this location there is a bridge that crosses the *contrafossa*, built by the British in 1819 (the bridge of the Venetian era was wooden and ended with a mobile section).

The **moat** is 215 ft. wide and 1,050 ft. long. This wet moat is in fact a canal dug to separate the original peninsula containing the medieval town of Corfu from the mainland, thus turning it into an island and making it more defensible. The map by Giovanni Battista Bragadin titled *Disegno topografico della citta di Corfu*, better known as the Tron map[8] for its dedication, refers to the canal as *cunette*, indicating that the water part was at first very narrow, and only in modern times was it widened and deepened to accommodate small craft. Most of the ditch is now a narrow canal for small boats, mostly silted, and the new land is occupied by squatters who built shacks.

There is a winged lion on the counterscarp, in front of the Savorgnan bastion (difficult to spot, except from the Versiata Tower or the top of the Land Castle). There are also niches for coats of arms on the face of the Savorgnan bastion. In fact, in 1908 Giuseppe Gerola made an inventory of the Venetian monuments in the Ionian islands of Cefalonia and Corfu, and found a vast number of heraldic elements on the walls of the Old Fortress alone.[9]

The main gate to the fortress was called **Porta Maggiore** and has the design of Michele Sanmicheli, who—along with his nephew Gian Girolamo Sanmicheli—worked on the modernization of the defenses after the 1537 siege. The gateway consists of two oval rooms and a corridor on both sides of it. Once opened in 1558, it replaced Porta Soranza as the entrance to the fortress.

The entrance is over a stone bridge that replaces the original, much narrower, which ended in a drawbridge, whose slots are visible in the architecture of the gate. The gatehouse is wide and solid, and above the doorway itself is the coat of arms of the Greek monarchy, the house of Glücksburg-Oldenburg (who ruled the country in 1863–1924 and 1935–1973), and which replaces the Venetian symbols of sovereignty placed here previously. Inside the gatehouse, on the left, there is a marble plaque commemorating the victory of Karl von Kronenburg over the enemy and dedicated in 1691.

The most impressive features of the enceinte are the bastions of **Martinengo** and **Savorgnan**. These massive bulwarks are masterpieces of military architecture. The bastions are solid, rising 26 ft. high over the moat, with earth revetted in ashlar masonry. Their interior flank features a square *orecchione*, with a *piazza-bassa*, while the salient juts into the sea and is more sloping. The faces of the bastions are 260 ft. wide, the flanks are 100 ft., and there is a 40-ft. *piazza-bassa* on the interior of the land walls.

The curtain between them is 560 ft. long and covered in stone only up to the parapet, but the bastions are entirely revetted. The wall is almost vertical, but the parapet on the bastions inclines at 45 degrees. The stone base of the bastion wall is clearly visible in the shallow water of the *contrafossa*, and this base is higher in the deeper waters on the sides of the fortress.

One distinctive feature is that the *piazza-bassa* actually has another tier from which to fire, almost at the level of the *piazza-alta*, accessed, like the latter, from the curtain. In fact, the *piazza-bassa* itself is quite high, right at the level of the cordon, at the start of the parapet. The *orecchione* protects the recessed flank, which includes an upper, open gun emplacement and a lower, casemated level.

Figure 83. View of the Martinengo's flank from the ditch below the bridge.

From the Land Castle there is a tremendous view over the bastions, the cavaliers, the moat and the glacis, and thus are visible the large stone gunpowder magazines on each of the bastions; the access to these, and the eight embrasures on the curtain between them, is separated by the gatehouse. These bastions have two embrasures flanking the curtain wall behind them, from their flat flank. This flank is not recessed and is much shorter than the flank opposite the moat.

On the scarp of the face of Savorgnan bastion is a large sculpted panel, whose sculpture of the lion of S. Marco is very affected by the weather.

Behind the curtain of the main gate is the *fossa*. This ditch is dry and has always been dry, as attested by the presence of gun ports at the ground level. Access to the ramparts is over a long, smooth slope along the entire length of the curtain. The moat is 74 ft. wide and

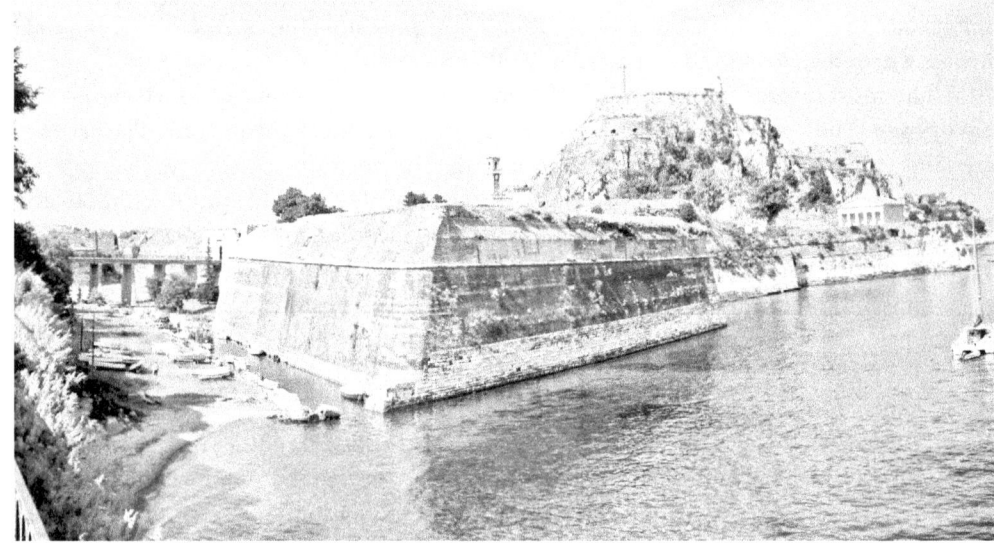

Figure 84. The ditch, the Savorgnan bastion and the southern part of the Old Fortress.

560 ft. long. On the stone bridge spanning the *fossa* there is a small Venetian church, while above the ditch are the cavaliers of the land bastions and, stretching between them, the British barracks.

Instead of the current, unassuming British quartering-hall over the entire length of the section behind the *fossa* and between the two cavaliers, in Venetian times this area held the Gradenigo barracks (to the south) and magazines (to the north). Between them there was an open space, where a large clock tower[10] (not the one existing today, which is from a later period) and the statue of Schulenburg were placed. This place was quite important, since behind it was the palace of the *provveditore* of Corfu—of which the double arched staircase with vaulted recesses remains to this day—and so, from this vantage point, the view once was unobstructed up to the city gate and beyond.

The **cavaliers** in Corfu more closely resemble their counterparts in Valletta than the Venetian ones built in Candia, Canea or Famagosta. They are built on the ground, not on the terreplein of the rampart, and thus they needed to be taller, so their architecture is more pyramidal, towering and less squat. Their horizontal plan is almost a square, with sides of 100 ft.

The access to the Martinengo cavalier displays worn stone stairs with their original Baroque columns topped with stone spheres, whereas Savorgnan's was altered when the British bakery was built behind it.

Access to the interior of the fortress is through three vaulted corridors under the barracks built by the British. Once inside, some Venetian remains are still visible, particularly the symmetrical front staircases of the *Palazzo del Provveditore*, and the fountain behind it. To the north, winding staircases reach the entrance to the Campana bastion, which guards the access to the upper level of fortifications.

From the gates to the round Campana bastion, two ways part: the staircase leading down to the lower ward and the road going up to the castle and the Venetian prisons (a small, one-story building located on the way to the top of the peak, dating from 1786, to which the British added another level).

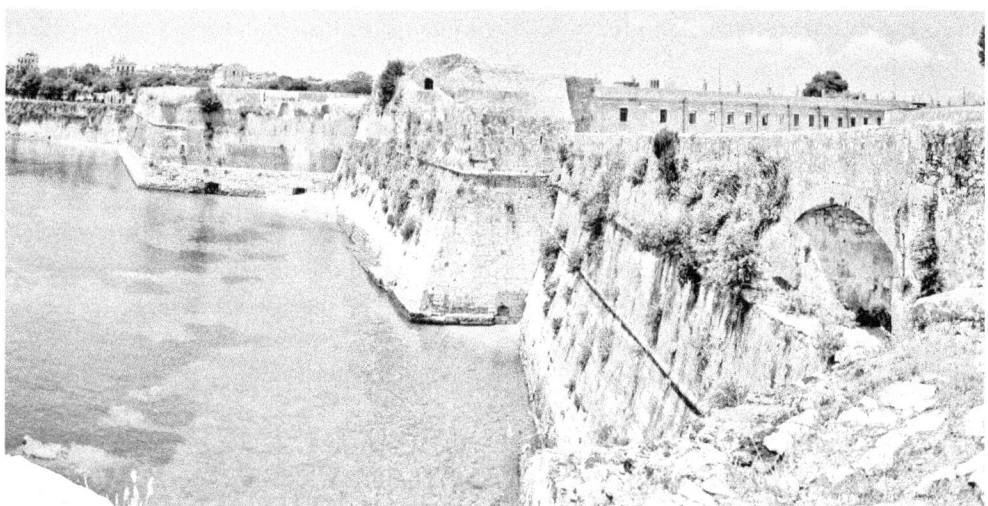

Figure 85. Savorgnan bastion and cavalier as seen from the Versiata tower.

The **Campana** bastion is a solid stone structure with the purpose of towering over the access to the upper levels of the islands. It was built in the second phase of fortification of the island, which is clear because right behind it there existed an earlier, much smaller round artillery tower (of which only half of the outer wall remains, encapsulated in the wall of Campana). A gunpowder magazine is right behind the platform of the bastion, from where a sentry box overlooks the front of the island, while four embrasures guard the area.

In front of the actual bastion there is a reinforcing wall with another gate, serving the purpose of a ravelin and accessible both around the rock and through a flight of stairs next to the old clock tower.

The expected curved passage cut into the bastion leads to the mid-level of the rock, from which the road offers a comprehensive view of the harbor quarter of Mandrachio, as well as of the Sea Castle.

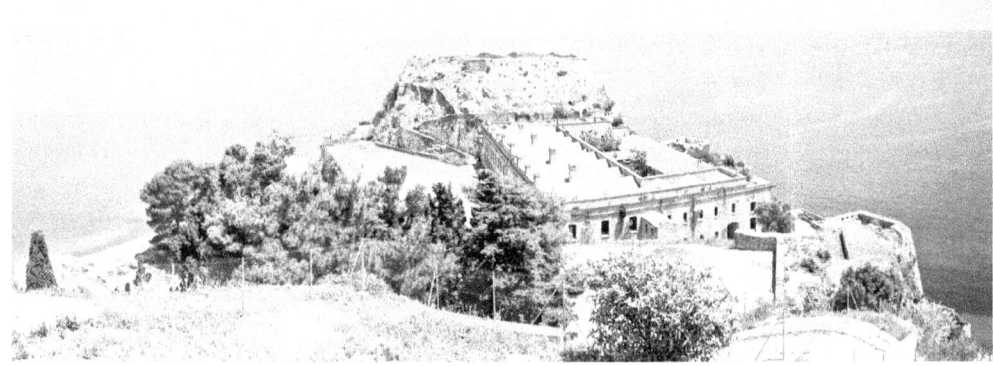

Figure 86. The Sea Castle, with the British hospital in the foreground.

The **Sea Castle** is a simple stone rectangle enveloping the top of the rock. In the Middle Ages it was more elaborate, with typical round towers crowned by merlons, but the requirements of Renaissance artillery warfare made them obsolete and it retained the bare necessities for its function: the flat platform for mounting cannons, with sloping stone walls to deflect gun balls.

To the right of the Sea Castle, in Figure 86, is a battery. Another one is accessible from the area at the bottom of the Land Castle. This side of the island was more fortified since it abutted on the sea, as opposed to the north side, where the Mandrachio harbor was located. The area where the British hospital sits is where the first cathedral used to stand.

From the top of the **Land Castle** you can observe the details of the fortifications on the land side, both bastions and their cavaliers, the curtain and the British barracks behind the *fossa*. Also visible is the wet ditch with the counterscarp and the glacis, now organized as an esplanade. Behind the tall houses of the town is the New Fortress on the hill of San Marco, while in the further distance two wooden areas point the positioning of the former outer forts of San Salvatore and Abraham.

The use of the rock is very similar to Spinalonga, and, as always, the Venetians have proven themselves masters of the use of terrain morphology and the ergonomics of building on rocky peaks. The entire town is laid in full view and one can see as far as the mountains of the interior, as well as to the coasts of Greece. This high point effectively commands the

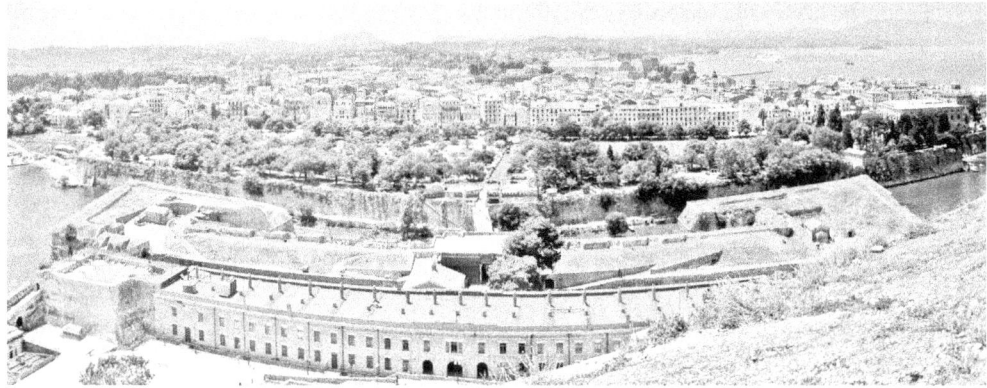

Figure 87. Panorama of the old town taken from the top of the Land Castle.

entire shipping and passage lanes to and fro the Adriatic by way of the Corfu channel, and certainly its importance in the Middle Ages and the Renaissance is thus revealed.

Below the parapet wall of the Land Castle, towards the town, is a thick battery with big gun ports, but this is actually British, built on top of a previous Venetian one. This is quite visible in the differences in construction and architecture: the initial Venetian feature is lower and has the cordon around it, while the British built it taller and incorporated the original walls as a base. The Venetian structure was similar to the Mocenigo *mezzaluna* in Spinalonga.

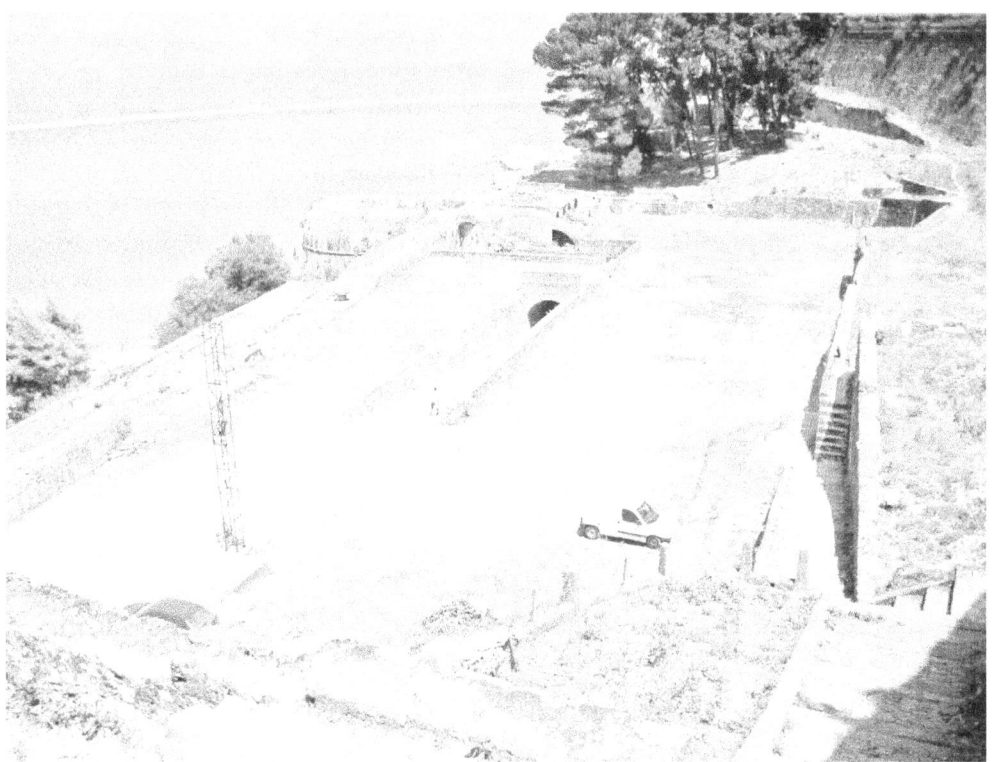

Figure 88. Overview of the lower ward of the Old Fortress, on the north side.

From the Campana bastion, through the usual curved passageway, a long cobblestone staircase travels down, along half the length of the wall, to the ground level of the old town. On the left of this exit is a stone relief with the lion of S. Marco, and its design and degree of erosion point to its great age.

This area was initially filled with lots of houses and public buildings, crammed together in a small space. There are a couple of places where stone staircases remained but lead nowhere, and one can see arches from the ground floor of constructions now gone. However—while most the south side was leveled by the British to offer an open parade ground in front of the original Anglican church—here, in the north, tall buildings survived into the 1940s. In Figure 88 is visible the sloped access to the Mandrachio Gate, guarded by its round tower, and flanked by the ground floor of the Pasqualigo Barracks and arches from storage facilities. In the background are the remains of the separation wall between this area and Caposidero.

The main feature of this part is the sea gate of **Mandrachio**, preserved in the form of a large complex, including a long access ramp, large storerooms, two doorways and a round artillery tower. The Mandrachio tower is a round artillery tower guarding the sea gate to the old town, located in the northern part of the island. Like its circular counterpart on the south of the island (Versiata tower), it has a thick parapet wall; however, although these both have the same architectural design as the round towers of Famagosta, these don't have three embrasures (at 90 degrees to each other), since neither tower has a gun port facing the open sea.

Right behind the tower there were large storage facilities, standing as tall as the tower itself, at 13 ft. Of these, the ground floor is preserved, as well as five large arches supporting the ceiling. Opposite them, on the other side of the small courtyard of the gate complex, there are facilities that were part of the underground levels of the Pasqualigo Barracks. The halls have a marble door frame crowned by a Latin inscription bearing the name of Francesco Flatro, and the year 1790. The inscription shows this was a military location, specifically dealing with gunpowder. Indeed, above this section the Pasqualigo Barracks were situated, a large three-story building lying along the length of sea walls close to the Campana bastion.

The Pasqualigo Barracks are a two-level structure, whose windows have been bricked. Inside, on the first floor, there is a large vaulted room with a cross ceiling, and a rusty old British cannon and stone cannon balls are scattered around. These facilities were developed at sea level, which makes them below the ground level of the old town. Along the foundations of the barracks descends a long slope, whose archway features the escutcheon of the Greek king.[11]

From the gunpowder room of the Pasqualigo Barracks, there is a steep staircase descending to sea level through two doorways, the final one opening right at the base of the circular Mandrachio tower. These two doorways are progressively smaller as you approach the harbor.

East of the Mandrachio tower, a smaller round tower, from an early Venetian enclosure, was included in the new sea walls and lost most of its defensive purposes. Thereafter, the defense rested on the thick walls and a series of casemates, supported by magazines and guardhouses.

This area of the sea walls was extended after the 16th century, and so the eastern part of the Mandrachio tower was incorporated into the walls, which were thickened and constructed with merlons and machicolations. Buried under the height of the wall-walk were casemates and magazines.

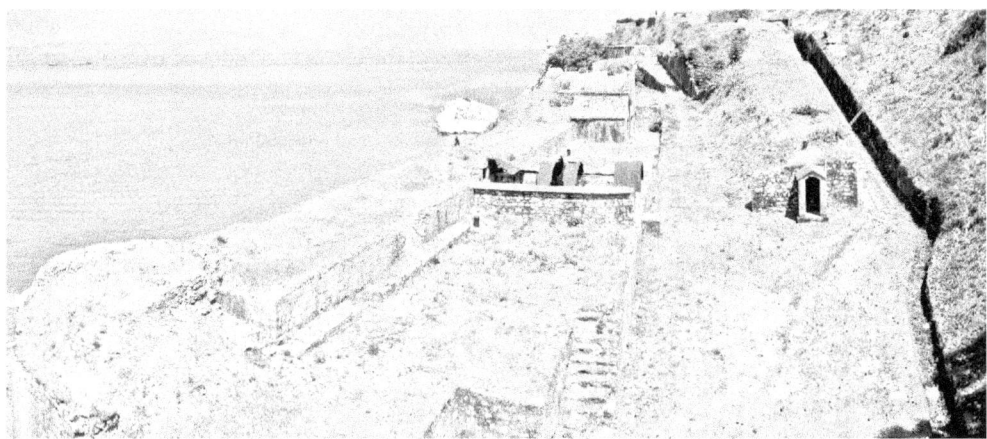

Figure 89. Military constructions of various periods, towards Caposidero.

As is still visible today, the morphology of the island is such that the eastern part (Caposidero) is difficult to landscape effectively. Being unsuitable for large-scale, mercantile quarters, this eastern part of the island, just below the Castello da Mar, was separated from the habitation quarters by a stone wall (parts of it still standing, with their Renaissance features). This wall ran from the Sea Fortress to the Mandrachio tower, and—besides these landmarks—one round corner tower also remains (although much smaller in diameter than the large artillery platform guarding the Mandrachio harbor).

These walls defend the area of Caposidero (a corruption of Capo San Sidero), in the east of the peninsula. This area had been left undefended prior to the siege of 1537, since landing here was deemed impracticable due to the high terrain and the Sea Fortress rising high above this point.

Eventually this area was incorporated in the defenses of the Old Fortress, and the walls follow the natural shape of the rock. At the cape they form two prominent salients (like those in Retimo), with several gunholes on the eastern part of these walls. Today, only one Venetian gunpowder magazine remains there, one of five, of various sizes and degrees of conservation, scattered across the Old Fortress.

On the north walls, Porta Soranza was the first point of entry from the port of Mandrachio, and it was positioned on the side, like the gate to the S. Angelo fort in Malta. Although replaced in function by the main gate and eventually walled in 1660, it is still visible on the north side of the walls.

The Venetians emphasized the separation of the narrow peninsula from the mainland by opening a channel called the ***contrafossa***. At the same time the free space of the esplanade was extended as an additional defensive measure. The work was completed in 1558.

Returning to the town, a distinctly unique feature of the Corfu's fortifications is the survival of the glacis in front of the Old Fortress, today organized as a large park. The size of the Spianata offers an insightful view of what size was considered appropriate for such an architectural element, given the artillery's performances in the 17th century: it has a width of 590–656 ft. in front of the bastions of the Old Fortress, and stretches from the south coast to the north coast. The south side is the best preserved: here, when the glacis ends, we find the Grimani Barracks, and right behind them the Raimondo bastion, preserved intact in the exterior

as well as interior structures, and which very recently has been subject to extensive restoration and preservation works. On the north side, the depth of the glacis was reduced by the addition of the Liston building, and later by the Royal Palace.

The New Walls and Outworks

In the late 16th century the walling of the new town took place, with a curtain protected by two bastions, one platform and a large fort in the north, known as the New Fortress. In the second phase of development (1669–1682), a string of outworks was laid before the frontline to strengthen the defenses. In Figure 90, the thick lines show the constructed walls, while the thinner lines are various modernization proposals.

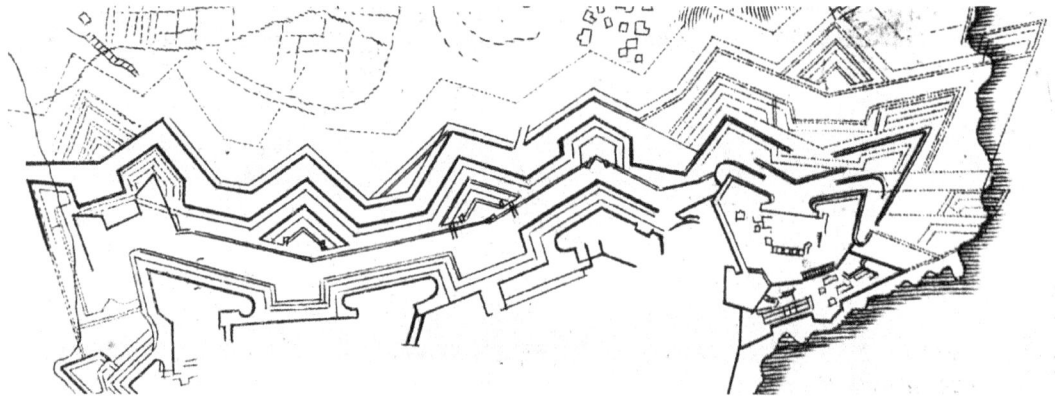

Figure 90. Vincenzo Coronelli, *Corphou*, 1696 (detail) (courtesy the Ministry of Culture and Tourism, Biblioteca Nazionale Marciana Venezia. All rights reserved).

From left to right, the defensive features are[12]:

Enclosure	Outworks	Forts
Valier bastion		
Raimonda Gate		
Raimondo bastion	S. Atanasio hornwork	S. Salvatore fort
	S. Atanasio ravelin	
S. Antonio *piattaforma*	Corner ravelin	
Porta Reale	Grimani ravelin	S. Rocco ravelin
Sarandario bastion	Grimani mezzaluna	
New Fortress	Scarpone hornwork	Abraham fort
Sei Venti bastion	S. Spiridon counterguard	
S. Zorzi cavalier		
Sette Venti bastion		
Punta Perpetua		

The new enclosure of the town relied on the large New Fortress to the north and a series of bastions linked it to the other shore. Previously, this area was *extramurros*, literally meaning outside the protection of the walls, and thus occupied at the peril of the inhabitants. As was the case all over Western Europe, there is a solid legal meaning in the differentiation between

areas called *intramurros* and *extramurros*.[13] Historical maps—like the one part of the Braun and Hogenberg atlas[14]—show this area occupied by houses, churches, hospitals, salt works and various other structures.

The decision to locate outside the walls of a town has a lot to do with the vocation of various Catholic orders, and as such we find S. Francesco churches outside the original medieval walls of Candia, Canea and Corfu, although integrated in the Renaissance enceinte at a later date.

To the north, the line started with the Valier bastion jutting into the sea; behind it was the Raimondo *mezzaluna* and between it and the eponymous bastion was the Raimonda Gate. In front of them was the S. Atanasio hornwork, and between its salients was the S. Atanasio ravelin. The Corner ravelin protected the curtain between Raimondo and piattaforma S. Antonio, while the Grimani ravelin guarded the Porta Reale, and the Grimani *mezzaluna* covered the salient of the Sarandario bastion. The wide Scarpone hornwork stood in front of the entire New Fortress, and between it and the sea was constructed the S. Spiridon counterguard.

Porta Raimonda was situated behind the Grimani Barracks, between the Valier and Raimondo bastions, and led to the suburb of Castrade.[15] It was removed by the British—along with the Valier bastion and the S. Atanasio hornwork—when they built the southern coastal road.

Porta Reale was the main gate into the city, and thus the most ornate, a work of the architect Ferrante Vitelli (who was also in charge of the entire section of the new walls, including the New Fortress). It was situated between the bastion of Sarandario and the platform of S. Atanasio. The gate had a large central doorway, flanked by two much smaller, single-person side doors. Four pillars, in Tuscan style, on high pedestals, divided the front in three sections. In the center stood the lion of S. Marco, and the frieze featured triglyphs and metopes decorated with rosettes and bucrania (ox skulls)—elements also encountered in other monumental gates, such as Porta de Terraferma in Zara, Porta Palio and Porta Nuova in Verona, or the gate of the fort San Nicolo in Sebenico. Between the entablature and the arch, was a large marble slab that accompanied two coats of arms that belonged to the Pisani and Contarini families.

This gate was exquisite and impressive among the works undertaken in the Levant, bearing a strong resemblance to the gate of Zara in Dalmatia and even the Porta Nuova and Porta Palio in Verona, all designed by Michele Sanmicheli. Apart from this gate, all the other Venetian gates in Candia or Cyprus were only one story high and not so embellished. The Porta Reale was demolished at the end of the 19th century to allow wider access to the main road inside the city.

Even though the curtain is all but gone, the S. Atanasio platform and the Raimondo bastion are intact, as well as the Sarandario bastion. The former houses a school and is the least affected by urban development; the latter two are almost entirely buried under modern buildings.

The access gate to the Sarandario bastion is a vaulted stairwell leading to the terreplein; this gallery is in stairs, similar to the galleries of the ears of the bastions of Candia. Because of its visible military and heritage features, the doorway of the old gallery—crowned by a keystone with a discrete Venetian nobleman's coat of arms—is marked by a sign directing passers-by further along the wall in search of the actual visitor entrance to the New Fortress.

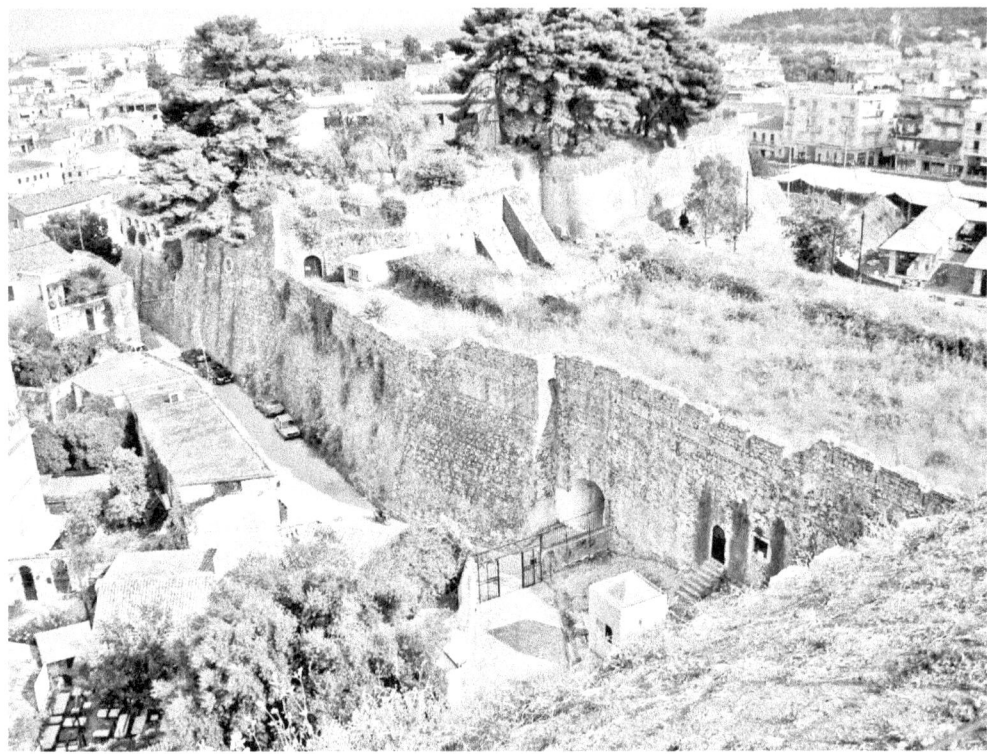

Figure 91. Sarandario bastion and curtain.

On the salient of the Sarandario bastion, the cordon is still intact, but the parapet is mostly gone; this bulwark still retains its embrasures in the stone parapet. Buttresses reinforce a portion in the middle of the face of the Sarandario bastion. A sentry-box has survived on the tip of the *orecchione*.

The sally port is located underneath the small curtain between the Sei Venti and Sarandario bastions, and is a tall, vaulted, curved passage, like the ones connecting the lower and upper levels of the Old Fortress, underneath the Campana bulwark. Because of its size, is exit in the ditch is covered by a thick parapet wall, reaching half the size of the curtain wall. This parapet continues to the interior, and is found ruined—but with its architectural features still decipherable—all along the huge stone wall of the New Fortress, like a *fausse-braye*.

Right behind the sally port, sheltered by the sheer height of the New Fortress, is the church of Santa Maria del Rosario, the church of the garrison, with a round relief of the lion of S. Marco *in moleca*, above its entrance, along with the text *Soli Deo laus honor et gloria*.

After the great siege of 1716, a new line of defense was built further inland, covering the two high hills in front of the new walls: S. Salvatore and Abraham. Between them, a strong ravelin was built and named S. Rocco. The distance between the New Fortress and Abraham hill is 820 ft., which, by the early 18th century, was within artillery range, so commander Schulenburg decided this hill had to be fortified to dissuade the enemy from occupying it. With a height of 167 ft., Abraham was also at about the same height as the upper section of the fortress in the time of the Venetians (that is, before adding the new tier of fire from the platform on top of the British barracks).[16]

These were much more complex fortifications than previously encountered in our research. It was already the age of Vauban, and so defenses were becoming more and more elaborate. These forts were centered on one or two retrenched bastions, which gathered around them casemates and batteries, linked together with caponiers and galleries. Abraham counted on the S. Giorgio bastion and its *mezzaluna*, with magazines and batteries. S. Salvatore was more complex: the S. Nicolo and Corner bastions, with the S. Mattia counterguard and the S. Giovanni Battista redan. Besides the caponiers and galleries running in this camp, others connected the fortified hill to the S. Atanasio hornwork, through the S. Giustina and S. Barbara redans. Between these two hills stood the S. Rocco ravelin, like a detached bastion, with four embrasures on its sides, covering the neighboring fortifications.

Nothing is left of the S. Salvatore fort, and in its place there is a modern prison; the ravelin was also lost during urbanization works in the 20th century. On the Abraham hill, however, there is still a tall quartering building with a Baroque portal,[17] and underneath the grass are visible traces of where the walls and ditch existed.

When the British came to rule, besides maintaining the existing fortifications, they also started fortifying the island of Vido, which, due to the developments in technology, had come within gunshot range of the Mandrachio harbor and parts of the old town. In fact, it is here that the Russo-Ottoman army set up batteries to shell Corfu, during the liberation from French republican forces in 1799.

There are several Venetian guns scattered around the town: one huge late 17th century cannon, made in Holland for the Serenissima, is inside the Old Fortress; and two upturned mortars were placed right at the entrance to the bridge leading to this fortress[18] (these two were removed a couple of years ago, restored, and mounted on replica carriages and are now displayed along with other period pieces on a platform above the Versiata). These last two bear the year 1684, same as another one in San Rocco Square (currently the main bus station for local transportation). This area was initially the Grimani ravelin, the main artery outside of the city, situated right in front of the Porta Reale (further along this road were the actual San Rocco village and the San Rocco ravelin).

The New Fortress

The most important element of defense was the New Fortress. Under the supervision of the Italian architect Francesco Vitelli, the New Fortress was built on the hill of S. Marco, in successive phases, between 1576 and 1645.

The complex of the New Fortress is formed by two symmetrical and almost identical demi-bastions—Sei Venti (south) and Sette Venti (north)—supported by a connecting cavalier, S. Zorzi, and placed behind the Scarpone hornwork. On the town side, the fortress has a demilune and a lower ward (with a demi-bastion and one bastion), with two gates, designed to lead to the port and to the city, respectively.

There are two monumental entrances to the New Fortress, its sea gate and the land gate. These two gates should not be at all confused with the tourist entrance or even the town access, which is, in fact, a postern, under the curtain. The sea gate (Porta Murata)[19] is more ornate, featuring a mighty winged lion. While the land gate is almost identical, it is the actual entrance to a part of the fortifications still in use by the Greek navy; thus the buildings on

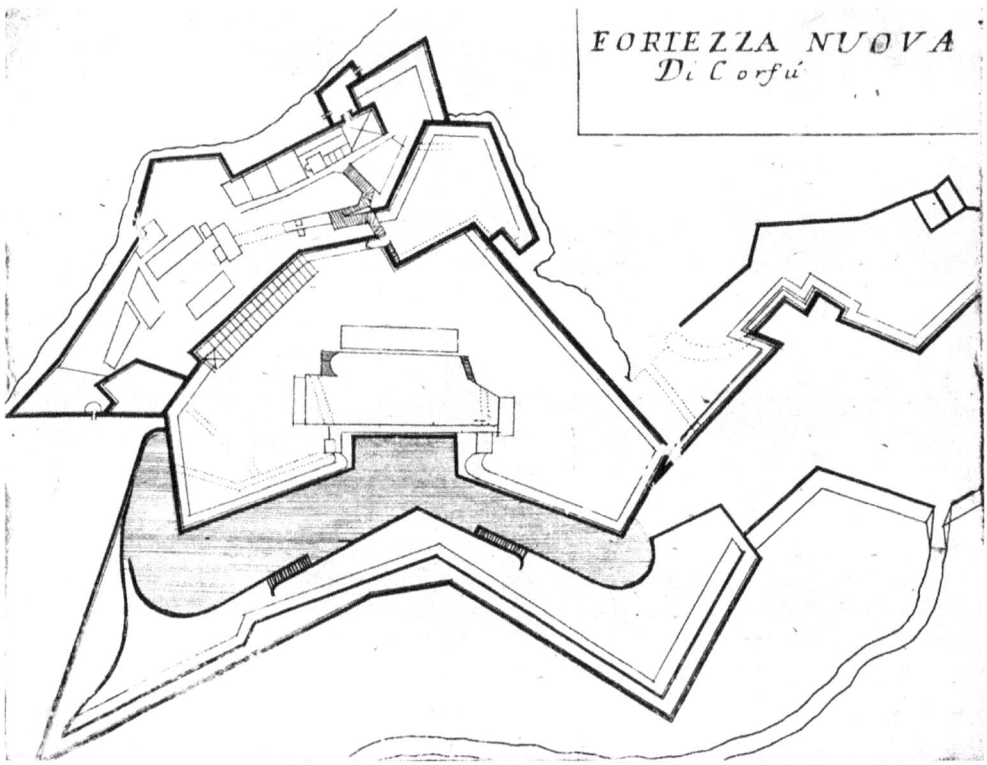

Figure 92. Vincenzo Coronelli, *Fortezza Nuova di Corfù e Fortezza Vecchia*, 1689 (detail; east is up) (courtesy of the Ministry of Culture and Tourism, Biblioteca Nazionale Marciana Venezia. All rights reserved).

the side of Spilia harbor are off limits to researchers.

Built in 1577–1578 along with the entire complex, the sea gate has a single arch flanked by Doric columns, with the walls crossed by ashlar bands; it is surmounted by an attic that supports a lion of S. Marco once flanked by two obelisks that culminated in two spheres (now removed).

On the northern section, including the New Fortress and Sarandario bastion, the walls were built on high ground of the San Marco hill, so not just the wall-walk but also the stone wall itself starts at a higher level than the tallest rooftops. Running north towards the sea, the earth subsides, and here the modern intrusion was larger, but the

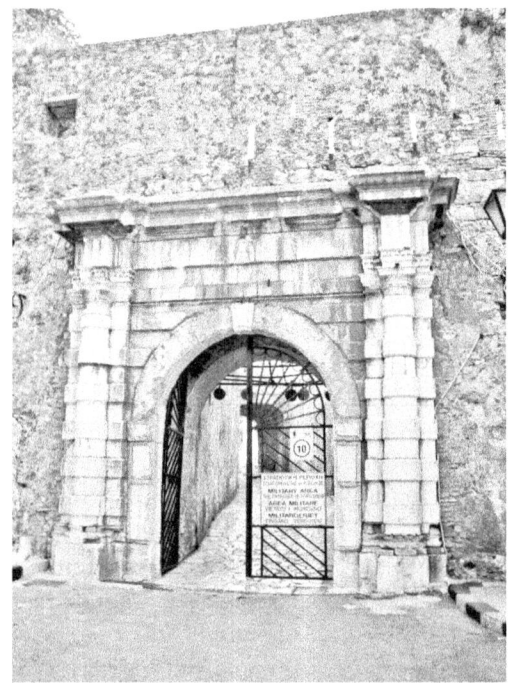

Figure 93. Land gate to the New Fortress.

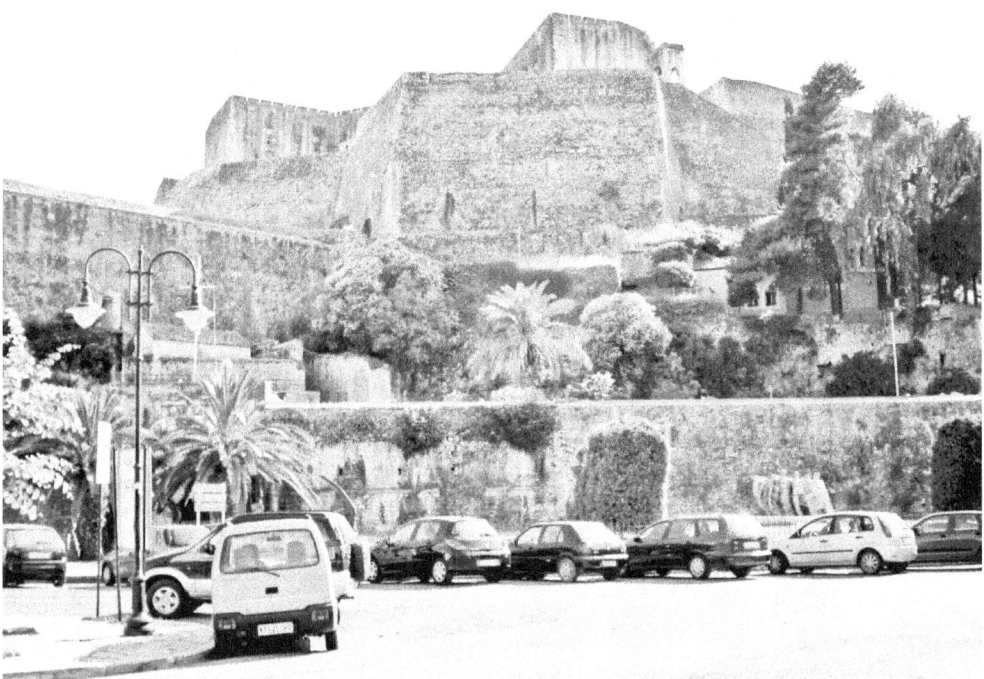

Figure 94. New Fortress. Note the sheer height of the structure.

street layout and the different architectural style clearly trace both the old walls and the distinctly old town perimeter.

On the inside, the postern opens in the back of the curtain where two paths ascend to the New Fortress, protected by thin walls with slits: one is short and runs up to the curtain, while the other runs all along the length of the wall towards the battery overlooking the Spilia harbor. Here is a low wall with arrow and handgun slits; this wall acts like a *fausse-braye* and protects the access from the battery to the curtain and to the sortie.

Towering above this section there is a huge, 6.6-ft. tall opening in the bastion wall, at 9 ft. above the ground, that is accessible through the tunnels underneath Sei Venti. Guns eventually placed here would have flanked the battery.

On this side the immensity of the New Fortress is clear, the walls rising up 26 ft. above the ground of the battery, which itself is a hill a good 15 ft. over the town level. Next, the same curved corridor allows access to the top of the gun battery, from which a similar passage connects to the original climbing road to the bastion.

The first solid defensive feature of the compound is the **demilune**, which covers the two gates of the New Fortress and is shaped like a trapeze, with sides of 88–147 ft., and one large 180-ft. part. It retains many of its original features, including cannon placeholders on the flanks facing the sea and the curtain, while on the smaller city side there are firearm ports.

While the current access to the New Fortress is from an open area close to the sally port, the architectural military complex was organized so that access was through its two gates (which now belong to the navy facilities and thus are off limits). Both these gates led to the same narrow street, where a long and winding road starts towards the top of the bastion.

At the end of this winding escalation is a tall arch added by the British. Halfway towards that top level stands the Calogero cavalier, which covers the lower ward and contains an intact, square gunpowder magazine.

Connecting the Scarpone to the sea was the Punta Perpetua, a section now rather unnoticeable that also closed a section of the lower part of the New Fortress. Between the bastion and the sea there is a much lower and less elaborate level of defenses, since its protection comes from the immense hill covered in stone above it. Even this lower level ranges from 16 to 65 ft. above sea levels, but the actual Venetian fortress is a staggering 110–160 ft. above the sea, and the British barracks rise a further 16 ft. over this level.

The British barracks double as a form of cavalier, to ensure another gunnery tier. The platform of the British barracks is definitely in much better shape than the rest of the fortifications, and even the difference in styles in visible. Once behind the British barracks, you can see the specific Renaissance access ports, with sides in stone, leading to an intricate maze of corridors and tunnels. Originally, before the British barracks existed, this was a large open space in front of the gates to the bastions. Built in the 1839, the barracks are a tall structure, three stories high, consisting of living quarters. A wide gun platform is on the roof, overlooking the Venetian fortifications. It has the shape of half a hexagon, and a strong spur as tall as the building itself reinforces it. The structure dominates the Venetian works and thus changes the skyline of the defenses. With the hornwork, bastions, cavalier and British barracks, this front ensured a tremendous four tiers of fire.

The upper level of the New Fortress consists of two almost identical bastions—**Sei Venti** and **Sette Venti**—with a long cavalier, S. Zorzi, built on the curtain between them. Although most modern maps mention both structures under just one name and usually call it "the double bastion Sette Venti," this is certainly a recent misconception. The historical maps of Giovanni de Honstein, *Pianta della citta e fortezza di Corfu* (the Roastein map, 1753), and Giovanni Battista Bragadin, *Dissegno Topografico della citta di Corfu* (the Tron map, second half 18th century),[20] identify them clearly as Sei Venti and Sette Venti, which certainly makes more sense.

The bastions have one rectangular flank and one *orecchione* with a *piazza-bassa*. The bastion by the sea, Sette Venti, has a much sharper angle at the salient, and so does the hornwork in front of it. Large, vaulted stone rooms are buried under the earth capping the bastions, with an entrance to the right of the main doorway; these are the main storage facilities of the New Fortress, due to their size and protection under earth.

Two identical and symmetrical gates allow access to the bastions. None of the access corridor is straight; all are curved (even if the topography allows it, as in the case of the entrance on the terreplein of the bastions). Having passed through the first corridors, you are immediately at the entrance to the extensive network of tunnels beneath the bastions; or, if you go around this, you are on the terreplein with its magazines and embrasures. Then you double back over the corridor you came through and reach the cavalier that services both bastions and the hornwork, overlooking the glacis to the fort on the Abraham Hill.

On each of the two bastions of the New Fortress is one large powder magazine, sunk below the surrounding ground level for increased protection. Usually such magazines are designed with pointed, not flat, roofs, to deflect incoming cannon balls; magazines have windows to allow a blast to disperse, since an explosion in closed quarters is even more

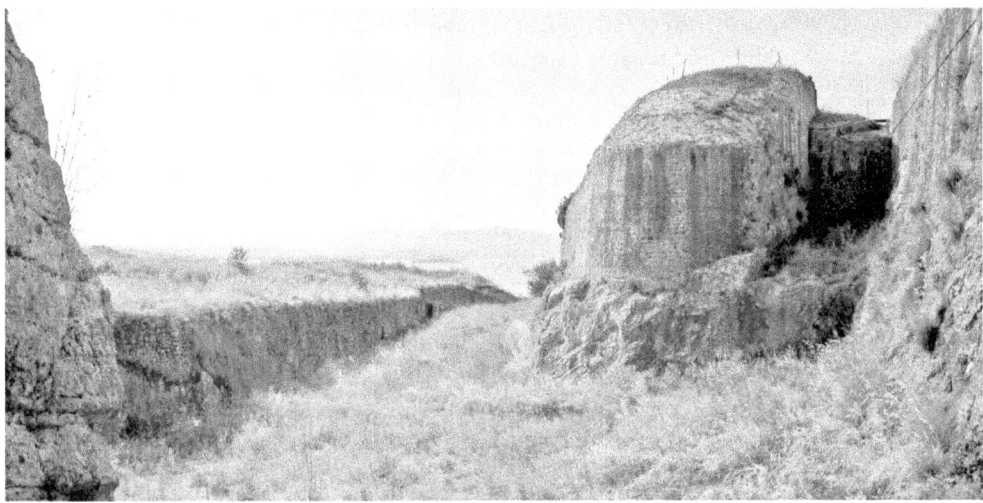

Figure 95. The ditch and the flank of the Sette Venti bastion.

damaging. Here in Corfu, the magazines are long, sturdy structures, with flat roofs, but more care was given to their exterior aspect and they feature arches and window frames.

On the bastions, much of the parapet is gone and the embrasures are mostly ruinous, although the slots for positioning the cannons are still visible. The cavalier offers a better view of the original layout of the bastions, which included four gun ports on the face of the bastions, and two on the circular flanks. An interesting feature of these bastions in Corfu is that there is a gun embrasure pierced in the tip of each *orecchione*.

The gun placements on the Sette Venti are much better preserved and offer a great impression of their original form. Overall alterations were made by the British, who adjusted the

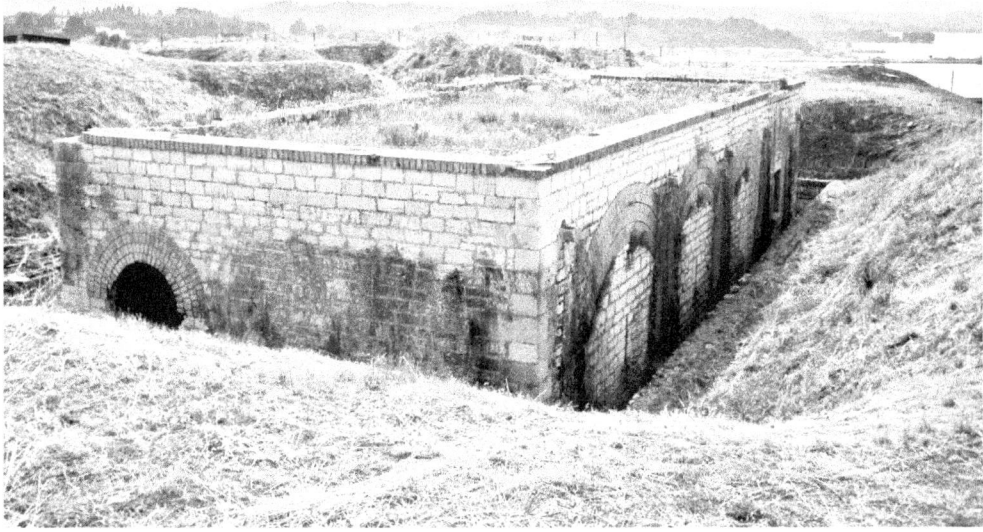

Figure 96. Magazine sunken in the terreplein of the Sette Venti bastion.

Renaissance ports with architectural designs suitable for their age and their military technology, whose more mobile and reliable cannons required banquettes for recoil and shallower ports. These features are encountered most clearly on the platform of the British barracks and also at the bakery building in the Old Fortress, right behind the detached cavalier of Savorgnan.

The S. Zorzi cavalier has six gun embrasures, but its stone coating is present only on the sides and corners and is supported by buttresses. The face of the cavalier is earthwork, like the face of the hornwork.

The bastions are similar in structure, except for the layout of their tunnels. The underground galleries are extensive, very well preserved, and maintained in good condition, including a coat of lime and lighting to ease the incursion from visitors, just like the insides of the artillery towers in Cerines (Cyprus). These tunnels are a rare treat, since not many of the contemporary fortifications are opened to the general public or even researchers, nor are they maintained with such care. Large, oval venting holes refresh the air in the otherwise humid catacombs.

The tunnels lead to two gun ports on separate flanks of the fortress and to the *piazza-bassa*. Initially, for access there were two very large doorways, which have since been walled up; only the arches remain. They were necessary since from this *piazza*, behind the *orecchione*, one can reach the ditch and from there the hornwork.

These bastions in the New Fortress are taller than the other bastions on the land front, which are actually at the height of the Scarpone hornwork in front of the New Fortress. The salient of the Sei Venti has collapsed down to the middle of its height; unlike the hornwork,

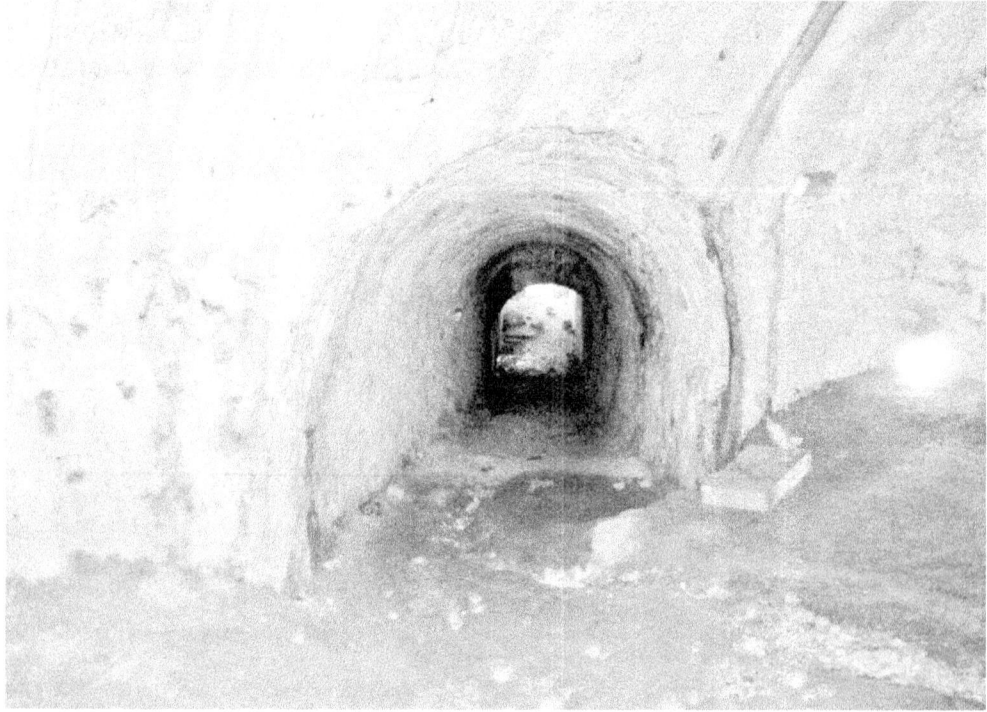

Figure 97. Tunnels inside the New Fortress.

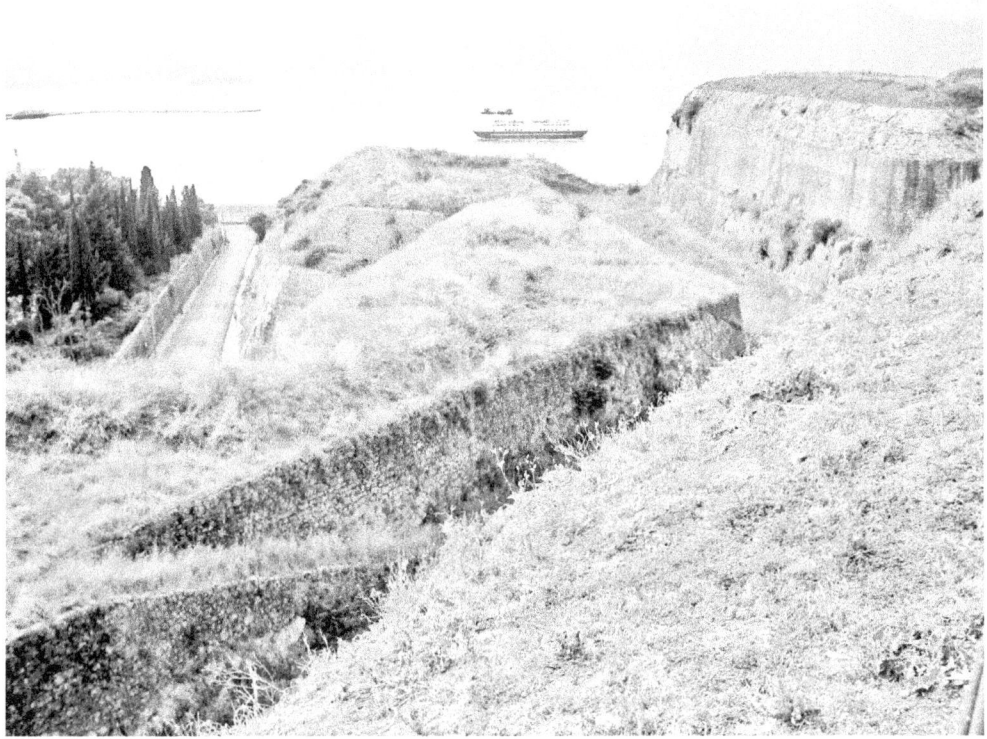

Figure 98. The Scarpone hornwork.

the bastion is entirely covered in stone and its slope is less steep. Most of the lower half of the bastions is solid bedrock, and stone is only used to create a smooth surface to withstand cannon fire. In this area the scarp is 20 ft. high.

The **Scarpone** hornwork in front of the bastions is built on a strong base of rock and is covered in stone on its lower half; above this the earth offers a sloping surface to deflect and better absorb cannon ball hits. The ditch is now a motorway,[21] but the counterscarp is still there. The moat here is wider than both the fossa between the bastion and the hornwork, and the fossa in the Old Fortress.

The Scarpone has, on the interior of its two half-bastions, two nicely preserved *piazza-basse*, with a strong parapet and two cannon embrasures each. On the wall between them there is a rich panel: a high-relief with the lion of S. Marco in the tympanum and a large marble slab with a dedication to Doge Alvise III Mocenigo in 1728. Another such heraldic panel is in the middle of the scarp of the southern half-bastion, with a relief of a lion and a long Latin inscription referring to the completion of the hornwork during the office of Doge Nicolo da Ponte in 1583.

The ditch is 8 ft. wide and the hornwork is short, rising only 6.6 ft. over the moat. Originally, this ditch ran along the line of fortification. At the same level with this remaining hornwork were the other exterior defenses: three ravelins, a counterguard and another hornwork at the end of the front, on the other shoreline. The actual moat was in front of this exterior line of defense, and this one was deeper, and its surviving counterscarp is roughly 13 ft. in height.

Figure 99. Face of bastion Sei Venti, with ditch and hornwork.

From the ditch, a surviving staircase goes to the top of the hornwork, while corridors through it reach the two *piazza-basse* in its middle. The hornwork retains its parapet and terreplein intact.

The Fortifications Today

The old town of Corfu is in great shape with a high preservation level. There is little destruction, and the fact that this location was never under Ottoman rule helped significantly. The old houses and neighborhoods are very well preserved, and the most Venetian neighborhood is still called Campiello—which is as Venetian as it gets.[22]

The city is a wonderful sight, and the resemblance to other locations of the Serenissima is astonishing. The streets and tall houses echo the urbanism of the Italian lands of Venice. Names of neighborhoods and places have remained unchanged for centuries—Campiello, Spilia, Spianata, San Rocco—and the same is true for the street layout, including the main thoroughfares, the one linking the Spilia Gate to the Spianata[23] and the one getting there from the former main gate.[24] Unmistakable Venetian urbanism is found in the area of Kremasti, when a typical *campiello* exists: a square with a church and a well, around which tall houses are lined.

The beautiful churches of the Venetian period were spared the passage of time, except the initial cathedral inside the Old Fortress, and the large Gothic church of Sta. Annunziata, whose large nave was destroyed in a World War II bombing raid and whose remains were irreverently removed.

The most important palaces are standing, one of them being the house where Ioannis Capodistrias was born. He went on to be the first head of state of independent Greece, from

1827 to 1831, and he ruled from Nafplio (Napoli di Romania), the erstwhile capital of Venetian Greece. His Western approach to administration brought him into conflict with local allegiances and practices, which led to his assassination in 1831.

The fortifications were quite altered, especially by the British, who removed most buildings from the south of the Old Fortress, raised the level of the New Fortress with their barracks, and, finally, upon leaving the island in 1863, removed the outworks and dismantled the outer forts (San Salvatore, San Rocco, and Abraham).

The British dismantled large parts of the land walls when they handed over the island to Greece, in 1863, although they only removed the outworks and some of the curtain wall, and filled the moat. Gone are the forts of Abraham and San Salvatore, the San Rocco ravelin, and the S. Atanasio hornwork at the south end of the walls. But the two bastions and the New Fortress are intact, as is a large part of the S. Antonio platform, and the same must be said about the Old Fortress.

The Greek authorities made some controversial decisions, such as to demolish the Porta Reale, a process that took several years at the end of last century. In the mid 20th century, the whole area of San Salvatore was overhauled and occupied by a large intrusive structure (prisons). Inside the Old Fortress, on the west and north side, a lot of large buildings that had survived Venetian times were removed. While it is true that British remodeling of the zone replaced several significant constructions, the large Pasqualigo barracks were demolished after World War II.

In all, Corfu town is a reflection of residential Venice, even more than the cities the Republic held in northern Italy itself. Its Renaissance and Baroque urbanism is unmatched by other towns in Istria or Dalmatia, and offers a glimpse into a unique past.

PART V. THE DEFENSES UNDER ATTACK

A short overview of the historical conflagrations between Venice and Turkey is appropriate to enable the reader to understand the importance of the military architecture of these islands and the essential role they played in all the wars of their age. We have analyzed the design and construction of these state-of-the-art Renaissance fortifications; now we must observe their siege-worthiness. Having presented the fortification works, we must now see how they fared when tested.

From the early 15th century on, Ottoman expansion westward posed a direct threat to Venetian interests in the Mediterranean. The Venetians had played an active part in the Frankish Levant, and the fall of Constantinople heralded a new era in Venetian-Turkish relations, characterized by defensive actions and efforts to preserve the lucrative trade routes. Unlike Spain, the Hospitaller Knights or even Genoa, Venice tried not to placate the Porte and was more interested in peace (except in the second half of the 17th century, when she embarked on bold, aggressive actions in the heart of the Ottoman Empire).

The Ottomans were a Turkish dynasty that rose to prominence by conquering many of the territories of the decaying Byzantine Empire and of the neighboring and lesser Oghuz principalities. By 1400, the majority of Byzantine territories in both mainland Asia and Europe were under Ottoman Turkish control, as well as the entire Balkans north of the Peloponnesus. In 1453, the Byzantine capital of Constantinople was conquered, bringing an end to the thousand-year empire of Eastern Rome.

After this, the Ottomans began to contest the control of the Mediterranean Sea with the Christian maritime states (Venice, Genoa, and the Hospitallers). Slowly but surely, the Turks began to conquer the territories of Latin states in the Eastern Mediterranean: the Hospitallers left Rhodes in 1522; Genoa lost the island of Lesbos to the Turks in 1462, and Chios in 1566; Venice lost Cyprus to the Turks in 1571, and over the course of the next 150 years, the Turks conquered most of her Greek possessions.

While successful in the east, the Turks were, however, stopped from expanding in the western Mediterranean in two important battles: the siege of Malta in 1565, where the Knights Hospitaller held the Ottomans at bay, and secondly, at the battle of Lepanto in 1571, when the combined fleets of the Catholic states obliterated the Turkish navy.

By the 17th century, the Ottoman Empire had entered into a decline, and the extremely long and very costly war of Candia (1645–1669) had undermined the economy, already crippled by endemic corruption and maladministration. Top administrative positions were officially

put up for sale, and any interested parties were obliged to deposit a sum commensurate with the expected income of the position, estimated for a certain number of years. This was the case of semi-autonomous rulers of outer territories such as Moldavia and Wallachia, where rich Byzantines from Constantinople bought the office for over a century (1711/14–1821). Meanwhile, the Janissary corps gradually degenerated into corruption and lawlessness, while its privileges attracted many ethnic Turks (despite its being officially a Christian-born slave unit) who were only in it for the benefits and tax exemptions, while decreased its battle-worthiness.

In many outlying provinces, the distance from the administrative capital in Constantinople and the inability to exercise systematic control often enabled local officials to establish themselves as virtually independent rulers. At the beginning of the 19th century, this was the case of Egypt, Serbia, and Yanina,[1] while mismanagement and subpar development bred heavy resentment within the Christian population, triggering the revolutionary movements of the 19th century all over the Greek world, from Moldavia to Cyprus, and from Wallachia to Crete.

On the other hand, upon acquiring Catholic territories in Greece, the Turks had given the Orthodox Church a much larger role and freedom on matters spiritual and administrative, as well as judicial and financial privileges. For instance, although there were obligations on the part of the Orthodox population to pay taxes in accordance with the sultanate's fixed policy, the amounts were under those imposed in Western societies, which endeared many locals to the lax government of the Sublime Porte.

The Venetian political and economic expansion in the Levant started in earnest with the capture of Constantinople in 1204 and the subsequent partition of the East Roman Empire, which allowed Venice to enjoy Mediterranean prominence (despite the constant rivalry and military conflicts with Genoa in the Aegean, Cyprus, and the Levant). This drive east was accompanied, in the 15th century, by the expansion in Terraferma, but it still relied heavily the lucrative eastern trade.

The first Venetian-Turkish conflagration started in 1463. A further six were to follow until the early 18th century, all centered on the Eastern Mediterranean and the Greek world. The constant Venetian loss of territory culminated in the war of Candia (1645–1669). The first Veneto-Turkish war (1425–1430) resulted in the loss of Thessalonica, the second Veneto-Turkish war (1463–1479) in the loss of Scutari, Negroponte and Lemnos), and the third Veneto-Turkish war (1499–1503) in the loss of Modon, Coron, Lepanto, Navarino, and Durazzo.[2]

In 1470 Venice lost the island of Negroponte (Euboea), and the war of 1499–1503 started with the defeat of Zonchio (1499), which marked the Turkish achievement of naval domination over the Aegean, and ended with the Ottomans taking possession of Modon and Coron, Santa Maura, but leaving Napoli di Romania, Malvasia, Cefalonia and Zante (the latter for an annual tribute). In the meantime, the Republic acquired the large and rich island of Cyprus (1489), a more than satisfactory compensation for the loss of Negroponte a few years earlier.

The relationship between Venice and the Porte was, however, good under the rule of Selim I and Suleiman I (at least in the first decades of his rule). In a time when the permanent representation of a state in another was an exception, Venice had a permanent representative at the Porte (in fact, the leader of its local community, the *bailo*).

The strategic reasons for the conflict between Europe and the Ottoman Empire began during the reign of Sultan Selim I (1512–1520), who had originally formed a good relationship with his western neighbors, particularly Venice and Hungary, and concentrated his expansionary ambitions towards the East, Middle East and Africa. After defeating the Shiite Persian Safavids at the Battle of Chaldiran (1514) and extending the boundaries of his empire to the current Iraq, Selim annihilated the large Mamluk realm by conquering Syria, Palestine and Egypt, and also incorporated in his territories the holy cities of Mecca and Medina. In doing so, however, the state had reached a limit on the eastern frontier and had to look for enterprises elsewhere.

The Ottomans hardly had a long time strategy to pursue. Basically, they would pick a fight with an immediate neighbor. The famed intention to reach Rome, attributed mostly to Suleiman I, was never pursued, actively or otherwise. There wasn't a firm manifested intention to reach Rome, neither by sea nor by land (except in the two undetermined moves against Apulia, in 1480 and 1537).

In 1537, Suleiman signed an alliance with King Francis I of France against Charles V (emperor of the Holy Roman Empire and king of Spain), and they invited Venice to join them. The Venetian Senate decided to remain in a neutral position, and this prompted Suleiman to retaliate.[3]

In August 1537, the Ottoman fleet besieged Corfu, but the assault was repulsed. However, the entire island was ransacked, and all the captives were sold as slaves in Constantinople. The Ottomans moved swiftly, and all the possessions in the Aegean owned by the Republic or by Venetian aristocrats were captured: Skyros, Patmos, Andros, Ios (property of the Pisani family), Astipalaia (property of the Querini family), Paros (property of the Venier family), Tine, and Naxos (property of the Sanudo family). This prompted the Catholic princes to join in the first Holy League, formed in early 1538, but the big battle sought at Preveza, in September 1538, proved indecisive at best, due to the lack of trust—and therefore cooperation—between the Venetians and the Genoese. The problem was that Spain and Venice had a profound distrust for each other, enhanced by the fact that Charles V's admiral in the Mediterranean was leading Genoese, Andrea Doria.

Eventually, faced with this strategic defeat, the Serenissima sued for peace in 1540 and lost everything at stake, including essential positions such as Napoli di Romania and Malvasia, which hadn't actually been conquered by the Turks. Malvasia is very much like Grabusa in Candia, a fortress perched on the high rock that covers the entire island, and whose steep mountain sides offer only one reasonable access; this made its possession very important for the Republic. On the other hand, Napoli di Romania was the capital of their territories in the Peloponnesus and was situated on a peninsula protected by several modern, round artillery towers.

11

The War of Cyprus, 1570–1574

After the peace with the Ottomans in 1540, the Republic of Venice had followed a wise policy of neutrality, both in the Mediterranean and in Italy, where the Italian Wars (1494–1559), between the parties of the Valois and the Habsburgs, were drawing to a close anyway.

In the wake of the victorious Christian defense of Malta (1565), Venice possessed two important positions in the Eastern Mediterranean—Cyprus and Crete—which secured its trade with Beirut and Alexandria in the Levant. Selim II the Drunk (1566–1574) felt the need to prove himself as soon as he ascended to the throne, having some tough shoes to fill after the long and successful rule of his illustrious father Suleiman the Magnificent. So the new sultan set his eyes on the nearby Venetian territory of Cyprus. This war was the only Venetian-Turkish conflict officially announced by a messenger from the sultan. A declaration of war was made on March 28, 1570.[1]

The defensive policy of the Venetians centered on gathering a fleet to relieve the island. Venice had prepared a fleet of 30 ships under the command of Francesco Zane, who sailed to Corfu, and then moved to rendezvous in Suda with the 20 galleys of Marco Querini from Candia. Spain promised 60 ships commanded by Gian Andrea Doria, Genoa 1 galley, and the pope 12. Malta promised 3, as did the Duke of Savoy, the Medici of Florence and the house Este of Ferrara.[2] But Zane's large formations moved slowly, without a predetermined plan and without a single command, and eventually proved inconsequential to the overall relief effort.

The foreign help assembled at Otranto, waiting for the Spanish fleet coming from Messina, and only on August 19 did both fleets, assembled under the command of Marcantonio Colonna, proceeded to join the Venetian fleet of Francesco Zane, sheltering in Suda Bay.

In June 1570, the Ottoman army, commanded by Lala Kara Mustafa Pasha, came from the Dardanelles on 350 ships of various sizes, boarding tens of thousands men, sailing to a gulf near Limisso, in the south of the island of Cyprus. The troops included about 50,000 infantry, 2,500 cavalry and 80 guns. The Venetians had a total of 5,000 infantry and 500 cavalry available, which they concentrated in Nicosia and Famagosta, the strong points of the island.[3]

The Turks went directly to lay siege to Nicosia, the capital of the island, which was defended by a garrison of about 3,000 men commanded by the governor of the island, Niccolo Dandolo.

The Siege of Nicosia (1570)

The configuration of the ground, the weaknesses in the design of the fortifications (namely lack of outworks), and the relative suddenness of the Turkish attack in the summer of 1570 substantially subverted the value of Nicosia's fortifications, and the city fell after a brief siege, on September 9, 1570.

The main weakness of the fortification was the lack of outworks—which allowed the Turks to engage the main walls directly and quickly. A large fleet was assembled in Crete by the Holy League and had just passed Rhodes when it was turned back by the news of the fall of Nicosia.[4] Reassembled the following summer, with similar strength, it crushed the Ottoman fleet at Lepanto.

After landing near Limisso on July 1, 1570, the Turks of Mustafa Pasha marched quickly and invested Nicosia itself, from the high hills opposite the Constanza and Podocatarro bastions that had not been included in the fortification works of previous years.

The siege lasted seven weeks, from July 22 to September 9, 1570. The only significant Venetian sortie was on August 15, but the governor of the Cyprus, Niccolo Dandolo, was unwilling to commit all of the reserves, and it amounted to nothing, despite initial Venetian success in overrunning the forward works of the Ottomans.[5]

The Turks obviously had the sheer advantage in numbers, so much so that, the day before the storming of Nicosia, they mounted an all-out attack that targeted four bastions (from D'Avila to Caraffa), on a front larger than any of the sieges of Birgu (1565), Candia (1648–69) or Corfu (1716).

They managed to climb the Constanza face in early hours of the day of September 9, 1570, surprised the defenders, and, after taking that bastion, spread out to outflank the others—first Podocattaro and Tripoli. Further significant resistance was offered in the Cathedral Square, the Lusignan Palace and, finally, the bastion of Barbaro, the last to be stormed. As with the forces inside the palace, the defenders laid down their arms on false promises; they were all put to the sword. The massacre that followed killed almost all the inhabitants of the city (20,000 souls) and enslaved the others.[6]

The initial redesign of Nicosia focused on the street pattern, which was meant to be altered to a more manageable military form (grid or radial); this could be partly to blame for the lack of communication lines adequate enough to stem the Turkish attack on the Constanza bastion.[7] The truth is that the town is huge, and it was hardly possible to maneuver companies of heavy foot swiftly from the north to the south bastions. The Venetians simply needed far more soldiers in order to man the walls properly.

The Siege of Famagosta (1570–71)

After the fall of Nicosia on September 9, 1570, the Turks slaughtered most of its defenders and carried away to slavery the population of the town. The heads of the leading officials of the island were sent to Cerines, with an offer to surrender the place in exchange for their lives, livelihood and safe passage—which was accepted, since that fortress had but a few modernizations and thus was not capable of withstanding any serious siege by a significant army.

The same move was attempted in Famagosta, but the town fared much better militarily,

and the fate of their counterparts in Nicosia did not deter the commander, Marcantonio Bragadin, from refusing to hand over the place. Chiefly, he was counting on the partial demobilization of the besieging army for the winter, which would buy him time until the arrival of a relief force.

It was not the custom of the age to mount campaigns in winter, or, generally, in any unsuitable environment. In fact, it was very difficult, given the logistics of the time. That is what the Hospitallers had counted on in the Turkish siege of 1521; this can be seen in the fact that they only summoned reinforcements from Kos and Lindos to Rhodes in November,[8] after five months of siege, when it became clear than Suleiman II would not break off the battle. By that time, however, the defenders were running empty on victuals and materials and they had no solution but to yield the great Gothic town. In fact, the resilience of Ottoman siege of Rhodes was due to the presence of the sultan himself on site.

At Famagosta, as expected, in the winter months, the siege turned into a simple land blockade, and most of the Turks returned to the mainland. A significant portion of the original army were Bashibazouks, and these irregular troops were self-financed and thus lived off booty. When the winter came, they simply disbanded and went home, only to rejoin the siege in spring.

The Siege of Famagosta lasted from September 22, 1570, to August 4, 1571, and was the most dramatic battle of the war for Cyprus. The besieging Turkish army, which peaked at 200,000, faced a city defended by a scantily reinforced host of 8,000 Venetians and local aux-

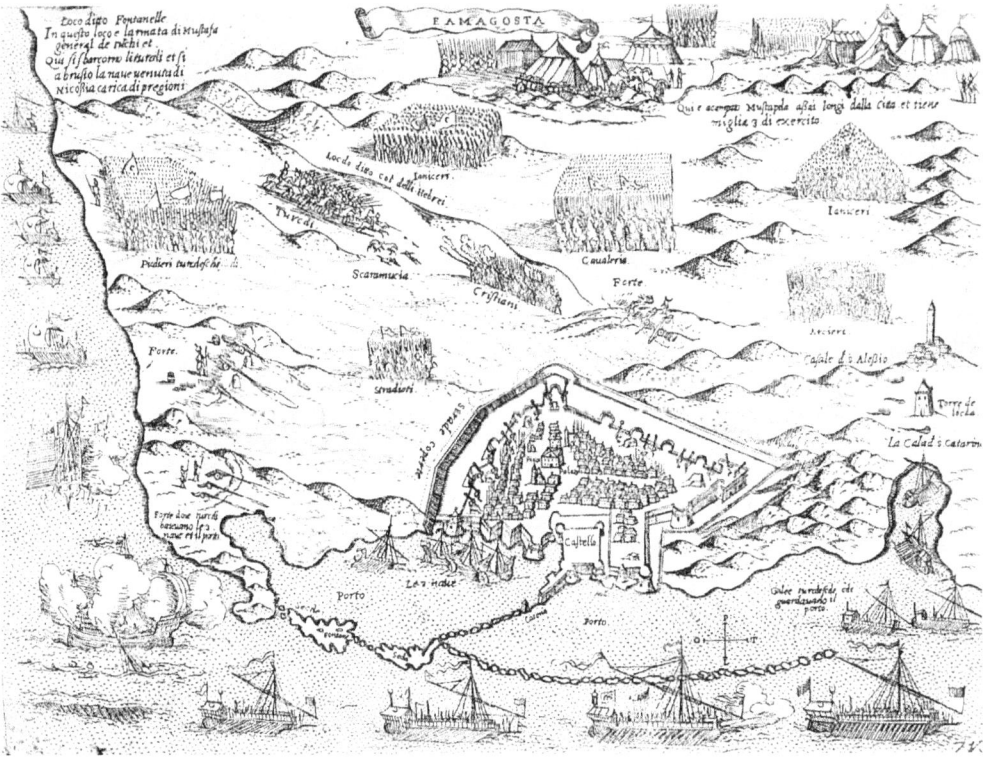

Figure 100. Giovanni Francesco Camocio, *Famagosta*, 1574 (courtesy the Ministry of Culture and Tourism, Biblioteca Nazionale Marciana Venezia. All rights reserved).

iliaries. After ten months the garrison was reduced to 1,500 men, while 50,000 Ottoman soldiers had perished.

There are detailed maps of the siege by Giovanni Camocio, Stefano Gibellino and Simon Pinargenti, as well as narratives of the siege of Famagosta from actual participants—such as Pietro Valderio, *La Guerra di Cipro* (1573)—and chroniclers—such as Paolo Paruta, *Storia Veneziana* (1599). From their writings come the figures of Marcantonio Bragadin, Venetian military commander in Famagosta, his lieutenants, and the locals and their heroic resistance against all odds.

The defenders survived the land blockade for the whole winter. With the arrival of spring, they were expecting to receive substantial aid from Venice. However, the great fleet assembled in 1570 and destined for Cyprus had already turned back from Castelorizzo upon hearing the news of the loss of Nicosia, assuming Famagosta would not survive for long either. The logistics of the time meant that keeping a ship manned and supplied at sea was costly and very difficult over a great length of time. This meant the ships had to return to port in winters and needed to be commissioned again next spring. So the same arduous task of putting together a joint fleet from several navies—chiefly Venice, Spain, the Hospitaller Knights and the papacy—had to be started all over again, both diplomatically and logistically, in early 1571. The result, just like in 1570, was that the fleet did not arrive in time. In fact, it maneuvered between Cerigo and Corfu and eventually engaged and crushed the Turks at Lepanto, the climatic naval battle of the age. For the logistics of the age, Cyprus was just a bridge too far.

It's worth mentioning here that the leader of the allied fleet of 1570, the Venetian admiral Francesco Zane, advocated an ambitious strategy: to take the war to the Dardanelles, to steer the entire fleet north and cut the vital sea supply routes to Constantinople.[9] This wise strategy was enacted during the great war of 1645–1669, leading to major naval engagements in the Aegean and ensuring the survival of Candia for the better part of that 25 years of conflagration.

With the advent of spring, at the start of April 1571, the Ottomans resumed the assaults on the walls of Famagosta, concentrating on the Arsenal Tower, the Land Gate and the entire front between them. Meanwhile, the beleaguered army received reinforcements in January, when a flotilla of 13 galleys and 4 ships from the former grand allied fleet of 1570, under the command of Marco Querini, forced the blockade and landed 1,700 men and 150 guns, plus food and ammunition. But the city's inventories showed that the victuals were running low by then.[10]

By the middle of May, the Turkish trenches had reached the counterscarp, and from their forts, on May 19 the bombing began, on daily basis, and lasted for the next 70 days.

Undermining was a specialty of the Turkish siege machinery and something they relied heavily on, even in the age of gunpowder artillery. Especially since their guns and gunnery were not on par with their European counterparts, the Ottomans tended to compensate with the old tactic of mining the walls. On June 21, a mine opened a breach in the bastion of the Arsenal, and the subsequent assault was driven back after five hours.

A landmine exploded on June 29 under the ravelin, where the Venetians had repelled six assaults already. From the drawings of George Jeffery[11] it is clear that the Land Gate complex counted on an outer ravelin, over the counterscarp, accessed from the current ravelin by a bridge spanned to the counterscarp. This place features prominently in the historical accounts

as having been subjected to heavy fighting. Thus, on July 9, to stop the Turks who were gaining a foot inside at the start of the Land Gate structure, the Venetians blew up the ravelin themselves, killing thousands of the enemy.

However, the Turkish assaults targeted this point again from July 14 to 19, along with attacks on the Santa Napa and Andruzzi bastions. Then the focus changed, and a general attack occurred uninterrupted, from July 29 to 31, on all the bastions from the Land Gate to the Arsenal, culminating with another big mine blowing off the front of the Arsenal, leaving only the flanks standing.

In the wake of this additional failure, Lala Mustafa sent a generous peace offer on August 1, which pledged that the defenders would be allowed to return with weapons and possessions to Crete, the closest Venetian territory, and that for this purpose the Turks themselves would provide the transport vessels. For the Cypriots of the city, the pasha offered the freedom to follow the troops or stay under Ottoman suzerainty.

By this time, the defenders were reduced to 700 soldiers, one for every 195 ft. of the defensive perimeter. With no relief in sight, the Ottoman offer was accepted in good faith by the Venetians and the Famagustans, on August 4.

On August 5, Bragadin and his lieutenants were invited to formally hand over the keys of Famagosta to the pasha, who arrived in the Turkish camp in full regalia and with a suite of 200 soldiers. Here the pasha invited the leaders to his tent and, after a short conversation, changed his temper and assaulted them and their retinue, killing most of the leaders.

The motivation for Lala Mustafa's deception and cruelty are not known, because he left no explanation for his deed. Compared to its European counterparts, the Ottoman Empire was a structure less keen to accurately record its history and to search for explanations for leadership actions. The historical sources come from the Cypriot participants at the formal surrender meeting, who all survived the slaughter. Also, a young Venetian—Nestor Martinengo—was saved by a eunuch and eventually made his way to Syria in a one-man fishing boat.[12]

The account of Pietro Valderio[13] mentions that the pasha's disposition was good but worsened towards the end of the discussions, on various grounds, such as the alleged execution of few war prisoners, and the refusal to designate a Venetian noble or officer as a hostage. However, it is very clear that his actions were not rushed, but premeditated, since the Ottoman troops in the camp were quick to spring into action and kill all the Venetian soldiers present, as well as raise the chain of the harbor to trap the already-embarked veterans.

Bragadin's lieutenants were beheaded on the spot, while he had his nose and ears cut off. After a couple of weeks, on August 17, he was paraded through the main streets of Famagosta and flayed alive in the square between the palace and the cathedral. His skin was tanned and stuffed and send to Constantinople, from which a fellow Venetian citizen smuggled it in 1580. It now lies at rest in the church of SS. Giovanni e Paolo.[14] His funeral monument is crowned by a marble bust, on the background of a fresco with allegories and a long dedication. The church is closely associated with the leadership of the Republic after the 15th century, and many doges are buried there, as well as several land and naval commanders, so his burial there is a contemporary recognition of his valor and martyrdom. A bronze bust of Bragadin is now displayed in the armory within the premises of the Pallazzo Ducale in Venice, where one of the frescoes on the ceiling of the Senate Room depicts his execution.

Meanwhile, the long-negotiated Holy League was finally signed in May by all the states

178 Part V. The Defenses Under Attack

concerned. The pope was able to persuade Philip II to participate in the alliance against the Turks, and the Holy League, made up of the Republic of Venice, the Pope and the king of Spain, was formed on May 25, 1571. They were later joined by Florence, Savoy, Urbino, Ferrara, Parma, Mantua, Genoa and Lucca.

But the grand allied fleet was joined by the Spanish navy in Messina only at the end of

Figure 101. Ruins of the Church of Sta. Annunziata in Corfu, where the fallen from Lepanto were buried. Note the effigy on the right side and the typically Italian bell-tower.

August, and so could not have reached Cyprus before October anyway. This new, united, large allied fleet, set sail to engage the Turks, counting on a total of 200 galleys, 1,800 guns, 28,000 soldiers, and 12,500 sailors and rowers.[15]

On the morning of October 7, 1571, the allied fleet, led by Don Juan of Austria, came in sight of the Curzolari, islets at the mouth of the Gulf of Lepanto, and the Ottoman navy immediately went out and drew up in order of battle in front of the enemy.

The first to engage were the galleasses in the center of the Christian line, which helped the left wing pin the Turkish right wing onto the shore of the Gulf of Patras and crushed it within the hour. Meanwhile, the Ottoman left wing, led by Uluj Ali and formed mostly by corsairs, fared better and eventually escaped the debacle, disengaging when the Turkish center gave way too. By the end of the clash, the Ottomans had lost 170 galleys sunk or captured, and suffered 30,000 casualties, while the Christians lost only 10 galleys.[16]

The battle was one of the most celebrated victories in Christendom. News of the victory of Lepanto produced a remarkable joy in all the countries of the Catholic world, and the pope declared it a feast day.[17]

In spite of the great exploit at Lepanto, lack of further significant Spanish involvement meant that the Venetians had to sue for peace, forsaking the island of Cyprus. While the Ottoman expansion had been checked in the western Mediterranean at Malta, after the fall of Famagosta, they held on to the Eastern Mediterranean (until the arrival of the English in 1878).

Through the mediation of the king of France—who had been traditionally, since Francis I, on more than good terms with the Turks—peace was signed on March 7, 1573. Venice renounced Cyprus, Dulcigno and Antivari[18]; paid, in three installments, a war indemnity of 300,000 ducats; and renewed the tribute for the island of Zante[19] in exchange for preserving her old privileges throughout the Ottoman Empire.

The issue with the apparent Ottoman naval prowess is that it exhibits similar aspects to that of other people with no actual seafaring background. Just like that of the Arabs previously, the Turkish naval golden age lasted only two or three generations and left no lasting traces. The Turkish exploits were solely the result of exceptional personalities, not of serious technological achievements. Basically, it comes down to dare and numbers, and once the able commanders—mostly from regions with naval traditions predating the Turkish possession—were physically gone, they left no unique legacy for the next generations, other than their memory. Apart from a few exceptional decades in the middle of the 16th century, the Turkish fleet showed no particular expertise in the construction of ships and had no significant commanders.

A real naval tradition requires not only generation after generation of seafarers but also improvements and innovations in construction and navigation techniques, and that is precisely where the absolute Venetian superiority lay and what the republic trusted to turn the tide in the next confrontations.

12

The War of Candia, 1645–1669

By the 17th century, the Turks were more interested in maintaining their superpower image in the Eastern Mediterranean than in preserving their lucrative trade with their main Western partner, Venice.

The first occasion for war came in 1638, when the Venetians attacked and destroyed a fleet of Barbary pirates who had taken refuge in the Ottoman port of Valona.[1] The city was bombed, causing the wrath of the Sultan Murad IV, but war was averted by paying a compensation of 250,000 gold coins.[2]

On September 28, 1644, the Knights of Malta attacked and captured a convoy of Muslim pilgrims sailing to Alexandria, on the way to Mecca for the pilgrimage of Hajj, among whom were high Turkish dignitaries, such as the great eunuch of the palace and a sister of the Sultan.[3] The Maltese unloaded their booty on the shores of Crete, thus involving, indirectly, the Venetian authorities.

When the news of the act reached Constantinople, the French ambassador (since many of the Hospitaller Knights were French) and the Venetian *bailo* were summoned to court to account for their alleged connivance with the martial monks. Both ambassadors protested the innocence of their respective countries, so the sultan ordered a punitive expedition against Malta.

The reigning sultan was at the time the mentally unstable Ibrahim, new to the throne (1640–1648). As was customary for any new sultan, he had to prove himself a worthy ruler by virtue of his military prowess, which meant mounting an offensive campaign. Another reason for wars of conquest starting quickly after a new sultan arrived on the throne was that the military machinery—chiefly the Janissary slave-soldiers—clamored for significant pillaging opportunities as means to increase wealth. The Ottoman armies were more accustomed to share in the spoils of war than their increasingly professional European counterparts.

In the early summer of 1645, the Ottomans had gathered an army of 50,000 men, including 7,000 Janissaries, and more than 400 ships. These were mostly transports and ships of lesser quality, but among them were 50 galleys from Constantinople, and 25 sent by various provincial governors.[4]

Having first sailed for the sheltering bays of the southern Peloponnesus, the fleet weighed anchor from Navarino on June 20, 1645, then put to the sea directly towards Crete. Three days later it appeared unexpectedly at the gulf of Canea. Stopping in Navarino Bay meant they were already committed for the west and had passed the approaches to Crete, thus making their next move a turn back.

The fact that the Porte choose to deceive Venice shows its feeling that the Turkish navy and army needed the element of surprise in order to storm an important city in Crete or even reach the Sea of Candia intact. This second fear was not at all unfounded, since immediately after the Venetian fleet mobilized, and when eventually a decent and intrepid commander was put at its helm, it managed to control the waters north of Crete and the entire Aegean all the way to the Dardanelles. Yet despite the acknowledgment of its own shortcomings, the Porte refused (in the 1650s) the Venetian overtures for peace with full restitution, which was a rebuttal due to pride, not to political wisdom.

The leadership was certainly the critical point of all strategic choices throughout the Venetian wars and for all pan-European coalitions such as the Holy League. In the case of coalitions of the 16th century, except for Don Juan of Austria, the victor of Lepanto, the allied fleets were plagued by a loose command and divergent and egotistical interests. While Venice indeed counted on great naval commanders, many times the leadership was awarded to political generals (men chosen based on the political patronage or family ties, and not primary on competence), and such choices proved ill fated.

The first sea commanders appointed in the wake of the Turkish surprise attack—Niccolo Ludovisi and Antonio Capello—displayed a lack of meaningful action. As a result, the Turks were able to take Canea and then to land troops to overrun the rest of the island.

In the first year of the war, Venice still feared Turkey as a worthy sea power, and called upon the Christian West, getting attention only from the Holy See, Malta, Tuscany and the Spanish of Naples. These countries were still tied to the old Christian ideal of common defense against the Turks, and also by their basic geopolitical situation—being already in a state of almost permanent quasi-war with the unruly Barbary pirates, and thus with their nominal Ottoman overlords. Besides the obvious situation of the Hospitaller Knights of Malta, Tuscany also had its own local martial monks, the Knights of S. Stephen, equally involved in fighting the Muslim pirates in the western Mediterranean.

While the government of France's cardinal Mazarin had refused Venice's request for help at the start of the conflagration—mainly since it was involved in a strenuous war with Spain (1636–1659), which had surpassed the duration of the Thirty Years' War—it was Louis XIV, the Sun King, who sent troops to Crete in the 1660s. The change of gestalt is visible: in the 16th century, Spain had been the Defender of the Faith, while France nearly fell under the sway of iconoclastic Calvinism; in the 17th century, however, France was the Defender of the Faith, and Louis XIV the Champion of Catholicism.[5] Spanish troops had relieved Malta in 1565; French troops nearly saved Candia in 1669.

The Siege of Canea (1645)

On June 23, 1645, the Ottoman army arrived off the coast of the Canea, and under the protection of the guns of the ships, the Ottomans proceeded to land on the west beach of the island.

To secure the sea in front of Canea for landings, the island of S. Teodoro was stormed first. Biagio Giuliani, commander of a small fortress there, guarding the approaches to the port of Canea, colossally outnumbered, and faced with the futility of the resistance, set fire to the magazine, killing himself and a host of attackers.[6]

After the Ottomans gained foot in Crete, Canea came under systematic bombardment from land and sea, and suffered frequent assaults on the walls. The city, enclosed by curtains that were long and bastions too distant for effective flanking (especially on the western front), was defended only by 800 soldiers, 500 militia, and 100 guns under the command of Antonio Navagero.[7]

The Venetian fleet stationed in Suda Bay—consisting of the galleys of the realm of Candia—felt too weak to engage the Ottomans and to try to dislodge the troops from their sea support, but it did sent three galleys into Canea, with a reinforcement of several hundred men.

The Venetian fleet at anchor in Suda Bay failed to act, and blame was justly put on the commander Antonio Capello, who refused to answer the call of the commanders in Canea to sail out, engage the enemy and scatter its fleet. Capello choose not to act alone, instead waiting, in vain, to be joined by the Venetian fleet stationed in Corfu, which, however, had clear orders to patrol and block access in the Adriatic. This Venetian grand fleet was itself also waiting to be reinforced by the republic's Italian allies. The Italian states had gathered a fleet of 20 galleys under the command of Niccolo Ludovisi and these, combined with a similar-size allied fleet, only arrived off Zante on August 29, 1645, seven days after the surrender of Canea. Later, it made little impression in the waters off Crete for the rest of the year, failing to recover the city or stop further Turkish advances.[8]

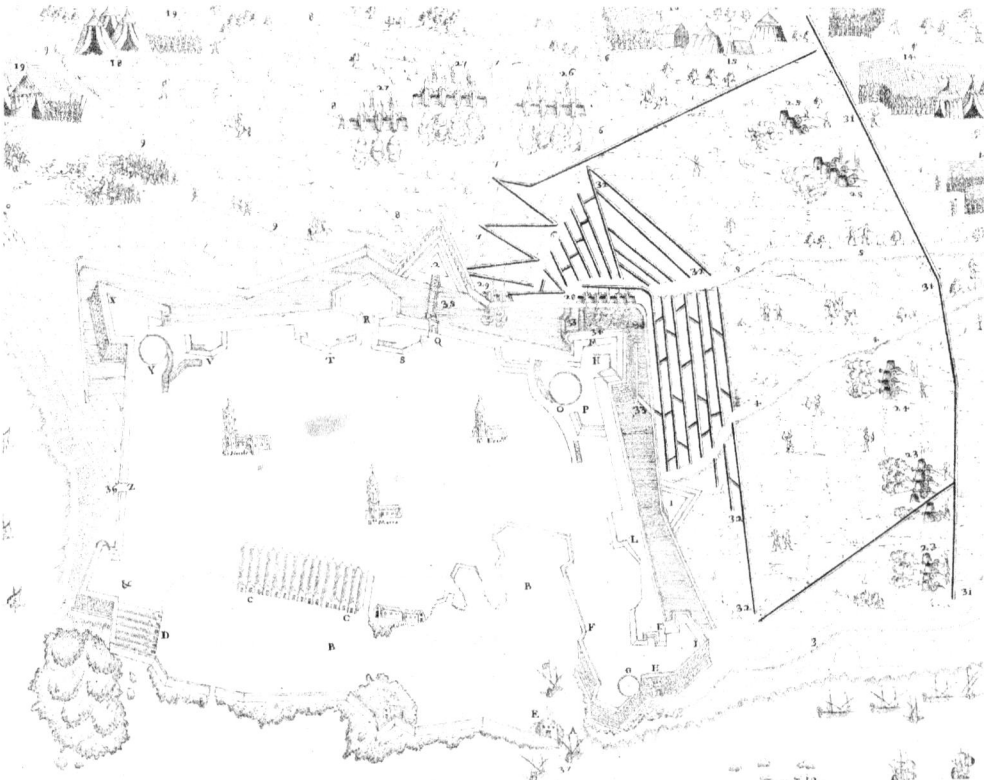

Figure 102. *Citta' della Canea*, map of the siege of Canea in 1645 (courtesy the Ministry of Culture and Tourism, Biblioteca Nazionale Marciana Venezia. All rights reserved).

Andrea Cornaro, governor of the island, was busy gathering and organizing the militias in the island, of which only a few hundred, however, managed to arrive in Canea. The Venetians had secured one land route, hurrying troops from the Gulf of Suda, overland, over the peninsula of Akrotiri and entering the city at the original Sabbionara Gate.

In all, no one moved effectively to its aid, and Canea had to rely on its own strength alone. Although scarce in resources and manpower, the fortress did everything to keep the enemy at bay, with the defenders laboring ceaselessly to dig tunnels for countermines, covering breaches, and staging sorties to disrupt enemy engineering. However, the the valor of the Venetians alone could not achieve anything more than to delay the fall of the city.

The map of the siege, Figure 102, shows the Turks focused their attacks and trenches on the isolated corner bastion of Schiavo, which, although covered by a strong cavalier behind it, was too far from the Gritti bastion on its right flank.

After an abortive Venetian attempt to break the siege on land, on August 17, the Turks exploded a mine under the Schiavo bastion, which was partly occupied by enemy soldiers. While the Venetians did manage to repel this attack as well, so few of them remained that further resistance was futile. The vivid chronicle by Sertonaco Anticano gives detailed accounts of their acts of bravery, as well as names of all the important officers who fell.[9]

Running out of supplies and men, and rather than lose the city in an assault, the commanders chose to sue for peace, which was agreed by treaty on August 22, 1645.[10] Canea surrendered after two months of continuous assaults and bombardments, and the people and the garrison were allowed to sail away in galleys, with the honors of war, while 500 infantry took the land route and went east to reach Retimo and Candia and fight another day.

The capture of Canea gave the Turks an important base of operations. In 1666 a major effort by the French and the Venetians to remove the Turkish from their main base at Canea was unsuccessful (as was another siege, conducted in 1692 by Aloisio Mocenigo, and Canea and Crete itself were forever forsaken after that).

The Siege of Retimo (1645)

Shortly after the conquest of Canea, and having failed against the island fortress of Suda, the Turks went after Retimo, the third largest town in Crete. As we have seen, the city was defended only by a citadel and a long, straight wall with very limited flanking capabilities.

Figure 103 shows the city of Retimo under attack, as well as the parallel lines dug by the assailants. The Turks concentrated on the Sabbionara bastion, which, although the strongest, was effectively isolated from the next bastion by a too-long curtain. The bastion also lacked recessed flanks or any kind of outworks.

Following the failure of the first Ottoman assault, the Venetians attempted a sortie, but this failed. On October 20, after another assault was initially rejected, the enemy finally broke into the city, slaughtering all those who could not take refuge in the citadel, including the governor of Candia, Andrea Cornaro, who was shot in the chest while directing the movement of civilians into the fort.[11]

Once inside the town, the Turks besieged the citadel and started digging approaches to S. Paolo's bastion, since here the earth was softer than the rocky outcrop towards the sea and the harbor. On November 13, the commander of the fortress, Luigi Minotto, surrendered in

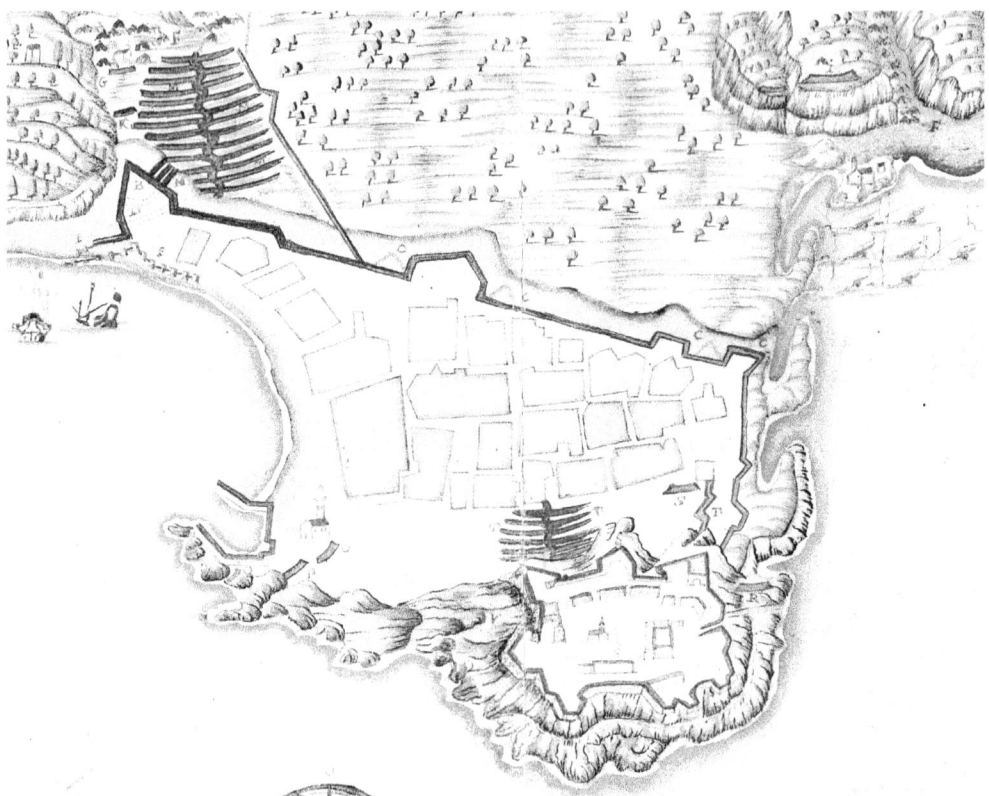

Figure 103. *Pianta della citta' et fortezza di Retimo*, 1646 (courtesy the Ministry of Culture and Tourism, Biblioteca Nazionale Marciana Venezia. All rights reserved).

exchange for the freedom to leave for the garrison.[12] It has to be said that much had changed in the attitude of the Ottomans, who kept their word and treating their vanquished fairly— a far cry from the fates of the commanders of Modon (1500) and Famagosta (1571), who were gruesomely executed.[13]

After Retimo, apart from small castles and auxiliary troops, the way was opened towards the capital. The following spring, the Turks began to move from Retimo towards Candia, securing their rear by taking the towns and forts of the rest of the island.

In 1645 Bonriparo fell, and once it became clear the siege of Candia turned into a long blockade. In 1647, the Ottomans moved against Castel Chissamo in the west of the island, Castel di Apicorno and Milopotamo south of Suda, and Paleocastro and Temene near Candia and Girapetra in the southeast. They marched slowly to acquire the entire island. The southern, largest fort, Castel Selino, fell in 1653, after Sitia was evacuated in 1651.

One of the very few land battles—that was not a simple skirmish—of the whole war occurred on June 31, 1647, on Crevaquori hill, 40 miles from Candia. The European army, numbering 5,000 infantry and 500 cavalry, managed to miss on an easy win.[14]

Although the Venetians did recover the island of S. Teodoro in 1650,[15] by 1651 the Ottomans had placed the whole of Crete under their control, with the exception of Candia and the strong island fortresses such as Grabusa, Suda and Spinalonga, and were blockading and bombarding the capital.

Apart from the sieges on land, naval operations proved crucial to the course of the war. Venice counted on its sea power to intercept the invader and destroy its lines of communication, to isolate its occupation forces and thus compel it to abandon the island.

The reaction of Venice was quick, but not as determined as it could and should have been—and blame was rightly assigned to the active command. The head of the fleet had been entrusted to the nephew of Pope Gregory XV, Niccolo Ludovisi, and such a political nomination proved ominous. The disparity of opinions, unpropitious weather conditions and irresolution prevented a decisive blow against the invaders. After the fall of Canea and the inactivity of the allied fleet of over 60 galleys in the last half of 1645, the Venetian Tommaso Morosini was put in command of the fleet, now almost entirely Venetian, that sailed in 1646.[16]

Morosini argued that to retake Canea and relieve the entire island it was necessary to send the fleet to the Dardanelles, thereby blocking supplies to Constantinople itself, where most victuals arrived by sea and which was the port of call of the Turkish fleet. His aggressive strategy was approved, and ships were sent to the Dardanelles, at the narrow point of Canakkale, to prevent the release of the Ottoman fleet.

In Turkey, the interruption of the sea trade with Constantinople wreaked economic havoc: the Porte reduced privileges and raised taxes, causing widespread clamor; the payment of pensions to 30,000 orphans and widows was suspended for one year; and the currency was devalued by a third.[17] This had a political backlash: viziers were murdered and replaced in quick succession, and the sultan Ibrahim I himself was deposed in 1648.

Although weak compared to its rival in terms of ground forces, Venice possessed a fleet at least on equal footing with the Porte in terms of numbers and certainly outmatching it in quality, and its strategy was to stop supplies to the army of occupation in Crete.

Here the two strategic objectives are revealed: the Ottomans needed to supply the troops landed in Candia and therefore avoided as much as possible any significant clash with the Venetian fleet, while the Venetians, having the need to prevent the arrival of supplies and reinforcements, sought to engage the enemy fleet and destroy it to gain total control of the sea.

Naval blockade of the magnitude required was not possible because the extent of the Ottoman Empire in the Mediterranean was such—they held all the shores from the Ionian Sea to the Gulf of Sirta, plus the vassal Barbary ports of the Maghreb—that the ports and the routes by which they could ferry men and equipment to their invasion in Candia were too many to check them all. The Turks organized convoys from Rhodes, Egypt and the Peloponnesus.

Venice boldly engaged their enemy in their domestic waters, steadily pushing north the line of engagement. Magnificent victories were recorded by the Venetians throughout the Aegean, and Tommaso Morosini and Lazzaro Mocenigo swept away the Turks from Euboea (January 27, 1647), Phocaea (May 12, 1649), and Naxos (July 10, 1651).[18]

The Venetians mounted consecutive summer campaigns (1654–57) to blockade the Dardanelles, to stop the sortie of the Ottoman fleet and even to force the straits into the Sea of Marmara. Tenedos and Lemnos fell in 1654, to serve as a base for ships and troops manning the blockade of the Straits. With these points closing the supply lines to Constantinople, the Venetians would have pressed on and driven the Turks off Candia—now left without their naval cover—but the following year these major islands were reconquered by the Ottomans and Venice lost the opportunity to relieve Candia. Also, fortifications were built in the Dardanelles during the war of Candia, making unlikely the resumption of the naval blockade.

In the Dardanelles from 1654 to 1657 bloody battles were fought and the Ottoman navy was repeatedly crushed, as on June 26, 1656, when it suffered its heaviest defeat after that of Lepanto.[19] Unfortunately, all the Venetian naval commanders of these campaigns met their doom during the battles. On the last of these Dardanelles engagements, in 1657, the great Venetian hero, naval commander Lazzaro Mocenigo, died.[20] Already a national hero for his previous victories during the war, he reached the status of myth in Venice after death. In fact, beside his bust in the family palace on Rialto Island, behind the S. Stae church, there is a bust of him in the Venetian Pantheon[21] and a large painting in the Naval Museum. Having already lost an eye in previous military engagements, this is how he is depicted in all these instances. This aesthetic choice proves he was immortalized in the moment of his military glory.

The Siege of Candia (1648–1669)

The encirclement of Candia lasted for the largest part of the war, from May 1648 to September 1669. The town held out for 20 whole years, thanks to its stupendous defenses and to the fact that its supply lines by sea remained largely open.

Candia and its massive, strong walls revealed themselves as the insurmountable obstacles they were designed to be. As we have seen, the walls of the city were impressive, reinforced by a complete set of ramparts, bastions and advanced outworks (ravelins, hornworks, crownworks and redans). This chain of advanced forts was constructed over the counterscarp of the moat and linked together by a maze of trenches. Candia was one of the best examples of Italian-style fortifications (which were matched, and later surpassed, only by the genius of the French engineer Vauban in the second half of the 17th century).

After the peace of Vasvar (1664) ended the war with Austria, Turkey was able to concentrate all its army towards taking Candia itself. On the sea, the Turks found respite after barely escaping the chokehold on their capital in the Dardanelles campaigns. The years 1661–1666 were almost blank as far as warfare was concerned.[22]

In the autumn of 1666, Grand Vizier Ahmed Koprulu landed on the island in person, at the head of massive reinforcements, to oversee and press to completion the siege against the heroic resistance of the Venetians, which was led by the *provveditore generale* of Candia, Antonio Barbaro, General Wertmüller, the Savoyard officer of Swiss origin in command of the Venetian artillery, and the *Capitano Generale da Mar* (Captain General of the Seas), Francesco Morosini. Morosini—who was to rise to the highest appreciation during the later Morean War, when his exploits brought him election as doge—was inextricably linked to the War of Candia, since his earlier investiture, at only 27 years of age, in 1646, as commander of the land forces on the island. He held this magistracy twice, 1646–1661 and 1667–1669.

In the spring of 1667, Koprulu began construction of a new, fortified camp for his 70,000 men, against which were pitted the 6,800 infantry of the Venetian garrison.[23] This fortified camp was in the area south of Candia now known as Fortezza, called by the Turks Inadiye (Nova Candia), since a virtual town had emerged complete with houses, storehouses and mosques, not a mere tent camp. Gerola found evidence of this settlement in the form of stone walls.

In this phase of the war, land troops were needed, apart from the mercenaries, available in Europe after the closure of the Thirty Years' War. This time France had strengthened

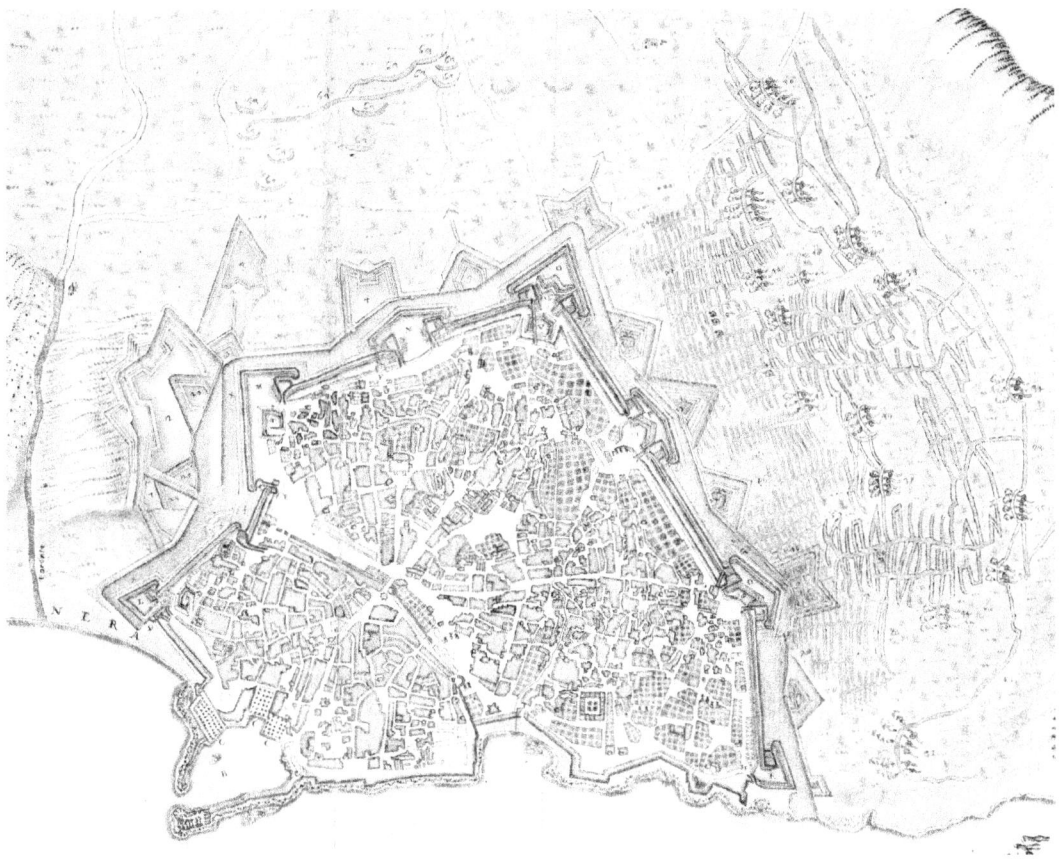

Figure 104. *Pianta della citta di Candia assediata dall'armata ottomana con il terzo attacco fatto dal Gran Visir l'anno 1667 sotto il Generalato dell'Ecc.* Antonio Barbaro, 1667 (courtesy the Ministry of Culture and Tourism, Biblioteca Nazionale Marciana Venezia. All rights reserved).

Catholicism within its borders and was now ready to defended it outside of them, so cardinal Mazarin, minister of the young Louis XIV (1643–1715), answered the call. In the summer of 1660 he sent a body of 4,200 soldiers under the command of Prince Almerigo d'Este.[24]

Koprulu launched a powerful attack on May 24, the first of over 50 assaults over the next two and a half years. Figure 104 depicts the situation from 1666 to 1667, when the Turks had concentrated their attacks on the western front of the place, from the Martinengo bastion to the Panigra bastion, and shows the Turkish batteries and the parallel lines of trenches dug. From May to November of 1667 the Turks attacked the ramparts 30 times and were always rejected, and the besieged garrison mounted 17 sorties, at the cost of 3,200 defenders and also over 20,000 Turks.[25] In February 1667, further French reinforcements reached Candia, but these were fewer than expected because shortly thereafter the first of a long series of wars undertaken by Louis XIV (the War of Devolution, 1667–68) would break out.

However, in 1667 a Venetian military engineer, Andrea Barozzi, defected to the Turks and advised them on the weak spots in the town's defenses,[26] especially where they met the coast at S. Andrea bastion on the west and the Sabbionara bastion on the east. This prompted

the Turks to concentrate their fire and attacks here. Thus, in the last two years of the siege—as contemporary maps of Antoine de Fer and those collected in the tome *Carte topografiche ... della guerra di Candia*[27] show us—the Turks had opened trenches towards these bastions. In fact, by the end, S. Andrea was completely ruined and overrun by the Ottomans, so much so that upon reconstruction after the war, it was altered severely from its original form.

The last significant effort was made in June of 1669, when Louis XIV of France sent 6,000 soldiers commanded by the Marquis of Noailles and the Duke of Beaufort, a very strong contingent that was sure to turn the tide of war.[28] Immediately after landing on June 19, the French insisted on employing aggressive tactics, and on the morning of June 25 their forces sallied forth; but their endeavor ended in sad failure, with the duke himself (a relative of the French king) missing in action.[29]

A further blow came when the French expedition lost their fleet's prize, the large ship *Therese*, to an accidental explosion on July 24, 1669.[30] Following these setbacks the French abandoned Candia, leaving Commander Francesco Morosini with a much reduced garrison and very limited supplies. In the last 28 months of the siege of Candia, in continuous assaults and bombardments, over 80,000 Turks and 20,000 defenders of the city perished.[31]

By August, there were only 3,000 Venetian troops in the city, so a council of war, convened by Morosini on August 30, decided to surrender and to enter peace negotiations. The final treaty was signed on September 16, 1669, and the town was evacuated on September 27, 1669. Almost half of a millennium of Venetian rule had ended.

Morosini signed at his own initiative the surrender of the city, obtaining permission from the Ottomans for all the population to retreat with all their movable property. The garrison was allowed to leave the city with weapons and with full military honors. No one paid any ransom or war indemnity.

Back home, Morosini soon went to trial for treason and cowardice, but was acquitted. However, this trial must be understood in the highly bureaucratic context of the aristocratic commercial republic: Morosini had taken a decision that surpassed his level of authority, without counsel and consent from the proper hierarchical command. However, he had received a mandate to defend Candia until further notice, and could not have taken any other strategic decision.[32]

The loss of Candia brought to an end four and a half centuries of Venetian dominion over the island. The peace allowed the Venetians to maintain small but vital naval bases (Grabusa, Suda, Spinalonga) in Crete, and also to retain Tine, Cerigo and certain conquered territory in Dalmatia.

13

The War of Morea, 1684–1699

The climactic war of Candia had ended with an affirmation of the naval superiority of the republic, and so the subsequent victorious war of Morea capitalized on that superiority with the most extensive territorial conquests from the Porte in all of Venetian history.

However, this is the case because in previous conflicts Venice had been on the defensive, which meant the Ottomans had better chances of winning since they were thoroughly prepared. Also, the lesson of the naval campaigns in the previous war was that the Ottoman ability to deploy land armies around the Aegean depended mainly on naval logistics, despite the availability of roads, since their quality and reliability was low throughout their realm.

After the glorious feats of arms in the naval battles of the War of Candia, it became clear, for the first time in their history, that Venice should actually try to defeat Turkey, by then a mere shadow compared to the era of Suleiman the Great.

The war of Morea was the only one of the seven Veneto-Turkish conflicts in which the Serenissima had the role of aggressor. This uncharacteristic choice was largely due to the new naval policy inaugurated by the republic decades earlier: the Senate had decided to proceed to a considerable expansion of the group of sailing warships, creating the so-called *Armata grossa*.[1] Meanwhile, in the aftermath of the War of Candia, the lessons learned from the fighting record of the Dutch and English mercenary sailing ships prompted Venice to undergo a navy buildup that focused on these ships as opposed to the usual galleys. Thus, the Venetian navy was reformed into the *Armata grossa*, formed by the modern ships and armed merchantmen, and the *Armata sottile*, the regular rowing boats (galleys and galleasses).

The Morean War (1684–1699) also represents the last expansion drive of the Serenissima aiming at the reconquest of the old possessions in Greece, as well as the hinterland behind her ports. The conflict is part of the victorious counterattack of the Christian front formed in 1683 to disinvest Vienna from the great Turkish siege. In the summer of 1683 the Ottomans presented themselves, commanded by Grand Vizier Kara Mustafa, under the walls of the capital of the German emperor. Vienna stood defended by Count Ernst Rudiger von Starhemberg, who, resisting for two months, gave time to King John III Sobieski of Poland, the dukes of Lorraine and Baden and other German princes to rush to the rescue and defeat the Ottomans in the landmark battle of Kahlenberg (September 12, 1683).[2]

Venice was invited to join the Habsburgs to crush the common enemy of Renaissance Europe and accepted the opportunity. The advances on land by the imperials and their allies were covered on sea by the might of the Venetian armada.

The hero of the war was Francesco Morosini, re-elected *capitano generale da Mar* in 1684, 15 years after the fall of Candia. After the conquest of Castelnuovo[3] in the Bay of Cattaro, Morosini led the joint Venetian, papal, Maltese and Tuscan fleets to invest the island of Santa Maura and forced its surrender in July 1684.[4]

He then turned his armies against the fortresses of the southern Peloponnesus, which not only were former, prized Venetian possessions but also covered good sheltered bays, very suitable for dropping anchor in times of need, and opened the way to the conquest of the interior of the Morea. First to be conquered was Coron; this was followed by Sarnata, Calamata, Chielafa, and the main inland base of Mistra.[5]

Continuing from victory to victory, in 1685 and in 1686, the Venetians—under the land command of the Swede Otto Wilhelm Königsmarck—took Navarino, Modon, Argos and Napoli di Romania, where they updated the defenses of this former capital of the Venetian region. The campaign of 1687 recorded new victories, as Morosini manned an expeditionary force that conquered Patras, Corinth and Lepanto. In September 1687, at the conquest of Athens, a Venetian gunshot struck the Parthenon and ignited the ordnance stored there by the Ottomans, seriously damaging the magnificent temple of Pallas, the masterpiece of Classical architecture, leaving the monument in the state of partial destruction that we see today.

In just four years, the Most Serene Republic had regained all that it had lost in the Ionian Sea and in the Morea from 1503 to 1669 and more (since it had never actually mastered the interior of the peninsula, only significant ports and island fortresses).[6]

In 1687, the Venetian Senate decided on something unprecedented (since it was forbidden for people still alive and was very rare even for the deceased): to place a bronze bust of Morosini in an admiral's parade uniform in its building, with this inscription: *Francisco Mauroceno Peloponnesiaco adhuc vivo Senatus*. This bust is now in the second room of the armory, in the Palazzo Ducale with the Senate. His name also receives the cognomen referring to his conquests—the Peloponnesus—in ancient Roman fashion. Also, a marble bust, from his very short tenure as doge, stands on the side of the loggia in Corfu, with Morosini surrounded by four cherubic children representing the Virtues and holding his background canvas. The date in the inscription is 1691, which corresponds to his tenure as doge; however, in a list of Venetian monuments in Corfu, Giuseppe Gerola describes his apparel as "berretto del comando,"[7] which is an incorrect identification of *corno ducale*.

The symbols of his glorification don't stop here: a triumphal arch was built as a doorway to the Senate, from the staircase that starts on the side of S. Marco Square (now closed to the general public), to commemorate his feats in Morea and Albania; and in front of the pedestrian gate of the Arsenal—itself a monument to the victory of Lepanto—is a bronze column symbolizing a galley lantern, with a dedication to his conquest of the Peloponnesus. These commemorations gave Morosini unprecedented and uncharacteristically iconic status in the ultimate lay and equalitarian republic of the Renaissance.

Back on the front, after an attempt against Negroponte (1687) was thwarted by rough seas and an epidemic that broke out in the ranks, claiming Königsmarck himself, Morosini decided to retire in the Morea, the conquest of which had gained him so much popularity hat he was chosen for the highest office in the Republic.

On April 3, 1688, Francesco Morosini was unanimously elected doge of Venice. The eternal symbols of Venetian regalia—the seal and the *corno ducale*—were shipped to him

Figure 105. Bust of Morosini as doge, on the wall of the Venetian Loggia in Corfu.

while on campaign, in Aegina.[8] He died in 1694 of old age, at Napoli di Romania, while returning for another campaign in Greece.

After him, less able commanders tried to mount significant offensives, but apart from the reduction of Malvasia, the last Turkish post in the Morea (1690), failed to recover Canea (1692) or to hold on to Chios (conquered in 1694 and lost the next year).

When the allies of Venice put an end to the war with the Treaty of Karlowitz (1699), the republic obtained the Morea, Aegina, Santa Maura, and small gains in Dalmatia and Albania.[9] Venice stopped paying tribute for the use of the island of Zante,[10] but restored Lepanto and the islands of the Archipelago to the Ottomans.[11]

The Serenissima enjoyed peace for the next 15 years, while almost all of Europe, from the Atlantic to the shores of Lake Ladoga, was involved in the War for the Spanish Succession (1701–1714) or the Great Northern War (1700–1721).

14

The War of 1714–1718

The exploits of the Morean War were due to the extensive war preparation and readiness displayed during the war of Candia, as well as a strong desire for revanche in Venice.

In the next war, since the Turks took the initiative, they were better prepared, mustering strong forces against one single target and thus overrunning each Venetian fortress one by one, in quick succession in 1715.

Venice had not been idle in all its decades of government over the Peloponnesus. Fortress were modernized by adding bastioned lines (Modon, Santa Maura), and a large and innovative fortress was built on top of the very high Palamidi hill overlooking the medieval and Renaissance defenses of Napoli di Romania, capital of *Regno di Morea*. The fortification here makes

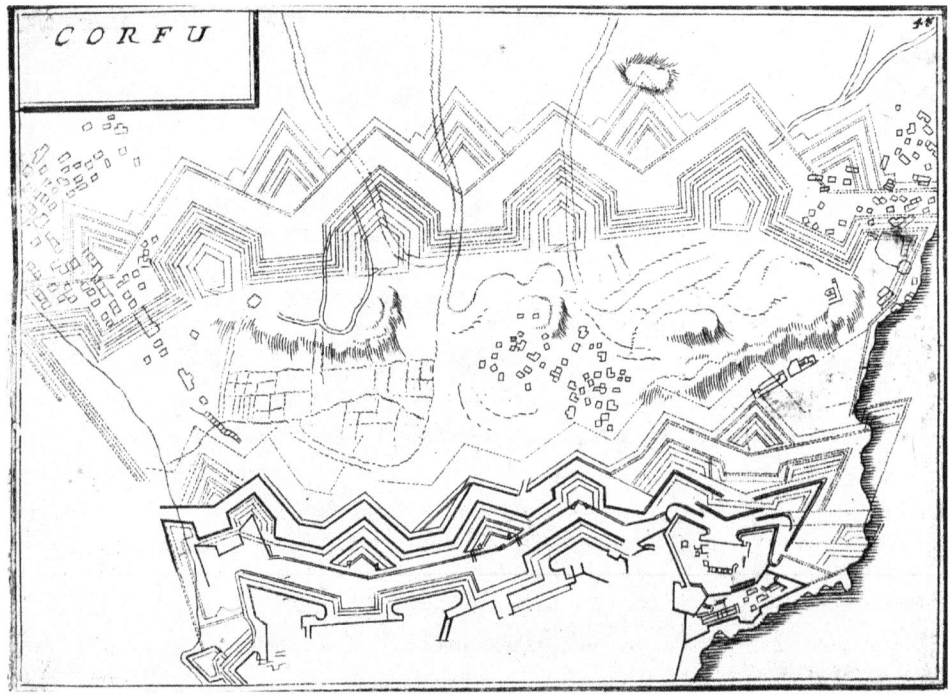

Figure 106. Vincenzo Coronelli, *Corphou*, 1696 (courtesy the Ministry of Culture and Tourism, Biblioteca Nazionale Marciana Venezia. All rights reserved).

use of the terrain, with a steep stairway climbing the mountain, protected by a high parapet. On top, the solution adopted foresaw the advent of the entrenched camp: The bastions observe the morphology, and the defense is ensured by the strongpoints, not by the presence of the curtain (which is neglected).[1]

While Venice did possess a fleet of considerable power, its land forces were too small for all her domain. If in the previous war Venice had counted on significant mercenary support, by this century it had exhausted its resources, and this conflagration found it with just some isolated garrisons, difficult to reinforce or relieve. Even the forces manning the modernized fortresses of the Morea were not up to size, so in the early months of 1715, when the Turks attacked Morea and the neighboring islands of Aegina, Tine, and Cerigo, they found little resistance. The attack was swift and overwhelming, taking Corinth, Napoli di Romania, Patras, and the last Venetian possessions in Crete: Suda and Spinalonga. After the Turks passed into the Ionian, where they forced the surrender of Santa Maura, it was obvious to assume that the next target would be the island of Corfu.

Corfu had been constantly prepared for this showdown ever since the 1540s, and—as we have seen—successive construction phases over time produced the design in Figure 106. The map shows the New Walls, with Fortezza Nuova at the right, followed on the left by the Sarandario bastion, Porta Reale, Piattaforma S. Atanasio, Raimondo and Valier bastions, and their outworks, starting with the Scarpone crownwork (still standing today). The map also shows plans to extend the line of fortifications to include the high hills of Abraham (right) and San Salvatore (left), and to enclose them with two demi-bastions and four large bastions—similar in design to the Margherita and Cottonera Lines in Malta—and complete them with five ravelins. This would have been a good idea, since it was from these hills that the Turks bombed the defenses during the siege. Later in the century, the hills were occupied by two forts by the same names, and defended access paths linked them to the main line of fortification behind them.

The commander of the place, Johann Matthias von Schulenburg, arrived in Corfu in February 1716 and immediately began to see to the condition of the existing fortifications. Corfu was not to be given up so easily; it was not just another colony far away or some trading post recently acquired and sparsely populated. It was a very Venetian city, the key of the gulf of Venice (the Adriatic Sea). Corfu was heavily colonized and linked to the metropolis, Italian in every way. Even today the same feeling prevails over most of the old city.

The navy tried to maneuver to intercept the Ottoman landing fleet and block the road to the Ionian Sea; however, in early July, the Turks slipped past and managed to make landfall in the gulf of Govino. The next day the Venetians brought their ships in line to offer battle, which turned into a crushing victory for them.[2]

However, on July 6, the Ottoman fleet had already landed a strong host of 20,000 men under the walls of the city of Corfu, vastly outnumbering the 5,300 soldiers of the garrison. By July 12, there were 12,000 Turkish soldiers ready to attack, and the cannons were already trained.[3]

The Siege of Corfu (1716)

Starting with July 24, the Turks began launching the first massive assaults in the direction of the New Fortress, concentrating on overtaking the outlying hills of San Salvatore and Abraham (which at the time were not yet defended by the later, 18th century forts).

By August 4, the Ottomans were making such headway against the forts and the outer works, and were so sure of immediate victory, that they sent a herald requesting the unconditional surrender of the fortress, with the promise of sparing the lives of the occupants. They mounted the all-out assault on August 6 but had to content with building more trenches and carefully planning their approaches.[4]

Meanwhile, after intercession from the pope, Austria had entered the war to save Venice, in May 1716. This opened the possibility of a drive behind the enemy lines and the diversion of Ottoman reinforcements to Serbia. The imperials moved swiftly, and on August 5, the great commander Prince Eugene of Savoy destroyed a 200,000-man Ottoman army at Peterwardein.[5] The news arrived quickly in Corfu, along with a 1,500-strong reinforcement contingent sent by Venice.

Following a sortie on August 18, which destroyed the batteries constructed on Abraham hill, the next day 3,000 Janissaries with assault ladders, swords and maces attacked the 400 German mercenaries guarding the Scarpone hornwork and managed to plant their flags only feet away from the Sette Venti bastion.[6]

The severe storm of August 20—celebrated by the Corfiots, to this day, as a devine act—wrecked trenches and wetted the ammunition, and thus the Turkish efforts for another attack on the Porta Reale were jeopardized; distraught by their failure, despite another artillery barrage, on August 22, the Turks embarked in hurry, leaving behind supplies and heavy military equipment.[7]

In 1717 Schulenburg reconquered Preveza and the other Ionian isles, and in 1718 he besieged Dulcigno, when Austria abruptly entered in diplomatic negotiations with Turkey that ended the war, leading to the peace of Passarowitz.[8] It's difficult to assume another campaign in 1718 would have been as swift in recovering the Morea as was the one in the 1680s. For one, on the sea, Venice was not longer so powerful, and did not venture in the Aegean anymore, but had to content with closing off the Adriatic, after the engagement off Cape Matapan (1718).[9]

After the war, Schulenburg was put in charge of the defense of all sea possessions of the republic, and he strengthened Corfu and Zara, above all. He ended his career for the republic in the command of the fortress of Verona.

Schulenburg was hailed as a hero, and a statue of him was erected in the Old Fortress, in front of the governor's palace (a building now gone). Eventually, it was moved across the moat from the gate of the fortress, to the head of the stone bridge over the ditch.

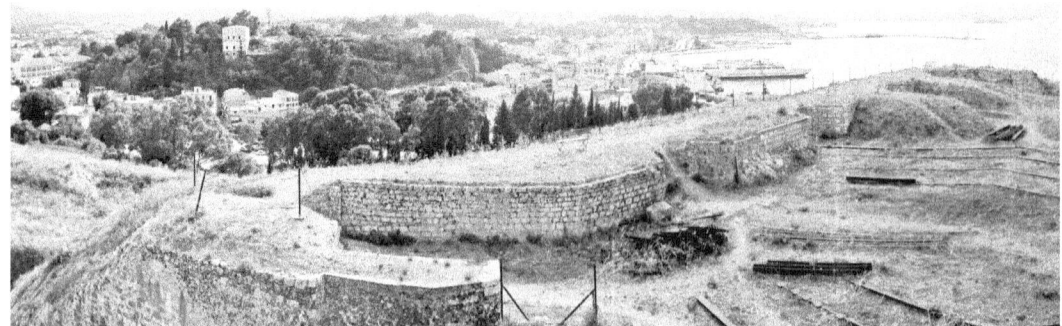

Figure 107. View of the Abraham hill from the New Fortress. Sette Venti in the foreground.

Not many statues have survived in the world that were erected by previous sovereign powers and dedicated to their heroes. In this case, there was a common cause, both Venetian and Greek, for which men such as Beaufort, Morosini and Schulenburg fought to safeguard their cities, people and way of life. In Corfu, Schulenburg is still a revered hero, and a street that leads to the gate of the Sarandario bastion bears his name. The memory of heroes involved

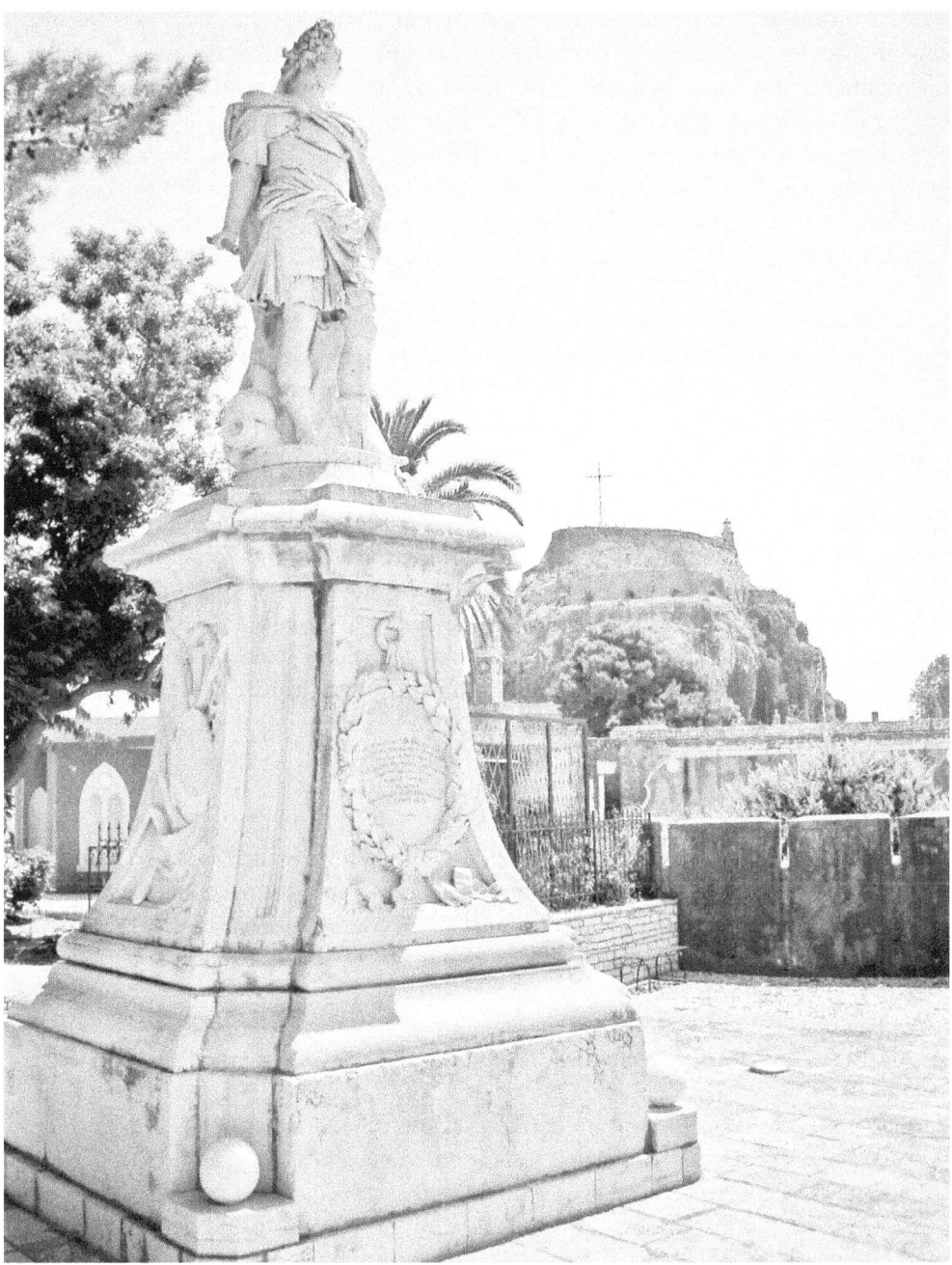

Figure 108. Schulenburg still watching over the fortifications of Corfu.

in the defense of the city against the Ottomans is kept in Heraklion too, where the street along the walls, from the former S. Giorgio Gate to the Sabbionara bastion, is dedicated to the Duke of Beaufort (cousin of the king of France), who lost his life during the siege.

For every war with the Porte there is a large figure that stands out, and Venice had the grace to honor it accordingly. The magnitude of this honor increased over time, with the changing of the approach towards public displays of gratitude in Venice.

After the war of Cyprus, Bragadin, the martyr of Famagosta, was interred in the burial church of the doges (Ss. Giovanni and Paolo). His funeral monument is one of the largest there, with a bronze statue on a marble ledge, over a long epitaph, surrounded by angels and flanked by pilasters. In the Ducal Palace there is another bronze bust of Bragadin, commissioned along with another one, rather too similar in appearance, for Agostino Barbarigo, hero of Lepanto, where he commanded the victorious left wing and died from his battle wounds.

For the next war, Lazzaro Mocenigo was the consummate hero, and had he managed to force the lifting of the siege of Candia, he would have gained the fame of latter counterparts. For in the next war, after the conquest of Morea, Francesco Morosini rose to a position unachieved by any other Venetian: not only was he elected doge while on campaign, he was also awarded a bronze bust in the Senate (now in the Armory of the same building, the Ducal Palace). Also, a monumental portal was erected at one of the exterior exits of the Sala dello Scrutino (Voting Hall), along with a column in front of the gate of the Arsenal.

This was a time of great exuberance in Venice, such that the Barbaro family redid the façade of Santa Maria del Giglio (Zobenigo) and had the family leaders sculpted in niches normally reserved for saints. The patriarch of the family, Antonio Barbaro, is presiding over bas-reliefs of naval battles and of the most important fortifications in the Venetian Republic (Zara, Candia, Padua, Corfu, and Spalato) and Rome. The reliefs are so accurate that in the case of Candia you can recognize the harbor, shipyards, Castello del Molo, the Voltone Gate, and the main churches, along with all the bastions. The sculpted map of Corfu displays the same vacillation between 2D and 3D as its undoubted model, the map of Andrea Marmora.[10] Antonio Barbaro led the defenses of Candia for many years, holding the office of *provveditore generale* of the island starting in 1667.

After the safeguarding of Corfu, Schulenburg was awarded a near-life-size statue placed in front of the Provveditore Palace, in the center of the Old Fortress of Corfu; it now stands in front of the bridge, on the Spianata. Another statue of him is tucked away in the courtyard of the Capitan's Palace in Verona, where he ended his career in the position of military governor, which was a great honor, considering that Verona was regarded as the land counterpart of Corfu in terms of strategic defensive importance for the republic, and that together they were the keys of the republic.

Over this whole, protracted conflict, this "Hundreds Years' War" of the Mediterranean (1470–1718), there wasn't a single significant pitched battle between the Venetian and the Ottoman land forces. Virtually all their wars were made up of sieges and sea battles. Geopolitically, it makes sense, because—with the exception of the large islands of Negroponte, Cyprus, Crete, and Corfu—there was little room to engage on land around the Venetian strong points in the Aegean and even eastern Adriatic. Even on the mainland, their ports acted like islands, concentrating all their force in the stronghold and counting on naval supremacy to deter the enemy and to maintain communication lines and rush reinforcements.

The location where you gave battle was a show of your strength, either of your defensive line or your striking capabilities: the Turks pressed on the Venetians, engaging them at Zonchio (1499) at the tip of the Peloponnesus; next they penetrated deeper and had to be attacked at Preveza (1538). Some 30 years later they were sheltering in the same waters, at Lepanto (1571), but the next century the Venetians pushed them back hard: the battle lines were drawn at the very entrance to the Dardanelles, and the Turks hardly ventured out of the Aegean that century. Pushed out of the Ionian after 1571, the Ottomans returned in 1716 when they successfully escorted their landing party all the way to the Channel of Corfu; eventually, they were limited again at the Peloponnesus after the battle of Cape Matapan (1718).

Even on the Italian mainland, Venice hasn't participated in a large land battle since Marignan (1515). This should, however, be put in the context of the peace that followed the Italian wars and that saw the Italian states less involved in the conflicts of the peninsula. Even when they were engaged, they did it mostly as side partners for the real powers (France and the Habsburgs).

After the siege of Corfu, no other siege targeted the grand Renaissance fortresses built by the Venetians all over the Levant. Silence and tranquility settled over the walls that had proudly and effectively withstood assault after assault by the largest and most relentless army of their time.

Conclusion

The Republic of Venice was the quintessential state of the Renaissance, where the wealth of the seas and the resources of its people met to create a wonder the world won't stop revering.

We have seen how the setting of the territories of the Republic of Venice—far-flung islands with limited or no hinterland—meant that the best strategy for the defense of her realm was to focus on mastery of the seas and proper fortification of the key points. It was not just a preoccupation for the preservation of her borders, but also for the maritime interests of her citizens and the safeguarding of her subjects.

The Renaissance marked a revolution in military architecture, too. From the antiquated system of defense with square towers and high, thin curtains emerged the transitional system with low, thick walls and circular towers, and eventually the perfected plan of the bastioned fortification was developed. This revolution was acknowledged in the period, as its authors, the Italian architects, call it *fortificazione alla moderna*.

Venice employed these latest techniques and designs and called on some of the most important and prolific architects of Italy, counting on the services of masters such as Michele Sanmicheli and Giulio Savorgnan. They were among those who made fundamental contributions to the development of fortifications, particularly in designing and perfecting the most characteristic features of the bastioned system. Such architects were responsible for the projects or even supervision of the construction of the fortifications on the three largest islands of the republic during the Renaissance. We analyzed these accomplishments in the Parts II–IV of the book.

Venice gained Cyprus in 1489, when the Queen Caterina Cornaro bequeathed the island to her hometown. The kingdom had been a prosperous crusader state ruled by a French dynasty who lavished sumptuous Gothic churches and cathedrals on the territory. Thus the cultural imprint of the new rulers is seen almost entirely in the realm of military architecture. The strategy of defense called for focus on the capital, Nicosia, and the port towns of Famagosta and Cerines. The previous medieval strongholds, the mountain castles in the high Pendaktylos range, lost their importance, along with the various crusader structures on the southern coast.

Famagosta was modernized at the start of the 16th century with a front of round artillery towers to guard a wall backed by a terreplein. However, only one perfected bastion was built, the mighty Martinengo, with two retired flanks with *piazza-basse* and cavaliers for additional

support. The crusader citadel was enveloped by walls all around, and its square towers became embedded in the new, round ones. The same solution was used in the harbor fortress of Cerines, and here we also find tall, horse-shoe corner towers designed in the Byzantine period.

The most ambitious project of urban development in the Venetian Renaissance was the design of the bastioned fortifications in Nicosia in the form of a perfect circle. In the age when invention met philosophy, the drive for the perfect city led to the urban planning of Valletta and especially the round shape of Nicosia, circle of the perfect proportion, personified by the Vitruvian man. A future phase would have included the redrawing of the street pattern to a grid, but that never came about, since the Turks took over the city shortly after the fortifications were completed.

The large island of Crete had been the prized possession of the Republic of Venice ever since the Fourth Crusade she detoured made her a strong political actor in the Eastern Mediterranean. For two centuries, before the start of her active expansion on mainland Italy, this territory at the end of the Aegean had been the largest tract of land owned by Venice. Its feudal, productive and maritime importance made it an intrinsic part of the republican realm. As such, the numerous members of patrician families who settled there had themselves built impressive country manors and especially embellished city palaces, and several of these still existed at the start of last century, when the seminal work of Giuseppe Gerola was produced.

While the inland defenses were initially medieval and had been for centuries, Venice was quick to implement there as well the latest designs and construction techniques, under the supervision of some of the most illustrious military architects of the Renaissance. In the 16th century, two large building programs in the wake of wars with Turkey led to the modernization of the three most important towns of Candia, Canea and Retimo, as well as the building of the island fortresses of Suda and Spinalonga. In the latter, Venice displayed feats of engineering and design, making the best use of their topography. As for the capital of Candia, the development continued with the encirclement of the first modern enclosure with a front line composed of a variety of detached works—an architectural novelty also introduced to the theory of fortifications by Italians. By the time of the climactic war with the Ottoman Empire, the island of Crete was bristling with defenses—although of different qualities and from different eras—more than any other island in the Mediterranean.

The place where the architecture and culture of Venice has put its mark most, outside its hinterland, is undoubtedly Corfu. The town is almost unchanged in appearance since the last days of the republic in 1797. The key to the Adriatic, port of call for squadrons of ships guarding the approaches to the Gulf of Venice, Corfu was of paramount importance to the city in the lagoon. Therefore, it was always prioritized in the fortification programs of the republic, and careful consideration was given to its protection.

Thus, in time, it became the most fortified town in the Mediterranean, after Valletta and its bay. Consecutive stages of the most advanced technology were employed in Corfu, and its front line was gradually pushed forward. Eventually, it counted on a fortified island citadel, with a wide glacis (still extant), and on three lines of defenses on the mainland, comprising bastions, outworks, and a group of state-of-the-art, 18th century, advanced forts. From the earlier use of the medieval defenses of the town's peninsula, to their transformation into round artillery towers, followed by their replacement with modern bastions, Corfu was constantly upgraded. Once the city expanded, consideration was given to the protection of the new settlement, and the latest types of structures were used to secure the line, with bastions,

Conclusion

platforms, hornworks, ravelins, and—in the early 18th century—with detached forts with intricate fixtures, covering the approaches to the town.

After exploring in detail all the elements of the spectacular fortifications of these places, from an architectural, technological and operational point of view, next we saw how these fortification fared under duress. In Part IV we analyzed the political and military relationship of the two great powers of the Renaissance in the Eastern Mediterranean, and the crucial role played by the fortifications erected by Venice on her principal islands.

Constant expansionist drives by the Ottoman Empire collided with the resistance of the Republic of Venice and resulted in seven wars for the defense of its territory in the Mediterranean. During the Renaissance, the clash between these titans was central to that age and was epitomized in the landmark battle of Lepanto of 1571.

The fortifications the Serenissima built to protect her lands and her subjects have proved their worth. Wave after wave of assailants were crushed on her stones and earthworks. First came the Ottoman attack on Cyprus, where they ran against the Renaissance project of Nicosia, with its 11 identical, large, arrow-head, earth-filled bastions. The circular shape of the walls of Nicosia caused high ground to the south to be excluded from the new fortifications, and this shortcoming was seized on by the Ottomans, who built their batteries here, reducing the town before it could be relieved by the Christian fleet sent to Cyprus. The other major fortress of the island, Famagosta, resisted one year of siege against all odds.

The 17th century brought with it the long war of 1645–1669, with the longest siege in recorded history: the siege of Candia. For almost 22 years the Turks tried by all means to enter the capital of the island, throwing themselves at the maze of mathematically projected and mutually supporting fortifications, digging trenches and sapping underneath. The stones have braced the tide. The valiant defense by the Venetian army, aided by regulars and volunteers from the west, grinded to a halt the might of the Ottoman land forces for years, and the eventual surrender of the place was due to exhaustion of resources, not to a collapse of the defenses.

After a victorious campaign that freed southern Greece during the Christian steamroller that pushed back the Turks from the gates of Vienna in 1683, momentum was once again on the Ottoman side, and all was lost for Venice by 1716, when its dreaded foe landed on Corfu and marched on its defenses. The Venetians rallied once again and manned the bastions and ravelins, and from the tiers of fire amassed on the New Fortress repelled attack after attack.

The mastery of the Venetian military architecture was enhanced by able commanders who made the best of the resources at hand. The long and arduous conflict with the Porte brought forward the figures of heroes such as Bragadin in Famagosta, Morosini in Candia and Schulenburg in Corfu, and the metropolis rewarded their feats of arms with recognition during and after their lifetimes.

The Venetian strategy of relying on forts to guard its far-away territories proved ultimately successful. With such possessions scattered across many islands, keeping a mobile land force for quick intervention was unsuitable, so the cities had to be able to fend for themselves. Combining the latest designs, great engineering and dedicated manpower, the defenses could hold for years, which was uncommon in the age of gunpowder siege.

While Venice did hold on to Corfu until the very end of its existence, she did lose the island and towns of Cyprus and Crete, and her departure from the islands of the Eastern Mediterranean brought about stagnation, decay, deterioration and eventual destruction. Unfortunately, too frequently, it was during the 20th century that the most damage was done

to the beautiful palaces and bastions of the Renaissance, as is the case of the main cities in Crete. The last decades have brought the expected reconsideration and renewed efforts for their preservation and promotion.

These enthralling examples of land art are impressive even today, and their importance in the history of military architecture and the Mediterranean as a whole commands respect and admiration.

Appendix I: Chronology

810—Treaty between Eastern Roman Empire and Frankish Empire, de facto independence for Venice
1191–1489—Lusignan Kingdom in Cyprus
1202–1204—Fourth Crusade
1204—conquest and partition of Constantinople; Venice formally assigned Crete, along with other possessions in the Aegean
1204—Genoese led by Enrico Pescatore occupy Crete.
1211—Venice in control of all Crete
1364–1367—last great revolt by the Greeks in Crete
1378–1381—Venetian victory in the War of Chioggia against Genoa, fought in the Lagoon, Adriatic, Aegean, Levant
1386—Venice acquires Corfu
1404–1428—Expansion in mainland Italy (Verona, Padua, Vicenza, Brescia, Bergamo)
1409–1420—definitive possession over the important cities in coastal Dalmatia (Zara, Sebenico, Spalato, Cattaro)
1425–1430—First Veneto-Turkish war, loss of Thessalonica
1453—Fall of Constantinople to the Turks
1463–1479—Second Veneto-Turkish war, loss of Scutari, Negroponte and Lemnos
1473—death of the last Lusignan king of Cyprus, James II. Rule by his Venetian widow, Caterina Cornaro
1489—Caterina Cornaro cedes the island to her homeland
1499–1503—third Veneto-Turkish war, loss of Modon, Coron, Lepanto, Navarino, and Durazzo.
1499—Venetian naval defeat at Zonchio
1509–1516—War of the League of Cambrai
1509—Venetian defeat at Agnadello, from Imperial, French and Papal troops
1516—Treaty of Brussels. Venetian borders in Italy largely unchanged until the end of the Republic.
1522—Hospitaller Knights leave Rhodes
1530—Hospitaller granted Malta and Tripoli by Spain
1537–1540—Fourth Veneto-Turkish war, loss of Napoli di Romania, Malvasia, Naxos and the islands of the Archipelago (except Tinos)

Appendix I: Chronology

1537—Ottoman siege of Corfu town and pillage of the island
1538—Turkish raid on Crete
1538—Christian defeat at Preveza
1538–1557—modernization of Old Fortress of Corfu
1538–1539—Michele Sanmicheli designs fortifications in Crete
1540—start of fortification program for the modernization of Candia, Canea
1540—Venetian enlarge castle Cerines
1540s—new Magistracies: Fortresses, Sea Militia, Artillery Administrator
1550–1559—Gian Girolamo Sanmicheli works on the enceinte of Famagosta
1551—Tripoli lost to the Turks, Gozo and Menorca raided
1560—Christian defeat of Djerba
1565—Siege of Malta, major Christian victory
1567–1569—Giulio Savorgnan designed the new fortification of Nicosia
1570–1573—Fifth Veneto-Turkish war, loss of Cyprus
 1570—storming of Nicosia; surrender of Cerines
 1571—surrender of Famagosta
 1571—Turkish raid on Crete
 1571—major Christian victory at Lepanto
1573—start of fortification program in Retimo, Paleocastro, Spinalonga, Suda, S. Teodoro and Grabusa
1576–1578—Ferrante Vitelli builds the New Fortress in Corfu
1576–1588—construction of New Fortress and new city walls in Corfu
1640—construction of fort of Marati
1645–1669—Sixth Veneto-Turkish war (War of Candia)
 1645—loss of Retimo
 1645—surrender of Canea
 1646–1651—Turks occupy the castles of Bonriparo, Chissamo, Apicorno, Milopotamo, Paleocastro, Temene, Girapetra, Sitia
 1647—Venetian naval victory near Euboea
 1648–1669—Siege of Candia
 1649—Venetian naval victory at Phocaea
 1650—Venetian recover the island of S. Teodoro
 1651—Venetian naval victory at Naxos
 1654–1657—the Dardanelles campaigns, tactical Venetian victories
 1666—French failure to recover Canea
 1669—surrender of Candia
1669–1682—construction of extensive outworks in Corfu
1683—Turkish defeat at Vienna
1684–1699—Seventh Veneto-Turkish war
 1684—conquest of Santa Maura, Coron, Mistra
 1685–1686—conquest of the Morea
 1687—conquest of Athens
 1692—Venetian failure before Canea, loss of Grabusa
 1699—peace of Karlowitz: integration of Morea and territories in Dalmatia
1714–1718—Eight Veneto-Turkish war

Appendix I: Chronology

- **1715**—loss of Morea, Aegina, Tinos
- **1715**—loss of Spinalonga and Suda in Crete
- **1716**—defense of Corfu
- **1718**—peace of Passarowitz, loss of Morea
- **1797**—French occupation of Venice and dissolution of the Republic
- **1797–1799**—first French occupation of Corfu
- **1800–1807**—Russian protectorate over the Ionian Islands
- **1807–1814**—second French rule in Corfu
- **1815–1863**—British protectorate of the Ionian islands
- **1821**—start of the Greek war of independence; with revolts also in Crete and Cyprus
- **1830–1840**—Egypt holds Crete for the Ottoman Empire
- **1863**—Corfu and the Ionian Islands united with Greece
- **1878**—England occupies Cyprus
- **1898**—Crete autonomous under international occupation
- **1898**—removal of Ottoman rule in Crete by the International Powers
- **1913**—union of Crete with Greece
- **1914**—Cyprus crown colony of England
- **1960**—Cyprus independent from England

Appendix II: Glossary

arsenal—structure used for the construction, repair and storage of weaponry and ammunition.
bastion—main feature of the Renaissance fortification. Large, solid constructions projecting from the main line of defense. The bastion has two flanks and two faces; a gorge and a salient.
***Capitano generale da Mar* (Captain General of the Seas)**, direct commander of Venetian forces, in the field of active duty.
cavalier—gun platform raised on top of bastions or curtains, to create a new tier of artillery fire
cordon—semicircular cornice, separates the scarp from the parapet
counterscarp—opposite the scarp, it secures the exterior of the ditch.
crownwork—outwork consisting of a bastion with two demi-bastions on its sides.
curtain—section of wall between two bastions or a gate and a bastion
demi-bastion—half built bastion with only one face and one flank
ditch—deep, wide trench circling the entire defensive works to hamper assaults
Doge (duke)—highest individual office in the Venetian state, head of state, position elected for life.
drawbridge—hinged section of bridge, that can be drawn up to close the gate
embrasure—opening cut in a parapet, through which a cannon would be placed and manned, without exposing its crew.
enceinte—the entire physical boundaries of a fortification, forming a continuous circuit of defensive walls
Fortificazione alla moderna—system of fortification developed in the 16th century in response to the advent of artillery
glacis—wide open field cleared in front of the ditch.
hornwork—defensive element consisting of two demi-bastions liked by a curtain wall
magazine—place for the storage of gunpowder, and ammunition.
mezzaluna—ravelin of a rectangular shape, placed in front of a curtain.
orecchione—curved or straight structure connecting the face and the flanks of a bastion
outwork—defensive works situated outside the main line of fortification. Includes ravelins, hornworks, crownworks, mezzaluna, redans
parapet—the top part of a rampart, provides shelter for troops behind it.

piattaforma—platform, flat bastion, acting like a cavalier placed in the middle of the curtain.

piazza-bassa—platform in the recessed flank of a bastion, designed to offer additional, protected, tier of fire

postern—covert access ways, under the walls, that facilitate sallies against besiegers

Provveditore (Provider)—central representative in the territories, superseding local authorities in most aspects (including military).

rampart—The embankment surrounding a fortified place

ravelin—usually a triangular structure, placed in front the walls to protect a gateway.

scarp—defensive work consisting of a slanted wall, meant to increase the structural stability of the wall.

Stato da Mar (State of the Sea)—the Venetian territory outside Italy proper, formed, over time, by the lands in Istria, Dalmatia, the Ionian Islands, southern Greece, Crete, the Aegean, Cyprus.

Stato da Terra—Venetian territory on the Italian mainland (Terraferma)

terreplein—broad surface of earth atop the rampart, extending between the vertical parapet, and interior edge of the rampart

Appendix III:
Table of Architectural Features

The following table presents the main architectural features of the fortifications analyzed in this book.

	Cyprus			Crete			Corfu
	Nicosia	Famagosta	Cerines	Candia	Canea	Retimo	Corfu
Renaissance enclosure	●	●		●	●	○	◐
Citadel		●	●	●		●	
Medieval enclosure			○	○	◐		
Monumental Gates	●			◐	○	○	○
Civilian Gates	●	●		●	●		●
Round Artillery towers		●	●				●
Bastions	●	●	●	●	●	●	●
Piattaforma				●			○
Demi-bastions				●	●		●
Bastion gate		●	●	●	○		●
Cavalier		●		◐	◐	●	●
Piazza-bassa		●	●	●	●	●	●
Ditch	●	●	●	●	◐	○	◐
Counterscarp	○	●	●	◐	◐	○	◐
Ravelin		●		○	○		○
Mezzaluna				○			○
Hornwork				○			◐
Crownwork				○			
Redan				○			
Glacis		●		○	○	○	◐
Gunpowder Magazine				○	●	●	●

Legend:
● preserved
○ lost
◐ some preserved, some lost

Chapter Notes

Chapter 1

1. There is a tremendous amount of literature on the general topics of the art of Venice and the history of the republic, so it is quite difficult to recommend all the scientific works. On Venetian art and architecture see John Ruskin, *The Stones of Venice* (London: Smith, Elder, 1851–1853); Deborah Howard, *The Architectural History of Venice* (New Haven, CT: Yale University Press, 2002); Joanne M. Ferraro, *Venice: History of the Floating City* (Cambridge: Cambridge University Press, 2012); Marcello Brusegan, *I Monumenti di Venezia: Storia, arte, segreti, leggende, curiosita* (Roma: Newton Compton Editori, 2007); Guido Zucconi, *Venice: An Architectural Guide* (Venice: Arsenale Editrice, 2006); and Patricia Fontini Brown, *Art and Life in Renaissance Venice* (London: Pearson, 2005).

2. On the history of Venice, apart from the wealth of primary sources, see the following: F. C. Lane, *History of Venice* (Turin: Einaudi, 1978); Fernand Braudel, *Civilization and Empires of the Mediterranean in the Age of Philip II* (Cambridge: Cambridge University Press, 1966); Eric Dursteler, ed., *A Companion to Venetian History, 1400–1797* (Leiden: Koninklijke Brill NV, 2013); Elisabeth Crouzet-Pavan, *Venice Triumphant: The Horizons of a Myth* (Baltimore: Johns Hopkins University Press, 1999); and John Jeffries Martin and Dennis Romano, eds., *Venice Reconsidered: The History and Civilization of an Italian City-State, 1297–1797* (Baltimore: Johns Hopkins University Press, 2000).

3. Gaetano Cozzi, "I rapporti tra stato e Chiesa," in *La Chiesa di Venezia tra riforma protestante e riforma cattolica*, ed. Giuseppe Gullino (Milan: 1990), 11–36.

4. In fact, the flag of Amalfi features the same eight-point cross as the symbol of the Knights of S. John, since this is the Cross of S. John and also because their relationship is not just heraldic, nor by coincidence: the Order evolved from the hospital in Jerusalem opened and run by Amalfitan traders in the early 11th century.

5. Romania is a medieval toponym referring to the country of the Romans, i.e., the inhabitants of the Eastern Roman Empire. Only since the 18th century have they been called Byzantines. The Greeks of this New Rome, as well as all their neighbors and nations that came into contact with them—even Turks—used the term "Romans." In the late Middle Ages, Romania became better identified as the area in Europe around Constantinople, and the name survives to this day as the Turkish Rumelia. In Italy herself, Romagna is the province around Ravenna (the seat of the administration of Constantinople in Italy in the 6th–8th centuries).

6. Interestingly, the fate of these new kings was gruesome, and both the Latin Emperor and the King of Thessalonica lost their lives within the next 18 months, in struggles with the aggressive Second Bulgarian Empire.

7. For the context and the effects of the Fourth Crusade, see Donald Nicol, *Byzantium and Venice: A Study in Diplomatic and Cultural Relations* (Cambridge: Cambridge University Press, 1988), Chapters 8–9; Robert Lee Wolff, "Romania: The Latin Empire of Constantinople," *Speculum* 23, no. 1 (1948): 1–34; and David Nicolle, *The Fourth Crusade 1202–04: The Betrayal of Byzantium* (London: Osprey, 2011).

8. Trogir, Croatia.

9. Perast, Montenegro.

10. Budva, Montenegro.

11. Ulcinj, Montenegro.

12. For a concise presentation of the expansion and organization of the *Stato da Terra*, see Michael Knapton, "The Terraferma State," in *A Companion to Venetian History, 1400–1797*, ed. Eric Dursteler (Leiden: Koninklijke Brill NV, 2013), 85–124.

13. Angelo Emo, *Giornale storico del viaggio in Africa della veneta squadra* (Venice: G. Novelli, 1787).

14. This miscalculation is not particularly clear, and it cannot be blamed entirely on geopolitical factors, since confinement to the Mediterranean did not stop Austria from creating, in Trieste, her own East India Company.

15. Alfredo Viggiano, "Politics and Constitution," in Dursteler, *Companion to Venetian History*, 47–85.

16. For a complete and detailed chronology of Venetian possessions outside of its hinterland, see Benjamin Arbel, "Venice's Maritime Empire in the Early Modern Period," in Dursteler, *Companion to Venetian History*, 132–34.

17. Michael Knapton, "The *Terraferma* State," in Dursteler, *Companion to Venetian History*, 94.

18. Andrea Da Mosto, "Archivi dei Rettori dei dominii della Repubblica Veneta," in *L'Archivio di Stato de Venezia: Indice generale, storico, descrittivo ed analitico* (State Archives, Venice, Vol. 2, 1940), pp. 3–6.

19. For instance, after the peace of Passarowitz of 1718, the position of *provveditore generale* was established

for the Ionian islands, gathering together the last posessions of Venice in the Mediterranean.

20. Panagiota Tzivara and Spyros Karydis, *L'Archivio dei Provveditori Generali da Mar: Alla ricera delle sue trace* (Athens: Enalios, 2002).

21. Eugenio Bacchion, *Il Dominio Veneto su Corfu (1386–1797)* (Venice: Edizioni Altino, 1956), 158–59.

22. Benjamin Arbel, "Roman Catholics and Greek Orthodox in the Early Modern Venetian State," in *The Three Religions*, ed. Nili Cohen and Andreas Heldrich (Munich: Utz, 2002), 73–86.

23. The Millet was a term for the confessional communities in the Ottoman Empire, which were assimilated to nations and were allowed to apply their own cannon law.

24. Crete had many anti–Ottoman revolts in 1770, 1821, 1841, 1858, 1866–69, and the final one in 1897.

25. Foustel de Coulanges, *The Ancient City: A Study on the Religion, Laws, and Institutions of Greece and Rome* (Baltimore: Johns Hopkins University Press, 1980).

26. The entire period of Frankish rulers on Greek soil (1204–1718) is known in historiography as *Frankokratia*. Of course, by the 13th century—when several Latin states emerged from the partition of the Eastern Roman Empire in 1204—Western civilization had already developed clear separation lines and strong distinctions, particularly in language, that differentiated the Italian peninsula, Gaul and Germania. Indeed, originally, states such as the Latin Empire of Constantinople, Kingdom of Thessalonica, the Principality of Achaia, and the kingdom of Cyprus were ruled by Frankish nobles, but the rise of wealth, power and influence of the Italian peninsula meant aristocratic families of various Italian states gained influence and land in these territories, from Ionia to Cyprus, not to mention the islands of the Aegean, many of which were virtually ruled like private estates and feudal fiefs. Even Aragon set a foot on the Greek mainland, with seigneur overlordship over the state of the Catalan Company in Athens and Neopatras (1311–1390). The term *Venetokratia* is also used more specifically for the solid Venetian territories.

Chapter 2

1. Piero Lucchi and Camillo Tonini, eds., *Navigare e descrivere: Isolari e portolani del Museo Correr di Venezia XV–XVIII secolo* (Venice: Marsilio, 2001).

2. John H. Pryor and Elizabeth Jeffreys, *The Age of the Dromon: The Byzantine Navy ca. 500–1204* (Leiden: Brill, 2006).

3. Didactic panel, Naval Museum of Venice.

4. Huge galley lanterns, complete with their tall posts, some over 16 ft. tall, are in the Correr Museum. In the Naval Museum of Venice there is a post with three lanterns that belonged to a *galleazza*.

5. Angus Konstam, *Renaissance War Galley 1470–1590* (London: Osprey, 2002).

6. Didactic panel, Naval Museum of Venice.

7. Guido Candiani, "Stratégie et diplomatie vénitiennes: Navires angle-hollandaises et blocus des Dardanelles, 1646–1659," *Revue d'Histoire Maritime* 9 (2008): 251–82.

8. Guido Candiani, *I vascelli della Serenissima: Guerra, politica e costruzioni navali a Venezia in età moderna, 1650–1720* (Venice: Istituto Veneto di Lettere, Scienze ed Arti, 2009).

9. M. E. Mallett and J. R. Hale, *The Military Organization of a Renaissance State: Venice c. 1400 to 1617* (Cambridge: Cambridge University Press, 1984), Chapters 12–13.

10. Ernle Bradford, *The Sultan's Admiral: The Life of Barbarossa* (New York: Harcourt, Brace and World, 1968).

11. Claire Judde de Larivière, *Naviguer, commercer, gouverner: Économie maritime et pouvoirs à Venise (XVe–XVIe siècles)* (Leiden: Koninklijke Brill NV, 2008), Chapter 1.

12. Jan Glete, *Warfare at Sea, 1500–1650: Maritime Conflicts and the Transformation of Europe* (London: Routledge, 2000), 35–39.

13. Matteo Casini, "Immagini dei capitani generali 'da Mar' a Venezia in età barocca," in *Il "Perfetto Capitano": Immagini e realtà (secoli XV-XVII)*, ed. Marcello Fantoni (Rome: Bulzoni, 2001), 219–70.

14. Mallett and Hale, *Military Organization*, Chapters 12–13.

15. A Spanish proverb reads, "quedarse a la luna de Valencia" ("to be left out under the moon of Valencia," i.e. outside the walls), with the meaning of having arrived too late, after the gates closed.

16. Mallett and Hale, *Military Organization*, Chapter 10.

17. This Venetian program from the second half of the 16th century is similar to the great works undertaken, almost at the same time, by the Spanish in the New World, mainly under direction of the Antonelli family of Italian architects.

Chapter 3

1. Jean-Denis Lepage, *French Fortifications, 1715–1815* (Jefferson, NC: McFarland, 2009), 56.

2. Robert Curley, ed., *Britannica Guide to War: War on Land* (London: Britannica Educational Publishing, 2012), 56–61.

3. Eugène Viollet-le-Duc, *Histoire d'une forteresse* (Paris: 1874), 363.

4. Buonaiuto Lorini, *Delle fortificazioni* (Venice: 1596), 37.

5. Drepano, Greece.

6. Francesco Tensini, *La fortificatione, guardia, difesa et espugnatione delle fortezze esperimentata in diverse guerre* (Venice: 1624), 39–41.

7. Currently known as Koules.

8. Girolamo Maggi, *Della fortificatione delle città* (Venice: 1564).

9. Jean-Denis Lepage, *French Fortifications, 1715–1815* (Jefferson, NC: McFarland, 2010), 82–83.

10. Jean-Denis Lepage, *Vauban and the French Military Under Louis XIV* (Jefferson, NC: McFarland, 2010), 45–50.

11. In Rhodes, a portion of the counterscarp in front of the Post of Spain has slumped and offers the perspective of how a very deep ditch could have been approached by the besiegers.

12. Christopher Duffy, *Siege Warfare Fortress in the Early Modern World, 1494–1660* (London: Routledge and Kegan Paul, 1979), 11–12.

13. See Fig. 59, Chapter 8.
14. See Fig. 70, Chapter 9.
15. Simon Pepper, "Sword and Spade: Military Construction in Renaissance Italy," *Construction History* 16 (2000): 22–24.
16. There is also a Sangallo bastion, with much simpler features, in Rome (part of an overcostly—and thus abandoned—plan by Pope Paul III to modernize the Aurelian Walls).
17. Pepper, "Sword and Spade," 13–32.
18. William Wallace, "'Dal disegno allo spazio': Michelangelo's Drawing for the Fortifications of Florence," *Journal of the Society of Architectural Historians* 46, no. 2 (June 1987): 119–34.
19. Michael E. Mallett and J. R. Hale, *The Military Organization of a Renaissance State: Venice c. 1400 to 1617* (Cambridge: Cambridge University Press, 1984), 441–42.
20. Paul Davis and David Hemsoll, *Michele Sanmicheli* (Venice: Mondadori Electa, 2004).
21. Walter Panciera, "Giulio Savorgnan e la costruzione della fortezza di Nicosia," in *La Serenissima a Cipro: Incontri di culture nel Cinquecento*, ed. Evangelia Skoufari (Roma: Viella, 2013), 131–42.
22. Horst De la Croix, "Palmanova: A Study of Sixteenth Century Urbanism," *Saggi e memorie di storia dell'arte* 5 (1966): 23–41.
23. Claudia Bonardi, "Gli anni settanta: Il soprintendente Vitelli, un bombardiere e un ingegnere di acque," in *Fortrezze "alla moderna" e ingegneri militari del ducato sabaudo*, ed. Micaela Viglino Davico (Turin: Celid, 2005), 287–93.
24. Amalia Tsitouri and Anna Triposkoufi, eds., *Venetians and Knights Hospitallers: Military Architecture Networks* (Athens: Hellenic Ministry of Culture, 2002), 158.
25. Giuseppe Gerola, *Monumenti veneti nell'isola di Creta: Ricerche e descrizioni fatte dal dottor Giuseppe Gerola per incarico del R. Istituto Veneto di Scienze, Lettere ed Arti* (Venice: R. Istituto Veneto di Scienze, Lettere ed Arti, 1905–1931).

Part II

1. This is, to this day, celebrated in Venice in the first week of September, by a series of reenactments of which the most famous is the gondola race known as Regatta Storica.
2. Robert Holland and Diana Markides, *The British and the Hellenes: Struggles for Mastery in the Eastern Mediterranean 1850–1960* (Oxford: Oxford University Press, 2006), Chapter 9.
3. Kolossi, Cyprus.
4. David Nicolle, *Knight Hospitaller, 1309–1565* (London: Osprey, 2001).
5. Paphos, Cyprus.
6. David Nicolle, *Crusader Castles in Cyprus, Greece and the Aegean 1191–1571* (London: Osprey, 2007).
7. Amalia Tsitouri and Anna Triposkoufi, eds., *Venetians and Knights Hospitallers: Military Architecture Networks* (Athens: Hellenic Ministry of Culture, 2002).
8. In the British world, in the 19th century, the same function, yet enhanced and updated, was fulfilled by the chain of Martello towers (of which many exist even in North America, such as on the Plains of Abraham in Quebec or in Halifax, Nova Scotia).
9. For instance, the failure to do so and relieve Minorca in 1756 cost Admiral John Byng his life.
10. In which the Spanish Bourbons entered on the side of their French cousins, and where, in fact, they acted quite bravely and successfully against the British even in the continental U.S., from Florida to the Illinois and the Upper Missouri.

Chapter 4

1. Unfortunately, the beauty of the Gothic in Cyprus and Rhodes is not in the scope of the present project, but the study of the civilian Latin East could be the object of future research.
2. Gilles Grivaud, "Aux Confins de l'Empire Colonial Vénitien: Nicosie et ses Fortifications (1567–1568)," *EKEE* (Nicosia) 13–16, no. 1 (1987): 273–74.
3. John Thomson, *Through Cyprus with the Camera: In the Autumn of 1878* (London: Sampson Low, Marston, Searle, and Rivington, 1879).
4. Gianni Perbellini, "Cipro e Venezia nel Mediterraneo," in *Candia e Cipro: Le due isole "maggiori" di Venezia*, ed. Mauro Scroccaro and Michalis Andrianakis (Milan: Biblion Edizioni, 2010), 110.
5. Panos Leventis, *Twelve Times in Nicosia: Nicosia, Cyprus, 1192–1570: Topography, Architecture and Urban Experience in a Diversified Capital City* (Nicosia: Cyprus Research Center, 2005), Chapter 6.
6. Marian Moffett, Michael Fazio, and Lawrence Wodehouse, *Buildings Across Time: An Introduction to World Architecture* (London: Laurence King, 2003), 308–09.
7. Their troublesome and disruptive activities were only brought to a definitive halt by the decisive actions marking the rise of a new world power: the U.S. Tripolitan Wars of the early 1800s. This action is the origin of the phrase "to the shores of Tripoli" in the "Marines' Hymn."
8. Stephen C. Tucker, *Battles that Changed History: An Encyclopedia of World Conflict* (Santa Barbara, CA: ABC-Clio, 2011), 173–78.
9. M. E. Mallett and J. R. Hale, *The Military Organization of a Renaissance State: Venice c. 1400 to 1617* (Cambridge: Cambridge University Press, 1984), 429–61.
10. George Jeffery, *A Description of the Historic Monuments of Cyprus* (Nicosia, Cyprus: Government Printing Office, 1918), 26–30.
11. Leventis, *Twelve Times in Nicosia*, 275.
12. The same southern area of the city is where the Greeks were to live in Nicosia under the Ottomans too (the neighbourhood of Trypiotis).
13. Paolo Paruta, *Guerra di Cipro* (Venice: 1572).
14. Leventis, *Twelve Times in Nicosia*, 273.
15. See Francesco Valegio's map, *Nicosia*, in Chapter 4.
16. Leventis, *Twelve Times in Nicosia*, 275.
17. Currently Famagusta Gate.
18. See Gerola's photograph, captioned "S. Georgio Gate," in Chapter 7.
19. Currently Paphos Gate.
20. Currently Kyrenia Gate, northern Nicosia.

Chapter 5

1. M. E. Mallett and J. R. Hale, *The Military Organization of a Renaissance State: Venice c. 1400 to 1617* (Cambridge: Cambridge University Press, 1984), 429–61.
2. Such as the hotels build on top of the bastions Sabbionara in Candia and Gritti in Canea, or the S. Angelo mansions in Birgu, Malta.
3. This old Christian church separated in the 4th century from the main body of creed, and its followers migrated eastwards, first into the Sassanid Empire. From there they spread actively to the people of Central Asia, going as far as the Mongol tribes. Thus, when the hordes of Genghis Khan and his heirs swept towards the west, they counted on a sizeable proportion of Christian Nestorian Mongols. This presence is the origin of the Prester John legend—the story of the powerful Christian kingdom in the East—which was very popular in the crusades.
4. See the author's photo, "Cannon of French origin, Famagosta," in Chapter 3.
5. For instance, you can still admire in Bernardo Bellotto's *Vienna Viewed from the Belvedere Palace* (1760) both the famous city walls of the 1683 siege and the intact glacis, beyond which the town developed in the 18th century, with the Belvedere Palace and Charles Borromeo Church. Eventually, after 1849, Emperor Franz Joseph I (1848–1916) demolished the walls and constructed the beautiful Vienna Ring in the space previously occupied by both the walls and the glacis.
6. In Rhodes in the 1920s, the Italian authorities' policies of restoration and preservation of the walled town were impressive for that time.
7. Among its heraldic embellishments, Rhodes retained a huge variety of symbols, even many religious figures. Candia, as well, retained a Pantocrator figure over one of the main gates.
8. Tim Pickles, *Malta 1565: Last Battle of the Crusades* (London: Osprey, 1998).
9. See Chapter 10.1.
10. George Jeffery, *A Description of the Historic Monuments of Cyprus* (Nicosia, Cyprus: Government Printing Office, 1918), 103.
11. Pietro Valderio, *Guerra di Cipro* (Venice: 1573); Pietro Contarini, *Historia delle cose sucesse dal principio della Guerra mossa da Selim Ottomano a Venetiani* (Venice: 1572).
12. The Turkish name for the Arsenal bastion comes from Canbulat, the Bey of Kilis, killed in combat in the vicinity of this bullwark, and subsequently his tomb is under the bastion. A similar sign of devotion to fallen heroes and landmarks of battle is the Bayraktar Mosque built in Nicosia, on top of the Constanza bastion, the first one scaled by the Ottomans, in memory of a standard-bearer slayed on the spot.
13. John Thomson, *Through Cyprus with the Camera: In the Autumn of 1878* (London: Sampson Low, Marston, Searle, and Rivington, 1879).
14. Lorenzo Calvelli, *Cipro e la memoria dell'antico fra Medievo e Rinascimiento: La percezione del passato romano dell'isola del mondo occidentale* (Venice: IVSLA, 2009), 32.
15. This lion hasn't been moved at least in the last 70 years, as you can actually spot it in a clip of the 1954 Paul Newman movie *Exodus*. In fact, the first part of the movie was shot, for historical accuracy, in Cyprus, and the port of Famagosta was an obvious aesthetic choice. In many of the scenes you can see the beautiful town and its monuments as they were in the early 1950s, and observe how little they have changed since.
16. It is quite interesting that a lot of Shakespeare's plays with modern stories and with settings outside England take place in cities and territories belonging to the Republic of Venice (Cyprus, Verona, Padua, and Venice).
17. Jeffery, *A Description of the Historic Monuments*, 106.

Chapter 6

1. Kristian Molin, *Unknown Crusader Castles* (Cambridge: Cambridge University Press, 2001), 98.

Part III

1. Uncovered and deciphered by Arthur Evans, colleague and friend of Heinrich Schliemann, the discoverer of Troy.
2. Although literally translated most of the time as "Kingdom of Candia," in fact *Regno* has more the sense of "realm" or "rule," just like the German word *Reich*. Thus, the Peloponnesus was organized as *Regno di Morea*, once acquired by 1685.
3. Renata Salvarani, "Creta, le origini della colonizzazione veneziana," *Medioevo*, December 2005; David Jacoby, "Italian Migration and Settlement in Latin Greece: The Impact on the Economy," *Schriften des Historischen Kollegs*, Kolloquien 37 (Munich) (1997): 97–127.
4. Maria Georgopoulou, *Venice's Mediterranean Colonies* (Cambridge: Cambridge University Press, 2003), 19.
5. David Holton, ed., *Literature and Society in Renaissance Crete* (Cambridge: Cambridge University Press, 1991).
6. The names correspond to the works of Giuseppe Gerola and are, in fact, largely phonetic transliteration of Greek toponyms. In parentheses are the names of the noble proprietary families.
7. Giuseppe Gerola, *Monumenti veneti nell'isola di Creta: Ricerche e descrizioni fatte dal dottor Giuseppe Gerola per incarico del R. Istituto Veneto di Scienze, Lettere ed Arti*, vol. 3 (Venice: R. Istituto Veneto di Scienze, Lettere ed Arti, 1917), 250–316.
8. Agia Triada Monastery, Our Lady of the Angels Monastery and Arkadi Monastery.
9. Ibid.
10. Muhammad Ali hails from a period of severe centrifugal drives in the Ottoman state, when the laxity of this state turned against itself, stimulating independence moves by powerful local rulers: the pashas of Telepeni, Bosnia or Egypt, the dahias in Belgrade. This same internal weakness was speculated by the Greek communities all over the Ottoman world, from Crete and Cyprus to Moldavia and Wallachia.
11. Robert Holland and Diana Markides, *The British and the Hellenes: Struggles for Mastery in the Eastern Mediterranean 1850–1960* (Oxford: Oxford University Press, 2006), Chapter 4.
12. In fact, its leader, Eleftherios Venizelos, was to be

one of the most important prime ministers of Greece in the first part of the 20th century.

13. John Knight Fotheringham, *Marco Sanudo: Conqueror of the Archipelago* (Oxford: Clarendon, 1915), 87.

14. Incidently, Enrico Pescatore was, in fact, Lord of Candia, but of the Candia in Piedmont, not Crete.

15. A similar fortified manor is the complex of the Dandolo Mansion, south of Acharavi, Corfu (see Part IV).

16. Gerola, *Monumenti*, vol. 3, 250–316.

17. Peter Lock, "The Frankish Towers of Central Greece," *The Annual of the British School at Athens* 81 (1986): 101–23.

18. Gerola, *Monumenti*, vol. 3, 250–316.

19. Frangokastello, Greece.

20. Kissamos, Greece.

21. The most famous Turkish mariner, he led the Ottoman fleet to victory at Preveza in 1537; projected Ottoman power in the western Mediterranean, where he pushed back the Spanish from important towns and harbors of North Africa; and, in collusion with the French, made landings on the Italian coast.

22. Agios Theodorou, Greece.

23. Dia, Greece.

24. Antikythira, Greece.

25. However, the names used currently differ from the Venetian maps and the photos of Gerola. Such a situation proves even more troublesome for Canea.

26. See Chapter 10.1.

27. On the island now named Palaiosouda.

28. In the 17th century, various foreign architects and engineers were employed in *Stato da Mar*, like the French Antoine de Ville who designed the forts Giuliano and S. Andrea in Pola, the German Christoph von Dagenfeld who built the forts S. Giovanni and Baron for the defense of Sebenico, or the Savoyard Ferrante Vitelli in Corfu.

29. Gerola, *Monumenti*, vol. 1, part 2, 564–69.

30. Like S. Andrea in Pola and S. Nicolo in Sebenico, this island fortress was meant to close off the mouth of the gulf.

31. William Miller, "The Venetian Revival in Greece, 1684–1718," *The English Historical Review* 35, no. 139 (1920): 365.

Chapter 7

1. Vincenzo Coronelli, *Atlante Veneto* (Venice: 1690).
2. Currently August 25 Street.
3. Giorgio Corner, *Il Regno di Candia* (Venice: 1625).
4. Now Eleftherios Venizelou Square.
5. The area now known as the neighborhood of Kastelli (see Chapter 8).
6. Along the current Dikaiosynis Street.
7. This is a common architectural feature of western European tradition, and many towns, even in Spanish Colonial America, had a *Plaza de Armas*, while in Paris, the *Champ de Mars* played a major role for many years during the French Revolution.
8. Now Eleftherias Square.
9. Gerola, *Monumenti*, vol. 3, 86–88.
10. Maria Georgopoulou, *Venice's Mediterranean Colonies* (Cambridge: Cambridge University Press, 2003), 84.
11. Many sources present this reproduction as the original loggia of Candia, not only because it makes for a great photo but also because it is included in the Gerola collection, which tends to mislead.

12. These crates were photographed by Gerola in 1902.

13. Now Eleftheriou Venizelou Square.

14. Now Agia Paraskevi in Chalkis.

15. Gerola, *Monumenti*, vol. 2, 111–30.

16. In the current Kornaros Square.

17. There is also a Turkish fountain now placed on the orecchione of the S. Francesco flank, on the climb at the end of the Ikarou Street. In Rhodes, too, there are a lot of beautiful Ottoman fountains, among the remarkable elements of Ottoman architectural endeavors.

18. In the countryside beautiful Venetian fountains have also survived, like those in modern Vrondissi and Spili—the latter very similar to Italian fountains like Fontana delle Sette Cannelle in Tuscania (Lazio), Fontana del Calamo in Ancona, or Fontana delle 99 Cannelle in l'Aquila.

19. Ruth Gertwagen, "The Venetian Port of Candia, Crete (1299–1363): Construction and Maintenance," in *Mediterranean Cities: Historical Perspectives*, ed. Irad Malkin and Robert L. Hohlfelder (London: 1988), 141–58.

20. Martino Ferrari Bravo and Stefano Tosato, eds., *Gli arsenali oltremarini della Serenissima: Approvvigionamenti e strutture cantieristiche per la flotta veneziana (secoli XVI–XVII)* (Milan: Biblion Edizioni, 2010).

21. Although independent since 1358, the city of Ragusa displays the same cultural heritage as any other Dalmatian or otherwise Venetian entrepot, so such architectural connections are not surprising.

22. This is literally "water," since the Turkish word for "sea" is *deniz*.

23. Gerola, *Monumenti*, vol. 1, part 1, 148–54.

24. See Vincenzo Coronelli's illustration *Pianta del Castello di Candia* in Chapter 7.

25. Mauro Scroccaro and Michalis Andrianakis, eds., *Candia e Cipro: Le due isole "maggiori" di Venezia* (Milan: Biblion Edizioni, 2010).

26. Ioanna Steriotou, "The Venetian Walls of Chandax in the XVI–XVII Century," *Europa Nostra* 56–57 (2003): 42–56.

27. Kalokairinou Street, Chandakos Street, Dikaiosinis Street.

28. Antoine de Fer, *La Ville de Candie pour la 3e fois attaquée de L'Armée Ottomane et deffendue par celle de la Serenissime Rep. de Venise*, 1669.

29. In fact, many such Christian depictions survived on the walls of Rhodes: S. John, S. Athanasius, S. Peter. This was not by ignorance, since the Ottomans did undertake reconstruction of significant portions of the wall that were more or less destroyed during the great siege of 1521, and Ottoman plaques acknowledging their works exist on the Tower of Spain, as well as beams of wood carved with Muslim phrases in the gates of Amboise and S. John.

30. See Fig. 104, Chapter 12.

31. Buonaiuto Lorini, *Delle fortificazioni* (Venice: 1596), 141–42.

32. In fact, the identification of individuals invited to relocate was done based on religion, not ethnicity, and so there was even a large group of Turkish people—the Karamanlides—that were removed from Anatolia for being Christians.

33. A typical structure of Western civilization, a building designed for the sick, inhabitants and travelers, to quarantine them to avoid the spread of contagious maladies. In Valletta a beautiful example is preserved.
34. Currently Nea Dimokratia Avenue.
35. Currently Ikarou Avenue.
36. Lorini, *Delle fortificazioni*, 142–43. Galileo Galilei, *Trattato di fortificazione* (Padua, 1593), caption V.
37. Gerola, *Monumenti*, vol. 1, part 2, 377–78.
38. This structure was removed, along with the monumental S Giorgio Gate, to make way for the current Nea Demokratia Street, which, in fact, follows the line of the aqueduct, in its last part.
39. See Chapter 8.3.
40. Alessandro Spiridone Curuni and Lucilla Donati, *Creta veneziana: L'Istituto Veneto e la Missione Cretese di Giuseppe Gerola: Collezione fotografica 1900–1902* (Venice: Istituto Veneto di Scienze, Lettere ed Arti, 1988).
41. Similarly, in Famagosta, the chapels of the Hospitallers and Templars, two adjacent halls, are now operating as day bars.
42. Gerola, *Monumenti*, vol. 1, part 2, 412.
43. A causal correlation can be observed between the presence of British administration at the time and the adoption of such solutions.

Chapter 8

1. Which became *Castelo Vecchio* once the town expanded its enclosure in the 16th century.
2. See the building known as the Lusignan House in Nicosia.
3. Martino Ferrari Bravo and Stefano Tosato, eds., *Gli arsenali oltremarini della Serenissima: Approvvigionamenti e strutture cantieristiche per la flotta veneziana (secoli XVI–XVII)* (Milan: Biblion Edizioni, 2010).
4. Ibid.
5. On Archoleon and Sifaka streets.
6. Today, Canevaro Street.
7. Today, Elefttherios Venizelos Square.
8. Gerola, *Monumenti*, vol. 3, 61–62.
9. At the north of the intersection between current Archoleontos and Kallergon Streets.
10. In the area of the current Greek Tourism Organization building.
11. Kevin Andrews, *Castles of the Morea* (Athens: Gennadeion Monographs, 1953), 211–18.
12. Ioanna Steriotou, "Management of Fortifications in Greece": Projects of Restoration and Renovation-Rehabilitation," *Europa Nostra* 64 (2010): 26.
13. Andrews, *Castles of the Morea*, 211.
14. Until quite recently, the Xenia Hotel obstructed the view of and access to the Gritti bastion. Built exactly on top of this bastion, its construction severely damaged the interior shape of the bastion, and restorations were undertaken several years ago.
15. Gerola, *Monumenti*, vol. 1, part 2, 461.
16. Ibid., 459.
17. Along the current Nikeforou Foka Street.
18. Among the significant fortifications of the Mediterranean, a covered way can still be found today at the fortress of Victoria, Gozo.
19. Currently Nikeforou Foka Street.
20. Currently Meletiou Piga Street.
21. This was part of the nation-wide governmental Xenia Project, which, starting in the 1950s, designed a chain of engaging modernist hotels all over Greece (another Xenia Hotel is on Castel del Torro in Nafplio).
22. Ioanna Steriotou, "Management of Fortifications in Greece: Projects of Restoration and Renovation-Rehabilitation," *Europa Nostra* 64 (2010): 25–26.

Chapter 9

1. Until the middle of the 16th century, Venetian cartographers spelled the town name as Rettimo, but from then on all European mapmakers used the above name.
2. There were such houses in Canea (photographed by Gerola) and even in Candia, but those in Candia were gone by 1900s. Gerola was the one that explained the mystery of the absence of Renaissance doorframes in Candia: he found dozens of lintels and architraves with coats of arms and gothic motifs in the Turkish cemetery, removed from their frames to be used as Islamic headstones.
3. Maria Georgopoulou, *Venice's Mediterranean Colonies* (Cambridge: Cambridge University Press, 2003), 160–61.
4. Currently Ethn. Andistaseos Street.
5. Cres, Croatia.
6. Gerola, *Monumenti*, vol. 3, pp. 71–75.
7. All along the current Gerakari Street, up to the present intersection with Makariou Street.
8. Gerola, *Monumenti*, vol. 1, part 2, 178–81.
9. The corsair Uluj Ali Reis was actually an Italian renegade who had been captured by Hayreddin Barbarossa, had turned Muslim and rose to become pasha of Algiers.
10. Mauro Scroccaro and Michalis Andrianakis, ed., *Candia e Cipro: Le due isole "maggiori" di Venezia* (Milan: Biblion Edizioni, 2010), 83.
11. See Fig. 69, Chapter 9.
12. See Fig. 69, Chapter 9; Fig. 103, Chapter 12.
13. Gerakari Street and Kountouriotou Street.

Part IV

1. Chlemoutsi, Greece.
2. Andravida, Greece.
3. Near modern Killini, Greece.
4. Camillo Tonini and Giandomenico Romanelli, eds., *Corfu "Perla del Levante": Documenti, mappe e disegni del Museo Correr* (Milan: Biblion Edizioni, 2010), 86–87.
5. Hans Schmidt, "Il salvatore di Corfù: Johann Matthias von der Schulemburg," *Quaderni del Centro tedesco di studi veneziani* 42 (1991): 3–29.
6. Robert Holland and Diana Markides, *The British and the Hellenes: Struggles for Mastery in the Eastern Mediterranean 1850–1960* (Oxford: Oxford University Press, 2006), Chapter 8.
7. Similar regulations pointed to construction and organization of castles in the island of Rhodes, such as Lindos, Feraklos, Monolithos, and Archangelos.
8. Angelokastro, Greece.
9. Gardiki, Greece.
10. Kassiopi, Greece.
11. Amalia Tsitouri and Anna Triposkoufi, eds., *Vene-

tians and Knights Hospitallers: Military Architecture Networks (Athens: Hellenic Ministry of Culture, 2002), 162.

12. There are few general online sources, but both consider it medieval and its builder to have been none other than the most famous member of the Dandolo family, Doge Enrico Dandolo (who instigated the Fourth Crusade to occupy the Eastern Roman Empire in 1204). Such misplacements definitely compromise those specific presentation attempts.

Chapter 10

1. In Alipiou Street.
2. These Venetian building are usually painted crimson, as well as the private buildings of the period (much like in Crete).
3. Renzo Vianello and Gianpaolo Nadali, *Calli, campielli e canali* (Venice: Helvetia, 2003).
4. Camillo Tonini and Giandomenico Romanelli, eds., *Corfu "Perla del Levante": Documenti, mappe e disegni del Museo Correr* (Milan: Biblion Edizioni, 2010), pp. 125–29.
5. Gouvia, Greece.
6. By the time of the Greek independence war (started in 1821), the West has come to see the Greeks only as the heirs of Athens, ignoring their cultural transformation during the Middle Ages of the Eastern Roman Empire. While certainly proud of their ancient origins, the political culture of the Greeks strove for the realization of the unity and liberation of Hellenes on all sides of the Aegean and the deliverance of Constantinople. The choice of this Neoclassical form for the English church in Corfu expresses this narrow identification of Greece solely with the core lands of classical antiquity.
7. Tonini and Romanelli, *Corfu*.
8. Ibid., 116–17.
9. Giuseppe Gerola, *Apunti sui monumenti veneti di Cefalonia e di Corfu* (Venice: 1908).
10. There was a beautiful baroque clocktower in Retimo, whose remains Gerola photographed. In Candia, the clock was mounted on the belfry of the S. Marco Cathedral. Similar to Retimo are the clocktowers of Trau, Zadar and especially Cattaro.
11. Corfu today has two coat of arms of the Kings of Greece of the Glücksburg dynasty, as commander of the army, one above the land gate, and one at the entrance to the Mandrachio gate, on the land side.
12. The outer forts are not actually presented on this particular map.
13. It is the same meaning as the Spanish Intramurros of Manila, the old town subject to fierce battles in 1944.
14. Braun and Hohenberg, *Civitates orbis terrarium* (Cologne: 1572).
15. Modern Garitsa, Corfu.
16. In the Naval Museum of Venice there is a very beautiful painting of Corfu, with a bird's-eye view of the city, and showing in full the complete circuit of fortifications, including the outer forts from the 18th century.
17. Visible in the author's photo captioned "Bust of Morosini as doge," Chapter 14.
18. See the author's photo captioned "Venetian mortars in front of the guardposts," Chapter 3.
19. Tonini and Romanelli, *Corfu*, 125.

20. Ibid., 109–17.
21. Currently Lochagou Spyrou Street.
22. Vianello and Nadali, *Calli, campielli e canali*.
23. Currently Nikiforou Theotoki Street.
24. Currently Evgeniou Voulgareos Street.

Part V

1. Ioannina, Greece.
2. Durres, Albania.
3. André Clot, *Suleiman the Magnificent: The Man, His Life, His Epoch* (Milan: Fabbri, 1992).

Chapter 11

1. Paolo Paruta, *Guerra di Cipro* (Venice: 1572), 45.
2. Kenneth Setton, *The Papacy and the Levant 1204–1571, Vol. 4, 1551–1571* (Philadelphia: American Philosophical Society, 1984), 967.
3. Ibid., 965–71.
4. Ibid., 974–94.
5. Paruta, *Guerra di Cipro*, 55–56.
6. Ibid., 60.
7. Panos Leventis, "Projecting Utopia: The Refortification of Nicosia, 1567–1570," in *Chora 5: Intervals in the Philosophy of Architecture* (Montreal: McGill-Queen's University Press, 2007), 227–58.
8. Konstantin Nossov, *The Fortress of Rhodes 1309–1522* (London: Osprey, 2010), 60.
9. Setton, *The Papacy and the Levant*, 974–1004.
10. Paruta, *Guerra di Cipro*, 120.
11. George Jeffery, *A Description of the Historic Monuments of Cyprus* (Nicosia, Cyprus: Government Printing Office, 1918), 107.
12. Setton, *The Papacy and the Levant*, 1042–43.
13. Pietro Valderio, *Guerra di Cipro* (Venice: 1573), 197–204.
14. Known in Venice as San Zanipolo.
15. John Francis Guilmartin, *Gunpowder and Galleys: Changing Technology and Mediterranean Warfare at Sea in the Sixteenth Century* (Cambridge: Cambridge University Press, 1974).
16. Angus Konstam, *Lepanto 1571* (London: Osprey, 2003), 56–89.
17. Among the thousands of wounded at Lepanto was Cervantes, the author of the famous *Don Quixote de la Mancha*.
18. Bar, Montenegro.
19. The issue of paying tribute for Zante is found in all the treaties with the Porte, and only after Karlowitz was the island finally and officially relinquished to Venice.

Chapter 12

1. Vlora, Albania.
2. Kenneth Meyer Setton, *Venice, Austria and the Turks in the Seventeenth Century* (Philadelphia: American Philosophical Society, 1991).
3. Sertonaco Anticano, *Frammenti istorici della guerra di Candia* (Bologna: 1647), 21–23.
4. Setton, *Venice, Austria and the Turks*, 127.
5. France's position as champion of Catholicism was

maintained even during the revolutionary 19th century, after various Republican experiments stretching over decades; thus, it was Napoleon III who saved the States of the Church in 1859 and 1866, and only his abdication allowed the fall of Rome, in 1870.

6. Anticano, *Frammenti istorici*, 77.
7. Ibid., 90.
8. Setton, *Venice, Austria and the Turks*, 127–29.
9. Anticano, *Frammenti istorici*, 77.
10. Setton, *Venice, Austria and the Turks*, 127.
11. Anticano, *Frammenti istorici*, 310–11.
12. Ibid., 343.
13. Cut in half and flayed alive, respectively.
14. Setton, *Venice, Austria and the Turks*, 147.
15. Ibid., 158.
16. Ibid., 128.
17. Ibid., 138.
18. Ibid., 145–47, 154–59.
19. Francesco Frasca, "Mediterraneo e Venezia (1645–1718): La strategia marittima della Serenissima nelle guerre del Levante," *Rivista Marittima*, 2008, 109–18.
20. In the Naval Museum of Venice are the remains of beautiful side ornaments from a galley, supposedly the flagship of Lazzaro Mocenigo, that blew up on July 19, 1657, during the last battle of the Dardanelles, when its powder magazine was hit by a Turkish shore battery.
21. Organized in the Venetian Institute of Science, Letters and Arts.
22. Heinrich Kretschmayr, *Geschichte von Venedig*, vol. 3 (Stuttgart: Scientia Verlag, 1964), 332–35.
23. Elias Kolovos, "A Town for the Besiegers: Social Life and Marriage in Ottoman Candia Outside Candia (1650–1669)," in *The Eastern Mediterranean Under Ottoman Rule: Crete, 1645–1840*, ed. Antonis Anastasopoulos (Rethymno: Crete University Press, 2008), 103–75.
24. Setton, *Venice, Austria and the Turks*, 190.
25. Johann Bernhard Scheiter, *Novissima praxis militaris* (Brunswick: 1672), 34.
26. Maddalena Redolfi, *Venezia e la difesa del Levante: Da Lepanto a Candia 1570–1670* (Venice: Arsenale, 1986), 146.
27. *Carte topografiche, piante di città e fortezze, disegni di battaglie della guerra di Candia (1645–1669)*, Ms. It. VII 200 (10050), BNMV.
28. Setton, *Venice, Austria and the Turks*, 224–25.
29. A street now bears his name, close to the S. Giorgio Gate, from which he sortied on his fateful attack.
30. Christopher Duffy, *The Fortress in the Age of Vauban and Frederick the Great: 1660–1789* (London: Routledge, 1985), 219.
31. Scheiter, *Novissima praxis militaris*, 34.
32. A similar contractual bond, recorded by Pietro Valderio, faced Bragadin in his mandate from the Venetian state and brought him into conflict with the desires of the local populace, who urged him to discontinue the defense of Famagosta.

Chapter 13

1. Guido Candiani, "Lo sviluppo dell'Armata grossa nell'emergenza della guerra marittima," *SdV Storia di Venezia*, 2003.
2. Like the date of the victory of Lepanto, this day has thenceforth been a feast day in the Catholic Church.
3. Hercegnovi, Montenegro.
4. William Miller, "The Venetian Revival in Greece, 1684–1718," *The English Historical Review* 35, no. 139 (Jul. 1920): 343–66.
5. Christopher Duffy, *The Fortress in the Age of Vauban and Frederick the Great. 1660–1789* (London: Routledge, 1985), 221–22.
6. Among the spoils of war sent to Venice was a magnificent stone lion that adorned the port of Piraeus in Athens; the lion is currently located at the entrance of the Grand Arsenal. A smaller and less impressive one was brought from Delos to be displayed in the same area, symmetrically around the Arsenal Gate—itself embellished in honor of Lepanto as a triumphal arch with a large and beautiful lion of S. Marco.
7. Gerola, *Monumenti*, 12.
8. Kenneth Meyer Setton, *Venice, Austria and the Turks in the Seventeenth Century* (Philadelphia: American Philosophical Society, 1991), 357.
9. This maximum extent of Venetian dominion in Dalmatia marks a frontier line that has not changed since and is observed even today, between the states of Croatia and Bosnia-Herzegovina.
10. An issue featured in all previous peace treaties with the Porte.
11. Gregory Hanlon, *The Twilight of a Military Tradition: Italian Aristocrats and European Conflicts, 1560–1800* (London: University College London Press, 1998), 172.

Chapter 14

1. In the Alps there is a more perfect example of such a design: the large fortress of Fenestrelle.
2. William Miller, "The Ionian Islands Under Venetian Rule," *The English Historical Review* 18, no. 70 (1903): 233.
3. Kenneth Meyer Setton, *Venice, Austria and the Turks in the Seventeenth Century* (Philadelphia: American Philosophical Society, 1991), 442.
4. Ibid., 443.
5. Ibid., 435.
6. Ibid., 443.
7. The end of the siege is still celebrated in Corfu on August 24.
8. Christopher Duffy, *The Fortress in the Age of Vauban and Frederick the Great. 1660–1789* (London: Routledge, 1985), 226.
9. Frederic C. Lane, *History of Venice* (Turin: Einaudi, 1978).
10. Andrea Marmora, *Della historia di Corfu* (Venice: 1672), 365.

Bibliography

Primary Sources

Anticano, Sertonaco (anagr. Antonio Santacroce). *Frammenti istorici della guerra di Candia.* Venice: 1648.

Basilicata, Francesco. *Relatione di tutto il Regno di Candia.* Venice: 1630.

Boschini, Marco. *Il Regno tutto di Candia.* Venice: 1651.

Brusoni, Girolamo. *Della historia d'Italia, dall' anno 1625 fino al 1679.* Torino: 1680.

Contarini, Pietro Giovanni. *Historia delle cose sucesse dal principio della guerra mossa da Selim Ottomano a Venetiani.* Venice: 1572.

Corner, Giorgio. *Il Regno di Candia.* Venice: 1625.

Coronelli, Vincenzo Maria. *Morea, Negroponte and Adiacenze.* Venice: 1686.

Coronelli, Vincenzo Maria. *Atlante Veneto.* Venice: 1690.

Dapper, Olfert. *Description exacte des isles de l'Archipel et de quelques autres adjacentes.* Amsterdam: 1703.

Emo, Angelo. *Giornale storico del viaggio in Africa della veneta squadra.* Venice: 1787.

Foscarini, Michele. *Historia della Republica veneta.* Venice: 1699.

Galilei, Galileo. *Trattato di fortificazione.* Padua: 1593.

Lorini, Buonaiuto. *Delle fortificazioni.* Venice: 1596.

Lusignan, Etienne de. *Chorograffia et breve historia universale dell'isola di Cipro principiando al tempe di Noe per insino al 1572.* Bologna: 1573.

Maggi, Girolamo. *Della fortificatione delle città.* 1564.

Marmora, Andrea. *Della historia di Corfu.* Venice: 1672.

Monanni, Raffaele. *Descrizione topografica di Candia.* Venice: 1631.

Oddi, Angelo Degli. *Città, fortezze, porti, redotti et spiaggie del Regno di Candia.* Venice: 1601.

Paruta, Paulo. *Guerra di Cipro.* Venice: 1572.

———. *Storia Veneziana.* Venice: 1599.

Pozzo, Bartolomeo dal. *Historia della sacra religione militare di S. Giovanni Gerosolimitano detta di Malta.* 1715.

Scheiter, Johann Bernhard. *Novissima praxis militaris oder Neu-vermehrte, und Verstarckte Festungsbau und Kriegsschul.* Brunswick: 1672.

Tensini, Francesco. *La fortificatione, guardia, difesa et espugnatione delle fortezze esperimentata in diverse guerre del cavaliero Francesco Tensini da Crema.* 1624.

Valderio, Pietro. *Guerra di Cipro.* Venice: 1573.

Valerio, Andrea. *Historia della Guerra di Candia.* Venice: 1679.

Secondary Sources

Anastasopoulos, Antonis, ed. *The Eastern Mediterranean Under Ottoman Rule: Crete, 1645–1840.* Rethymno: Crete University Press, 2008.

Andrews, Kevin. *Castles of the Morea.* Athens: Gennadeion Monographs, 1953.

Andrianakis, Michalis, ed. *The Old City of Hania.* London: Adam, 2000.

Arbel, Benjamin. *Cyprus, the Franks and Venice: 13th–16th Centuries.* London: Ashgate Variorum, 2000.

———. "The Reign of Caterina Corner (1473–1489) as a Family Affair." *Studi Veneziani,* n.s., 26 (1993): 67–85.

Arbel, Benjamin, Bernard Hamilton, and David Jacoby, eds. *Latins and Greeks in the Eastern Mediterranean After 1204.* London: Routledge, 1989.

Avcioglu, Nebahat, and Emma Jones. *Architecture, Art and Identity in Venice and Its Territories, 1450–1750.* London: Ashgate, 2013.

Bacchion, Eugenio. *Il dominio Veneto su Corfu (1386–1797).* Venice: Edizioni Altino, 1956.

Baldini, Isabella, ed. *L'avventura archeologica di Giuseppe Gerola dall'Egeo a Ravenna.* Ravenna: Edizioni del Girasole, 2011.

Benevolo, Leonardo. *The Architecture of the Renaissance.* London: Psychology, 2002.

Berti, Maurizio. "La conservazione delle strutture continue nei sistemi bastionati moderni." *Materiali e strutture: Problemi di conservazione* 1, no. 2 (2003): 93–110.

Blackmore, David S.T. *Warfare on the Mediterranean in the Age of Sail: A History, 1571–1866.* Jefferson, NC: McFarland, 2010.

Boas, Adrian. *Crusader Archaeology: The Material Culture of the Latin East.* London: Routledge, 1999.

Borsari, Silvano. *Il dominio veneziano a Creta nel XIII secolo*. Naples: F. Fiorentino, 1963.

Bradford, Ernle. *The Sultan's Admiral: The Life of Barbarossa*. New York: Harcourt, Brace and World, 1968.

Braudel, Fernand. *The Mediterranean and the Mediterranean World in the Age of Philip II*. London: Collins, 1975.

———. *La Méditerranée, L'espace et l'histoire*. Paris: Flammarion, 1999.

Bravo, Martino Ferrari, and Stefano Tosato, eds. *Gli arsenali oltremarini della Serenissima: Approvvigionamenti e strutture cantieristiche per la flotta veneziana (secoli XVI-XVII)*. Milan: Biblion Edizioni, 2010.

Brooks, Allan. *Castles of Northwest Greece from the Early Byzantine Period to the Eve of the First World War*. Huddersfield, UK: Aetos, 2013.

Buonsanti, Michele, and Alberta Galla. *Candia Veneziana: Venetian Itineraries Through Crete*. Heraklion: Mystis, 2004.

Burckhardt, Jacob. *The Architecture of the Italian Renaissance*. Chicago: University of Chicago Press, 1987.

Burroughs, Charles. *The Italian Renaissance Palace Facade: Structures of Authority, Surfaces of Sense*. Cambridge: Cambridge University Press, 2002.

Cacciavillani, Ivone. *Lepanto*. Venice: Corbo and Fiore, 2003.

Calvelli, Lorenzo. *Cipro e la memoria dell'antico fra Medioevo e Rinascimento la percezione del passato romano dell'isola nel mondo occidentale*. Venice: Istituto Veneto di Scienze, Lettere ed Arti, 2009.

Candiani, Guido. "L'evoluzione della flotta veneziana durante la prima guerra di Morea." *SdV Storia di Venezia*, 2002.

———. "Francia, Papato e Venezia nella fase finale della guerra di Candia." *Atti dell'Istituto Veneto di Scienze, Lettere ed Arti* 152 (1993): 829–72.

———. "Stratégie et diplomatie vénitiennes: navires angle-hollandaises et blocus des Dardanelles, 1646–1659." *Revue d'histoire maritime* 9 (2008): 251–82.

———. *I vascelli della Serenissima: Guerra, politica e costruzioni navali a Venezia in età moderna, 1650–1720*. Venice: Istituto Veneto di Lettere, Scienze e Arti, 2009.

Canniffe, Eamonn. *The Politics of the Piazza: The History and Meaning of the Italian Square*. Aldershot, UK: Ashgate, 2008.

Canosa, Romano. *Lepanto: Storia della "Lega Santa" contro i Turchi*. Rome: Sapere, 2000.

Carter, Brett M. "Defending Renaissance Italy: The Innovative Culture of Italian Military Engineers." History Theses. Paper 65, Georgia State University, 2013.

Chambers, David S. *The Imperial Age of Venice, 1380–1580*. London: Thames and Hudson, 1970.

Chambers, David S., Cecil H. Clough, and Michael E. Mallett, eds. *War, Culture and Society in Renaissance Venice*. London: Hambledon, 1993.

Chambers, David S., and Brian Pullan, eds. *Venice: A Documentary History, 1450–1630*. Oxford: Blackwell, 1992.

Christakis, Giannis. *Historical Fortification Monuments of Crete (330 BC-1898)*. Heraklion: Kritika Letters, 2004.

Chrysa, Maltezou. "Crete During the Venetian Era (1211–1669)." In *Crete: History and Civilization*. Vol. B. Heraklion: Vikelaia Library, 1988.

Clogg, Richard. *A Concise History of Greece*. Cambridge: Cambridge University Press, 2002.

Clot, André. *Suleiman the Magnificent: The Man, His Life, His Epoch*. Milano: Fabbri, 1992.

Clutton, Elizabeth. "Political Conflict and Military Strategy: The Case of Crete as Exemplified by Basilicata's Relatione of 1630." *Transactions of the Institute of British Geographers* 3, no. 3 (1978): 274–84.

Cobham, Claude. *Excerpta Cypria*. Cambridge: 1908.

Coldstream, Nicola. *Nicosia: Gothic City to Venetian Fortress*. Nicosia: Anastasios G. Leventis Foundation, 1993.

Concina, Ennio. *L'Arsenale della Repubblica di Venezia*. Milan: Electa, 2004.

———. *Citta e fortezze nelle "tre isole nostre del Levante."* Venice: Arsenale Editrice, 1986.

Concina, Ennio, and Aliki Nikiforou-Testone, eds. *Corfu: History, Urban Space and Architecture, XIV-XIX Century*. Corfu, Greece: Cultural Society Korkyra, 1994.

Concina, Ennio, and Elisabetta Molteni. *"La fabrica della fortezza": L'architettura militare di Venezia*. Verona: Banca Popolare di Verona-Banco San Geminiano e San Prospero, 2001.

Costantini, Massimo, and Aliki Nikiforou, eds. *Levante veneziano: Aspetti di storia delle Isole Ione al tempo della Serenissima*. Rome: Bulzoni, 1996.

Coulanges, Foustel de. *The Ancient City. A Study on the Religion, Laws, and Institutions of Greece and Rome*. Baltimore: Johns Hopkins University Press, 1980.

Cozzi, Gaetano. "I rapporti tra stato e Chiesa." In *La chiesa di Venezia tra riforma protestante e riforma cattolica*, ed. Giuseppe Gullino, 11–36. Milan: Venezia, 1990.

Cozzi, Gaetano, Michael Knapton, and Giovanni Scarabello, eds. *La Repubblica di Venezia nell'eta moderna: Dal 1517 alla fine della Repubblica*. Turin: Utet, 1992.

Crevato Selvaggi, Bruno, ed. *Cefalonia e Itaca al tempo della Serenissima. Documentazione e Cartografia in biblioteche venete*. Milan: Biblion Edizione, 2013.

Croix, Horst de la. *Military Considerations in City Planning: Fortifications*. New York: George Brasilier, 1972.

———. "Palmanova: A Study of Sixteenth Century Urbanism." *Saggi e memorie di storia dell'arte* 5 (1966): 23–41.

Crouzet-Pavan, Elisabeth. *Venice Triumphant: The Horizons of a Myth*. Baltimore: Johns Hopkins University Press, 1999.

Curuni, Alessandro Spiridone, and Lucilla Donati.

Creta veneziana: L'Istituto Veneto e la Missione Cretese di Giuseppe Gerola: Collezione fotografica 1900-1902. Venice: Istituto Veneto di Scienze, Lettere ed Arti, 1988.

Da Mosto, Andrea. L'Archivio di Stato di Venezia. Indice generale, storico, descrittivo ed analitico. 2 vol. Venice: Archivio di Stato di Venezia, 1937–1940.

Davico, Micaela Viglino, ed. Fortrezze "alla moderna" e ingegneri militari del ducato sabaudo. Torino: Celid, 2005.

Davies, Paul, and David Hemsoll. Michele Sanmicheli. Milan: Electa, 2004.

Davies, Siriol, and Jack Davis, eds. Between Venice and Istanbul: Colonial Landscapes in Early Modern Greece. Hesperia Supplements. Vol. 40. Athens: The American School of Classical Studies at Athens, 2007.

Davis, Robert Charles. Esclaves chrétiens, maîtres musulmans: L'esclavage blanc en Méditerranée, 1500–1800. Arles: Actes Sud, 2006.

——. Shipbuilders of the Venetian Arsenal: Workers and Workplace in the Preindustrial City. Baltimore: Johns Hopkins University Press, 1991.

Del Negro, Piero. "La politica militare di Venezia e lo stato da mar nel Sei-Settecento." Studi veneziani 39 (2000): 113–22.

Del Torre, Giuseppe, and Alfredo Viggiano, eds. 1509–2009: L'ombra di Agnadello: Venezia e la terraferma. Venice: Ateneo Veneto, 2010.

Delbruck, Hans. The Dawn of Modern Warfare: History of the Art of War. Vol. 4. Lincoln: University of Nebraska Press, 1985.

Dickie, Iain, and Martin Dougherty, eds. Fighting Techniques of Naval Warfare: Strategy, Weapons, Commanders, and Ships: 1190 BC–Present. New York: Thomas Dunne Books, 2009.

Domini, Donatino, Marica Milanesi, and Maria Teresa Di Palma. Vincenzo Coronelli e l'imago mundi. Ravenna: Longo, 1998.

Duffy, Christopher. The Fortress in the Age of Vauban and Frederick the Great, 1660–1789. London: Routledge and Kegan Paul, 1985.

——. Siege Warfare: The Fortress in the Early Modern World, 1494–1660. London: Routledge and Kegan Paul, 1979.

Dursteler, Eric. Venetians in Constantinople. Baltimore: Johns Hopkins University Press, 2006.

Dursteler, Eric, ed. A Companion to Venetian History, 1400–1797. Leiden: Koninklijke Brill NV, 2013.

Enlart, Camille. L'architecture gothique et de la Renaissance en Chypre. Paris: Leroux, 1899.

Fantoni, Marcello, ed. Il "Perfetto Capitano": Immagini e realtà (secoli XV–XVII). Rome: Bulzoni, 2001.

Ferraro, Joanne. Venice: History of the Floating City. Cambridge: Cambridge University Press, 2012.

Finotti, Franco, Barbara Maurina, and Elena Sorge. Orsi, Halbherr, Gerola: l'archeologia italiana nel Mediterraneo. Rovereto: Museo civico, 2010.

Fortini Brown, Patricia. Art and Life in Renaissance Venice. Upper Saddle River, NJ: Pearson Prentice Hall, 2005.

Fotheringham, John Knight. Marco Sanudo. Conqueror of the Archipelago. Oxford: Clarendon Press, 1915.

Freitag, Ulrike, Malte Fuhrmann, Nora Lafi, and Florian Riedler, eds. The City in the Ottoman Empire: Migration and the Making of Urban Modernity. New York: Routledge, 2011.

Gamberini, Andrea, and Isabella Lazzarini, eds. The Italian Renaissance State. Cambridge: Cambridge University Press, 2012.

Gerola, Giuseppe. "Appunti sui monumenti Veneti di Cefalonia e di Corfu." Atti del R. Ist. Veneto. 1908.

——. Monumenti veneti nell'isola di Creta: Ricerche e descrizioni fatte dal dottor Giuseppe Gerola per incarico del R. Istituto Veneto di Scienze, Lettere ed Arti. 5 vols. Venice: Real Istituto Veneto di Scienze, Lettere ed Arti, 1905–1931.

Gertwagen, Ruth. The Contribution of Venice's Colonies to Its Naval Warfare in the Eastern Mediterranean in the Fifteenth Century. Palermo: Rossella Cancila, 2007.

Glete, Jan. Warfare at Sea, 1500–1650: Maritime Conflicts and the Transformation of Europe. London: Routledge, 2000.

Grant, R. G. Battle at Sea: 3000 Years of Naval Warfare. London: Dorling Kindersley Limited, 2011.

Greene, Molly. "Beyond the Northern Invasion: The Mediterranean in the Seventeenth Century." Past and Present 174 (2002): 42–71.

——. A Shared World: Christians and Muslims in the Early Modern Mediterranean. Princeton, NJ: Princeton University Press, 2009.

Grivaud, Gilles. "Aux Confins de l'Empire Colonial Vénitien: Nicosie et ses Fortifications (1567–1568)." EKEE (Nicosia) 13–16, 1 (1987): 269–79.

Guilmartin, John Francis. Gunpowder and Galleys: Changing Technology and Mediterranean Warfare at Sea in the 16th Century. Cambridge: Cambridge University Press, 2004.

——. "Ideology and Conflict: The Wars of the Ottoman Empire, 1453–1606." The Journal of Interdisciplinary History 18, no. 4 (1988): 721–47.

Hale, John Rigby. L'organizzazione militare di Venezia nel Cinquecento. Rome: Jouvence, 1990.

——. Renaissance Fortification: Art or Engineering? London: Thames and Hudson, 1977.

——. Renaissance War Studies. London: Hambledon, 1983.

——. War and Society in Renaissance Europe, 1450–1620. Kingston, ON: McGill–Queen's University Press, 1998.

Hale, John Rigby, ed. Renaissance Venice. Totowa, NJ: Rowman and Littlefield, 1973.

Hall, Bert. Weapons and Warfare in Renaissance Europe: Gunpowder, Technology, and Tactics. Baltimore: Johns Hopkins University Press, 1997.

Hanlon, Gregory. The Twilight of a Military Tradition: Italian Aristocrats and European Conflicts, 1560–1800. London: University College London Press, 1998.

Harding, Richard. *Seapower and Naval Warfare, 1650–1830*. London: University College London Press, 1999.

Hogarth, David George. *Devia Cypria: Notes on an Archaeological Journey in Cyprus in 1888*. London: H. Frowde, 1889.

Holland, Robert, and Diana Markides. *The British and the Hellenes: Struggles for Mastery in the Eastern Mediterranean, 1850–1960*. Oxford: Oxford University Press, 2006.

Holton, David, ed. *Literature and Society in Renaissance Crete*. Cambridge: Cambridge University Press, 1991.

Howard, Deborah. *Venice Disputed: Marc'Antonio Barbaro and Venetian Architecture, 1550–1600*. New Haven, CT: Yale University Press, 2011.

Jacoby, David. "Byzantium After the Fourth Crusade: The Latin Empire of Constantinople and the Frankish States in Greece." In *The New Cambridge Medieval History Vol. 5, c. 1198–c. 1300*, ed. David Abulafia, 525–42. Cambridge: Cambridge University Press, 1999.

_____. *Byzantium, Latin Romania and the Mediterranean*. Aldershot, UK: Ashgate, 2001.

_____. "Changing Economic Patterns in Latin Romania: The Impact of the West." In *The Crusades from the Perspective of Byzantium and the Muslim World*, ed. Angeliki Laiou and Roy Parviz, 197–233. Washington, D.C.: Dumbarton Oaks Research Library and Collection, 2001.

_____. "The Encounter of Two Societies: Western Conquerors and Byzantines in the Peloponnesos After the Fourth Crusade." *American Historical Review* 78 (1973): 873–906.

_____. "Italian Migration and Settlement in Latin Greece: The Impact on the Economy." *Schriften des Historischen Kollegs, Kolloquien* 37 (Munich) (1997): 97–127.

_____. *Recherches sur la Méditerranée orientale du XIIe au XVe siècle*. London: Variorum Reprints, 1979.

Jaques, Tony. *Dictionary of Battles and Sieges*. Westport, CT: Greenwood Press, 2007.

Jeffery, George. *A Description of The Historic Monuments of Cyprus*. Nicosia: Government Printing Office, 1918.

Kalligas, A.S., and Aristidis Romanos. *The Medieval City of Chania. Study of preservation of the city of Chania*. Athens: 1977.

Katele, Irene. "Piracy and the Venetian State: The Dilemma of Maritime Defense in the Fourteenth Century." *Speculum* 63, no. 4 (1988): 865–89.

Kingra, Mahinder. "The Trace Italienne and the Military Revolution During the Eighty Years' War, 1567–1648." *The Journal of Military History* 57, no. 3 (1993): 431–46.

Kitromilides, Paschalis, and Dimitris Arvanitakis. *The Greek World Under Ottoman and Western Domination*. Athens: Hellenic Museums Shop, 2008.

Kittell, Ellen, and Thomas Madden. *Medieval and Renaissance Venice*. Champaign: University of Illinois Press, 1999.

Konstam, Angus. *Lepanto 1571*. London: Osprey, 2003.

_____. *Renaissance War Galley 1470–1590*. London: Osprey, 2002.

Kretschmayr, Heinrich. *Geschichte von Venedig*. Stuttgart: Scientia Verlag, 1964.

Kruft, Hanno-Walter. *History of Architectural Theory*. London: Princeton Architectural Press, 1994.

Lane, Frederic C. *History of Venice*. Turin: Einaudi, 1978.

_____. "Venetian Merchant Galleys, 1300–1334: Private and Communal Operation." *Speculum* 38, no. 2 (1963): 179–205.

_____. "Venetian Shipping During the Commercial Revolution." *The American Historical Review* 38, no. 2 (1933): 219–39.

_____. *Venice. A Maritime Republic*. Baltimore: Johns Hopkins University Press, 1973.

Langdale, Allan. *In a Contested Realm: An Illustrated Guide to the Archaeology and Historical Architecture of Northern Cyprus*. London: Grimsay Press, 2012.

Larivière, Claire Judde de. *Naviguer, commercer, gouverner: Économie maritime et pouvoirs à Venise (XVe–XVIe siècles)*. Leiden: Koninklijke Brill NV, 2008.

Law, John. *Venice and the Veneto*. Aldershot, UK: Ashgate, 2000.

Lepage, Jean-Denis. *French Fortifications, 1715–1815*. Jefferson, NC: McFarland, 2010.

_____. *Vauban and the French Military Under Louis XIV*. Jefferson, NC: McFarland, 2010.

Leventis, Panos. "Projecting Utopia: The Refortification of Nicosia, 1567–1570." In *Chora: Intervals in the Philosophy of Architecture*, vol. 5, ed. Stephen Parcell and Alberto Pérez Gómes, 227–58. Montreal, Quebec: McGill–Queen's University Press, 2007.

_____. *Twelve Times in Nicosia: Nicosia, Cyprus, 1192–1570: Topography, Architecture and Urban Experience in a Diversified Capital City*. Nicosia: Cyprus Research Center, 2005.

Lock, Peter. "The Frankish Towers of Central Greece." *The Annual of the British School at Athens* 81 (1986): 101–23.

_____. *The Franks in the Aegean, 1204–1500*. London: Longman, 1995.

Lucchi, Piero, and Camillo Tonini, eds. *Navigare e descrivere: Isolari e portolani del Museo Correr di Venezia XV–XVIII secolo*. Venice: Marsilio, 2001.

Luttrell, Anthony. *The Hospitallers in Cyprus, Rhodes, Greece and the West: 1291–1440*. London: Variorum, 1978.

Malkin, Irad, and Robert Hohlfelder. *Mediterranean Cities: Historical Perspectives*. London: Frank Cass, 1988.

Mallett, Michael, and John Hale. *The Military Organization of a Renaissance State: Venice c. 1400 to 1617*. Cambridge: Cambridge University Press, 1984.

Marini, Luigi. *Biblioteca istorico-critica di fortificazione permanente*. Roma: 1810.
Martin, John Jeffries, and Dennis Romano, eds. *Venice Reconsidered: The History and Civilization of an Italian City-State, 1297–1797*. Baltimore: Johns Hopkins University Press, 2000.
McAndrew, John. *Venetian Architecture of the Early Renaissance*. Boston: MIT Press, 1980.
McKee, Sally. "Households in Fourteenth-Century Venetian Crete." *Speculum* 70, no. 1 (1995): 27–67.
———. "Inherited Status and Slavery in Late Medieval Italy and Venetian Crete." *Past and Present* 182 (2004): 31–53.
———. "Women Under Venetian Colonial Rule in the Early Renaissance: Observations on Their Economic Activities." *Renaissance Quarterly* 51, no. 1 (1998): 34–67.
Miller, William. "The Ionian Islands Under Venetian Rule." *The English Historical Review* 18, no. 70 (April 1903): 209–39.
———. *The Latins in the Levant: A History of Frankish Greece (1204–1566)*. New York: E. P. Dutton, 1908.
Mocenigo, Mario Nani. *Storia della marina veneziana: Da Lepanto alla caduta della Repubblica*. Venice: Filippi, 1935.
Moffett, Marian, Michael Fazio, and Lawrence Wodehouse. *Buildings Across Time: An Introduction to World Architecture*. London: Laurence King, 2003.
Molin, Kristian. *Unknown Crusader Castles*. New York: Hambledon, 2001.
Molteni, Elisabetta. "Le cinte murarie urbane. Innovazioni tecniche per un tema antico." In Donatella Calabi, Elena Svalduz, eds., *Il Rinascimento italiano e l'Europa. Vol 6. Luoghi, spazi, architetture*. Treviso: Fondazione Cassamarca-Costabissara Colla, 2010, pp. 41–62.
Molteni, Elisabetta, and Silvia Moretti. *Fortezze veneziane nel Levante: esempi di cartografia storica dalle collezioni del Museo Correr*. Venice: Musei Civici Veneziani, 1999.
Molteni, Elisabetta, and Silvia Moretti. "Maps and Drawings of Corfu in the Library of the Museo Correr." *e-Perimetron* 1, no. 1 (Winter 2006).
Morin, Marco. "La battaglia di Lepanto: Alcuni aspetti della tecnologia navale Veneziana." *SdV Storia di Venezia*, 2003.
Mugnai, Bruno, and Alberto Secco. *La guerra di Candia 1645–1669*. Milan: Soldiershop, 2012.
Murray, Peter. *The Architecture of the Italian Renaissance*. Chicago: University of Chicago Press, 1987.
Nicol, Donald M. *Byzantium and Venice: A Study in Diplomatic and Cultural Relations*. Cambridge: Cambridge University Press, 1992.
Nicolle, David. *The Fourth Crusade 1202–04: The Betrayal of Byzantium*. London: Osprey, 2011.
———. *Ottoman Fortifications 1300–1710*. London: Osprey, 2010.
———. *The Venetian Empire, 1200–1700*. London: Osprey, 1989.
Nossov, Konstantin. *The Fortress of Rhodes 1309–1522*. London: Osprey, 2010.
O'Connell, Monique. *Men of Empire: Power and Negotiation in Venice's Maritime State*. Baltimore: Johns Hopkins University Press, 2009.
———. "The Venetian Patriciate in the Mediterranean: Legal Identity and Lineage in Fifteenth-Century Venetian Crete." *Renaissance Quarterly* 57, no. 2 (2004): 466–93.
Ortalli, Gherardo, ed. *Venezia e Creta: Atti del Convegno internazionale di studi, Iraklion-Chanià*. Venice: Istituto Veneto di Scienze, Lettere ed Arti, 1998.
Panayotakis, Nikolaou, ed. *Crete: History and Civilization*. Herakleion: Vikelaia Library, 1988.
Parker, Geoffrey. *The Military Revolution: Military Innovation and the Rise of the West, 1500–1800*. Cambridge: Cambridge University Press, 1988.
Pavan, Gino, ed. *Palmanova fortezza d'Europa, 1593–1993*. Venice: Marsilio, 1993.
Pemble, John. *Venice Rediscovered*. Oxford: Oxford University Press, 1995.
Pepper, Simon. "The Meaning of the Renaissance Fortress." *Architectural Association Quarterly* 2 (1973): 21–28.
———. "Sword and Spade: Military Construction in Renaissance Italy." *Construction History* 16 (2000): 13–32.
Pepper, Simon, and Nicholas Adams. *Firearms and Fortifications: Military Architecture and Siege Warfare in Sixteenth-Century Siena*. Chicago: University of Chicago Press, 1986.
Perbellini, Gianni. *The Fortress of Nicosia: Prototype of European Renaissance Military Architecture*. Nicosia: Anastasios G. Leventis Foundation, 1994.
Perbellini, Gianni, ed. *Cipro, la dote di Venezia: Eredità della Serenissima e ponte verso l'Oriente*. Milan: Biblion Edizioni, 2011.
———. "The Evaluation of the Walled Towns: Kotor and Heraklion." *Europa Nostra Scientific Bulletin* 56–57 (2003).
———. "Management of the Monumental Environment and Its Landmarks." *Europa Nostra Scientific Bulletin* 64 (2010).
Pestalozzi, Anton. *Auf den Spuren von General Johann Rudolf Werdmüller in der Ägäis 1664–1667*. Zurich: Kommissionsverlag Berichthaus, 1973.
Pickles, Tim. *Malta 1565: Last Battle of the Crusades*. London: Osprey, 1998.
Pollak, Martha. *Cities at War in Early Modern Europe*. Cambridge: Cambridge University Press, 2010.
Porfyriou, Heleni. "The Cartography of Crete in the First Half of the 17th Century: A Collective Work of a Generation of Engineers." *Eastern Mediterranean Cartographies. Tetradia Ergasias* 25/26 (2004): 65–92.
Pryor, John, and Elizabeth Jeffreys. *The Age of the Dromon: The Byzantine Navy ca. 500–1204*. Leiden: Brill, 2006.
Pullan, Brian. *Crisis and Change in the Venetian Econ-*

omy in the Sixteenth and Seventeenth Centuries. London: Methuen, 1968.

Ravegnani, Giorgio. *Bisanzio e Venezia*. Bologna: Il Mulino, 2006.

———. *Il doge di Venezia*. Bologna: Il Mulino, 2013.

Redolfi, Maddalena, ed. *Venezia e la difesa del Levante: Da Lepanto a Candia 1570–1670*. Venice: Arsenale, 1986.

Ricci, Amico. *Storia dell'architettura in Italia del secolo IV al XVIII*. Modena: 1857.

Rigoli, Paolo. "Gli ultimi anni di Schulenburg a Verona." *Verona illustrata* 11 (1998): 31–56.

Rizzi, Alberto. *I leoni di San Marco: il simbolo della Repubblica Veneta nella scultura e nella pittura*. Venice: Arsenale Editrice, 2001.

Roessel, David. *In Byron's Shadow: Modern Greece in the English and American Imagination*. New York: Oxford University Press, 2002.

Rothenberg, Gunther E. "Venice and the Uskoks of Senj: 1537–1618." *The Journal of Modern History* 33, no. 2 (1961): 148–56.

Rothman, Natalie. *Brokering Empire: Trans-Imperial Subjects Between Venice and Istanbul*. New York: Cornell University Press, 2012.

———. "Interpreting Dragomans: Boundaries and Crossings in the Early Modern Mediterranean." *Comparative Studies in Society and History* 51, no. 4 (2009): 771–800.

Ruskin, John. *The Stones of Venice*. 3 vols. London: Smith, Elder, 1851–1853.

Salvarani, Renata. "Creta, le origini della colonizzazione veneziana." *Medioevo*, December 2005.

Schmidt, Hans. "Il salvatore di Corfù. Johann Matthias von der Schulemburg." *Quaderni del Centro tedesco di studi veneziani* 42 (1991): 3–29.

Scroccaro, Mauro, ed. *Dalle torri ai forti : itinerari tra le strutture difensive dell'Alto Adriatico*. Venice: Regione del Veneto, Marco Polo System, 2014.

Scroccaro, Mauro, ed. *Isole Ionie e Cicladi: Venezia tra Repubblica e feudalità*. Milan: Biblion, 2011.

Scroccaro, Mauro, and Michalis Andrianakis, eds. *Candia e Cipro: Le due isole "maggiori" di Venezia*. Milan: Biblion Edizioni, 2010.

Setton, Kenneth. *The Papacy and the Levant 1204–1571*. Vol. 4., *1551–1571*. Philadelphia: The American Philosophical Society, 1984.

———. *Venice, Austria and the Turks in the Seventeenth Century*. Philadelphia: The American Philosophical Society, 1991.

Shepherd, William. *Historical Atlas*. New York: Henry Holt, 1923.

Skoufari, Evangelia. *Cipro veneziana (1473–1571): Istituzioni e culture nel regno della serenissima*. Rome: Viella, 2011.

Skoufari, Evangelia, ed. *La Serenissima a Cipro: Incontri di culture nel Cinquecento*. Rome: Viella, 2013.

Spanakis, Stergios. "Relatione del. prov(r) genal dell'armi in Candia E. Antonio Priuli 1667, 30 Marzo." *Monuments of Cretan History* 6 (1969).

Spratt, Thomas Abel Brimage. *Travels and Researches in Crete*. London: John Van Voorst, 1865.

Steriotou, Ioanna. "Management of Fortifications in Greece: Projects of Restoration and Renovation-Rehabilitation." *Europa Nostra* 64 (2010): 19–31.

———. "The Venetian Walls of Chandax in the XVI–XVII Century," *Europa Nostra* 56–57 (2003): 42–56.

Stouraiti, Anastasia. "Colonial Mapping and Local Knowledge in the Venetian Empire, 1684–1715." *EUI Working Paper MWP* 15 (2008).

———. "Costruendo un luogo della memoria: Lepanto." *Storia di Venezia* 1 (2003): 65–88.

———. "Propaganda figurata: Geometrie di dominio e ideologie veneziane nelle carte di Vincenzo Coronelli." *Studi veneziani* 44 (2002): 129–55.

Stouraiti, Anastasia, and Mario Infelise, eds. *Venezia e la guerra di Morea: Guerra, politica e cultura alla fine del '600*. Milano: Franco Angeli, 2005.

Stubbs, John H., and Emily G. Makas. *Architectural Conservation in Europe and the Americas: National Experiences and Practice*. Hoboken, NJ: John Wiley and Sons, 2011.

Syndikus, Candida, and Sabine Rogge. *Caterina Cornaro: Last Queen of Cyprus and Daughter of Venice*. Munster: Waxman Verlag, 2013.

Tafuri, Manfredo. *Venice and the Renaissance*. Boston: MIT Press, 1995.

Tenenti, Alberto. *Piracy and the Decline of Venice, 1580–1615*. Berkeley: University of California Press, 1967.

Thiriet, Freddy. *Etudes sur la Romanie greco-vénitienne (Xe–XVe siècles)*. Reprint. London: Variorum, 1977.

Thomson, John. *Through Cyprus with the Camera: In the autumn of 1878*. London: Sampson Low, Marston, Searle, and Rivington, 1879.

Tonini, Camillo, and Giandomenico Romanelli, eds. *Corfu "Perla del Levante": Documenti, mappe e disegni del Museo Correr*. Milan: Biblion Edizioni, 2010.

Tsitouri, Amalia, and Anna Triposkoufi, eds. *Venetians and Knights Hospitallers: Military Architecture Networks*. Athens: Hellenic Ministry of Culture, 2002.

Tsougarakis, Dimitris. *Byzantine Crete: From the 5th Century to the Venetian Conquest*. Athens: S. D. Basilopoulos Historical Publications, 1988.

Tucker, Stephen C. *Battles that Changed History: An Encyclopedia of World Conflict*. Santa Barbara, CA: ABC-Clio, 2011.

Turnbull, Stephen R. *The Art of Renaissance Warfare: From the Fall of Constantinople to the Thirty Years' War*. London: Greenhill, 2006.

Tzivara, Panagiota, and Spyros Karydis. *L'Archivio dei Provveditori Generali da Mar. Alla ricerca delle sue tracce*. Athens: Enalios, 2012.

Viallon, Marie. *Venise et la porte Ottomane (1453–1566): Un siècle de relations véneto-ottomanes, de la prise de Constantinople à la mort de Soliman*. Paris: Economica, 1995.

Vigano, Marino. *"El fratin mi ynginiero": I Paleari*

Fratino da Morcote ingegneri militari ticinesi in Spagna (XVI–XVII secolo). Bellinzona: Edizioni Casagrande, 2004.

Viollet-le-Duc, Eugène. *Histoire d'une forteresse*. Paris: 1874.

Walsh, Michael, J. K. Nicholas Coureas, and Peter W. Edbury, eds. *Medieval and Renaissance Famagusta: Studies in Architecture, Art and History*. London: Ashgate, 2012.

Whyte-Jervis, Henry. *The Ionian Islands During the Present Century*. London: Chapman and Hall, 1863.

Woodward, David, ed. *The History of Cartography*. Volume 3: *Cartography in the European Renaissance*. Chicago: University of Chicago Press, 2007.

Index

Acre 39, 53
Agnadello 14, 15, 203
Alexandria 20, 39, 173, 180
Amalfi 12, 13, 209
Andrews, Kevin 8, 115, 125
Antivari 179
Archipelago 16, 78, 191, 203
Athens 190, 204, 210*n*26, 215*ch*10*n*6, 216*ch*13*n*6
Austria 8, 36, 41, 186, 194, 209

Baffo 40, 41, 51
Bailo 17, 19, 139, 171, 180
Barbarigo, Agostino 196
Barbaro, Antonio 186, 196
Barbarossa, Hayreddin 78, 129
Basilicata, Francesco 7, 85, 115
Beaufort, Duke of 188, 195, 196
Behaedin, Rahmizade 96, 131
Bergamo 5, 6, 14–16, 203
Birgu 30, 47, 59, 174, 212*ch*5*n*2
Boschini, Marco 7, 85, 115
Bragadin, Marcantonio 175–177, 196, 201, 216*n*32
Brescia 14, 203
Buffavento 40, 53

Candia 6, 7, 10, 30–33, 36, 37, 78, 79, 107–109, 117, 119, 128, 174, 176, 182, 196, 200, 208, 212*ch*5*n*2, 212*ch*5*n*7, 215*ch*10*n*10; barracks 87, 88; bastions 28, 29, 47, 64, 65, 93–108, 117, 122, 123, 133, 159, 187, 196; cavaliers 29, 48, 95, 96, 101, 102, 106, 117, 135, 153; churches 86, 88, 104, 106, 110, 129, 144, 159, 196; fountains 88, 89; gates 30, 38, 50, 86, 90, 93–96, 98–100, 102–104, 107, 123, 145, 159, 196, 211*ch*4*n*18; harbor 20, 89–93, 95, 107, 111, 134, 196; loggia 17, 86–88, 129, 144, 213*n*11; outworks 9, 27, 31, 32, 49, 95–98, 100, 102, 105; palaces 128, 214*ch*9*n*2; siege 9, 102, 184–188, 196, 201, 204

Candia, island 7, 9, 18, 20–22, 45, 74–84, 109, 137, 139, 170–173, 180–189, 192, 204, 212*ch*5*n*2, 213*ch*6*n*14
Canea 5, 10, 34, 36, 76–79, 109–110, 115, 128, 137, 159, 200, 208, 212*ch*5*n*2, 213*ch*6*n*25; barracks 87, 117–119, 126; bastions 35, 38, 90, 96, 102, 106, 115–127, 133, 183; cavaliers 29, 47, 65, 117, 119–123, 125, 153; churches 110, 129; fountains 113; gates 38, 86, 113, 114, 123, 125, 131, 183; harbor 20, 38, 89, 90, 110, 111, 117; loggia 113; outworks 117; palaces 110, 113, 128, 214*ch*9*n*2; siege 77, 180–183, 185, 191, 204
Capitano generale da Mar 23, 186, 190, 206
Castelfranco 77, 78, 119
Castelnuovo 190
Cattaro 10, 14, 20, 22, 45, 129, 190, 203
Cefalonia 10, 151, 171
Cerigo 10, 79, 176, 188, 193
Cerigotto 79
Cerines 10, 30, 35, 40, 41, 63, 71–73, 94, 119, 133, 134, 166, 174, 199, 200, 204, 208
Cherso 129
Chioggia 6, 12, 13, 79, 203
Chios 12, 41, 59, 170, 191
Chissamo 76–78, 80, 84, 184, 204
Constantinople 12, 13, 17, 18, 20, 45, 74, 76, 170–172, 176, 177, 180, 185, 203, 209*n*5, 215*ch*10*n*6
Corfu 5, 7, 10, 34–37, 45, 133, 137, 196, 200, 213*ch*6*n*28, 215*ch*10*n*15, 216*ch*14*n*7; barracks 23, 87, 145, 146, 156, 164; bastions 28, 29, 35, 48, 59, 65, 73, 81, 101, 117, 123, 134, 147, 150–167, 193–195, 215*ch*10*n*16; cavaliers 29, 148, 149, 153, 166; churches 86, 88, 144, 148, 160,

178, 215*ch*10*n*6; fountains 89, 145, 153; gates 23, 30, 31, 37, 86, 103, 106, 123, 145, 151, 156–159, 162, 168, 215*ch*10*n*11; harbor 20, 144–146, 156; loggia 129, 144, 190; outworks 27, 30, 31, 49, 57, 158–161, 167, 168, 193–194; palaces 110, 119, 128, 143, 144, 153; siege 9, 78, 139, 172, 174, 193–194, 204–205
Corfu, island 5, 9, 14, 20, 23, 37, 38, 42, 115, 139–142, 146, 155, 173, 176, 182, 193–197, 201, 203, 204, 213*ch*6*n*15
Cornaro, Andrea 183
Cornaro, Caterina 40, 199, 203
Corner, Giorgio 7, 85, 86, 115
Coron 10, 13, 20, 45, 171, 190, 203, 204
Coronelli, Vincenzo 7, 34, 85, 91, 94, 102, 115–117, 125, 147, 149, 158, 162, 192
Crete *see* Candia, island
Cyprus 1, 3, 5, 13–16, 18, 20, 23, 30, 36–46, 52–55, 63, 73, 75, 79–82, 110, 115, 119, 140, 159, 166, 170, 171, 173–176, 179, 196, 199, 201, 203–205, 208, 210*n*26, 211*ch*4*n*1, 212*n*15

Dalmatia 10, 13–16, 22, 23, 36, 37, 86, 90, 111, 140, 159, 169, 188, 191, 203, 204, 207, 213*ch*7*n*21, 216*ch*13*n*9
Dandolo, Enrico 13, 215*ch*9*n*12
Dandolo, Niccolò 173, 174
Dandolo, tower 140–142, 213*ch*6*n*15, 215*ch*9*n*12
Dardanelles 21, 173, 176, 181, 185, 186, 197, 204, 216*n*20
Dulcigno 14, 179, 194
Durazzo 171, 203

Famagosta 7, 9, 10, 14, 31, 40, 43, 53, 77, 108, 199, 208, 212*ch*5*n*4, 212*ch*5*n*15, 216*n*32; bastions 29, 41, 55–68, 73, 92, 99, 101, 134,

225

135, 156; cavaliers 29, 56, 59, 61, 64, 65, 68, 83, 117, 121, 122, 153; churches 37, 39, 43, 54, 55, 214n41; gates 30, 59, 62, 63, 67–69; harbor 20, 61; outworks 31, 68; palaces 25, 55; siege 173–177, 184, 196, 201, 204
Fer, Antoine de 96, 102, 188
Ferrara 58, 173, 178
Florence 14, 25, 36, 173, 178
France 8, 14–19, 22, 25, 26, 32, 41–46, 55, 76, 82, 102, 140, 144, 161, 172, 179–183, 186–188, 196–199, 203–205, 213ch6n28, 215–216n5
Frankokratia 18, 41, 139, 210n26
Friuli 14, 16, 46

Genoa 12–14, 39, 53, 73, 74, 76, 85, 90, 109, 118–120, 170–173, 178, 203
Gerola, Giuseppe 7, 8, 37, 75, 77, 80–84, 90, 92, 93, 96, 97, 100, 103–108, 110, 111, 113–115, 119, 123–126, 129, 131–134, 137, 138, 142, 151, 186, 190, 200, 212ptIIIn6, 213ch7n12, 214ch9n2, 215ch10n10
Girapetra 10, 76–78, 84, 184, 204
Govino 20, 146, 193
Grabusa 10, 37, 79, 80, 172, 184, 188, 204

Hospitaller Knights 24, 30, 40, 45, 102, 113, 115, 170, 175, 176, 180, 181, 203, 209, 214n42

Istria 14, 16, 22, 23, 36, 37, 140, 169, 207

Kantara 40, 53
Königsmarck, Otto Wilhelm 23, 190
Koprulu, Ahmed 186, 187
Kronenburg, Karl von 23, 151

Lemnos 171, 185, 203
Lepanto 3, 10, 15, 21, 144, 170, 171, 174, 176, 178–181, 186, 190, 191, 196, 197, 201, 203, 204, 215ch11n17, 216ch13n2
Lesbos 12, 170
Lesina 10, 17, 20, 90, 111, 129
Limisso 10, 40, 41, 173, 174
Lorini, Buonaiuto 6, 27, 28, 36, 102, 104
Lucca 5, 178
Ludovisi, Niccolo 181, 182, 185
Lusignan, dynasty 39, 40, 43, 45, 55, 63, 71–73, 174, 203

Maggi, Girolamo 6, 36
Malta 41, 42, 45, 60, 74, 76, 90, 110, 140, 157, 170, 173, 179–181, 193, 203, 204, 212ch5n2

Malvasia 3, 10, 24, 45, 171, 172, 191, 203
Marati 82, 204
Mocenigo, Aloisio 77, 183
Mocenigo, Lazzaro 23, 185, 186, 196, 216n20
Modon 10, 13, 20, 45, 133, 138, 171, 184, 190, 192, 203
Montferrat, Boniface of 13, 74
Morea 10, 14–16, 20, 23, 24, 41, 79, 80, 138, 139, 169, 172, 180, 185, 186, 189–197, 204, 205
Morosini, Francesco 3, 23, 87, 144, 145, 151, 186, 188, 190, 191, 195, 196, 201
Morosini, Tommaso 23, 185

Napoli di Romania 10, 24, 45, 133, 169, 171, 172, 190–193, 203, 214n21
Navarino 10, 133, 171, 180, 190, 203
Naxos 16, 78, 172, 185, 203, 204
Negroponte 7, 10, 14, 16, 41, 88, 171, 190, 196, 203
Nicosia 27, 30, 37, 40, 41, 71, 108, 127, 199–201, 204, 208, 211ch4n12; bastions 45–52, 64, 95–97, 133, 174, 212ch5n12; cavaliers 48; churches 39, 43, 47, 55, 86, 100, 121; gates 49–51, 94, 100, 103, 125; outworks 9, 49; palaces 43, 51, 214ch8n2; siege 173–176, 204

Padua 14, 15, 44, 58, 93, 110, 113, 128, 144, 196, 203, 212n16
Palamidi 27, 192
Paleocastro 79, 184, 204
Pallavicini, Sforza 37, 132
Palmanova 6, 27, 37, 46
Paruta, Paolo 6, 176
Peloponnesus see Morea
Pescatore, Enrico 74, 76, 85, 109, 203, 213ch6n14
Pisa 12, 13
Preveza 24, 41, 45, 115, 172, 194, 197, 204, 213ch6n21
Provveditore 17, 25, 55, 75, 87, 139, 148, 153, 186, 196, 207

Ragusa 10, 14, 90, 213ch7n21
Ravenna 12, 16, 209
Retimo 5, 10, 29, 36, 37, 38, 76–79, 183, 200, 208, 215ch10n10; barracks 131; bastions 36, 92, 129, 133–138, 157; cavaliers 135; churches 129, 133; fountains 88, 119; gates 30, 57, 131, 133, 134; harbor 129, 138; loggia 17, 129, 144; palaces 110, 128, 133; siege 183, 184, 204
Rhodes 24, 26, 29–31, 35, 40, 43, 44, 57, 60, 67, 72, 73, 85, 86, 92, 93, 104, 113, 115, 119, 126, 127, 134, 137, 170, 174, 175, 185,

203, 210ch3n11, 212ch5n7, 213ch7n30
St. Hillarion 40, 53, 71
San Teodoro 79, 119, 181, 184, 204
Sangallo, Antonio da 26, 35
Sanmicheli, Gian Girolamo 36, 37, 53, 64, 151, 204
Sanmicheli, Michele 17, 36, 46, 53, 93, 98, 102, 109, 115, 129, 131, 149, 151, 159, 199, 204
Santa Maura 10, 127, 171, 190–193, 204
Savorgnan, Giulio 36, 37, 45, 46, 93, 104, 115, 199, 204
Schulenburg, Johann Matthias von 23, 140, 145, 150, 153, 160, 193–196, 201
Sebenico 10, 36, 54, 159, 203
Selino 77, 78, 184
Senglea 58, 90, 136
Sicily 12, 43, 76, 173, 178
Sitia 36, 77, 78, 84, 204
Spalato 10, 14, 22, 86, 196, 203
Spinalonga 6, 7, 27, 37, 79–84, 150, 154, 155, 184, 188, 193, 200, 204, 205
Stato da Mar 2, 3, 7, 15, 16, 20, 38, 115, 139, 207, 213ch6n28
Stato da Terra see Terraferma
Suda 7, 10, 37, 79–84, 173, 182–184, 188, 193, 200, 204, 205

Tenedos 13, 185
Terraferma 6, 14–16, 22, 23, 36, 110, 113, 171, 209n12
Thompson, John 7, 44, 61
Tine 10, 16, 78, 172, 188, 193, 204, 205
Trau 14, 22, 129

Udine 113, 129

Valderio, Pietro 6, 177, 216n32
Valletta 22, 45–48, 80, 101, 117, 135, 136, 153, 200, 214n34
Vauban, Sébastien Le Prestre de 26, 32, 82, 161, 186
Verneda, Filippo 37, 140
Verona 5, 14, 33, 36, 44, 93, 102, 110, 113, 117, 128, 139, 144, 159, 194, 196, 203, 212n16
Vicenza 14, 44, 110, 113, 128, 203
Vido 79, 161
Vitelli, Ferrante 37, 140, 159, 161, 204, 213ch6n28

Werdmüller, Hans Rudolf 85

Zane, Francesco 173, 176
Zante 7, 10, 171, 179, 182, 191, 215ch11n19
Zara 10, 13, 14, 17, 20, 22, 36, 54, 86, 129, 133, 145, 159, 194, 196, 203
Zonchio 171, 197, 203

www.ingramcontent.com/pod-product-compliance
Lightning Source LLC
Chambersburg PA
CBHW081552300426
44116CB00015B/2846